Clarence Major and His Art

Clarence Major

AND HIS ART

Portraits of an
African American
Postmodernist

Edited by
Bernard W. Bell

The University
of North Carolina
Press | Chapel Hill
and London

© 2001 The University of North Carolina Press

All rights reserved

Manufactured in the United States of America

Designed by April Leidig-Higgins

Set in Minion by Keystone Typesetting, Inc.

The paper in this book meets the guidelines for permanence and durability of the Committee on Production Guidelines for Book Longevity of the Council on Library Resources.

Library of Congress Cataloging-in-Publication Data

Clarence Major and his art : portraits of an African American postmodernist / edited by Bernard W. Bell.

p. cm.

Includes bibliographical references and index.

ISBN 0-8078-2586-7 (cloth: alk. paper)

ISBN 0-8078-4899-9 (pbk.: alk. paper)

1. Major, Clarence—Criticism and interpretation.

2. Postmodernism—United States. I. Bell, Bernard W.

N6537.M337 A4 2001 700'.92—dc21 00-041775

05 04 03 02 01 5 4 3 2 1

Clarence Major's paintings are reproduced by permission of Clarence Major.

Contents

PAINTINGS

Acknowledgments

A thousand thanks to all those who have labored long and diligently to help bring this book to completion: to Clarence Major, whose talent, generosity, enthusiasm, and support for this project have been seminal and substantive; to Joe Weixlmann, whose support as editor of the *African American Review* was invaluable in publishing a special issue of that journal on Clarence Major; to the contributors to the earlier special issue as well as this book for their critical intelligence and cooperation; to my indispensable research assistants—Susan Searls, Carol Davenport, Janet Cooper, Beatriz Valdes, and Howard Rambsy—for their energy, industry, and computer expertise; to Minnie Goka for her irrepressible inspiration, her hospitality, and her editorial reminder to keep it short and simple; and to Associate Dean Ray Lombra and the Research and Graduate Studies Office at the Pennsylvania State University for the subsidy to assist in color reproduction of Major's paintings.

Introduction

Clarence Major's Transgressive Voice and Double Consciousness as an African American Postmodernist Artist

BERNARD W. BELL

Although Clarence Major's poetry is known in some circles and his novels in others, the full range of his work is neither widely known nor generally taught, even in black institutions. Poet, novelist, essayist, editor, anthologist, lexicographer, and painter, Major is one of our most compelling, challenging, prolific, and multitalented contemporary American artists of African descent. Inspired as a teenager by the impressionistic paintings of van Gogh and the symbolist poetry of Rimbaud, as well as by such black writers as Jean Toomer, Richard Wright, Chester Himes, and Willard Motley, Major has produced a collection of art whose trajectory suggests the complex dynamics of his transgressive voice and double consciousness as an African American postmodernist artist. By *transgressive* I mean boldly moving beyond traditional literary limits and cultural boundaries in experimenting with different, occasionally multiple, narrative voices. Although *voice* refers basically to informal everyday speaking and to formal public oratory, it is used here primarily to signify the reader's sense of the particular qualities of the human presence, especially intellectual, political, and moral sensibility, that has selected, constructed, and expressed the pattern of materials in the text. By *double consciousness* I mean, on the most basic level, the sociocultural and sociopsychological doubleness or dualism of Major's cultural productions. This double consciousness ranges from editing the *Journal of Black Poetry* and writing "A Black Criteria" in the late 1960s to writing a column for the *American Poetry Review* in the 1970s and founding the Fiction Collective with Ronald Sukenick, Raymond Federman, and other white writers in order to control the production and distribution of their avant-garde publications.

Some readers may resist—or reject—Major's bold assumption of the consciousness and voices of a Navajo guitar player and folksinger in his novel *Painted Turtle: Woman with Guitar* (1988), of a black southern matriarch in *Such Was the Season* (1987), and of blues singers in *Dirty Bird Blues* (1996). But as his boundary-crossing in these books and the discussion of hybrid identities in the introduction to his anthology of twentieth-century African American short stories, *Calling the Wind* (1993), make explicit, Major believes that "to some degree doubleness describes the condition of all Americans, whether or not they know it" (*Calling the Wind* xviii). A 1993 Califor-

nia exhibition of his watercolor paintings and the 1994 publication of *Juba to Jive*, the revised and expanded edition of his 1970 dictionary of African American slang, are additional milestones that chart the ironies and paradoxes of the boundaries Major has crossed to become one of the most critically respected black American postmodernist artists. Moving beyond the apparent academic exclusivity, aesthetic elitism, and critical jargon of much postmodern art, Major invites general readers and students, as well as book reviewers and literary critics, to join him in becoming explorers of interior landscapes and the complex contemporary relationships of life to art and language to literature.

Major's complex style and structure may be the primary reasons that we find his books on neither the *New York Times*'s best-seller lists nor Oprah's Book Club. Many readers, especially African Americans, not only reject a willing suspension of disbelief to experimental fiction by black writers but also resist the authority and authenticity of a black American postmodernist artist who seeks to reduce reality and the quest for an imaginary new democratic social order to a linguistic invention. But like Ishmael Reed, the most frequently identified and critically acclaimed African American postmodernist, Major responded to the excessive violations of artistic freedom and racial chauvinism of the Black Arts movement of the 1960s and 1970s by rejecting social realism. His imaginative processes and products are nevertheless still grounded in a compelling, occasionally playful blend of visual, visceral, and cerebral interior responses to social reality. Turning to a different muse and joining a Fiction Collective of white experimental writers to publish his novels during the 1970s and 1980s, Major challenges readers to join him in subordinating race to impressionistic and expressionistic explorations of sex, language, identity, and cultural hybridity as a liberating, imaginative construction and affirmation of self.

On one level, then, the dialectic and dialogic tension in Major's art is between Afrocentrism and Eurocentrism. Afrocentrism means many things to many people, based on their ideological position; it is not necessarily the demonizing of whites, the deification of blacks, or the disuniting of America. In contrast to the paradoxical enslavement and enlightenment of nonwhite, non-Western peoples by the Christianizing, civilizing agents of Eurocentrism, Afrocentrism is most constructively defined and practiced as a pedagogical mode of humanistic, critical inquiry that is grounded in the experiences of peoples of African descent. Unlike Eurocentrism, it does not legitimize itself by suppressing other points of view (Wiley 20–21). Instead, by affirming the evidence of paleoanthropologists, molecular biologists, and population geneticists that Africa was the cradle of humankind, Afrocentrism at its best seeks to validate and valorize a nonhierarchical, multiracial, multiethnic world order. Therefore, readers who respond to Major's

cultural syncretism and to highly selective details of the shifting moods of characters and scenes at specific moments will discover alternative, non-logical ways of knowing and being in the world with others.

Mapping the historical trajectory of the frequently quoted classic definition of double consciousness by W. E. B. Du Bois in *The Souls of Black Folk* (1903), Major glosses the comments on American ethnic identity by George S. Schuyler, Toni Morrison, Jack Hicks, William Boelhower, and Werner Sollors. He writes in his introduction to *Calling the Wind*:

> The American presence is so varied and so complex that exchange and conflict between the black image and the white image tend absurdly to diminish the richness of a network of ethnic cultures that truly is the American human landscape. Most individuals in these groups feel some sense of doubleness, feel their otherness *and* their Americanness. One indication of an internal struggle can be seen in their tendency to hyphenate the names signaling the two different selves—African-American, Native-American, Asian-American, Mexican-American, and so on. (xviii)

Black American postmodernism, in other words, strongly suggests a specific racial, historical, and cultural relationship to white American modernism and postmodernism. This relationship is best expressed through some form of oppositional discourse or dialectic derived from and appropriate to the particular experiences of difference, marginality, and Otherness that have shaped the consciousness of the artist, especially, in this case, his attitude toward life, art, language, and literature.

Even though he wrote the frequently anthologized "A Black Criteria" (1967), which called for black poets to destroy the hold of white standards on their minds and work, edited the *Journal of Black Poetry* (1968) and *The New Black Poetry* (1969), and published the often-quoted *Dictionary of Afro-American Slang* (1970), Major disavows ever being a black cultural nationalist. Because black cultural nationalism ranges widely in meaning from racial and ethnic pride to radical Pan-Africanist activism, and because he has long resisted violations of artistic freedom from blacks as well as whites, this disavowal reinforces Major's practice of subordinating politics to his aesthetic principles. Responding in 1973 to a question about the thesis of "A Black Criteria," he stated that he found "repulsive the idea of calling for black writers to do anything other than what they each choose to do. . . . No style or subject should be alien to them. We have to get away from this rigid notion that there are certain topics and methods reserved for black writers. I'm against all that. I'm against coercion from blacks and from whites" (O'Brien 129). In 1986 he told a reporter, "Even from the first, I kept writing about the human condition, not necessarily the black condition. . . . I do not write racial literature. I am a human being first, and then a black man. I

write books about people who are black, yes, but they are human beings first. Of course, I am a member of my family, my race, my culture, but I feel a kinship with people of good will and integrity, no matter their color or background" (Carlin 35). For many readers this statement probably evokes disturbing memories of their own double consciousness, as well as that of important modernist black writers, ranging from Jean Toomer and Countee Cullen to Robert Hayden and James McPherson.

Unlike these black modernists, and like white European American post-modernists Richard Brautigan, Donald Barthelme, and Ronald Sukenick, Major believes that the novel is a linguistic invention that exists on its own terms. He is therefore concerned, he explains to an interviewer, with writing "one that takes on its own reality and is really independent of anything outside itself. . . . You begin with words and you end with words. The content exists in our minds. I don't think that it has to be a reflection of anything. It is a reality that has been created inside of a book. It's put together and exists finally in your mind" (O'Brien 130).

How, then, is black postmodernism different from modernism? For many white academic literary critics the term *modernism* generally refers to the radical loss of faith in traditional nineteenth-century beliefs and values concerning the stability, order, and continuity of Western culture and civilization. This social and moral crisis was largely the result of developments in science and philosophy by people like Darwin, Marx, and Freud, as well as of the carnage and subjugation of peoples by machines, nationalism, and colonialism in the First and Second World Wars. Painters like Picasso and writers like Conrad, Eliot, Joyce, Woolf, Faulkner, and Beckett led impressionistic and expressionistic experiments in subject matter, style, and structure to reconstruct their personal anxiety about and alienation from the nature of modern reality, scientific truth, and conventional authority.

For most black academic literary critics and artists, modernism is related to the mass migrations during the world wars of blacks from the natural disasters, white terrorism, and deadly daily indignities of the rural, agrarian South to the illusory refuge and opportunities of the urban, industrialized North. Modernism for many of them meant the irresistible attraction of the radical cultural redefinitions of white and black American identities during the New Negro (Harlem) Renaissance of the 1920s and the continuing search into the 1940s for new modes of vernacular and formal artistic expression. These new modes of expression included innovative reconstructions and improvisations of black speech, myths, legends, rituals, and music. Thomas Dorsey, W. C. Handy, Eubie Blake, Louis Armstrong, Ethel Waters, Bessie Smith, Duke Ellington, Count Basie, Aaron Douglas, Augusta Savage, Claude McKay, Jean Toomer, Langston Hughes, Countee Cullen, Zora Neale Hurston, Rudolph Fisher, Jessie Redmon Fauset, Nella

Larsen, Sterling A. Brown, Gwendolyn Brooks, Margaret Walker, and Robert Hayden were among the stars of these decades of black modernism.

In contrast, as Cornel West observed in 1989:

> The current "postmodernism" debate is first and foremost a product of significant First World reflections upon the decentering of Europe that take such forms as the demystification of European cultural predominance and the deconstruction of European philosophical edifices. With the emergence of the United States as the world center for military arms, political direction, *and* cultural production and the advent of Third World politically independent nations, the making of a new world order seemed quite likely. Ironically, most First World reflections on "postmodernism" remain rather parochial and provincial—that is narrowly Eurocentric. For example, Jean-François Lyotard's well-known characterization of the postmodern condition, with its increasing incredulity toward master (or meta) narratives, a rejection of representation, and a demand for radical artistic experimentation, is an interesting but insulated Eurocentric view, a kind of navel-gazing in which postmodernism becomes a recurring moment within the modern that is performative in character and aesthetic in content. (87–88)

The ahistoricism of postmodernism, in short, undermines for many people its philosophy and rhetoric about the absence, silence, and impotence of those *subjects*—persons who are the sum of the psychic effects of their interactions with cultural and institutional codes—viewed as marginal and Other, especially blacks and women. Cultural critic bell hooks perceptively asks: "Should we not be suspicious of postmodern critiques of the 'subject' when they surface at a historical moment when many subjugated people feel themselves coming to voice for the first time?" (28).

Addressing the reinscription in much of postmodern theory of the absence of black women and the resistance of most black people to the relevance of postmodernism to their experience, bell hooks writes:

> Radical postmodernist practice, most powerfully conceptualized as a "politics of difference," should incorporate the voices of displaced, marginalized, exploited, and oppressed black people. It is sadly ironic that the contemporary discourse which talks the most about heterogeneity, the decentered subject, declaring breakthroughs that allow recognition of Otherness, still directs its critical voice primarily to a specialized audience that shares a common language rooted in the very master narratives it claims to challenge. If radical postmodernist thinking is to have a transformative impact, then a critical break with the notion of "authority" as "mastery over" must not simply be a rhetorical device. It must be re-

flected in habits of being, including styles of writing as well as chosen subject matter. (25)

Postmodern theory and practice, in short, must be transgressive in order to be transformative.

Black modernists and postmodernists are obviously influenced on some level by the traditions of Western culture and committed to the freedom of hybrid narrative forms. However, because the legacy of institutional racism and sexism that shaped and continues to shape their consciousness fosters ambivalence about their culture, and because the struggle for social justice continues, most modern and postmodern African American novelists, for example, are not inclined to neglect moral and social issues in their narratives. Unlike white postmodernists, they are deeply concerned with fictive visions that focus on the truths about the perversity of American racism and the paradoxes of African American double consciousness. Unlike their white contemporaries, black American modernists and postmodernists like Toni Morrison, Alice Walker, Toni Cade Bambara, Ishmael Reed, John Edgar Wideman, and Charles Johnson are not merely rejecting the arrogance and anachronism of Western forms and conventions. They are also rediscovering and reaffirming the power and wisdom of their own vernacular expressive tradition: African American ways of seeing, knowing, and expressing reality, centering especially on black speech, music, and religion.

But Major moves beyond black sites of cultural production and consumption, as well as beyond thematic and structural concerns with racial and political consciousness, to a preoccupation with exploring the boundaries of language and imaginative consciousness. This transgressive movement can be traced in his trajectory as a black postmodern artist, especially in his eight novels. Except for *Such Was the Season* and *Dirty Bird Blues*, they are primarily transracial, transcultural, expressionistic narratives that thematize a self-reflexive process of creation of a dynamic, multifaceted self and art. Each novel is told by an unreliable, dramatized narrator who is generally a black male and is often the protagonist. Except for the latest three, each is more fragmented, discontinuous, and open-ended in structure than its predecessor. Finally, each engages in self-conscious linguistic play that blurs the line between the worlds of fantasy and social reality.

As a collection of writing and art by and critical essays about one of the most outstanding yet underappreciated African American postmodern artists, this book should be useful to general readers, students, and scholars of African American culture and literature. Its interdisciplinary, transgressive organization, an attempt to highlight Major's aesthetic movement across

literary and cultural boundaries, illumines the complex, compelling relationship between writing and painting. Although Major's artistic vision is grounded in the historical experiences of black and Native American peoples, he boldly experiments with crossing boundaries of all types in realizing his creative potential as a cultural worker and an African American postmodern visual and literary artist. Therefore, a primary focus of this book is the relationship between modern abstract painting and the double voices of Major's literary texts.

Following this Introduction, the section of work by Major begins with thirteen of his poems. The first, a long epic poem on the Middle Passage, establishes the transhistorical, transracial, and transcultural identity of African Americans that informs this book as well as Major's art. It is discussed in the critical essay section by Linda Selzer. The other twelve poems, analyzed in Nathaniel Mackey's essay, are from four of Major's nine books of poetry. Following the poetry are brief excerpts from five of his eight novels—*Dirty Bird Blues*, *Such Was the Season*, *My Amputations*, *Reflex and Bone Structure*, and *All-Night Visitors*— each of which is subsequently examined in the critical essay section. Similarly, several of the sixteen representational and nonrepresentational paintings by Major that are grouped after page 150 are analyzed in an essay by Lisa Roney. The selection of Major's work concludes with an autobiographical essay and an interview by Larry McCaffery and Jerzy Kutnik in which we overhear a dialogue on black aesthetics, postmodern form, and Major's creative productions.

Major's work is followed by ten critical essays on his poetry, fiction, and paintings by specialists in the fields of American and African American studies. Linda Selzer reveals how Major uses a "technique of associative collage" to parody and subvert "the discourse of empire and . . . analy[ze] . . . the difficulties inherent in the project of fashioning an identity through art." Nathaniel Mackey argues that Major's poetry contains "deconstructive impulses . . . as a gesture on behalf of the repressed or ignored areas of experience and awareness, on behalf of civilization's discontents." Using Major's innovative fiction, Jerome Klinkowitz breaks down the binaries of realism and postmodernism and argues persuasively that Major's achievement "has been to show just how concretely we live within the imagination—how our lives are shaped by language and how by a simple act of self-awareness we can seize control of the world and reshape it to our liking and benefit." Lisa Roney intriguingly illumines how "Major's questions about his own identity as an African American and his relationship to the African American community seem to have led him to become a man of double vision, searching for a colorful, but color-blind existence, both through the visual image and the written word." Stephen Soitos convincingly demonstrates how in "its pursuit of metaphysical themes, its black double consciousness

parody of literary and detective forms, and its lack of final solution, *Reflex and Bone Structure* falls within the anti-detective tradition . . . but also extends the boundaries of the black detective tradition."

Using various critical paradigms, especially Calibanic discourse, James Coleman develops a compelling argument for the narrative achievement of *All-Night Visitors* as "a black male text that reflects the problems of black male freedom, empowerment, and voice in ways that are characteristic of other contemporary black male texts." Equally compelling is Stuart Klawans's argument for a connection between *My Amputations* and Cubism because both are "made up of jagged, discontinuous, paradoxical fragments, which evoke or suggest . . . someone who is both a figure drawn from life and a recollection of other fictional characters."

My essay demonstrates through a close textual analysis of *Such Was the Season* that while Major "succeeds in capturing the literary idiolect of the time, place, class, sex, and individuality of Annie Eliza," the black matriarchal narrator/protagonist, his "homecoming voice is characterized by social and cultural ambivalence" about her and his southern roots. Impressed by Major's resistance either to commodifying Zuni culture or to situating it in a "diorama," which would freeze it in time and space, Steve Hayward provides an intriguing interpretation of *Some Observations of a Stranger at Zuni* as Major's "postmodern response to the artist's representational paradox: How is it possible to follow the will-to-represent, without falling into a colonial will-to-dominate?" Finally, Joe Weixlmann argues that "Major's recent fiction shows that he has found ways to extend his reach as a novelist while continuing to explore the issues that have long fueled his literary imagination. Through the voices of his singers, and through his own singing voice(s), Major has staked out important new literary terrain in the past decade." The essays are followed by a selected bibliography, compiled by Clarence Major, that identifies most of his published writing in the United States from 1954 to 1999.

Clarence Major's aesthetic principles and practice clearly deserve wider critical and pedagogical attention by both black and white readers. As bell hooks states, "The idea that there is no meaningful connection between black experience and critical thinking about aesthetics or culture must be continually interrogated" (23). By showcasing Major's artistic achievements along with critical commentary on his work, this volume takes a giant step in providing the materials for this interrogation.

WORKS CITED

Carlin, Margaret. "CU Professor Savors Literary Award." *Rocky Mountain News*, 29 April 1986, 35.

hooks, bell. *Yearning: Race, Gender, and Cultural Politics*. Boston: South End
 Press, 1990.
Major, Clarence, ed. *Calling the Wind: Twentieth-Century African-American Short
 Stories*. New York: HarperCollins, 1993.
O'Brien, John, ed. *Interviews with Black Writers*. New York: Liveright, 1973.
West, Cornel. "Black Culture and Postmodernism." In *Remaking History*, edited
 by Barbara Kruger and Phil Mariani, 87–96. New York: Norton, 1987.
Wiley, Ed, III, ed. "Afrocentrism: Many Things to Many People." *Black Issues in
 Higher Education*, October 24, 1991, 20–21.

Poetry

The Slave Trade: View from the Middle Passage

I
I am Mfu, not a bit romantic, a water spirit,
a voice from deep in the Atlantic:
Mfu jumped ship, made his escape, to find relief
 from his grief on the way,
long ago, to Brazil or Georgia or Carolina—
 he doesn't know which;
 but this is real, not a sentimental
 landscape
where he sleeps free in the deep waves,
 free to speak his music:
Mfu looks generously in all directions
 for understanding of the white
 men
 who came to the shores
 of his nation.
 Mfu looks for a festive reason,
 something that might have
 slipped.

Mfu looks back at his Africa,
 and there at Europe,
 and over there at the Americas,
 where many of his kin were shipped
 and perished, though many survived.
 But how?
 In a system of slave-and-slaveholder
 locked in a dry struggle
 of social muck. Escape?
 No such luck then or now.

And Mfu hears all around him a whirlwind
 of praise, explanation,
 implication,
 insinuation, doubt, expression of
 clout—
 "It was a good time to be white,
 British and Christian." [H. A. C. Cairns]
And remembering the greed of the greedy white
 men of Europe

From *Configurations:
New and Selected Poems,
1958–1998* (Port Town-
send, Wash.: Copper
Canyon Press, 1998),
300–319. © 1998 by
Clarence Major. Re-
printed by permission
of Copper Canyon
Press, P.O. Box 271, Port
Townsend, WA 98368.

for—
ivory, gold, land, fur, skin, chocolate, cocoa,
 tobacco, palm oil,
coffee, coconuts, sugar, silk, captured Africans,
 mulatto sex-
slaves, "exotic" battles, and "divinely ordained
 slavery."

And it was, indeed, with reverie,
 heaven-on-earth for white men.

But Mfu is even more puzzled by the action
 of his own village:
Mfu, a strong young man, sold in half-light,
 sold in the cover of night, and muzzled,
 (not a mistake, not a blunder);
 sold without ceremony or one tap
 of the drum,
 sold in the wake of plunder—
 for a brush, not a sum of money,
 but a mere shaving brush,
 sold without consent of air, fish, water,
 bird or antelope,
 sold, tied with a rope and chain
 (linked to another young man
 from Mozambique's coast,
 who'd run like a streak
 but ended anyway in a slave boat
 without a leak or life-savers);
 sold, to that filthy Captain Snelgrave,
 sold by his own chief, Chief Aidoo.
Sold for a damned shaving brush.
 (And Chief Aidoo, who'd already lived
 sixty winters,
 never had even one strand of facial hair.)
Sold for a shaving brush.
 Why not something useful?
 Even a kolanut? A dozen kolanuts? Six
 dozen kolanuts?
Sold for a stupid shaving brush.
 And why didn't the villagers object?
 (After all, he'd not been sold from jail,

like Kofi and Ayi and Kojo and Kwesi
and that girl-woman Efua.)

And now Mfu's messenger, Seabreeze, speaks:
 "Chief Aidoo merely wanted your
 young wife,
 but before he could get his hands on her,
 she, in grief, took her own life—
 threw herself in the sea."
 Here in Mfu's watery bed
 of seaweed
he still feels the dead weight of Livingston's
 cargo
on his head, as he crosses—
 one in a long line of strong black
 porters—
 the river into East Africa;
 in his sea-floor bed of ocean-weed
he still hears white men gathered in camp
praising themselves, in lamp light,
 sure of their mission—
 "Go ye therefore, and teach all
 nations,
 baptizing them . . ." (Matthew
 28:19).

Mfu, raised from seed a good boy—to do all
 he could—
 never went raving mad at his father,
 never shied from work, one
 to never mope:
 therefore when father said hold
 the shaving mirror
 for the white man, he held the shaving
 mirror
 for the white man, teaching himself
 to read
 the inscription: Kaloderma Shaving Soap.

But now Mfu, like a tree, is totally without
 judgment
 or ambition, suspended between

going and coming
in no need of even nutrition—
gray, eternal—
and therefore able to see, hear, and know
how to shape memory into a thing of wholeness
and to give this memory
not "the Negro revenged" voice
of abolitionist Wm. Cowper—
bless him—
but to see, say, what went into the making
of what, in those days, they called
Negrophobia.

II
To understand the contour,
Mfu must tour deep into Europe first,
explore
its sense of Mother Nature: Mother Nature
in Europe is a giant pink pig
with a black baby at one tit
(this is good Europe: charitable, kind,
compassionate Europe)
and a white baby at the other. A sucking
sound,
plenty to go around.

And in the background,
without thought of remission, a band
of white slave-catchers
force Africans into submission
(this is bad Europe: evil,
mercenary Europe)
in order to chain them,
hand to hand and leg to leg
and ship them into slavery
in the new land.

Both Europes baffle Mfu.
Could it be solely about greed and profit?
But he must try to understand it,
first, the good Europe.
He pictures this:

In a long house somewhere
on the coast
of West Africa about fifty
Africans,
in simple white cotton robes,
are gathered, in a dim light,
each awaiting his or her turn
to be dunked, head-down,
into a big wooden bucket
of water.
Two rosy pink Christian white men,
in slightly more elaborate white robes,
in attendance—a link, surely, to Heaven.
They do the dunking.
These are the good white men
who wear Josiah Wedgewood's
medallion
of a pious-looking African face
with the inscription:
"Am I not a Man and a Brother?"
(1787)
But what is *really* happening?
One culture is modifying another,
and in the process (perhaps unwittingly)
modifying itself, in the name of its god;
as a Liverpool slaver, with its wretched cargo,
slides easily by
headed for the West Indies
or a port at Carolina,
with bodies packed in the pit.

The good white monk on his knees in prayer,
not interested in the gold of Afric,
or the Bugaboo or whether or not
a European looks more
like an orangutan
than does, say, an Ethiopian.
(And besides, the orangutan is not an African
animal.)
So, don't tell him stories
of this man-of-the-forest
kidnapping black babies,

thinking they his own kin.
Don't waste your time.
Don't tell him a good savage is one
 who will climb
 happily up a tree for you
and fetch you a piece of fruit like a good monkey.

Don't tell him your heathen jokes.
Don't laugh at Casper at the birth of Christ.
Don't make fun of the Hottentots.
Don't try to convince him that Africans have
 no souls.
The white monk, sin or not,
 has a secret vision of the Queen of Sheba,
 as a healing spirit for the down-trodden
 blacks,
and though this secular dream is out of rhyme
 with his devotion, much of his time is
 spent
on his vision of the Sable Venus,
 herself a Creole Hottentot,
 surrounded by chubby pink cherubs;
 he prays to black Saint Martin
 and to black Saint Maurice,
 in armor, patron saint
 of the Crusade
 against the Slavs,
the monk prays to the black Madonna,
who certainly must know something he doesn't
 know,
 prays to all the white saints too,
 (and you can name them)
and to Jesus, Mary and Joseph.

The white monk prays that these lean Children
 of Ham
 will be washed clean
by the spirit and say of the Lord
 and made as white
 as the light of day;
made to sparkle the way the little Dutch children
 wanted to make

their African playmate shine from
and take to Snow-white Soap.

Anyway, at the very least,
 black souls could be made pure
 as snow.
No more niggling over that issue.
Pure as snow, far from the mistletoe,
that thing too terrible to touch.
 And then when a French soldier
 brings home
 an African wife, the village
 grief and fear
 will surely fall to the ground like
 a leaf.

Mfu listens to the prayer
 and is puzzled by the contradiction
 implicit in its quest. It conceals a tyranny
 surely
 not innate,
one Mfu would like to believe is not meant,
 or mean-spirited.
The implication, though, is unfortunate.
But Mfu remembers many such occasions
 when such good men prayed and took
 action too
 in the name of goodness-over-sin
 that led to no good for anybody:
 That out-of-breath five year war
 in Surinam (1792).

They took and hung the leader
 on a hook by one of his ribs
 leaving him without a tear
 on the seashore to die
 a slow death.
The white monk, by the way, prays
 that the white Venus and the black
 eunuch,
 seen together like white on rice,
 will remain cool, nice and chaste.

The eunuch, after all, he knows,
is not Peter Noire. And even Peter Noire
can be made to leap
 out of a box
like those that French children play with
where a black Martinican maid,
 complete with apron and head-
 piece,
 springs up with a jolly smile,
 ready to dust.

Or Black Peter could serve as Bamboulinette,
 where we use his mouth as an ashtray.

Mfu is not sad,
 but he now wonders
 how necessary is it to give examples
 of the deeds of *bad* white men
when there were so many jolly good sinless
 deeds
 of the exceptional men of pink skin.
We have so many who fought for the dignity
 of all human beings. (But then,
 is there not something in *all* men
 that must be resisted—
 especially by themselves?)
And Mfu also wonders at the noble, dignified
 presence
 of black intellectuals and military leaders
among the good Europeans:
There is Jean-Baptiste Belley, sad, ironic,
 sardonic,
 aging, elegant, in the French Army,
 a captain during the French Revolution,
fighting, no doubt, for justice for all,
 with strong memories
 of having been born a Senegalese slave
 at remote Gorée (1747). Surely
 this man
 lived with irony as if it were a cancerous
 sore
 in his throat.

III
Ah ha! Mfu can now see the Americas from here.

There is a group of maroons being ambushed
 by white overseers with guns,
 in moonlight in the bushes,
 being yanked and gathered together
 on the Dromilly Estate, Trelawny.

 Haitian soldiers, cursing Napoleon,
 placing ropes around the necks
 of French soldiers and pulling them up
 by way of pulleys to hang them
 dangling from stakes,
 to hang in the sun till they die.

 And Hansel to Gretel:
 "I'm afraid to go
 to Africa because cannibals may
 eat me
 as they do one other."
 Little Red Riding Hood to her
 grandmother:
 "Dig, what makes your mouth so
 big?"

And Ignatius Sancho, there,
 with that wonderful, whimsical
 gaze of his.
 No tears.

A crying Barbados mulatto girl on her knees
 before a planter.
His head thrown back, face drinking the sky,
 and with eyes closed, face open,
his expression is both one of deep pleasure
 and great agony.

A Jamaican Creole noble lady sits on a porch
 while a black slave fans her.

Because of one slip,
a sambo, white as his tormentors,

strapped over a barrel,
 is being beaten with a bullwhip,
 and his entire backside is beet-red
 with blood.

A giant snake, sixty yards long,
 drops from a massive, ancient tree
 onto the back of a black horseman,
 right or wrong, you see,
 and wraps itself around both,
squeezing till the horse and the man,
 taking all they can stand,
 stop moving, then swallows first
the man then the horse.

Mfu can also see farther North—Georgia and
 Carolina:
 Black men women and children bent
 working—out of breath—
 the cotton the corn the cane,
 from can't-see to can't-see,
 from birth till death,
 with no stake in their labor.

 Never will forget the day,
 Never will forget the day,
 Jesus washed my sins away.

Who is that pink-faced general, dying?
 lying on the ground, dying out there,
as the battle of Bunker Hill rages on.
Another general, one who will perhaps
 become president, fights his way
free of a cluster of redcoats,
 without feeling the slightest thrill,
 while, on horseback
 in the background,
 his slaves watch for him to botch it.

 Pharaoh's army sunk in the sea,
 Pharaoh's army sunk in the sea,
 sho am glad it ain't me.

And a Negro soldier (strong as a Wagogo
 warrior and
 brave as KaMpande,
 King of the Zulus)
 aims his rifle at a redcoat
 while a major points
the frailest pink finger
 ever in danger of being shot off
 in a revolutionary war.

 Two white horses side by side,
 Two white horses side by side,
 Them the horses I'm gon ride.

A newspaper item: "and good white men, many
many, have come to believe that perhaps the sin
is not in keeping the niggers in chains but in
releasing them." (Catch a nigger by the toe . . . ?
"Let my people go!")

A cartoon (1789):
 A black man dressed like an English
 gentleman is bludgeoning a poor, suffer-
 ing white man over the head with an
 ignorant-stick. And in the background:
 Similar configurations dot the diminish-
 ing landscape. Message: Let them go
 and they will enslave you. Rationale:
 Abolition is folly.

This here is the white woman, France,
 (this time without the fabled black
 eunuch)
 with her arms outstretched to the slaves
 on knees before her,
 with arms lifted toward her
 thigh,
while Frozzard watches with the light
 of an approving smile in his eye.

Jefferson strokes his chin,
thinking about freeing his slaves.

Here they come around the bend.
But says oh well, maybe not.
Washington, on his deathbed, frees his slaves.
Thanks a lot.

> *On my way to heaven,*
> *Yes, Lord, on my way to heaven,*
> *On my way to heaven, anyway.*

Mfu remembers an Ashanti Ju Ju girl
 (who gave him a coin)
 saying, "We must believe that the good
 in human beings will prevail."
 And on front of the coin:
 Nemesis, antique goddess
 with raised left arm.
 Right hand holds olive branch.
 Obverse:
 Face of a young African man,
 sensitive and intelligent.
 And the inscription:
 "Me miserum."
This relic, the best, the girl said, was given to her
 by a never-mean Danish traveler from
 the West Indies
 where he'd seen, without reverie,
 the abolition of slavery
 in 1792.
 Sister Mary wore three
 links of chain,
 Sister Mary sho wore three
 links of chain,
 Glory, glory to his name . . .

IV
Mfu says this is to strain against the insanity
 that welcomes us at the other end:
 where one does not believe there is hope.
And one strains too to keep the gentle face
 of, say, Carl Bernhard Wadstrom,
 white man,
 bent over Peter Panah, black man,

teaching him to read.
And wish the configuration
 said something more
 than it does.

Mfu remembers Equiano.
 Equiano (1789) said: "We are almost a
 nation of dancers, musicians, and poets."

So, if this is so,
 why not celebrate?
 Mfu calls on all of his people
 of the Diaspora:
Come on, Connie,
 do the Congo Cakewalk!
Come on, ya'll, put Mfu in a trance!
 Come on, Sister Kate, cakewalk!
Come on, ya'll, do that heebie jeebie dance!
 Come on, Sadie, sing a Spiritual!
Come on, Luke,
 Come on, Duke, make that piano talk!
Come on, ya'll—
 Come on Frederick Come on Sojourner
 Come on Martin Come on Adam Come
 on Alvin Come on Muhammad Come on
 Jimmy Come on Bud Come on Lightning
 Come on Gwendolyn Come on Richard
 Come on Bojangles Come on Arna Come
 on Langston Come on William Come on
 John Come on George Come on Al Come
 on Ruth Come on Miles Come on Billie
 Come on Frantz Come on Jesse Come on
 Jean Come on W. C. Come on Cab Come
 on Ntozake Come on Senghor Come on
 Claude Come on Colin Come on Willie
 Come on Sara Come on Jacob Come on
 Malcolm Come on Thurgood Come on
 Archibald Come on Oscar Come on
 Chester Come on Joe Come on Jacobus
 Come on Elisa Come on Toussaint Come on Henri
 Come on Kwame Come on Ann Come
 on Phillip Come on Wardell Come on

Frank Come on Louis Come on Pearl
Come on Ella Come on Count Come on
Romare Come on Aimé Come on
Alexander Come on Angela Come on
Ralph Come on Olaudah Come on
Rudolph Come on Aretha Come on
Sutton Come on Hailie Come on Robert
Come on Lena Come on Nat Come on
Miriam Come on Ezekiel Come on
Satchel Come on Sidney Come on Harry
Come on Carl Come on Wallace Come
on Desmond Come on Toni Come on
John A. Come on Oprah Come on—
Come on, ya'll,
cotton pickers, computer punchers, migrants
and retreaters,
millers and tillers, mystery writers and hard-fist
fighters,
You can do more than Jackie Robinson
did for Wheaties, or Joe Louis did for
Chesterfield.
Mfu says, Come on, ya'll.
You can get out of the cotton field and
you can rise
above the coconut tree.
Mfu says you can get off your knee and change
your image.
Do it your way.
It's nobody's business but your own.
Mfu says let's gather in a sky chorus today,
with all of those gone and all of those
coming,
with Josephine and Leopold the King,
and make, he says, some sounds mean
what they're supposed to mean.

Inscription for the First Baptist Church
as It Comes Out on Saturday to Park

they joined each in cocked
ears a group of religious men
searching beyond the morning service or
luminous gifts the good fortune of people simply
transparent in mass;

they spoke in sensational uproarious voices into
media coming like metal lubrication oil, clearly
this protuberance of the prospects of summer church
with wet smacking children connected to each other
in some natural sin with olives falling

thru eerie smiles of irongray faces on wooden benches
where the certain thorns of these ages of flesh held
the bold, gentle speakers high up the totem pole safe
from skepticism even reinforced by the practical paper-
plates not to mention their insensible love songs

From *Symptoms and Madness* (New York: Corinth Books, 1971), 7. © 1971 by Clarence Major. Reprinted by permission.

The General Sense of Self

We weird thin strangers
come
cloaked sighing in flesh
passionate sparetime lovers

with an irreversible perspective
and a pose
so solid
falling rain cannot charm its ghost

soaked in repressed rhythms
our life myths
are sunk in the useless riddle of
the emptiest excuses

these wornout and yet desperate artifacts
not enhancing our humanity yet remain
imperishable as the idea of
killing food killing for dreams

an irreversible point
of
view
so crisis-ridden that
the mystic work of our submission
to the huge color of ignorance
is never never blasted
out of its monument
of soggy
and painful doubt

From *Swallow the Lake*
(Middletown, Conn.:
Wesleyan University
Press, 1970), 25. © 1970
by Clarence Major. Re-
printed by permission.

Conflict

the way stale milk invades clean air

• • •

air of stale milk, I was under
the influence of power flow the
 mouth of the 3 flowers of evil

 Rimbaud
 Baudelaire
 Verlaine)

not myself here except I know
(I *knew* beyond sense of the French
decadents example
 the heart of sweetheart smelling
Purex product beauty soap, dye drying
me. Of love, the fishy odor of a boat
where something in my mind happened.
I knew
how a small boat sways as I climb in-
to it,
 at Fox Lake Indiana 1953 I think I
might be off the year. But perfume conflict:
with fish, water's edge, grass & the deep
 perfumes of early morning, I knew.
My mother wore a certain fragrance I shall never
 delete.

I remember, also I knew a long time
 the strong stink mortal insult of those
big baggy men without sense
 in their eyes
standing on the trolley coming
 where they were going. That against the
nostrils. Or the way, in the deep decline of
Fulton Hall
 at the Art Institute, shadows circle
heads, but huge red RED splashes of "red
 color

From *Symptoms and Madness* (New York: Corinth Books, 1971), 12–13. © 1971 by Clarence Major. Reprinted by permission.

clash earthquake force in:to
　　　　the sudden gentleness of vestal green.　I
claim that knowledge, outside the fragments
　　　　of V, B & R. But that disorder was
not disorder　　　　　　　or chaos stricture of
birth order formation to, into anything eyes
　　　　break, or disrespect or match or touch.

The Unfaithful Wife: A New Philosophy

remember the way they said OUR
mamas used to survive the shit
our fathers had to drink

their way through. well. seems
coke hash grass anything was a
bigger success than you tho you

were a steady husband a good
father a provider and a trusty
pillow coke was adventure

and he'd be gone next day for-
ever which was
the magic of it for her memory

From *The Cotton Club*
(Detroit: Broadside
Press, 1972), 22. © 1972
by Clarence Major. Re-
printed by permission.

Private Line

direct. without the priest
you try to transfer your sins to me.

led along a small-town street to
the backside of a highschool gym
you used me sexually in the wet grass
and I fell for it, while

somebody's tv screen, its light
flattened against the poles
of our clutter. you divided me, the
hero of those weeks into whipped lubber.

i look back now with anticipation, a
fitted, adjustable spirit. between us
a large hull, clumsy grey triangle,
your cunt. obscured by my own ego.

yet you turn me into your assembled parts,
your motherhood, your open questions
worry about me too much, where you
dream me so often your husband
decides to leave you

From *Private Line*
(London: Paul Breman,
1971), 24. © 1971 by
Clarence Major. Re-
printed by permission.

Motion Picture

tell me. you did re-
search years back, through
friendship with
troubled and mis-used
makers of sounds beyond
the hollers the work
songs those who went
into recording studios
n got screwed. and now

you fly every
where you go. your own
metal. even teach-
ing your wife how. got
your own building your
own office space.

and the niggers all
dead in small apartments
with old crow

From *Private Line*
(London: Paul Breman,
1971), 15. © 1971 by Clar-
ence Major. Reprinted
by permission.

Vietnam

he was just back
from the war

said man they got
whites

over there now
fighting
us

and blacks over there
too

fighting us

and we can't tell
our whites
from the others

nor our blacks
from the others

& everybody
is just killing

& killing
like crazy

From *Swallow the Lake*
(Middletown, Conn.:
Wesleyan University
Press, 1970), 44. © 1970
by Clarence Major. Re-
printed by permission.

Author of an Attitude

(with one's ass on one's shoulder)

guess i was imper-
sonal as you, can. be
my back, standing
at the red bar, liquor of
the year;
 in that year in the middle
 of the day. but then you
 were real cool. and, could, &
 did. Speak. spoke to people be-
 fore they spoke
 to you. you weren't famous
 then. you saw you were
 a bitch, last time i saw
 nothing, so busy. glossy eyes,
 so blackeyed. we ate blackeyed
 peas, from paperplates dug your
 spoon through. don't think
you even recognized me.
so busy watching your-
self. trying to protect
your own ass, i guess

From *Private Line*
(London: Paul Breman,
1971), 12. © 1971 by
Clarence Major. Re-
printed by permission.

Dismal Moment Passing

This is, this is—
this *has* to be here like this
because I am inconsolable.
Even summer coming
failed
to enlarge the green accuracy of Nature.
Real summer, we won't see till Mexico.
Anyway, I think of my mother when I think of Nature,
her beliefs—like sheets flapping on a back porch line.
Some people might still wash things
and hang them up to dry.
Children play on the sidewalk.
At least they are happy.
I sit in my own opaque opening,
but I promise
to be better tomorrow.

From *Configurations:
New and Selected Poems,
1958–1998* (Port Town-
send, Wash.: Copper
Canyon Press, 1998), 21.
© 1998 by Clarence Ma-
jor. Reprinted by per-
mission of Copper
Canyon Press, P.O. Box
271, Port Townsend, WA
98368.

My Child

her curls, like black sparkling things
out of the interruptions of music or
endemic structure of just things, are simply
there, not even needing this poem, nor
me: a mirror, coming in my love to what I vainly
interpret as some vague property, a shadow of my-
self, an edge like cement to the city. Her fleecy
soft insides on her face uncommon intrigue so natural
in the brimming domestic shape of her intercourse
with me, enclosed in this ancient respect: her eye-
lids, her 3 year old rendition of the world is
not inferior to anybody's, her play accepts
the debt of herself, the simple undefined reality
of this—.

From *Swallow the Lake*
(Middletown, Conn.:
Wesleyan University
Press, 1970), 10. © 1970
by Clarence Major. Re-
printed by permission.

The Design

 the music and its harmony
measures in the space of my boredom,
remains stale the air, the music.

The house. The things around
 the little things around my terms with you.
You never come to terms with
my brain. My music is difficult, you never

 empty the ashtrays. I am tired of the
apartment is dull a place but it comes
to this each

item you left, a few belongings: the african woman
with a shrunken leg, one with
a jug, a king dancing. The harmony
does not change the paradox of my birth.

They talk about Mao Tse-tung these days, small
talk, you know. This is simply
a letter of what I might say.

In our cold rooms a mocking laugh
rattles inside the walls. Inside the planks
 of our mind, we think alike.

Well, let me tell you
of my new lady. But she says she belongs to
nobody, or the world. A coddle for a poor fool's
 pride. And pleasure. Contemporary moments.

Exist, these melodies, difficult phrases, the
 stray bits of speech, exist thru her presence.
SHE HAS COME DOWN
 front, baby. In the spaces, the music.

You say, they say, everybody says, even I say
 the important thing is her virtue: her sins
the building she lives in she lives in
chaos, in roots. In her cracked mirror in her mission

From *Swallow the Lake* (Middletown, Conn.: Wesleyan University Press, 1970), 11–13. © 1970 by Clarence Major. Reprinted by permission.

she lives in us, in everybody
 she lives in you.

We live anywhere, by the water, perhaps.
The blade of the water
 Does not wake her, cutting her.
When it runs low, the fire sweeps her face but
 does not burn into her sleep. I know
she is peaceful, I

sometimes sleep like a fifteen year old dog
 beside her fire. Warm, losing my touch
I face rough walls in terrible moments, a finger
 might knock the edge, tilt the concerto

but I stop to think. It would be like picking up
a little man, a huge black beard
 weighing down his face, his legs
are goat legs. He sings, like a bird.
And it does not puzzle, nor amaze
 any of us. Not even under the effect
of her capsules; she, in her aspects makes no excuses
for such rhythm out of context.

 I say it is because of motherhood and she
remains abstract, not giving anything away. Some-
time, like this time
 she leaves me feeling as commercial, plastic
as a sunrise on that post card
 you sent us from your vacation.

I say to her, Come
 into this home, this blue house of black
music. She knows the score
already, she was not as snowed as you, dear.

Now, things are working, we think alike.
No matter what I might say
 she is not bored.

Overbreak

there is a remarkable verb of
 things
here: a remarkable sensation of
 infected spirits feeding
& pushing bravely like nurtured waves in
 the machines of
the sensation, the tremor of water as it
 surrounds the heart beat
the perturbation the adjectives cluttered
 in things all trying to mark
or perhaps here *re*mark, consume an essence
 to define an ultimate dimness
in a district of some god or nothing real
 a paradox of evil devouring the
electricity of our flesh, the near-
 ly acceptable tangibility of
goodness, this assumption of so much excitement
 devilment in spirit of its romantic
durability achieves the temperature, the gas range
 fidelity of a sexual assessment baited
in the brain of riddles making human beings
 all by now mashed by the adam or atom
all by now electronic christmas trees, capricious
 and fierce things in which there is
a quality of which sharp contact is
 the qualification, a remarkable verb quiver
like some hypothesis, an
 irony, a quest, a breakdown, out
of delirium yet continues to enrich hedges
 of the self, definition or cause to become
somewhat more loyal—a description, A REEL OF DESCRIPTION
 that is found, over and emotion over,
everywhere, inspirational, forever from the defeat
 of word BEGINNING itself to its very taste
of blood & structure, a kind of actual property of
 suffering, lonely man & wo-man, responsible
here, tho not actual-ly a proposition of strength or
 strengthless-ness, in sympathy, in
itself, that first stroke, the food of the word
 the name contact the energy myth taboo all

From *Symptoms and Madness* (New York: Corinth Books, 1971), 16–17. © 1971 by Clarence Major. Reprinted by permission.

this dimness beneath the rhythm, scattered and
 colored, in social fires and thrills so
slow they burn the skin tight around the brain, quick
 dichotomy—good or evil & company, the
sense of a world smashed and re-realized, over & like
 nothing touchable in the particular land-
or inscape we know, in all its contradictions saves
 us yes saves us no here in this
sustained instant, as we turn in a tacit polarity

Prose

Dirty Bird Blues

Walking back they kept stopping for a taste. Stopped in front of the Catholic school on Michigan for a taste. Man hit it and handed it to Solly. He said: "You ever feel you just ramming yo head gainst a iron wall trying to get somewhere with yo music in this town?"

"Hell yeah," said Solly. "Too many goddamned blues guitar players in Chicago."

"It like Mister Lee say, this the mecca of the blues. They told me *that* down in N'Orleans. Fact is, that why I come up here. Everybody kept saying Chicago where it happening, go to Chicago, go to Chicago, N'Orleans a thing of the past."

"And you been here, what, four years?"

"Got here summer 19 and 46 and still ain't got nowhere. And I know I'm good. It ain't that I ain't good."

"You good, nigger," Solly laughed. "I can tell you that. And I ain't no expert. But—"

"Yeah, but there is a whole lot of other blues singers in this here town just as good."

"And better."

"I don't know bout no better, now."

Solly laughed. "How long you hanged out in N'Orleans?"

"Oh, man, let me see. I left Atlanna right round the time the war ended, in the wintertime that year. Everybody was saying go to N'Orleans, that where you can get work as a singer, go to N'Orleans. So I went to N'Orleans and never got nothing but handouts. Peanuts!"

Solly said, "N'Orleans and Chicago big towns. It hard to get anybody to pay any tention to you in a big town."

Man said, "I know. That why I gon go where I can be a big fish in a small pond."

"What you mean?"

"I got a lot of reasons to get out Chicago."

"So, Omaha, huh?"

"Yeah, Omaha. You know, it hit me: I coulda lost my life last night. I'm gon get outta this town while I can."

Solly didn't say anything.

"Solly, you ought to come on out with me. Debbie say they like the blues in that town. In a place like Omaha we wouldn't have so much competition."

"I got a family, man. But it sound good though." Solly handed him back the bottle.

"Move your family with you." Man hit it and handed it back. "We could turn that town out with soulful sounds."

From *Dirty Bird Blues* (San Francisco: Mercury House, 1996), 37–40. © 1996 by Clarence Major. Reprinted by permission.

"Yeah, yeah." Solly took a swig, wiped his mouth. "Here."

"Think about it, Solly. We can get a fresh start." Chugalugged one more time. Man held it out to him.

Solly waved it away. Man put it in his jacket pocket.

"You need a fresh start. I don't need no fresh start. But, say, what about Cleo? You give up on her?"

"Naw. Love that woman, man—"

"I know you do, nigger—"

"But I know I ain't about to get her back by pulling some drunk-ass trick like I did last night. I got to walk straight fore I can fly."

Looking at Man, Solly laughed nervously.

"I ain't lying," Man said. No question about it, he knew what he had to do now.

Solly wiped his mouth and his hand trembled.

A few moments later Man said, "This stuff all right but sho wish it was some good Dirty Bird." Then he started singing—

The jailer gave me whiskey.
The jailer gave me tea.
I say the jailer gave me whiskey.
The jailer gave me tea.
The jailer gave me everything but the key.

And Solly cackled at the ditty, saying, "You is a case, a real honest-to-goodness born case."

They stopped again at the corner of Indiana for a taste. Man was happy. Good liquor and a good friend. It was like he hadn't even been shot and his life wasn't getting away from him.

When they got back Holly had company. Sherry, girl from upstairs who was about Holly's age. She was nice-looking, kind of gypsy-looking with a sexy mole that Man liked though he knew she painted it on her cheek right there by her mouth. And she had these great big blinking eyes like everything was new to her. She had a kid too, a boy, year older than Annabel. Sherry was on welfare.

Annabel was sitting on the floor playing with her Christmas present, a pink doll with blue eyes.

Sherry didn't want a drink. "No, thank you," she said with a smile.

Man knew Holly wouldn't touch the stuff.

Solly got his guitar, got two glasses and poured himself and Man some joy juice, then settled back in the armchair.

Sherry said, "Guess I better get back upstairs. Andy going to wake up soon."

"Naw," Man said. "Stick around. I'll sing you a song. Just for fun. It Christmas, lady. How they say?—Be of good spirit."

Holly laughed, then Sherry kind of laughed too. She sat back down.

Man pulled a kitchen chair over and sat next to Solly, took out his harmonica, put his glass on the floor between his legs. He warmed up a little bit on the harmonica.

Solly tested his strings. "What we gon do?" he said.

"Whatever comes natural." Man started patting his foot. Held the harmonica with both hands. Hit the middle register, moved on up higher and higher. Breathing smoothly for more action, keeping control of the flow of air. Letting it come nice and easy. Now and then he held his nose, to get the breathing stronger. Now he hit a low note, and a lower one. Real soft-like. No spit. He never spat in the harmonica. No, sir. Said to Solly: "Ready?"

"Follow you."

Solly said, "Les go!" And Man cut loose with—

I'm sorry to tell you.
So sorry to have to tell you.
Yo mama Miss Sadie is a bald-headed lady.
Yeah, yo mama Miss Sadie is a bald-headed lady.
I hates to talk about yo mama, Miss Sadie.
I sho hates to talk about yo mama, Miss Sadie.
But you leave me nothing else to choose.
You leave me nothing else to choose.
She got hair growing on her feets
So long she can't wear no shoes.

Sherry and Holly were falling out, cracking up.

Man was thinking now this is the way to live. This was better than driving one of them big old pimp roadhog fish-scale diamond-dusted decorated Cadillacs with black-out tape on the windows, silver hubcaps, and tail fins long as canons, better than drinking good liquor and smoking Cuban cigars, maybe even better than most belly-grinding. Times like this he knew why he and Solly became friends. Why they stuck together. The music. Nothing but the music. They came alive in and lived in the music like pollen lived in a flower. And he remembered how they seemed to just understand this the first day they met. Understood it without talking about it. It was a recognition warm and big as a bowling alley. What they shared was always there. They could be together for days without talking and it was as though they were still telling each other all kinds of things, Man with his harmonica or voice and Solly with his guitar, a guitar with such a pretty sound you could've put a pleated skirt on it and some fool would have wanted to marry it.

Now Little Annabel got up and wobbled over to her mama and climbed up on her lap and sat there just looking at her daddy and Man. Didn't crack a smile. She was like that.

So Man wouldn't have to stop, Holly came over and filled his glass again. Bless her heart.

Such Was the Season

Cause I'd promised Juneboy to take him out to see the grave of his father, the next day, Sunday, we was up bright and early for the long drive up north to Lexington, which is where his father was killed in a gunfight with a white man at a gambling table in the back room of a gas station. They buried Scoop in Lexington cause it was cheaper than bringing him back here to Atlanta where he was born. His momma, Miss East Coast Clardia, was old by then and had no money anyway, and all of Scoop's three sisters—Zora of Magazine Point, Alabama, Honey Dripper, and that Cherokee one, the youngest, Selu—wont nowhere near Atlanta by then. Folk said Zora was out in California, Honey was up North maybe in Philly, New York, or Chicago.

So Jeremiah knowed I wont going to be in church for his sermon this morning. Even with the weather being warm and all, I still had to let my old hundred-year-old green Chevrolet warm up. I got up way fore Juneboy and made me some coffee and, from my back window, watched the sun come up. I do this most mornings these days. Sometimes I never even go to bed, I just fall asleep on the couch in the back room, watching television, and stay that way to bout five, when I wakes up and make coffee and wait for the sun.

When I had the coffee cup to warm my hands (which is good for my arthritis) I stood at the window, waiting for the first light. I couldn't keep from thinking bout Friday night and poor Renee and that whole affair but I didn't want to think about it too hard. I try to stay outta other peoples' business. When I heard Juneboy stirring, I put my cup down and went to the bathroom and put in my teeth. I washed my face and combed my hair and took my arthritis pill. Then I went back to the kitchen and poured a cup for Juneboy. I left it there on the counter so he could get it when he came out. I figure most peoples like me. They don't want nobody rushing in on them fore they got their eyes wide opened.

I turned on the television, forgetting for a minute that it was Sunday morning and there was no news but just church with all the preachers talking on every channel. I turned it off. Jeremiah had a series of sermons they televised from his church bout three years ago. I watched a few of them but I don't think television is any proper way to respect or praise the Lord. It's got too much sin behind it to have a clean face.

From *Such Was the Season* (San Francisco: Mercury House, 1987), 51–54, 56, 58–60. © 1987 by Clarence Major. Reprinted by permission.

I cooked Juneboy some eggs and bacon and made some toast and sat with him at the table while he ate. I myself just ate a sweet roll. I was kinda shy bout asting him bout his personal life so when he started asting me questions, I was happy cause that at least broke the silence with him just making chewing noise. He said, "Aunt Annie Eliza, you must be very proud of Jeremiah . . ." and he stopped for a minute, then said, "and, uh, DeSoto . . ."

I told him they compliments had made me a very happy mother. I told Juneboy I was might proud of DeSoto. You know DeSoto is smart. And gots lots of interests. He studied law enforcement. Course, Jeremiah got his doctorate in religion. Everybody knows bout this.

I told Juneboy bout the time I took a course called "Better Health" at Beulah Heights. Learned all bout how I was spose to be taking estrogen and progesterone cause of menopause; learned more than I wanted to know bout my own body! He wanted to know if the kids round here in the East Point area get encouragement to go on to college after high school. He hadn't seen much of it up North.

"Shoot, what you talking about?" I said. "Boy, all these kids round here got strong examples everywhere they turn. We got a Negro mayor, we got Fred in Congress, and on the state level we got lots of Negroes." I told him bout all the kids I knowed in the neighborhood, kids who'd growed up round here, running errands for me, delivering papers. A lot of them was doing well at Morehouse or Spelman or Emory. One boy who delivered my newspaper for five years is now a doctor with his degree from Emory and he got a practice up on Peachtree Street and most of his patients are rich white folks.

Well, I could have talked bout the neighborhood all morning but we had to get started, so when he finished I cleared away the dishes and got my cloth coat and my knit cap and he helped me get into the coat just like a perfect gentleman. You never would a believed his daddy died the way he did: The boy had such good manners.

It was a real pretty drive that time of the year, going out of the city, and, once we got out past Scottdale on seventy-eight, which is the best way to get to Athens and Lexington, I rolled down the window and the air was fresh and the morning smelled so good. It'd been months at least, since I'd been out this way. I couldn't member the last time I'd taken my old Chevrolet out on the highway like this. It felt good, even though I never was one much for driving. I smelled parched peanuts in the air. The sun was coming up real strong and melting the dew on the trees and shrubbery alongside the road. We was still driving through rich neighborhoods though, big old weeping willows and cucumber trees and umbrella trees and magnolias in the front yards. These was the rich folks who lived outside Atlanta. The mayor knowed a lot of these peoples; they'd helped to put him in office.

By the time we'd been on the highway bout a half hour I come just a

smelling a whole world of fresh blooming dogwood. I got a holly and a big old sweet bay in my backyard but I hadn't smelled dogwood like that since I was a little girl on our farm in Monroe, where all of us childrens was born. I was going to drive through Monroe after Loganville. I was trying to member the last time I'd been there. It sho was since the funeral of my youngest brother, Rutherford.

Well, the Chevrolet was holding up all right as we drove on through Loganville. Just on the other side of Loganville I drove into one of them rest stations and turned the engine off. Near where we stopped was one of them picnic tables. On it, eating crumbs was two yellow-chested warblers. I hadn't seen warblers like them in a long time. In my backyard I sometimes see myrtle warblers and them cerulean ones and all kinds of sparrows and once in a while I see a blackbird of some kind but can you imagine how excited I was to see them yellow-chested warblers! They mighta been what they call a magnolia warbler. I've forgot so much that I use to know. Anyways, I held Juneboy back, said, "Hush. Don't move. Look at them." I gave him a look. He was smiling. I think that must a been the first time I seen him smile that good since he was a little thing on a tricycle and I was babysitting for my baby sister just after she and Scoop broke up. We watched the yellow-chested warblers strut and peck till they flew away. They flew away together. Well, almost. One sort of looked up at us standing there and jerked his head round a few times, getting his eyes on us the right way. Then he made the decision. He took off and in no time to speak of the other one, probably the female, took off after him.

I went on up the path to the ladies' room. You member how not so many years ago going to the ladies' room for us colored folk wont so easy as all this. Most often when we was traveling on the road like this, we had to use the bushes. Inside the toilet, there was two other women. One on the stool (judging from the smell), the other one doing up her face. She was white and bout my own age. I saw her look at me through the mirror when I came in. Her smile was kinda plastic—you know, stiff. I smiled back at the lady and she said something bout how nice the weather was and I agreed with her.

I did my business and left. Lexington is bout eighty miles from Atlanta. We'd come only bout nine so far. I didn't know if I wanted to stop in Monroe or not. The family home was still there but Rutherford's illegitimate daughter, Sue Mae, owned it now, now that Momma, Poppa, and Rutherford hisself was all dead. Seeing it, I was sure, would bring back some good memories but maybe too many bad ones. Sue Mae had fought us in court after Rutherford's death and won. Just as I was thinking bout Rutherford, Juneboy said, "Aunt Annie Eliza, let's stop in Monroe. I haven't seen Grandma's and Grandpa's house since I was about six or seven years old."

.

Juneboy took a tiny camera outta his pocket and snapped a picture of the house. I guess he just wanted it. It sho didn't look like much as houses go but it looked a lot better than it did when I was little. Ruth had fixed it up a lot after Poppa died.

Juneboy came back and, wouldn't you know, ast me to show him Grand-poppa's (my poppa's) and Uncle Ruth's graves. My heart just sunk down to my stomach. I swear, child, I didn't want to get all them feelings moving inside me again. Ruth hadn't been dead more than a year. Juneboy was informed like everybody else but he didn't come down for the funeral. Too busy I guess. But then everybody in the family knowed he hated the South and everything in it and for years swore he would never set foot inside it again. Esther said he believed the South killed his father. If you ast me, that man kilt hisself with his wicked way of life. But you know you can't go telling the son of such a man a thing like that. I membered what he told me bout him wanting to get in touch with his roots, on Thursday right after he got in. And I guess wanting to see Ruth's and Poppa's graves was part of this need Juneboy had inside hisself.

.

I still can't find the words to tell you what we saw and how I felt and how Juneboy musta felt. There was no path longside a cornfield. There was no cornfield. Right where the path and the cornfield was years before was a big housing project. You know the kind. You see them all over Atlanta.

I started crying, child. I surprised myself crying like that. I looked at Juneboy and told him the truth. He took it pretty well. He didn't cry. Maybe he cried later but he didn't shed a tear when I pointed to where the weed path once was.

Juneboy said, "Aunt Annie Eliza, let's drive up in there and you show me where you think the cemetery was."

I drove up there and parked in one of the parking spots reserved for the tenants. A whole lot of Negro childrens was running round playing in the parking lot and I saw a few women looking out the windows at us. Me and Juneboy got out and I tried to figure out where I was in relation to the highway down there. I membered exactly where the weed path had been, so we went over there first. I looked down to the highway to try to judge my distance.

Juneboy said, "Is this where the footpath was?"

I told him it was, indeed. But what I couldn't figure for sho was how long it took to walk from the road up to the cemetery without doing it again.

Juneboy said, "So let's go down and walk back up."

We did and stopped when I felt like we had walked the right distance. "This is it, this area right here, all around here." We was standing in a

parking lot, not the one we parked the car in but one a bit south of it, around one of the buildings, on the back side. The ground was all concrete now and twenty-one years ago it had been the colored cemetery and Juneboy's father was down there now, with a lot of other colored folks, under concrete. It was the saddest thing. Nobody could come here to lay flowers on any graves and lucky for us, I guess, we hadn't brought any. I watched Juneboy looking round at the ground with such a, such a . . . I can't describe his expression. It reminded me of that face of the Indian on a pony you see on television, looking for the ancestral burial grounds and all he can see is these hamburger stands and gas stations.

"I'm sorry, Juneboy."

He touched my shoulder and said, "No need to be. Thank you anyway for bringing me."

I felt awful, just awful.

"In a way," Juneboy said, "it's a fitting burial for Scoop. It's like he has lent his flesh and spirit to the continuation of the culture. The little kids playing in those parking lots are the ongoing spirits of all those silent souls down beneath the concrete. Scoop's spirit reaches up through the hard surface and spreads like the branches of a summer tree."

My Amputations

Boy, was *he* hot to trot! Mason'd just left the Valenti-D'Amico place of operations in Little Italy and was walking north on McDougal. He held in his right hand, at stomach-level, a dark blue booklet, looked with dancing eyes at its cover; the thumb and index of his left hand poised, ready to lift the cover back. As he walked he read: United States Government Printing Office. He looked at the snapshot of himself on the fourth page: didn't like the expression puttering around the full mouth. The passport photographer's fault: no sensitivity to subject. Too much a mug shot. Number J111967. Cover again: in gold letters: Passport. Beneath those precious words, also in gold, was the United States' seal: an eagle facing left with a left-talon clutching thirteen arrows and a right one clamped around a branch of olives— strength and peace. That's *me*, jack, *strength and peace!* Not a native son for nothing! Above the eagle's head: a mandala with stars at center representing the original (again) thirteen colonies. Well, this was Mason's passport and he felt close to the lofty efforts those sparkling stars represented. He'd get on a soap box for them: you bet your boots: after all this was his country, too. Wasn't it? Opening the booklet again with proper reverence, he whispered aloud the language of the third page: "The Secretary of State of the United

From *My Amputations* (New York: Fiction Collective, 1986), 49–54. © 1986 by Clarence Major. Reprinted by permission.

States of America hereby requests all whom it may concern to permit the citizen(s)/national(s) of the United States named herein to pass without delay or hindrance and in case of need to give all lawful aid and protection." God! Just think! the support of the entire government behind his identity! Money talks, yessirree boy. He turned to the fourth page again: "Warning: Alteration, Addition or mutilation of entries is prohibited. Any unofficial change will render this passport invalid." Then this vital data: name, place of birth, date of birth, date of issue—which was February 3, 1980—and date of expiration—February 2, 1985. The picture again: although the expression was not his it was the face of "a serious writer" like those on the jackets of novels: the tormented look, the scowl, a permanent expression of cynical disapproval. A man of profound thought? Spare me. The next page gave him only a fluttering pause; "Notice: This passport must not be used by any person other than the person to whom issued or in violation of the conditions or restrictions placed herein or in violation of the rules regulating the issuance of passports. Any willful violation of these laws and regulations will subject the offender to persecution under Title Eighteen, United States Code Section fifteen-forty-four." This followed by blank pages for entries and departures, for visas. At the end of its last two there was more—the highlights: "This passport is the property of the United States Government. It must be surrendered upon demand made by an authorized representative of the Department of State. The passport is not valid unless signed by the bearer on page two." Mason stopped at the corner of Prince and placed his heavy left boot on the top of a fire hydrant, balanced the booklet on his knee, and with his trusty Bic signed the thing. Happy day: signature du titulaire. The gods smiled. Znotchy was in high gear. Mason stepped briskly: he was making it in America. Hotdog! Yet he was no penance payer: any judgment would be secular since he wasn't a 1940s James Cagney of the Lower East Side caught excruciatingly between Church and State. If repentance must be then make it a civic sacramental ordinance: his forgiving priest was his own knowledge that he'd done his so-called best, that the Forces had been so powerful, so overwhelming, and poverty and misuse so pervasive, that he could not have done better *otherwise*. Lie? The Department of Justice would not agree. So: absolution wouldn't be forthcoming? How about confession? Had the system nailed him so profoundly to the cross? He insisted that the angels of The System had lice under their wings. He too? You bet. Was there guaranteed another *sea* up ahead? No, but he had no trouble at all getting a driver's license in the desired name. He went downtown to the Municipal Building and stood in line like everybody else. That was the hardest part. The passport did the rest. Applying for a Visa Credit Card wasn't quite so copesettic. The computer said The Impostor already had one. "Uh, excuse me, I forgot." A day later, elsewhere, Mason

applied—with fingers crossed—for a Master Charge card. Luck would be with him.

Mason Ellis sang "Diddie Wa Diddie" like Blind Blake, crossed the street at Fifth Avenue and Forty-Second like the Beatles on the cover of *Abbey Road* and reaching the curb leaped into the air and coming down did a couple of steps of the Flat Foot Floogie. (Earlier, in his room at the Gramercy Park Hotel—just north of the park, he'd kissed himself in the mirror! Yes, yes, he'd moved: did ya think he wuz gonna stay in that fleabag . . . ?) He climbed the grand stairway. Inside he found Reference. Selected the volumes to update "his" activities. A photocopy machine added technological sparkle to a dreary corner by a drinking fountain. He took the books there and xeroxed the pages he needed. It was like discovering a map of the unknown world: The Grand Lake the Shadow Mountain the Rainbow Curve. Then: feeling paralyzed as in a dream unable to move he stood trim, halfway between sturdy shelves where he'd returned heavy volumes and a reading table, holding the copies at chest level. His cards exposed—? the dealer dealing from the bottom . . . ? was his opponent putting the squeeze on him? Was there some recent history of "himself" he had missed out on? What madness was responsible? Was he a man who'd missed a train because of a threat-of-loss . . . ? What'd The Impostor done since seventy-nine? Spare us. He longed for wish-fulfillment, it *alone*—and none of the above. Mason took the stairway down. Dazed—he started walking rather than taking any of the buses headed for Washington Square, or Cooper Square. As he threw himself against the Hudson winds sweeping up Fifth, choked on the gas fumes of the taxis racing down, he closed his eyes against Reagan posters pushing for president in November, against Carter posters too, everywhere—on the backs of buses, on billboards. Too much. Then *bong*: he bumped into—*what?*—a person? a light pole? a bus? Mason opened to see the big man stepping around him, cussing. But, uh, wasn't he Reverend Jack Mackins, the preacher of those wonderful reformatory sermons at Attica? Looking over his shoulder Mason felt pretty sure the huge wobbling fella *was* Mackins. A typical Sunday morning Mackins sermon: "One day each of you will open the closet door and step inside. You'll crouch there in the dermal membrane of darkness with the Lord. The darkness will not be illuminated by your whipped trust. You will have to earn strong faith. You must hear God breathing. The skin of his eyes will glow in the dark and fill you with fear and the nightfall cry of the loneliest whippoorwill on earth because of a light pouring out. Then you'll find yourself pushing like a sonofagun for the beginning. Your own, that is: you won't find it: what you'll discover will vary." Reverend Mackins raised his fist "to the heavens." "No matter what

your experience may be in *that* darkness, *endure—*do *not* perish! . . . Now, bow your heads, boys. Lord, save and forgive these poor boys sitting here on this holy day of rest, before me, in your care, without citizenship, locked up like cattle going to slaughter. Lord, they are not hopeless. I have walked among them and know the richness of their souls, the keenness of their minds. Lift them to your bosom. Nourish them in the wind of your voice, the fire of your breathing. Give them a chance for a life outside of crime, a sinless life: deliver them to a safe place beyond the excruciating controls of ethnic ghettos. Give them at least a little Civil Rights Movement or something to believe in. It's hell down here, Lord. (Give the women too an Equal Rights Bill: deliver them from bondage!) Dribble something down. I beseech you, One on High, perform frontal lobotomy on anybody who wants to fuck over somebody else without it being in dire self-defense . . ." Jeux d'esprit? Mason remembered this sort of outcry as being better than gold, sharper than a Saturday-night-switchblade entering a cliché. Mackins, dammit, had imagination! Mason'd gotten ideas for stories from those upstairs-thoughts . . . One term in one paragraph on one page of the sheets in his pocket worried him. It was: "post-modern." Mason didn't know what it meant. As he strolled southward still, he puzzled over it. Aside from its strictly utilitarian purpose—uprightness and stuckedness—it declared itself separate from modernism (so he'd read). Modernism depended heavily on the metaphoric: as a rejection of 19th Century Romanticism and its sentimentality it was made possible by many factors—among them (and this with a straight face): one) psychoanalysis; two) Einstein's theory of relativity; three) in Physics, the breaking of that hussy link between effect and sister cause; four) the downfall of Joyce Kilmer's tree; then five) that . . . locomotive; six) the rejection of the assumption that language offered a logical means by which one might understand—. (What'd all this wooden horse-trading talk really mean? was it some sort of new-fangled way of giving a bad weather report?) Then, what was metaphor? Was Mason to believe what he'd read about himself and metaphor? Maybe Garbo's "I want to be alone," was a metaphor? or "I am." Model for reality? Marcus Garvey's headgear was metaphor for Malcolm X's eyeglasses. Jelly Roll Morton was metaphor for Stevie Wonder. Huh? But this rejection of letting one thing stand for another . . . ? Interesting, yet . . . Maybe The Impostor *believed* the text represented nothing outside itself. I don't, thought Mason. Reverend Mackins knew God by his first name: was the name the same as the, uh, ah, spirit, I mean, body . . . ? Miss Inbetween was metaphor and Miss Acheass was metonymy. So be it. Text as permanent property—free of outside clut. Okay. Like Cubism: a peeled conceptual orange oozing Cezanne's blood and sperm: synthetic, analytical, geometric. Mason glanced up at the overcast dome. There was a promised full moon behind that shit. Hay-bob-a-re-

bop. He was on his way. Hi-de-hi-de-ho. Mason still had the will to endure: while ten thousand people choked to death on their grub each year here. Saaay whaaat? To say nothing of . . . *Hay*, shouldn't he cut out this shit and call a speakers' bureau? After all, he was a well-known author in need for some immediate action.

Reflex and Bone Structure

It isn't that I myself forget their names. The truth is I do not really give a shit about the names these men have who happen to be cops. One might be called *U* and he might be known to copulate with his victims, dead or alive. Another might be known as *A* because he looks like a bull, complete with horns. Still another could be called *D* as a symbol of door or doorway, and, if you like, you might even refer to one as *B*, if somehow you can see how he resembles a house.

But they all continue to come around and the rumor is Canada and I are both very much under suspicion and closely watched. They watch me only because of my involvement with him. I don't believe they would care otherwise. I'm not afraid. I do not even regret my involvement. I couldn't pull away from him now even if I dared doing so.

Anyway I still suspect the law enforcement officers of murdering Cora. Not only was she involved with a militant white group, she was also part of a revolutionary Black group, plus she was branching out into the women's liberation movement. Was a suffragette, but she believed firmly in sexual freedom which, in a way, explains her involvement with Dale. Without any loss of love for Canada and me.

Not that I can live with her attachment to Dale. But still, I refuse to play games. I mean, I can take on Halloween or even Christmas Day. I can handle a day like Labor Day, St. Patrick's Day, even April Fool's Day.

Sometimes I can even handle Canada from the inside out. Other times I must approach him at his edges, and not venture into him too much. He can be very difficult. It is his attitude. *He has an attitude!* He knows Cora is dead yet he has this way of pretending everything is all right and she's very much alive. He invents and reinvents the world as he wishes it to be.

From *Reflex and Bone Structure* (New York: Fiction Collective, 1975), 31–35. © 1975 by Clarence Major. Reprinted by permission.

I receive a picture post card. It's from Cora. She's on a beach somewhere in the Pacific Northwest. There's a man with her. They're holding hands and walking alone barefoot. The sand is wet and warm. In about twenty minutes they will be in a cottage arranging roses in a vase. After that they will take a

Boeing 707 to Victoria, British Colombia and check into a large room at The Empress where they will stay for five days, sleeping in separate beds. I receive another card. The picture shows Cora wearing a delicate taffeta iris colored dress, and smiling. The background is yellow. I draw a blank when I try to remember who the man was.

I draw a picture of Cora. I show it to Canada. "This is a forest covered area, complete with lowlands, rocks, stones, weeds, thunder and lightning, birds, and insects."

Canada draws a picture of Dale and shows it to me. I say, "This is not a tropical grassland."

I'm a detective trying to solve a murder. No, not a murder. It's a life. Who hired me? I can't face the question.

I'm tailing Cora and Canada and Dale. The three of them are riding together in a gasoline powered 1885 Benz. Ten miles per hour. Canada is driving. I'm walking. It takes them ninety years to reach the theater. The show has closed. The building is no longer there. The Village has changed.

Cora got weak, physically. While she was trying to recover, without becoming bedridden, she never saw Canada's eyes. He kept them behind the darkness of his eyeglasses. And she never pretended anymore, after that first time, that her father was still living. After seeing what sort of effect the trick had on Canada she knew better. The next time he'd probably really get mad. After all, she had long ago broken with her family.

She was like an animal trying to define and patrol her own space. She got sick of looking through commercial magazines, seeing the fashions. The way some girl-boy wanted her to dress.

She wanted to regain the spatial experience of being a child and she worked at it, sometimes. Her unconscious pictorial bias was for *herself* happy alone, walking across grass and under the limbs of trees, harmless animals nearby. She dreamed of it unaware, really, of how far she was from such a life. But unlike "everybody else," Cora was not afraid of her own unconscious life. She believed in the interplay between it and what she saw and felt everyday. Like Canada's dick. Or his face. Or the pots and pans. Or the stove and the kitchen table or the butter knife which, sometimes, she felt like running through Canada's back.

She still believes in electric scanners. I can testify to that! She believed in a lot of things and shit that people hadn't gotten around to even thinking

about. Stuff like the gentle loving nature of a pure essence called *Odocoileus virginianus*—she claimed it had something to do with wildlife and man's lack of mercy. I don't know. I don't pretend to know. She was into Mother Dependency. Unweaned creatures.

But she was moral as hell, and nothing is more moral than hell except perhaps heaven. Cora didn't believe in killing people. The *idea* of a person, from her point of view, was sacred. Ironic she herself got wasted in such a manner.

But this is not a speech made over a grave. Its nature is more that of a crossword puzzle or the mood of a mystery novel. In fact I plan to write a mystery novel. Cora would certainly approve of it if I put her in it. This, right here, could be it.

Cora goes to too many parties and she gets drunk too easily. While Canada is drunk, Cora plays around. And that is what leads to fights. What people call good plain dirty fun.

One night I kissed naked Cora in a musty hallway when she was trying to squat. For some reason I couldn't believe she was really that tired.

They found some of her teeth near the window.

And the police department plays it up big. They bring out their gadgets and hook them to whatever they want to inspect. Even hook them up to people.

"Give me the spoon."

"I don't have it."

"Fingerprint the neighbors."

"Why?"

"You heard me."

"Here. Put the silicone beneath the skin. The prints turn out better. Inject it."

"It's dark in here. . . ."

"Go out to the car. Get the ultra violet ink."

"Your mother."

One young man was wearing rubber gloves and picking his teeth with a dirty toothpick.

Dry blood was being wiped out on narrow sheets of paper. My thoughts:

these motherfuckers care nothing for Cora and they automatically think Canada killed her. Fuck 'em.

They had already drawn a circle around the large area where the disaster took place. And one was sprinkling white powder within that area. Also there were the scattered pieces of a suitcase.

The whole scene made me want to leave.

All-Night Visitors

I was overjoyed. She was a shapely Afro-American, the color of a Chinese. She was very together. I hadn't seen her since returning from Vietnam. She didn't look much different now than she had then: except she had gained some charming weight.

I remembered all those miles of delicious pussy, the *tupa* goodness of her! *Shimo!* Her thick protruding clitoris, trimming her, her inner lips, but most of all—what an expert she was at handling my *cokke*. How she had milked, milked me, milked, milked me! And she wasn't as mean as most black chicks. She had a spongy goodness, she was getting into herself, last time seen, in a way, but . . .

But there she was!

"Come in, baby!"

"Thank You." Pause. "How are you?"

That last dark convulsive night, her sensitive voice: "I'll just have to get someone else," Anita said ingeniously. "Sure, I guess you will," I answered. "You see," she countered, "I can't go on like this, Eli. At first, I imagined you cared for me. I mean, I'm human, you know, I need certain things, and well . . . you're not giving me what I *need*!" That night was tinged with mist. A Socialist poster was trapped on a brick wall, a kind of American infraction. I strolled beside her, silent, bestial. The heaping stink of the flavor of this urban captivity wedging in. And her cutting verbal inoculation! Her mouth a cove. Her red dress, black in the encroachment of night. Her heels slapping the sidewalk. Unrequited love! What a *thankless* bastard I had been! There boys went by with the word, "Warrior" impressed on the cloth of their backs, a kind of justice for them. Some legacy! I saw a bat circling slowly around inside a werewolf's medieval dwelling of the mind. She was at a deep blue brink. "But, of course we're still friends." "Somebody else?" "No, Eli." I frankly didn't accept *that*. I couldn't feel self-righteous, but I craved it this instant. Our footfalls. Her hands in her trench-coat pockets. Her long eyelids, still. And my hands, the tips of my shoes.

Anita's face was the kind that is difficult to remember because it possessed

From *All-Night Visitors*, unexpurgated ed. (Boston: Northeastern University Press, 1998), 64–68. © 1969, 1998 by Clarence Major. Reprinted by permission.

a kind of universal beauty, that is, by any standard. There was a film of white-yellow overtone to the deeper red-brown of her complexion, so that she came through, usually, depending on the light, as caramel creamy rich, a glowing darkness suggesting ancient rapture. Her eyes were deep brown. If I were angry with her about something, I picked on the stupidity in her eyes as justification for my violent moments of intense hatred for her whenever it was obvious that she wasn't devoting her entire life to booting and accentuating *my* essence in the world. Her mouth was large, juicy. A few teeth in the back missing. Its wetness, hollowness, was excellent aid to her natural fellatio skill. She had no academic argument pro or con to inhibit her overwhelming self-confidence and spontaneous ability to enjoy lovemaking with the sense of fulfillment an artist knows through creating pleasurable art. Her nose was the only slightly off-beat component of her face: it was rather flat, with a kind of bulbous head, and the ridges were like Brazil nuts; she had a good high forehead, pronounced, high cheekbones, a firm, protruding chin; a softness altogether that detracted from the unfortunate nose.

She now stood facing me in my living room. I was, for the moment, speechless. I had thought of her quite a bit lately. A sad half-smile on her face. She lifted a finger, pointed at me. (Goddamn! That finger—it suddenly came back to me: at the orphanage *that bitch*! The Warden used to push her finger into my face between my eyes, jabbing; her mouth going yakety-yak!) "You're really—Oh forget it!"

"What's wrong, Anita?"

She had her face covered. I went to her. She was trying to cry; her shoulders shook. I held them.

Finally she lifted her face. "Have a drink with me Eli?"

"Sure."

Strange that I could almost later completely forget her.

Outside, the night air was thick and damp, but warm, like walking through a green pool of dark water. Peaceful because she *wasn't* the world to me.

Anita beside me was murmuring: "This time, Eli . . . I think I've found *him*. I'm really nice to him, too."

"You mean your man?"

"Don't say it *like that*."

"What other way is there to say it?"

"Well, anyway, on Sundays, I cook him all kinds of wonderful meals. You should have seen some of the nice—"

"Why should *I* see them?"

"There you go getting mad already!"

"All right! I won't say anything!"

"Well, if you're going to be mad I'll just—"

"I'm sorry Anita. Go on, tell me."

And she went on: "He loves salads! You never cared for them, did you? He loves all kinds of salads . . . You know: onion, lettuce, tomatoes, grated cheese—real salads."

"I'm guilty of a crime."

"You are, indeed."

"I tried my level best."

I detected in Anita's tone a high wind over a cellar of frustration. Just how deeply unhappy was she, and to what extent would she cover it? Why tell me? He would soon cause my fist to ache.

In any case, we went to a modest bar and ordered scotch on the rocks. Her face, in the great shadows of silky, purple hair, seemed gently trapped in furious unhappiness. But she was still a very lovely woman. But what was happening to any woman? What were they letting the world do to them? Not just black women, all women! That great hump rump bang ugh bang bag they were in, selling body. The idea of body, a commodity.

I didn't want a woman who was going to do much moralizing about anything. At this time, I wanted in a woman complete femininity; this I found extremely necessary. Or other times, my relationship to women had been hypothetical. (In Vietnam, I hadn't bothered them. They seemed so sad.)

". . . I have a nice place, now. He helps me—Harold, I mean—with the rent and groceries."

"Do you hear wedding bells?"

"I doubt it. He's—well, I won't say . . ."

"Live with you?"

"No, we have an arrangement. What's your girl's name?"

"I don't have one."

"Ah, come on! *You?*" A tempered laugh.

"I want you." Want the flesh but what else?

She finally said, "I have scotch at my place."

Unlike New York, you cannot hail a taxi cab on the street in Chicago any time and any place you want one. Only theoretically in New York. I stepped inside a phone booth and called a livery service.

Literary Self-Portraits

Necessary Distance

Afterthoughts on Becoming a Writer

CLARENCE MAJOR

People have a tendency to ask a writer, *Why* did you become a writer? *How* did you become a writer? Every writer hears such questions over and over. You ever hear anybody ask a butcher a question like that?

So, what's so special about being a writer? Maybe we are simply fascinated by people who are brave (or foolish) enough to go against—and lucky enough to beat—the odds.

We seem fascinated in the same way by the lives of people in show business, and probably for the same reasons the lives of the writers interest us.

It is also always amazing to see someone making a living doing something he or she actually enjoys.

I never seriously tried to deal with the questions till I was asked to write my life-story. If my autobiography were going to make sense, I thought I'd better try my best to answer both questions.

So, my speaking this way to you is an effort to answer these questions—for myself and possibly for others. I don't expect to succeed—but here goes.

It seems to me that the impulse to write, the *need* to write, is inseparable from one's educational process—which begins at the beginning and never ends.

In some sort of non-objective way, I can remember being an infant and some of the things I thought about and touched. I had a sister, but my sister didn't have a brother. I had no self because I was *all* self. Gradually, like any developing kid, I shed my self-centered view of the world: saw myself reflected in my mother's eyes, began to perceive the idea of a self. In a way it was at this point that my *research* as a writer, and as a painter, began. (For me, the two impulses were always inseparable.) The world was a place of magic, and everything I touched was excruciatingly *new*. Without knowing it, my career had begun.

In his meditation on the art of fiction, *Being and Race*, novelist Charles Johnson says, "All art points to others with whom the writer argues about what is. . . . He must have models with which to agree . . . or outright oppose . . . for Nature seems to remain silent. . . ." Reading this passage reminded me of Sherwood Anderson's short story "Death in the Woods," in which the narrator retells the story (we are reading) because his brother, who had told it first, hadn't told it the way it was supposed to be told. In a

Originally appeared in *Black American Literature Forum* 23, no. 2 (Summer 1989): 197–212. Reprinted in *African American Review* 28, no. 1 (Spring 1994): 37–47. © 1989, 1994 by Clarence Major. Reprinted by permission.

similar way, that early self of mine had already started its long battle with the history of literature and art.

In the early stages of that battle, some very primary things were going on. By this, I mean to say that a writer is usually a person who has to learn how to keep his ego—like his virginity—and lose it at the same time. In other words, he becomes a kind of twin of himself. He remains that self-centered infant while transcending him to become the observer of his own experience and, by extension, the observer of a wide range of experience within his cultural domain.

Without any rational self-consciousness at all, early on, my imagination was fed by the need to invent things. My older cousins taught me how to make my own toys—trucks, cars, houses, whole cities. We used old skate wheels for tires. Our parents couldn't afford such luxuries as toys—we were lucky if we got new clothes. Watching physical things like the toys we made take shape, I think, showed me some possibilities. (William Carlos Williams said a poem is like a machine. If I understand what he meant, I can see a connection between what I was making at age seven and poems and stories I tried to write later on.)

Plus the *newness* of everything—trees, plants, the sky—and the *need* to define everything, on my own terms, were givens. At my grandparents' farm, my cousins and I climbed trees and named the trees we climbed. Painfully, I watched my uncle slaughter hogs and learned about death. I watched my grandmother gather eggs from the chicken nests and learned about birth. I watched her make lye soap and the clothes we wore. But I didn't fully trust the world I was watching. It seemed too full of *danger*, even while I dared to explore it and attempt to imprint the evidence of my presence upon it—by making things such as toys or drawing pictures in the sand.

Daydreaming—as necessity in the early disposition of a writer—is not a new idea. Whether or not it was necessary in my case, I was a guilty practitioner. I say this because I had an almost *mystical* attachment to nature. If looked at from my parents' point of view, it was not a good sign. I could examine a leaf for hours or spend hours on my knees watching the way ants lived. Behaving like a lazy kid, I followed the flights and landings of birds with spiritual devotion. The frame of mind that put me through these motions was, later, the same frame of mind from which I tried to write a poem or a story: daydreaming, letting it happen, connecting two or three previously unrelated things, making them mean something—together—entirely new. I was hopeless.

And dreams—in dreams I discovered a self going about its business with a mind of its own. I began to watch and to wonder. I was amazed by some of the things I had the nerve to dream about. Sex, for example. Or some *wonderful*, delicious food! One guilty pleasure after another! The other self

often invented these wonderful ways for me to actually get something—*even* a horse once—that I *knew* I wanted, something no one *seriously* wanted to give me.

At times, waking up was the hard part. Dream activity was all invention—maybe even the rootbeds of all the conscious, willful invention I wanted to take charge of in the hard indifference of daylight. Unlike the daydreams I spent so much time giving myself to, these dreams were not under my control. Later, I started trying to write them down, but I discovered that it was impossible to capture their specific texture. They had to stay where they were. But I tried to imitate them, to make up stories that *sounded* like them. The pattern of these dreams became a model for the imaginative leaps I wanted to make (and couldn't—for a long time!) in my poetry and fiction.

My first novel, written at the age of twelve, was twenty pages long. It was the story of a wild, free-spirited horse, leading a herd. Influenced by movies, I thought it would make a terrific movie, so I sent it to Hollywood. A man named William Self read it and sent it back with a letter of encouragement. I never forgot his kindness. It was the beginning of a long, long process of learning to live with rejection—not just rejection slips. And that experience too was necessary as a correlation to the writing process, necessary because one of the most *important* things I was going to have to learn was *how* to detect my own failures and be the first to reject them.

Was there, then, a particular point when I said, *Hey! I'm going to become a writer!* I think there *was*, but it now seems irrelevant because I must have been evolving toward that conscious moment long, long before I had any idea what was going on. (I was going to have to find my way—with more imperfection than not—through many disciplines—such as painting, music, anthropology, history, philosophy, psychology, sociology—before such a consciousness would begin to emerge.)

I think I was in the fifth grade when a girl who sat behind me snuck a copy of Raymond Radiguet's *Devil in the Flesh* to me. This was *adult* fiction! And judging from the cover, the book was going to have some good parts. But as it turned out, the *single* good part was *the writing itself*. I was reading that book one day at home, and about halfway through, I stood up and went crazy with an important discovery: *Writing had a life of its own!* And I soon fell in love with the *life* of writing, by the way of this book—Kay Boyle's translation of Radiguet.

From that moment on, up to about the age of twenty, I set out to discover other books that might change my perception—forever. Hawthorne's *The Scarlet Letter* showed me how gracefully a story could be told and how terrifying human affairs—and self-deception within those affairs—can be.

Conrad's *Heart of Darkness* caught me in an aesthetic network of magic so powerful I never untangled myself. I then went on to read other nineteenth-century—and even earlier—works by Melville, Baudelaire, Emerson, Dostoyevsky, and the like.

But I always hung on—with more comfort—to the twentieth century. I read J. D. Salinger's *The Catcher in the Rye* early enough for it to have spoken profoundly and directly to me about what I was *feeling* and *thinking* about the adult world at the time that its agony affirmed my faith in life. Richard Wright's *Native Son* was an overwhelming experience, and so was Rimbaud's poetry. But the important thing about these discoveries is that each of them led to Cocteau and other French writers, going back to the nineteenth century; Salinger led me to a discovery of modern and contemporary American fiction—Hemingway, Faulkner, Sherwood Anderson, and on and on. Wright led to Dos Passos, to James T. Farrell, to Jean Toomer, to Chester Himes, to William Gardner Smith, to Ann Petry, to Nella Larsen and other African-American writers; and Rimbaud led to the discovery of *American poetry*—which was not so much of a leap as it sounds—to Williams, to Marianne Moore, to Eliot, to cummings. This activity began roughly during the last year of grade school and took on full, focused direction in high school. Now, none of these writers was being taught in school. I was reading them *on my own*. In school we had to read O'Henry and Joyce Kilmer.

But during all this time, it was hard to find books that came *alive*. I had to go through *hundreds* before hitting on the special ones, the ones with the power to shape or reshape perception, to deepen vision, to give *me* the meaning to understand *myself* and other things, to drive away fears and doubts. I found the possibilities of wedding the social and political self and the artistic self in the essays of James Baldwin. Autobiographies such as Billie Holiday's *Lady Sings the Blues* and Mezzrow's *Really the Blues* were *profound* reading experiences: These books, and books like them, taught me that even life, with more pain than one individual had any right to, was still worth spending some time trying to get *through*—and, like Billie's and Mezz's, with dignity and inventiveness.

Although I was learning to appreciate good writing, I had no command of the language myself. I had the *need* to write well, but that was about all. Only the most sensitive teacher—and there were two or three along the way—was able to detect some talent and imagination in my efforts. Every time I gathered enough courage to dream of writing seriously, the notion ended in frustration or, sometimes, despair. Not only did I not have command of the language, I didn't have the *necessary distance* on experience to have anything important to say about even the things I knew something about.

I daydreamed about a solution to these problems: I could *learn* to write,

and I could go out and *live it up* in order to have experience. But this solution would take time. I was not willing to *wait*. In my sense of urgency, I didn't have that much time.

Meanwhile, there were a few adults I ventured to show my efforts to. One teacher told me I couldn't *possibly* have written the story I showed her. It was *too good*—which meant that it was a hell of a lot better than I had thought. But rather than gaining more self-confidence, the experience became grounds for the loss of respect of *her* intelligence. Among the other adults who saw my early efforts were my mother—who encouraged me as much as her understanding permitted—and a young college-educated man who was a friend of the family's. He told me I was pretty good.

I was growing up in Chicago, and my life therefore had a particular social shape. The realities I was discovering in books didn't—at first—seem to correspond to the reality around me. At the time, I didn't have enough distance to see the connections.

The fact is, the writerly disposition that was then evolving was *shaped* by my life in Chicago—in the classroom and on the playground—as well as it was being shaped during the times I spent alone, with books, and anywhere else, for that matter. Which is only one way of saying that a writer doesn't make most of his or her own decisions about personal vision or outlook.

Jean-Paul Sartre, in *What Is Literature?*, makes the observation that Richard Wright's destiny as a writer was chosen for him by the circumstances of birth and social history. One can go even further and say that it's as difficult to draw the line between *where* a sensibility is influenced by the world around it and where it is asserting its own presence in that world, as it is to say whether or not essence precedes existence.

To put it *another* way, the educational process against which my *would-be* writerly disposition was taking formation was *political*. Political because I quickly had to learn how to survive—for example, on the playground. It was not easy since I had an instinctive dislike for violence. But the playground was a place where the *dramas* of life were acted out. Radiguet's book (and Jean Paul Rossi's *Awakening*, too) had—to some extent—dealt with the same territory. As a microcosm of life, it was no doubt one of the *first* social locations in which I was forced to observe some of the ways people relate—or don't relate—to each other. Among a *number* of things, I learned how to survive the *pecking*-order rituals—with my wits rather than my fists. This was an area in which books and art could not save me. But later on, I was going to see how what I *had* to learn—in self-defense—carried over to the creative effort.

The classroom, too, was *not* a place where one wanted to let one's guard down for too long. To be liked and singled out by a teacher often meant getting smashed in the mouth or kicked in the stomach on the playground. If one demonstrated intelligence in school, one could almost certainly expect

to hear about it later, on the way home. It was simply not cool for *boys* to be smart in class. A smart boy was a sissy and deserved to get his butt kicked.

I had to be very quiet about my plans to become a writer. I couldn't talk with friends about what I read. I mean—why wasn't I out playing basketball?

All of this, in terms of education—or plans to become a writer—meant that if you wanted to learn anything (or try to write something, for example) you had to do it without *flaunting* what you were doing. Naturally, some smart but less willful kids gave in, in the interest of survival; they learned how to *fail* in order to live in the safety zone of the majority. And for those of us who didn't *want* to give in, it was hard to keep how well we were doing a *secret* because the teacher would tell the class who got the best grades.

I was also facing another crisis. If, for example, I wanted to write, eventually I had to face an even larger problem—publication. I thought that, if I were ever lucky enough to get anything published (say, in a school magazine or newspaper), that would be a success I would have to keep quiet about among most of my friends and certainly around those out to put me in my place. And God forbid that my first published work should be a poem. Only sissies wrote poetry.

But I couldn't go on like that. I remember once breaking down and saying to hell with it. I walked around the school building with a notebook, writing down *everything* I saw, trying to translate the life around me, minute by minute, into words. I must have filled twenty pages with very boring descriptions. A girl I liked, but didn't have the nerve to talk to, saw me. She thought I was doing homework. When I told her what I was up to, she gave me this strange, big-eyed look, then quickly disappeared—*forever*—from my life.

I now realize that I must have been a *difficult* student for teachers to understand. At times I was sort of smart, at other times I left a *lot* to be desired. One teacher thought I might be retarded, another called me a genius. Not knowing what else to do with me, the administrators—in frustration—appointed me art director of the whole school of 8,000 students during my last year.

Why art director? Actually, as I implied, my first passion was for painted pictures rather than the realities I discovered in books. Before my first clear memories, I was drawing and painting, while the writing started at a time within memory. So, I think it is important (in the context of "how" and "why," where the writing is concerned) to try to understand what this visual experience has meant for me.

About the age of twelve, I started taking private art lessons from a South Side painter, Gus Nall. I even won a few prizes. So, confidence in my ability

to express myself *visually* came first. But what I learned from painting, I think, carried over into the writing from the beginning.

My first articulate passion was for the works of Vincent van Gogh. This passion started with a big show of his work at the Art Institute of Chicago hung in the early fifties. There were about a hundred and fifty pieces.

I pushed my way through the crowded galleries—stunned every step of the way. I kept going back. I was not sophisticated enough to know how to articulate for myself what these things were doing to me, but I knew I was *profoundly* moved. So—on some level—I no doubt did sense the *power of the painterliness* of those pictures of winding country paths, working peasants, flower gardens, rooftops, the stillness of a summer day. They really got to me.

Something in me went out to the energy of Vincent's *Sunflowers*, for example. I saw him as one who broke the rules and transcended. Where I came from, no socially well-behaved person ever went out and gathered *sunflowers* for a vase in the home. No self-respecting *grown man* spent ten years painting pictures he couldn't sell. On the South Side of Chicago everything of value had a price tag.

Vincent, then, was at least one important model for my rebellion. The world I grew up in told me that the only proper goal was to make money and get an education and become a productive member of society and go to church and have a family—pretty much in that order. But I had found my alternative models, and it was too late for my world to get its hooks in me. I wasn't planning to do anything less than the greatest thing I could think of. I wanted to be like van Gogh, like Richard Wright, like Jean Toomer, like Rimbaud, like Bud Powell.

In the meantime, I went home from the van Gogh exhibition and tried to create the same effects from the life around me: I drew my step-father soaking his feet in a pan of water, my older sister braiding my younger sister's hair, the bleak view of rooftops from my bedroom window, my mother in bed sick, anything that struck me as compositionally viable. In this rather haphazard way, I was learning to *see*. I suspect there was a certain music and innocence in Vincent's lines and colors that gave me a foundation for my own attempts at representing—first, through drawing and painting, and very soon after in poetry I was writing. The poems I first tried to write were strongly imagistic in the Symbolist tradition.

I made thousands of sketches of this sort of everyday thing. I was responding to the things of *my* world. And I had already lived in two or three different worlds: in a Southern city, Atlanta; in a rural country setting; and now in Chicago, an urban, brutal, stark setting. We moved a lot—so much so that my sense of place was always changing. Home was where we happened to be. Given this situation, I think the fact that Vincent felt like an alien in his own land (and was actually an alien in France, and that this

sense of being estranged carried over emotionally into his work) found a strong correlating response in me.

If there were disadvantages in being out of step, there were just as many advantages. I was beginning to engage myself passionately in painting and writing, and this passion would carry me through a lot of difficulties and disappointments—simply because I *had* it. I saw many people with no passionate interest in *anything*. Too many of them perished for lack of a passionate dream long before I thought possible.

At fourteen, this passionate need to create (and apparently the need to *share*, too) caused me to try to go public—despite the fact that I knew I was doing something eccentric. One of my uncles ran a printing shop. I gathered enough confidence in my poetry to pay him ten dollars to print fifty copies of a little booklet of my own poetry. The poems neglect the influence of Rimbaud, van Gogh, and Impressionism generally—I *even* used French words I didn't understand.

Once I had the books in hand, I realized that I didn't know more than *three* people who might be interested in seeing a copy. I gave one to one of my English teachers. I gave my mother three copies. I gave my best poet friend a copy. I may have also given my art teacher Mr. Fouche a copy. The rest of the edition was stored in a closet. They stayed there till, by chance, a year or two later, I discovered how bad the poems were and destroyed the remaining copies.

Shortly after the van Gogh exhibition, the Institute sponsored a large showing of the works of Paul Cézanne, whose work I knew a bit from the few pieces in the permanent collection. I went to the exhibition not so much because I was *attracted* to Cézanne but because it was *there*—and I felt that I *should* appreciate Cézanne. At fifteen that was not easy. And the reasons I found it difficult to appreciate Cézanne as much as I thought I should had (I later learned) to do with my inability to understand, at a gut level, what he was about, what his *intentions* were. Cézanne's figures looked stiff and ill-proportioned. His landscapes, like his still lifes, seemed made of stone or wood or metal. Everything in Cézanne was unbending, lifeless.

I looked at the apples and the oranges on the table and understood their *weight* and how important the sense of that weight was in understanding Cézanne's intentions. I wanted to say, yes, it's a great accomplishment. But why couldn't I *like* it? I was not yet sophisticated enough to realize that all great art—to the unsophisticated viewer—at first appears *ugly*, even repulsive. And I had yet to discover Gertrude Stein in any serious way, to discover her attempts to do with words what Cézanne was doing with lines and color.

It took many years to acquire an appreciation for Cézanne—but doing so, in its way, was as important to my development as a writer as was my passion for van Gogh. But the appreciation started, in its troubled way, with that big show. When I finally saw the working out of the *sculpturing* of a created reality (to paraphrase James Joyce), I experienced a breakthrough. Cézanne appealed to my *rational* side. I began going to Cézanne for a knowledge of the inner, mechanical foundation of art, and for an example of a self-conscious exploration of composition. All of this effort slowly taught me how to see the significant aspects of writing and how they correspond to those in painting. Discovering *how* perspective corresponded to point of view, for example, was a real high point.

These two painters, van Gogh and Cézanne, were catalysts for me, but other painters were important for similar reasons: Toulouse-Lautrec, Degas, Bonnard, Cassatt, Munch—for intensely scrutinized private and public moments; Edward Hopper—for his ability to invest a view of a house or the interior of a room with a profound sense of mortality; Matisse—for his play, his rhythm, his design. I was attracted by the intimacy of subject matter in their work.

I also had *very* strong responses to Gauguin. He excited and worried me at the same time. At first, I was suspicious of a European seeking *purity* among dark people. (And I placed D. H. Lawrence in the same category.) Later, I realized Gauguin's story was more *complex* than that (as was Lawrence's.) But more important to me was the fact of Gauguin's work: painting with flat, blunt areas of vivid colors. Their sumptuousness drew a profoundly romantic response in me. Not only did I try to paint *that way* for a period, I also thought I saw the possibility of creating simple, flat images with simple sentences or lines.

For a while I was especially attracted to painters who used paint thickly. Turner's seascapes were incredible. Up close they looked abstract. Utrillo's scenes of Paris, Rouault's bumpy people, Albert Ryder's horrible dreams, Kokoschka's profusion of layered effects—these rekindled feelings that had started with van Gogh. (Years later, I came to appreciate Beckman and Schiele for similar reasons.) To paint that way—expressively, and apparently fast—had a certain appeal. It was just a theory but worth playing with: In correlation, it might be possible to make words move with that kind of self-apparent urgency, that kind of reflexive brilliance. The expressionistic writers—Lawrence, Mansfield, Joyce, and others—had done it.

I kept moving from one fascination to another. Later, the *opposite* approach attracted me. The lightness of Picasso's touch was as remarkable as a pelican in flight. If I could make a painting or poem *move* like that—like the naturalness of walking or sleeping—I would be lucky.

I was easily seduced. I got lost in the dreams of Chagall, in the summer

laziness of Monet, in the waves of Winslow Homer, in the blood and passion of Orozco, in the bright, simple designs of Rivera, in the fury of Jackson Pollock, in the struggle of de Kooning, in the selflessness of Vermeer, in the light and shadow of Rembrandt, in the plushness of Rubens, in the fantastic mystery of Bosch, in the power of Michelangelo and Tintoretto, in the incredible sensitivity and intelligence of Leonardo da Vinci, in the earthly dramas of Daumier and Millet. (Later on, when I discovered African-American art, I got equally caught up in the works of Jacob Lawrence, Archibald Motley, Henry Tanner, Edward Bannister, and others. I was troubled from the beginning at the absence of African-American painters, novelists, poets, generally, I might turn to as models. I was seventeen before—on my own—I discovered the *reason* they were absent: The system had hidden them. It was that simple. They had existed since the beginning but were, for well known reasons, made officially nonexistent.)

Although this learning process was a slow and very long one, and I wasn't always conscious of even the things I successfully managed to transfer into my own paintings and writing, I can now look back and realize that I must always have been more fascinated with technique—in painting and in writing—than I was by subject matter. The subject of a novel or a painting seemed irrelevant: a nude, a beach scene, a stand of trees, a story of an army officer and a seventeen-year-old girl in a foreign country, a lyrical view of a horrible accident. It didn't matter! What did matter was *how* the painter or storyteller or poet had seduced me into the story, into the picture, into the poem.

I also felt the need to submerge myself in the intellectual excitement of an artistic community—but I couldn't find one. Just about every writer I'd ever heard of seemed to have had such nourishment: Hemingway in Paris among the other expatriates. . . . But I was not in touch with any sort of *exciting* literary or artistic life (outside of visits to the Institute) on the South Side. True, I had met a couple of writers—Willard Motley and Frank London Brown—and a few painters—Gus Nall, Archibald Motley, and a couple of others—but I felt pretty isolated. Plus these people were a lot older and didn't seem to have much time to spare. So, I had clumsily started my own little magazine—a thing called *Coercion Review*. It became my substitute for an artistic community and, as such, a means of connection (across the country and even across the ocean) with a larger, cultural world—especially with other writers and poets.

I published the works of writers I corresponded with, and they published mine; and in a way this became our way of *workshopping*—as my students say—our manuscripts. When we found something acceptable, it meant—or

so we thought—that the particular piece had succeeded. We were wrong more often than not. It was an expensive way to learn what not to publish (and how to live with what couldn't be unpublished).

Seeing my work in print increased my awareness of the many problems I still faced in my writing at, say, the age of eighteen. I wrote to William Carlos Williams for help. I wrote to Langston Hughes. They were generous. (In fact, Williams not only criticized the poetry but told me of his feelings of despair as a poet.)

Rushing into print was teaching me that I not only needed distance on approach (the selection of point of view, for example) and subject matter *before* starting a work, but I needed also to slow down, to let a manuscript wait, to see if it could stand up under my own developing ability to edit during future readings, when my head would be clear of manuscript birth fumes. As a result, my awareness of what I was doing—of its aesthetic value—increased. I became more selective about what I sent out.

During all this time, I was also listening to music. Critics of African-American writing often find reason to compare black writing to black music. Each of my novels, at one time or another, has been compared to either Blues songs or jazz compositions. I've never doubted that critics had a right to do this. But what was *I* to make of the fact that I had *also* grown up with Tin Pan Alley, Bluegrass, and European classical music? I loved Chopin and Beethoven.

Something was wrong. It seemed to me that Jack Kerouac, for example, had gotten as many jazz motifs into his work as had, say, James Baldwin. At a certain point, when I noticed that critics were beginning to see rhythms of music as a basis for my lines or sentences—to say nothing of content—I backed up and took a closer look. I had to argue—as least with myself—that *all* of the music I'd loved while growing up found its aesthetic way into my writing—or *none* of it did.

True, I had been overwhelmingly caught up in the Be-bop music of Bud Powell when I was a kid—I loved "Un Poco Loco," thought it was the most inventive piece of music I had ever heard, loved all of his original compositions ("Hallucinations," "I Remember Clifford," "Oblivion," "Glass Enclosure," and on and on—and, as I said before, I swore by the example of his devotion to his art).

But I soon moved on out, in a natural way, from Powell into an appreciation of the progressive music of other innovators—such as Thelonius Monk, Lester Young, Sonny Stitt, John Coltrane, Clifford Brown, Miles Davis, Dizzy Gillespie, Charlie Parker, Dexter Gordon, and Ornette Coleman—and, at the same time, I was discovering Jimmy Rushing, Bessie Smith, Billie Holiday, Joe Turner, Dinah Washington—singers of my father's generation and before.

My feeling, on this score, is that African-American music generally (along with other types of music I grew up hearing) had a pervasive cultural importance for me. I think I need to take this assumption into consideration in trying to trace in myself the shape of what I hope has become some sort of sensitivity not only to music but also to poetry, fiction, painting, and the other arts—film, photography, and dance.

I've already mentioned the importance of other disciplines—anthropology, history, philosophy, psychology, sociology—in an attempt to lay some sort of intellectual foundation from which to write. Without going through the long, hopelessly confusing tale of my own confusion and profoundly troubled questing, I think I can sum up what I came away with (as it related to themes I chose or the themes that *chose me*) in pretty simple terms.

I remember my excitement when I began to understand cultural patterns. Understanding the nature of kinship—family, clan, tribe—gave me insight into relationships in the context of my own family, community, country. I was also fascinated to discover, while reading about tribal people, something called a caste system. I immediately realized that I had grown up in communities, both in the South and the North, where one kind of caste system or another was practiced. For one to be *extremely* dark or *extremely* light often meant that one was penalized by the community, for example.

Totem practices also fascinated me because I was able to turn from the books and see examples in everyday life: There were people who wore good-luck charms and fetishes, such as rabbits' feet on keychains. I became aware, in deeper ways, of the significance of ritual and ceremony—and how to recognize examples when I saw them. It was a breakthrough for me to begin to understand *how* cultures—our own included—rationalized their own behavior.

The formation of myths—stories designed to explain why things were as they were—was of deep interest to me. Myths, I discovered, governed the behavior and customs I saw every day—customs concerning matters of birth, death, parents, grandparents, marriage, grief, luck, dances, husband-and-wife relationships, siblings, revenge, joking, adopting, sexual relations, murder, fights, food, toilet training, game playing. You name it.

Reading Freud (and other specialists of the mind) I thought would help me understand better how to make characters more convincing. At the same time I hoped to get a better insight into myself—which in the long run would also improve my writing. I read Freud's little study of Leonardo da Vinci. I was interested also in gaining a better understanding of the nature of creativity itself.

But even more than that, I was interested in the religious experience

psychologists wrote about. I consciously sought ways to understand religious frenzy and faith in rational terms. I was beginning to think how, as too much nationalism tends to lead to fascism, too much blind religion could be bad for one's mental health. To me, the human mind and the human heart began to look like very, very dangerously nebulous things. But at the same time, I kept on trying to accept the world and its institutions at face value, to understand them on their own terms. After all, who was I to come along and seriously question *everything*? The degree to which I did question was more from innocence than from arrogance.

I was actually optimistic because I thought *knowledge* might lead me somewhere refreshing, might relieve my burden of ignorance. If I could only understand schizophrenia or hysteria, mass brainwashing and charisma, paganism, asceticism, brotherly love. . . . Why did some individuals feel called to preach and others feel overwhelmed with galloping demons? What was the function of dreaming? I skimmed the Kinsey reports and considered monastic life. I read Alan Watts and was a Buddhist for exactly one week.

I liked the gentle way Reich criticized Freud and, in the process, chiseled out his own psychoanalytical principles. If I ever thought psychoanalysis could help me personally, I was not mad enough to think we could afford it. I did notice, though, how writers of fiction and poets too, from around the turn of the century on, were using the principles of psychoanalysis as a tool for exploring behavior in fiction and poetry. So I gave it a shot. But the real challenge, I soon learned, was to find a way to absorb some of this stuff and at the same time to keep the *evidence* of it out of my own writing.

Yet I kept hoping for some better—more suitable—approach to human experience. If a better one existed, I had no idea. But there wasn't much to hold on to in psychoanalysis or psychology, and even less in sociology— where I soon discovered that statistics could be made to prove anything the researcher wanted to prove. If the *very presence* of the researcher were itself a contamination, what hope was there for this thing everybody called objectivity?

While I was able to make these connections between theory and reality, I was still seeking answers to questions I had asked since the beginning—*Who and what am I?* Questions we discover later in life are not so important. Everywhere I turned—to philosophy, to psychology—I was turned back upon myself and left with *more* questions than I'd had at the start.

Growing up in America when I did, while aiming to be a writer, was a disturbing experience. (Every generation is sure it is more disturbed than the previous one and less lucky than the forthcoming one.) This troublesome feeling was real, though; it wasn't just growing pains. There was something else, and I knew it. And I finally found part of the explanation.

My *sense* of myself was hampered by my country's sense of *itself*. My country held an idealistic image of itself that was, in many aspects of its life, vastly different from its actual, unvarnished self. Examples: There were severe poverty, ignorance, disease, corruption, racism, sexism, and there was war—all-too-often undeclared.

But I, as a writer, could not afford the luxury of a vision of my own experience as sentimental as the one suggested by my country (of itself, of me). As I grew up, I was trying to learn *how* to see through the *superficial* and to touch, in my writing, the essence of experience—in all of its possible wonderment, agony, or glory.

Despite the impossibility of complete success, I continue.

I was to be as forthright as possible with these afterthoughts—because I know that afterthoughts can never *truly* recapture the moments they try to touch back upon. Each moment, it seems to me, in which a thought occurs has more to do with *that* moment itself than with anything in the past. This, to my way of thinking, turns out to be more positive than negative, because it supports the *continuous* nature of life—and that of art, too. The creative memory, given expression, is no enemy of the past, nor does its self-focus diminish its authority.

"I Follow My Eyes"

An Interview with Clarence Major

LARRY McCAFFERY & JERZY KUTNIK

It was during the period of turmoil and transformation of the 1960s that Clarence Major first achieved literary recognition, initially as an editor, poet, and anthologist, and then—following the controversial publication in 1969 of his sexually charged, highly controversial first novel, *All-Night Visitors* from Maurice Girodias's Olympia Press—as one of postmodern fiction's most versatile and radical innovators. Major's first publication was a pamphlet of (mostly forgettable) poems entitled *The Fires That Burn in Heaven* (1954); following a stint in the Air Force, Major began editing *Coercion Review* (1958–61), which gradually brought him into contact with such leading poetry figures as William Carlos Williams, Robert Creeley, and Allen Ginsberg. Over the years, Major has made editorial contributions to such journals as the *Journal of Black Poetry*, the *American Book Review*, and the *American Poetry Review*, as well as editing two collections of student work—*Writers Workshop Anthology* (1967) and *Man Is a Child* (1968). He first gained national attention with the publication of *The New Black Poetry* (1969), a controversial anthology of contemporary black poetry which he edited. Its eclecticism drew criticism from conservative and liberal factions of the black artistic community, who were both already heatedly discussing the implications of the "black aesthetic" being promoted by writers like Ishmael Reed, Ed Bullins, and Amiri Baraka. In addition to his creative work as a poet and fiction writer, Major has also published a wide variety of reviews, manifestoes, and critical essays (some collected in his 1974 critical study *The Dark and Feeling: Black American Writers and Their Work*).

Major's first important poetry collection, *Swallow the Lake* (1970), explored some of interests that would recur in his later fiction (music, alienation and psychic dismemberment, male-female relationships, the relationship of art and reality, sex and death, etc.) in a wide variety of styles and voices. Three more collections followed rapidly: *Private Line* (1971), *Symptoms and Madness* (1971), and *The Cotton Club* (1972). Major's poetry is characterized by the same rich, unsettling mixture of humor and anger, passion and intellect, self-consciousness, free-wheeling energy, and formal daring found in his fiction.

Because Major has mainly avoided the socialist realist mode favored by most black American writers in favor of expressionistic, metafictional modes, his fiction has subsequently been analyzed primarily in terms of its "experimental" or "anti-realist" features. Unfortunately, this focus has

Originally appeared in *African American Review* 28, no. 1 (Spring 1994): 121–38. Reprinted in Larry McCaffery, *Some Other Frequency: Interviews with Innovative American Authors* (Philadelphia: University of Pennsylvania Press, 1995). © 1994 by Larry McCaffery and Jerzy Kutnik. Reprinted by permission.

tended to relegate Major to the "avant-garde ghetto," where his works have never attained the popularity or critical acclaim given his more publicly visible contemporaries such as Alice Walker, Toni Morrison, and Ishmael Reed.

However, as with many other figures from postmodernism's "first wave" of literary innovators, what once seemed "anti-realistic" to a generation raised on the illusionistic assumptions of traditional realism today can be recognized as new approaches to realism. These approaches either describe a reality that itself seemed "unrealistic" by earlier norms or, as seems more relevant for Major's work, find fresh methods to depict irrational, contradictory inner lives and selves that resist traditional formulations. Many of the features of Major's fictions are in fact designed to give voice to various irrational impulses and contradictory versions of self and personal identity that traditional realism couldn't give expression to. Thus, Major's best fiction often presents a fiercely passionate vision of jagged, tortured beauty that is analogous to that found in Goya, van Gogh, Hendrix, or Eric Dolphy. While such non-literary analogies are always suspect, they are appropriate in this case due to Major's convictions concerning the inadequacies of verbal logic, which sustains the realistic novel, as a means of conveying the truth about experience.

The themes and forms of these books seem to trace a movement away from the radical sense of personal fragmentation and insecurity, graphic sexuality, and outrage found in the early works (*All-Night Visitors* [1969] and *NO* [1973]) to a middle period in which his interests in metafictional explorations of the fiction-making process and metafictional methods and formal concerns find their most extreme expression in *Reflex and Bone Structure* and *Emergency Exit*, to his recent explorations of more narrative styles and formal structure in works like *Such Was the Season* (1987). But as Major takes great pains to suggest in the following interview, such an evolution represents less a move "away from anti-realism towards realism" than different stages in an ongoing effort to find a suitable means to give expression to his sense of himself.

As it happens, most of the early versions of "self" are prismatic, cubistic constructs reflecting not self but a shifting series of public, private, and imaginary selves. Most of Major's fiction unfolds as a bewildering array of discrete bits of visual images, fragments of contradictory plot elements, different voices, and reflexive ruminations about fiction. Major's novels nearly all focus on men whose lives are either coming apart or never had achieved any unity in the first place. Reading Major's important middle works like *Reflex and Bone Structure* (1975), *My Amputations* (1986), and what is perhaps his most important single novel, *Emergency Exit* (1979), one feels much as one did in reading Kerouac and Burroughs, Rimbaud and Artaud—figures who, like Major, felt the need to refashion an entire new

language and set of narrative assumptions in order to conjure up "spaces" of the imagination and emotion never given voice to previously. Major thus developed a variety of discontinuous, collagelike structures to capture the movement of a mind which refuses to reduce his experiences to the sorts of unified narrative voices and causally related plot elements found in the realistic novel. As with other writers from this period who were exploring similar methods—for example, his fellow Fiction Collective writers Steve Katz, Raymond Federman and Ronald Sukenick—the result for Major is akin to a jazz musician's improvisations, whose various tones, rhythms, motifs, and other sound patterns, expressed in different keys and tones, provide a means of access to the artist's inner self. The act of writing down the work we are reading thus should be seen as being not an effort to find a unified self, voice, or plot but an attempt to provide a means to give expression to the multiple, contradictory aspects of himself. His novels, then, represent not the illusions of realism but the illusoriness of those illusions.

Although the influence of jazz and poetry on Major's fiction has been widely noted, his writing has probably been even more deeply influenced by the visual. Major began his artistic career as a painter (he attended the Art Institute of Chicago briefly at age seventeen), and has continued to produce paintings, which he has exhibited in galleries and exhibitions on numerous occasions. Major remarks in the following interview that he is "a visual thinker," and this quality is evident in the important role that visual descriptions and imagery have always played in his narratives. Although *Emergency Exit* (1979) is his only book in which Major has introduced reproductions of his paintings to reinforce or analogize the written materials, his use of visual images as objective correlatives that reveal emotional resonances of the inner, literally unspeakable emotional lives of his narrators and characters has been a constant feature of his fiction.

The following interview is based on a conversation that took place in early January 1992 at Clarence Major's home in Davis, California. Before the interview, the interviewers, along with McCaffery's wife, Linda Gregory, and Major's wife, Pamela, had gone out for lunch in order to catch up on the news and gossip. Back at Major's house, there was time before the interview to roam about, examining the plants and small trees (whose presence indoors seemed not at all incongruous) and the many paintings by Major that hang on the walls. The conversation with Major was friendly but serious, the atmosphere and mood combining with Major's reflective comments and soft voice to create an aura of quiet reflection.

JERZY KUTNIK: To what extent do you see yourself as consciously working out of a sense of a "black aesthetic," or black narrative traditions?

CLARENCE MAJOR: There is no single "black aesthetic." There has been a sequence or series of scenarios that can be defined as "black aesthetics," corresponding roughly to historical periods. There were the black writers of the Antebellum (1853–1865), the Postbellum (1865–1902), the Old Guard (1902–1917), the Harlem Renaissance (1917–1929), and the Social Protest (1929–1959) periods. They had their ideas about what a black writer in America should be doing, whom a black writer should be addressing, and so on, that emerged out of specific literary and historical contexts. Despite all the different agendas throughout all the various periods, black writers were always working against a single dominant impulse in American culture: the use to which white America put blackness. Whiteness was about not being black. Thus, black people were invested with all the negative crap against which white America defined itself. Black writers worked always to humanize black people and to overthrow the burden of this symbolism. To be human meant to be whole—good and bad, complex, and so on. At the same time, the Old Guard, for example, resisted the young writers of the Harlem Renaissance, who were trying to assert a new kind of black presence and consciousness.

KUTNIK: And this presence wasn't likely to be accepted by whites?

MAJOR: The point had less to do with white models or white acceptance and more to do with feeling they had to be "proper." The accommodationists were about putting one's best foot forward for the white world, or for an equal reading public. In other words, you should never hang your dirty laundry out, never let the world know what's going on behind the scenes. If you have marital problems, family problems, drinking problems—all that should be kept quiet. Meanwhile you emphasize the positive, put your best face forward, that kind of thing. That was the black middle-class take on reality, and the same take was presented in literature, which was to be very uplifting. Then along comes Claude McKay with a book like *Home to Harlem*, which lets it all hang out, which shows the prostitutes and the pimps and the numbers runners and all the other good-time people—it was about people and situations that people like Weldon Johnson were calling the dirty laundry.

The point is that what people refer to as "black aesthetics" isn't some mysterious, inherent set of guidelines, but a set of historical motives. Aesthetics aren't a set of abstractions existing outside historical circumstances and daily reality; they're always grounded in the needs and aims of specific artists and audiences, influenced by the social setting and context. Richard Wright was concerned with the conditions of poverty, injustice, and so on that Sinclair, Wolfe, and other white protest writers of the thirties were. Chester Himes wrote about those kinds of conditions too in books like *Cast the First Stone* and in some of his other forties novels. Later on in the sixties,

you get this idea of the black aesthetic which comes out of Black Nationalism and operates as the cultural arm of that political movement. It's meant to be purely functional in relation to the political aim, but it seemed to me to be essentially replacing Eurocentric thinking with Afrocentric thinking.

LARRY MCCAFFERY: It's always struck me that there was a risk in this whole approach. Even if Afrocentric thinking seems somehow more "appropriate" to the experience of black people, the insistence on having black people adopt this mode of thinking winds up substituting one set of limitations, controls, norms, for another.

MAJOR: That was essentially the problem I wound up having with this whole black aesthetics concept. The thrust of the movement wasn't so much an attempt to say Eurocentric thinking is limiting our attempts to function as artists and as individuals—I would have obviously supported anything concerned with opening up fresher or more liberating options for black people. Instead, you had this attempt to replace the Eurocentric with something that closed down the view of the writer and restricted it to the service of certain political ideologies that were as stifling as the ones they hoped to replace. That's why I instinctively opposed it, even before I could articulate the sources of my opposition. I knew there was something wrong. What I tried to propose even that early in the sixties (and what I still propose today) was something far more flexible, which is what I am trying to do with my anthology, *Calling the Wind: Twentieth Century African-American Short Stories*—namely, to find the terms on a more personal level, to get the best of all the different kinds of cultural influences feeding into my experience, and to come up with a personal aesthetic. It might at least be liberating for me.

MCCAFFERY: You can make the same argument about the great debate raging these days on college campuses about the canon.

MAJOR: Exactly! We talk about opening up the canon so that we can bring the rest of the world alongside Western thinking, get outside of the restrictions we've traditionally imposed on our educational system, and somehow open up the whole process. Now of course I'm all in favor of the opening up of Western thought to other modes of thinking (who couldn't be?), but the minute you start talking about challenging the Western canon, the people who depend on it for their living get very terrified. It's not that anybody wants to derail Shakespeare—everyone should have to study Shakespeare. But everyone should also have to study equally important writers and philosophies of other cultures. Why not?

MCCAFFERY: Since you started publishing fiction back in the late sixties, your work has consistently been discussed by critics like Jerry Klinkowitz and myself primarily in terms of its concern with its own processes and

status as pure invention. Unfortunately, this emphasis on your works' alleged "non-referential" or "non-realistic" features ignores the possibility that these features might function in the service of a new kind of realism; it's also been used to relegate your work to the rarefied "art for art's sake" (or the "narcissistically self-indulgent") category, and hence marginalize it. My question, then, is: How would you yourself describe the role that formal innovation has played in your fiction? Is the common distinction between "realism" and "experimentalism" valid?

MAJOR: Absolutely not. Those distinctions have always seemed superficial. Since *Such Was the Season* looks very much like a piece of realism on the surface, some people claimed that I had jumped ship, betrayed my experimental goals. But that book is just as "experimental" as my other work in terms of realistic norms. For example, even though Juneboy appears in what passes for a realistic setting, he's also being presented through this folksy, down-to-earth woman's point-of-view, which filters everything through colloquial speech mannerisms and idioms in an utterly subjective manner.

MCCAFFERY: You once described writing as a way of finding yourself both as a writer and as a person, adding, "I think the two processes are integral and interchangeable and inseparable, the continual redefinition of the self and the process of learning how to write every day. I find it's an endless lesson. You don't really carry that much information and skill from one piece to the next unless you're doing the same thing over and over again. Each act of writing becomes a whole new experience, which is why it's so difficult." You went on to say that your writing reflects the fact that you literally feel different every day. I mention this because, subjective or not, Annie Eliza's perspective in *Such Was the Season* is undeniably more stable or consistent than what we find in your earlier work. Is this stability a reflection of your now feeling less fragmented personally, more certain of who and what you are?

MAJOR: In terms of my own psychology, I do feel more secure—secure enough at least so I don't feel the need to ask the same questions that drove me to create characters like the ones you find over and over again in *All-Night Visitors* and *NO*. But what we're talking about here, both in terms of my writing and my life, is an evolution, not a sharp break. Exploring different personae in my earlier novels was something that grew out of my sense of personal fragmentation. Those feelings have changed somewhat as I've gotten older and had the opportunity to resolve some of those conflicts about myself and recognize integration rather than separation. When you're young, you haven't had the experiences that allow perspective on who you are or how to know what "you" consist of. From a personal

standpoint, of course, this confusion can be very troubling, but an artist needs to take advantage of these things to produce anything worthwhile. Back when I was starting out to write, it felt perfectly natural to have my work reflect this sense that I was literally a different person every time I sat down to write. It was an interesting challenge to find narrative contexts for different parts of myself that needed voices to express themselves. So in something like *Reflex and Bone Structure* I consciously played with this whole concept of author/narrator identity, though in fact there were several personae there: the narrator, the protagonist, and the implied author. In *My Amputations* I had an implied author, the protagonist, and the narrator all working together in a concerted way. To write a novel in those days with "stable" characters or narrators would have basically falsified my own experience. Today the opposite would be equally false. All along it's seemed that to do anything but reflect my own self (or selves) wouldn't make sense. Why write out of some phony sense of narrative stability if that doesn't reflect how I feel about myself? There was a sense I didn't really want a stable identity, at least in terms of being an artist. There was something liberating about not knowing who I was going to be when I sat down to write. Projecting myself into these different personae let me discover things about these concrete presences which were outside of myself but also coming out of myself. In the process, I learned a lot about myself.

KUTNIK: In this regard, your presentation of Annie Eliza in *Such Was the Season* seemed a departure for you in that she didn't seem to be someone based on yourself.

MAJOR: There's been a steady movement in my writing toward diminishing that dependency on self. By the time I got to the creation of Annie Eliza, I had made an enormous breakthrough. This was my first novel where I was not the model for the main character. The Zuni novel, *Painted Turtle*, was a further leap in that direction, and now I'm writing a novel whose main character is not remotely anything like me.

MCCAFFERY: Granted that readers of *Such Was the Season* may not be encouraged to identify you with the narrator—but what about Juneboy? Weren't there autobiographical impulses that started the book?

MAJOR: I started *Such Was the Season* after I had taken a trip to Atlanta, and to some extent Juneboy is based on some of my experiences on that trip. But—and this is pretty true in terms of all the autobiographical material in my work—those correlations start to break down very quickly once narrative and aesthetic demands and all sorts of other things start to operate on these "facts." Like Juneboy, I hadn't been to Atlanta since I was eighteen, but I didn't stay a week like he did. And I didn't make a trip with my aunt to try

to find my father's gravesite either—or discover that it was under ten miles of concrete, in, or rather under, a housing development. There was also no political scandal in the works like there is in the novel, although like Juneboy I did meet the mayor of Atlanta and Martin Luther King's wife, Coretta, at a dinner party at my cousin's house. But overall I'd say my own presence is so diminished in Juneboy's identity that he is at best a catalyst rather than a true persona. By the time you get to *Painted Turtle*, "I" am not present at all, except in the design and creation of the book. These very general connections between autobiography and fiction are always present in my books, somewhere, though you may have to dig deeper in some works than others to recognize them. But as a novelist I've always felt that my obligation is to follow whatever ideas I'm trying to work through in a particular book, not to dramatize something which actually took place.

KUTNIK: Your *DLB* [*Dictionary of Literary Biography*] autobiographical essay mentions that you began *Painted Turtle* with a woman narrator but finally decided you couldn't write it effectively that way. Were you feeling that it was somehow inappropriate to write from a woman's perspective? What finally allowed you to maintain a female narrator's voice throughout *Such Was the Season*?

MAJOR: I don't credence gender-specific arguments about the impossibility of men writing from women's perspectives (and vice versa), just as I don't believe that blacks can't write about whites, or whites can't write about blacks. If you can make it come alive, you can write anything. With *Painted Turtle*, what happened was that, for various reasons, I was unable to make that particular Zuni woman come alive. *Painted Turtle* taught me that, if I were going to write in a woman's voice, it had to be a voice I felt comfortable with—one that would come naturally rather than something I'd have to invent completely. That was a big help when I started *Such Was the Season* a year later. For reasons that are hard to explain, I found in *Painted Turtle* that I felt closer to the voice of the guy who falls in love with her. Strangely, a lot of people remember the book as being narrated by a woman. Maybe her voice is still present as a kind of sub-text.

At any rate, from the outset I felt more secure with the woman's voice I was using in *Such Was the Season*. I didn't have to think about inventing that voice because I'd grown up hearing it, I knew its rhythms from the way my relatives in the South speak. It was already there, so all I had to do was just sit at the computer and correct the voice by ear, the way you would write music. If the rhythm was wrong or the pitch off, I knew it instinctively because I'd lived with that voice all my life.

KUTNIK: Do you recall what the origin of the Zuni novel was?

MAJOR: It had to do with the fact that a black man—a huge African— apparently visited the Zunis in the 16th century with a group of Spanish explorers and then stayed on. He must have seemed extremely commanding to the Zuni, because he became some kind of god for them—he had dozens of wives, and he appears in a lot of early Zuni legends and stories, and so on.

KUTNIK: I don't remember him appearing in the novel.

MAJOR: He doesn't. He is irrelevant to contemporary Zuni culture, which is finally what I wound up wanting to explore. And since, in effect, he's been dead for them for a long time (since the 19th, or maybe even the 18th, century), I decided he wouldn't have any presence in my novel, either. Letting go of this story was disappointing—after all, he had triggered my interest in the Zunis in the first place, which had started me going down to New Mexico, visiting the reservation, and getting to know some people. But in the end his presence just didn't fit into my story.

MCCAFFERY: What sorts of research did you do for *Painted Turtle*?

MAJOR: The trips I made to New Mexico (I was teaching at UC–Boulder then) helped me get a sense of the Native American cultures in that part of the country; I also did a lot of research while I was teaching at UC–San Diego in 1984. To make that novel come alive, I had to learn a whole different culture. This took three years of research during which I absorbed tons and tons of stuff that was arriving from every conceivable discipline and in every conceivable way. I read the myths and anthropological transcripts, plus lots of sociology about the kinds of health conditions you find at Zuni, their education—really just about everything. I started writing the book at the kitchen table in San Diego while still fascinated by the African man, so in early drafts he was present as a kind of mythic figure.

MCCAFFERY: Gerald Vizenor has recently argued that there are interesting analogies between Native American narrative traditions and those being described today in terms of "postmodernism." He suggests that these connections have to do partly with the primarily oral nature of Native American literature which, once written down, undergoes certain transformations that non–Native Americans would find "experimental" or formally unusual. Maybe even more important, of course, their writing grows out of a completely different way of looking at reality—they certainly don't view life in terms of the linear, rational, causal kinds of structures that are the essence of what the realistic novel is. As you got to know Zuni storytelling modes better, what kinds of conclusions did you draw about their writing practices?

MAJOR: Zuni storytelling is completely non-linear. The traditional stories about Coyote never build towards a resolution the way Western narratives

tend to do. Coyote wanders around involving himself in a complex network of activity that defies morality (and sometimes common-sense logic). He gets involved in one thing after another, but these episodes aren't put together in terms of progression, tension-and-resolution, and the other things we associate with the novel. It's the same with the birds of the various festivals. They have their acts, their routines, but there's always an open-endedness, a resistance to closure. Things don't have to turn out the same way at the end of the process.

MC CAFFERY: Did your own experiences as a black American make you feel a special sense of empathy with Zuni culture?

MAJOR: I think so—certainly in the sense of identifying my own experience with that of the Zunis as a subculture. Being a black man also probably allowed me to sense things that individual Zuni characters might feel in any given situation. I could immediately relate to what they would feel in social situations where they would feel uncomfortable, marginalized, that kind of thing. In fact, I found that Native Americans often suffer as much discrimination as black Americans, right in their own area, the minute they cross the line of the reservation. Indians can walk into just about any motel in New Mexico and find themselves being turned down for no good reason. That's just how it is. This might not happen as often to a black American in the West.

MC CAFFERY: One of the things about *Such Was the Season* that rang very true to me had to do with Annie Eliza's being so wrapped up with the soap operas that they seemed every bit as real as anything else. Your early novels and poems also frequently examined technology's effects on people—usually from a negative perspective, it seems.

MAJOR: Television is a very "real" part of life for a lot of people. It's an extension of what their daily lives are all about, not something removed from them. I've known any number of people who are basically housebound or who simply don't go out doing things in the world for whatever reasons. People like Annie Eliza become personally or even metaphysically wrapped up in the world of television so that its boundaries literally become the boundaries of their world.

MC CAFFERY: It's like what Baudrillard talks about regarding Disneyland—the illusion does not just seem as real as the real world, it is more real.

MAJOR: Right, since Annie Eliza's television is never turned off, that world is always "on" for her; she goes to sleep with it on, and it's on when she wakes up—what could be more real than that? It's the way she lives. Besides, it's what she needs. When old people who have always had their family

around them suddenly find themselves in a silent house, well, you can imagine how much they miss this bombardment of voices. Television fills the void, provides familiar voices, even if the voices are artificial. At least that space that's been vacated isn't empty.

MCCAFFERY: Since your generation of innovators emerged in the sixties, there's been an ever-increasing expansion of the so-called "media-culture"— this rapid expansion of images, advertising, information (the "dance of biz," as Bill Gibson refers to it)—into just about every conceivable aspect of our public and personal lives. This expansion may have especially dramatic, and potentially harmful, effects on black people because the images, the people and the situations, they're encountering in the media are so predominantly white and middle-class—and as such they have the potential to distort people's perception of reality. But you seem to be looking at the positive role that, say, television plays in Annie Eliza's life rather than implying she's being manipulated or having her sense of racial norms or values impaired.

MAJOR: That's because Eliza is looking at human issues—love, death, pain— that she's known all her life (and known completely) rather than racial issues. In her own life she has always identified with universals—like raising children, deception, infidelity, seduction—that have nothing to do with relative things like color or caste. Another important thing about her situation is that she's middle class. She's owned her own house for thirty years, and she identifies with the financial level of these people she's watching on the soaps. So on the social level their world is accessible to her. In my view, this is not such a huge leap either. Writers, too, can make this entry, imaginatively, into other cultures and genders, and make it viable and real in their works.

MCCAFFERY: In an interview you did with Jerry Klinkowitz in the seventies, you said: "All words are lies, in any arrangement, that pretend to be other than the arrangements that they make on the page." The idea that words and fiction are essentially formal aesthetic constructions rather than representations of something existing off the page was, of course, very much in the air in the early days of postmodernism. Do you still agree with the point you were making back then? Or was this something that very much needed to be emphasized at a certain moment, but not at others?

MAJOR: Using such an emotionally charged term as *lies* in that statement may have deflected readers away from the point I was trying to make. What I meant to say—and this seems as perfectly reasonable to me today as it did then—is that a word is just a sign, a symbol, and as such it can never really represent the thing it names. Words are entirely different from things, separate from their referents. They're autonomous entities, with their own

linguistic realities, their own histories, their own separate presences. Like other authors working against the grain of traditional realism, I thought it important back in the seventies to keep reminding readers that when writers start putting words on the page, they're not "representing" anything except the way their mind works. But once you say that, what does a writer do with it? Having said this fifteen years ago, and then worked through all those reflexive concepts in my books, I simply don't need to do that again.

KUTNIK: And except in very broad ways, you don't repeat yourself very often, either thematically or in your formal concerns. With each new book, it's as if you've thrown yourself into a literary void—which is a risk for any artist. But in this sense, choosing to write *Such Was the Season* in a seemingly realistic mode was perfectly in keeping with what you'd been doing all along—that is, trying out new approaches.

MAJOR: Like I said, writing *Such Was the Season* that way didn't mean I'd abandoned an interest in innovation. I was trying out all sorts of new things when I was writing *Such Was the Season*, even if these didn't have to do with my earlier compulsion to keep readers constantly focused on the page. The voice is what is innovative in that novel. I wanted to give that voice such a commanding presence that it would, in fact, become the main subject matter of the novel. I wanted to make it impossible for readers to stop thinking about the voice once they had started reading the book, to make that voice always uppermost, so that even though it was describing the things that were going on (the way voices do in traditional novels), they'd be constantly having to confront its own presence.

KUTNIK: Were there any models you had in mind for the kind of thing you were after here with voice?

MAJOR: *Huck Finn.* Before starting *Such Was the Season*, I had reread *Huck* and once again, sentence after sentence after sentence, I found myself wondering, How did Twain make that voice come alive like that—make it so real? I may not have succeeded, but what I wanted to do in *Such Was the Season* was create a voice that would have the same kind of undeniable presence as the one Twain created for Huck. I wanted to create a text in which the voice is literally the book's main subject matter—as I believe it to be in Twain's book.

MCCAFFERY: What you're saying would at first seem to contrast with the work you did for the *Dictionary of Afro-American Slang*, which distinguishes Afro-American idioms and voice from their English equivalents. I'm reminded of the remarks made by certain black writers to the effect that, "English is my enemy." Having someone like Twain be such a strong

influence indicates that you don't personally feel the sense that, as a black American author, you have to be constantly working "against" the English language—the language of oppression, and so on.

MAJOR: There isn't any conflict. I'm now working on a new, revised edition of the *Dictionary of Afro-American Slang*, but my interest in this area doesn't really conflict with my appreciation of mainstream American idioms. What black people speak is actually very much in the mainstream of American speech. Not only is it not separate, it actually informs American speech in all sorts of ways. You can even argue that it's the nucleus of American speech, one of its roots. Black speech, as a matter of fact, influences Huck Finn's voice, as well. The history of the American language can't be separated from black speech. It's just been there all along, so intrinsic to American speech that there's no conflict whatsoever.

KUTNIK: Has black slang changed much in the last fifteen years?

MAJOR: Absolutely, especially with all the new slang that's been emerging out of these new subcultures—hip-hop, rap, and so on. I've compiled thousands of words and phrases that have been coined or just surfaced in the last ten years. I find them in different places—and not necessarily print sources—magazines, journals and novels—but also rock videos, songs, films, street talk.

MCCAFFERY: In the courses I teach in rock music I use rap as a way of talking about the role that language has played in the black communities and the admiration for the person that can speak well. This whole tradition of "rapping" and "dissing"—improvised contests to see who can use language the most skillfully—has always been there in black culture.

MAJOR: The saying always was, "He's well-spoken. He's got a preacher's voice. That boy's gonna grow up to be a preacher, he's so well-spoken." [Laughs.]

MCCAFFERY: You were immersed in blues and jazz, growing up. You lived in Chicago in the late fifties and early sixties, when the music scene there was really happening. Muddy Waters, and so on. That scene obviously had a strong impact on your work, just as it did for so many others, white guys like Kerouac, Coover, Sukenick, and Federman, as well as black writers. Is rap going to have a similarly liberating effect or influence on young black writers today?

MAJOR: It's already happening. I'm editing an anthology that includes works by the younger writers, and I can see the evidence of rap running through a lot of their work.

MCCAFFERY: Jazz, blues, and rap are distinctly black art forms that use black vernacular, the idioms you hear out on the streets, in the ghetto, and so on, as well as having formal roots in earlier folk arts. But at least in this century, you've also got all these white musicians just waiting to "borrow" features of these forms and turn them into something the more "refined" that white audiences will relate to (and purchase). You've also got brilliant, formally innovative black artists like Charlie Parker, Ornette Coleman, Jimi Hendrix, and Prince who keep pushing things to the next level, practically reinventing the forms, maybe to stay ahead of the white guys.

MAJOR: Yes, although I personally have trouble with the concept of artistic "refinement" whenever this winds up moving so far in certain directions that it becomes inaccessible to people. You can see this in the social history of jazz in particular—the way it's become institutionalized and removed from our lives. Jazz has its roots in the folk tradition—in blues and even going back beyond blues. When you follow its evolution, you see a progression of refinement that removes it from everyday accessibility. After a while, it becomes an acquired taste; in order to really hear what's going on, you have to be educated in classical music, and it becomes something you have to learn to appreciate. Pretty soon you find yourself putting on a tux when you want to go listen to it, rather than having it as part of your daily life, the way it should be, even if it is highfalutin' music.

MCCAFFERY: You began your career apparently thinking you were going to be a painter—you were at the Chicago Art Institute for a while, and so on. Did this background in the visual arts have any lasting impact on your literary sensibility?

MAJOR: No question about it. I was drawn to painting in the first place because I'm a visual thinker, which isn't something that's going to disappear later on when you're writing.

KUTNIK: Who were some of the writers and other artists who had a significant impact on your literary sensibility early on?

MAJOR: Van Gogh and Cézanne among the painters. Gertrude Stein, Jean Toomer, Rimbaud, Henry Miller, D. H. Lawrence, Richard Wright, Radiguet, and Genet among fiction writers. Bud Powell has to be mentioned in here somewhere as well.

KUTNIK: What do you mean when you say you're a "visual thinker"?

MAJOR: I remember things better visually than verbally. I make connections between things more on the basis of visual associations than verbal or logical ones. If you tell me your name, I may not hear it as well as I can see it.

KUTNIK: How does your being a visual thinker relate to writing fiction versus poetry? Is there a difference? Most people would say that in poetry you think more in terms of images, visual things.

MAJOR: That's true, creating poetry is more directly involved with images. But this isn't an either/or thing. I often try to get those same kinds of images in my fiction writing.

KUTNIK: Do you find any basic differences in the creative process involved in writing poetry versus fiction?

MAJOR: There are, of course. When you're writing a poem you're concentrating on pushing language in certain directions that you don't ordinarily travel in when you're writing fiction. I try to use the language of poetry when I'm writing a novel, but only up to a certain point. You don't want to push things so far that your material becomes inaccessible as a story.

MCCAFFERY: What "poetic qualities" are you looking for in your fiction writing?

MAJOR: Mostly a certain lyrical quality—tone, pace, cadence, the music of speech. This isn't true in every case: There are things I attempt in fiction that don't lend themselves too well to a lyrical treatment. That's okay. I don't need to do the same thing over and over. But overall, when my fiction is at its best, it usually has a kind of lyrical quality. I think Annie Eliza's voice, for example, has a kind of lyrical quality. Even though her voice seemed familiar to me, it wasn't something I thought of as being my private voice, which meant that the lyrical, poetic quality was something I had to think of consciously while writing.

MCCAFFERY: You've said that you think of some of your recent stories as being prose poems really; you've also said that some of your poems wind up being stories. When you start out writing something, how clear is it that something is going to be a story or a poem? What's the basis of this judgment?

MAJOR: I don't always immediately know. Usually I do, because there's a different engagement involved in writing poems versus fiction. This gets even more complicated when you factor in other kinds of writing I do. For example, *Surfaces and Masks* started off as a journal I was keeping when we were living in Venice. Somehow these entries kept resisting being turned into prose, so after a very short time I let them come out in terms of lines. I realized that something about the material needed to be rendered in terms of measure, meter, and stanza breaks rather than in journal entry forms.

MC CAFFERY: Is there any actual difference between the narrative voice you create in your fiction versus the one in your poetry?

MAJOR: Formally, yes, and in the classroom I always try to make those distinctions because I don't want to confuse students. But for all practical purposes, I don't separate things out like that. In fact, I'm usually trying to bridge the two by informing the narrative possibility with a lyrical quality.

MC CAFFERY: When an interviewer once said that audiences tended to have difficulty with even relatively mild disjunctures in fiction that they would readily accept in poetry, you made an interesting point about audience acceptance of truly radical narrative structures in film. Can't fiction writers take more chances today precisely because readers are now used to dealing with film and TV shows based on the principle of juxtaposition and montage?

MAJOR: The problem is that audiences today tolerate a lot less disjuncture in fiction than they do with other art forms. People were much more willing to accept innovations in film even as early as the twenties. Audiences had no trouble with any of the stylistic innovations introduced by Chaplin or Buster Keaton. Jump cuts, leaps, animation, and all that camera technology stuff—they all made perfect sense to audiences. When you try out something analogous in a novel, you're somehow put aside as unreadable, inaccessible. I guess narrative or fictive conventions have had a longer time to rigidify, so readers have more difficulty when somebody is doing something different with narrative material, whereas with film or rock videos or whatever, the medium is so new that its audience just accepts the idea that its conventions are more fluid.

KUTNIK: Why didn't the radical experimentation of work written by your generation of postmodernist fiction writers help break down these readerly expectations?

MAJOR: What happened is that the spirit of radical experimentalism and innovation gradually mellowed out during the seventies and eighties, and is now finding its way into the mainstream of American writing. That's true of a lot of other things about the sixties that have filtered into our daily lives without our really being aware of it. Certainly that's true of fiction. The radical fiction that writers like Barthelme, for example, was doing in the sixties was so radical in nature that it had to affect later writers. Subliminally their influences are there throughout just about the whole spectrum of American fiction today—so much so that we don't notice that they're present in a more diffuse way in the culture and in American fiction writing. This summer I read 200 novels for the National Book Award, and I can see

the innovation there. It's more muted today than it was back when I was starting out as a writer, but it's there nevertheless. I remember a story about a couple of guys who are waiting beneath a precipice to shoot a lion. A couple of lions are up above them, not knowing the men are down there, and the guys can't move, of course, because the lions might come down on them. So what does the writer do with this situation? At the end of the story he says: "Well, I've given you this dramatic situation, and I hope that's enough. I mean, what more do I need to do? This is it, this is life, what more do you want?"

MCCAFFERY: I agree that the sixties brand of radical experimentalism has had a pervasive effect on recent writing, but there are also some crucial differences. Part of this has to do with changes in the world today, especially the expansion of the media culture, the greater bombardment that everyone today is subjected to, the greater facility with which everything can be reproduced, reified, commodified. This changes the whole function of innovation: "The new" becomes merely another commodified style rather than having any social or aesthetic impact.

MAJOR: Part of what's new is the constantly changing technical means by which literature is being made and consumed. I'm thinking of computer network fiction, hypertexts. The speed with which new technologies erode is equally staggering. The minute I upgrade my computer it's already obsolete. So, what's new? "New" in the Ezra Pound sense no longer stands still, even for a moment. And at the same time—even with all our questing for the self-directed technologies—the younger generation of writers seem to be desperately reaching back for the homespun, the tried-and-tested formulas of the past, despite the innovations they've absorbed. I see all of this as exciting and very promising.

MCCAFFERY: You've said elsewhere that trying to create the distinction between poetry and prose turns out to be a trap and that "a book that was written a hundred years ago becomes not only a literary experience when you read it, it's like a historical experience because the language is not our language anymore. . . . literature is unlike any other art form because it has the problem of language as its material, and also the problem of our perception which is always gouged out of this thing we call reality." You seem there to be making a distinction between perception and language, and then locating literature's uniqueness as having to do with the fact that, since its "materials"—language—change over time, there is always necessarily this "problem of language." But isn't this true of other art forms as well? For instance, in painting don't you find changes in perception also affecting the "materials" art's created out of? If you look at Impressionist paintings

(which I know you love), you can see artists registering these sorts of changes in their work. In other words, is literature really unique in its ongoing concern with the elements that produce meaning in it?

MAJOR: Literature is unlike the other arts. If we're talking about oral storytelling—the essence of literature—we're talking about pure language. Naturally it's going to be limited to those who can speak and understand it. And it's also always evolving in ways that lines and colors (in painting) and stone (in sculpture) are not. Those materials evolve in their own very different ways and aren't subject to the constant practical communication uses language is subject to. A word's purity can be destroyed in a way that the color yellow, theoretically, cannot.

KUTNIK: Do you see any connection between your painting and your writing, beyond your having such a visual imagination? For instance, are there any formal issues or problems that you found yourself being drawn to early on in your painting that you took up in your fiction as well? It would seem that painters have to be reflexively concerned with the materials they're using in a way that's analogous to the reflexive concerns you were dealing with so much in your early novels.

MAJOR: The reflexive "problem" all writers have to face is that the materials fiction is created out of—that is, words, language—"mean something," in the sense of making references to the outside world. That's why I feel these materials are so different from those used for painting and sculpture. Colors and textures and shapes in these other forms don't "refer" to anything. The same is true for dance, of course, which has no "material" except the body—and the body isn't really operating in the same way that paint, texture, and color do in painting, or the way language does for literature. With dance you have space defined by the presence of the body.

MCCAFFERY: I am struck with a passage in *My Amputations* in which your narrator says: "He came to realize he wanted it all flat or upright and permanent like cubism—like things: surfaces." Did that express what you're aiming for when you're writing? Why did he want it this way?

· **MAJOR:** He wants it flat like cubism because in art you control, define, and assign meaning to things otherwise swept along in the tide of time and space. In cubism, he would be able to use all sides of the experience—stop, weigh it, think about it, reflect on it. *Cubism* is just a term to refer to an attempt to gain control of the shape of his life and to give it meaning.

KUTNIK: An unusual formal feature of *My Amputations* is the way the prose is presented almost as a series of physical objects—"blocks" of material that aren't related in the way that paragraphs or other organizing prin-

ciples are in linear narratives. This seems like it might be related to the visual orientation of your imagination.

MAJOR: That's because I literally tend to "see" my books this way. In the case of *My Amputations*, I remember the very day the book came to me. Pamela and I were walking up a hill to the Jewish cemetery in Nice, and I said, "I'm going to write a book in blocks of prose. Just panels. Not paragraphs." The only thing I needed to know at that point was that this book had to be a book composed in blocks or in panels.

KUTNIK: The title *Such Was the Season* has its source in Jean Toomer. What's involved for you in selecting titles for your works?

MAJOR: Sleeping on it seems to work best for me. I let it be the last thought before I fall off to sleep, and by the time I wake up the title will have taken care of itself. I always have a title when I'm working on something, although I don't always end up using it. I grabbed *My Amputations*, for example, somewhere along the way in the middle of the book. The same was true with *Such Was the Season*, which was called "Juneboy" for a while; then I realized that wasn't a good title since it's not Juneboy's story at all, which made me start shopping around for another title until I was eventually led to *Such Was the Season*.

MCCAFFERY: Your first two published novels, *All-Night Visitors* and *NO*, dealt obsessively and relentlessly with sex (which may not be a strange preoccupation for a young writer) and also with death—but individually, and in the way it connects with sexuality. How do you explain that fascination?

MAJOR: Thank you for bringing that up. When people talk about those two books they always mention the sex, but they forget the death. [Laughter.] But is there anything particularly unusual about my preoccupation with death? In fact, this preoccupation with sex and death is probably more of a young man's thought or activity than it is for an older person who's had a chance to adjust after the initial shock. If they're alert at all to what's up, young men are inevitably very interested in sex. That typically comes first, followed a bit later when they're around twenty-one by the shocking news that they're going to pass on. It may take five or six years for the shock to wear off. Death really is one of the biggest discoveries you ever make in your life: "My God, I'm going to die!" That news can kick your ass for quite a while until you get used to it.

MCCAFFERY: Were there any more abstract sources of your interest in the relationship of sex and death? Had you been reading Freud early on, for example?

MAJOR: Yes, I had read widely in psychology when I was young. There's no escaping Freudian thought for any of us in the twentieth century, certainly not for our generation. I was definitely aware of that as a young man, but I was also interested in trying to define another kind of the self outside those kinds of definitions. But all that sex/death material was gut-level stuff that came not from anything I had read but out of my own personal reaction to getting the news. I honestly wasn't consciously putting much of anything into those early books. Beyond wanting to keep the energy level up, I was just including whatever bebopped into my head and hoping for the best.

MCCAFFERY: I gather that you find yourself incorporating intellectual interests into your recent works more than you did earlier. Does this interfere with keeping your creative energy level up?

MAJOR: Maintaining that early energy level is just as hard as the creative recklessness we just talked about. And, yeah, I'm reluctant to try and write out of areas that don't have any experiential, gut-level basis to them. So I consciously try to keep my intellectual interests out of my writing. I've found that those things interfere with my writing rather than help.

MCCAFFERY: Tell us a bit about the circumstances surrounding the publication of *All-Night Visitors*. The story goes that Girodias forced you to edit (or hatchet) the book, the result being that all the sex was left in but much of the background materials were jettisoned. Being edited that way certainly made your book have a very peculiar "feel" to it. Granted that you must have been disappointed in the way your book was cut, weren't there some benefits that came of this? For instance, the cuts probably made it look more radically experimental than it would have if the full version had been published.

MAJOR: Well, it's important to note that, since I did all the revisions myself, I had some control over the end result. This wasn't a matter of having somebody else go through my book and having no input on what happened. I thought about it and decided I wanted the book published enough so that I was willing to do what they were asking, and then I tried to edit the book in such a way so that it would still be something I could live with.

MCCAFFERY: You mentioned at the outset of the interview that your early works seemed to feed off your own personal sense of fragmentation. I'm wondering about the "creative problems" that being in a more secure personal position pose. Many of the writers I've interviewed admit that they were rather displaced people when they were younger—and that this in a sense helped them gather material for their works, that the incoherence of their daily lives and the kind of experiences that they were having fed into

their work. But what happens when you find yourself a more stable person? Can that fuel your imagination as much as in the earlier situation? Or can you simply "recall" this earlier point in your life and feed off of that?

MAJOR: You're describing something that most writers don't want to admit (or talk about at all!) but that affects almost any artist who does a significant amount of early work living on the margins, somehow, of success. In my own case, becoming a university professor, having a stable relationship with Pamela, and a more secure sense of myself—these things have placed me in a radically different lifestyle and personal situation than those I was in when I started out writing. Of course, these changes have been enormously benefi-cial to me from a purely personal standpoint, but almost inevitably they are also going to present creative challenges. What happens is that you sacrifice some things—certain "negative" emotional energies that you can some-times channel into your work, maybe a kind of direct empathy and contact with situations and people you don't encounter later on, or a kind of attitude like "Since I'm out there on the margins, I'm going to do this really wild stuff that seems right to me, and fuck the establishment!" In other words, there are frequently all sorts of frustrations, financial and personal difficulties going on in the lives of many artists that can produce a positive, exciting sense of creative recklessness and originality in their work (though it's only fair to add here that, most of the time, these circumstances wind up destroying the artist). If you do manage to make worthwhile art out of this situation and gain some recognition, that youthful sense of recklessness and energy will almost inevitably be sacrificed, but hopefully those sacrifices are offset by the other things you've gained—financial security, medical insur-ance, middle-class comfort. Sometimes I don't think people are really fair about this with artists who wind up being put on the defensive when "The Good Life" finally appears one day, miraculously it seems, after everything that's come before. It's as if the audience is pissed off because now they're not going to be given their vicarious share of pain and anger and humilia-tion any more.

Still, there's no question that lessening your anxieties and gaining these middle-class comforts do wind up having an impact on your work. I know I'm not so adventurous as I used to be—or let's say that being adventurous doesn't come so "naturally" as it did when I started out. I have to work harder to find innovations. I have to struggle against being content with what's familiar or the experimental approaches I've already used. Having a lot more experience in doing innovative work limits your options. I do know that I have to work harder to achieve the kind of genuine recklessness that came as second nature to me when I was younger. I remember sitting at my desk when I was twenty-five, banging the typewriter, throwing the

carriage bar, radio going on this side, the window open, the neighbor beating their children. I was in that world, watching and listening and writing and getting the sounds of that world into my work. I was not thinking about it, just letting whatever was in my soul come pouring out on the page. Well, I can't do that anymore. What I can still do, though, is try to be daring. I still find myself sitting down to write something (now at the computer terminal rather than the manual typewriter I used to peck away on) and feel myself pushing for some of that sense of recklessness I used to possess. Come on, come on, push for it! Devil may care, get it in there!

In terms of creativity, the good side to all this is that I don't think you ever completely lose touch with whatever it was that drove you to do what you did earlier on. Or at least if you want to keep it bad enough, you don't have to lose it. For instance, I think this six-hundred page novel I've been working on recently has some of that craziness. It's just that now I've got to want it, whereas earlier it was just in the air, all around me, something I didn't have to grab because it was the air I was breathing.

Critical Essays

Reading the Painterly Text

Clarence Major's "The Slave Trade: View from the Middle Passage"

LINDA FURGERSON SELZER

Many writers of the black diaspora have embarked upon figurative journeys to the troubled waters of the Middle Passage in their poetry, fiction, and criticism. Their attempts to wrest meaning from this historical site of terror speak to a compelling identification of the Middle Passage as the originary moment of the black diasporic migration. In his well-known modernist poem, "Middle Passage" (1945), Robert Hayden presents a redemptive critique of the past through a mélange of imagined voices that ultimately articulates a passage through suffering to affirmation. More recently, in her widely acclaimed *Beloved* (1987), Toni Morrison turns to the Middle Passage to chart the possibilities for individual and communal agency in the face of radical dislocation and systematic terror. Charles Johnson's controversial postmodern allegory of African American history, *Middle Passage* (1990), places its protagonist on a mid-Atlantic voyage that radically alters his conception of personal identity, leading him to understand the self as fluid rather than fixed, formed by each person's confrontation with an Other. Finally, in an important recent critical work, *The Black Atlantic* (1993), Paul Gilroy attempts to "rethink modernity" through the history of the black Atlantic, seeing in its process of "cultural mutation and restless (dis)continuity" a challenge to established categorizations of history and nationalist definitions of culture (2). Contrasting with traditional narratives of the search for origins in some utopian or prelapsarian past, these figurative returns to the troubled history of the Middle Passage are suggestive of black writers' continuing struggle with issues of identity and representation in their art.

In "The Slave Trade: View from the Middle Passage" (1994), Clarence Major makes his own distinctive voyage across the Atlantic in a poem that is devastating in its attack on the discourse of empire and subtle in its analysis of the difficulties inherent in the project of fashioning an identity through art.[1] In contrast to the "speakerly text" Henry Louis Gates describes as characteristic of fiction growing out of the African American folk idiom, Major's poetry typically offers instead what might be called a "painterly text"—one that presents readers with a complex collage of historical, literary, and philosophical allusions, street talk, cartoons, puns, folk tales, children's songs, advertising slogans, and references to international locales. A talented painter as well as a writer, Major has recently described himself as

Originally appeared in *African American Review* 33, no. 2 (1999): 209–29. © 1999 by Linda Selzer. Reprinted by permission.

"a visual thinker," one who tends to "make connections between things more on the basis of visual association than verbal or logical ones" (McCaffery and Kutnik 132). By drawing upon actual works of art to illustrate the various ways in which blackness has been framed by the designs of others and by offering its own reconfigurations of specific European landscapes, Major's poem ultimately raises difficult questions about representation, self-expression, and the emancipatory potential of art, while simultaneously delineating the special province of the painterly text.

I

Hope, Hope, Fallacious Hope
Where is Your Market, Now?
—J. M. W. Turner,[2] from a poem displayed
with his painting, *The Slave Ship*, 1840

Charting a dizzying route over three continents and several time periods, "The Slave Trade" is composed of four major sections that move from the African past to Europe, the Americas, and, finally, to the present-day United States. From this comprehensive vantage point the poem attempts to negotiate the crisscrossing conceptual routes of a triangular trade whose operating principles are Christianity, commerce, and colonialism. The poem begins with "a voice from deep in the Atlantic," identified as belonging to "Mfu," an African who committed suicide during his own Middle Passage voyage (11). Most of the poem, however, is actually narrated by an implied, present-day author who is moved by Mfu's spirit to give voice to the African's experiences. Mfu's position beyond the grave—where he sleeps "free to speak his music"—contrasts with the situation of the implied author, whose identification with Mfu can be read as an attempt to achieve a hermeneutic standpoint from which to make sense of the slave trade's legacy:

> Mfu, like a tree, is totally without
> judgment
> or ambition, suspended between
> going and coming
> in no need of even nutrition—
> gray, eternal—
> and therefore able to see, hear, and know
> how to shape memory into a thing of wholeness (13)

Assuming the positionality of a mid-Atlantic suicide who preferred death to slavery, the implied author attempts to make "a thing of wholeness"

out of the fragmented past of the black diaspora. The attempt itself is suggestive of a tenuously held hope that the individual need not be overwhelmed by the weight of slavery's history. Indeed, from his unique mid-Atlantic position, Mfu is able to look "generously in all directions" in search of a "festive reason, / something that might have / slipped" (11). The African searches, essentially, for a reason to affirm life in the face of the historical reality of slavery—a reason he might have overlooked before.

That search takes Mfu first to Africa, where his personal history of betrayal unfolds against a larger history of empire. African complicity in the slave trade is depicted through the participation of Mfu's father, chief, and village in his sale. Mfu's memories emphasize both the unnaturalness of his having been sold "without consent of air, fish, water, / bird or antelope," and the senselessness of his having been traded "for a damned shaving brush. . . . / Why not something useful? / Even a kolanut?" (12). A long passage in which ten separate lines begin with the emphatic word "Sold" underscores Mfu's recognition that his sale was intentional—"not a mistake, not a blunder" (12). As his memories fall upon him like the "weight of Livingston's / cargo / on his head . . . / one in a long line of strong black / porters" (13), Mfu begins to make connections between his personal history, the fate of other African peoples, and the white presence in Africa. Mfu's personal history in Africa thus serves as a starting point for the poem's investigation of a system of exploitation that stretches all the way from the indigenous porters who carry missionaries' cargo in Africa to the black porters who serve white travelers on railroad trains in the United States.

By the end of the first section of "The Slave Trade," Mfu's search has led not to "reasons," but to the self-serving rationalizations of a wider discourse of empire through which whites and their black Others are represented. "Praising themselves," confident about "their mission" to "teach all nations, / baptizing them," white missionaries simultaneously construct their own righteousness and a benighted Other as an object of knowledge and power (13). Mfu's personal history unfolds within a wider discourse that in fact serves as a condition of possibility for his sale—"a whirlwind / of praise, explanation, / implication, / insinuation, doubt, expression of / clout" (11). Against this whirlwind, Mfu's otherworldly point of view is offered as a position from which such hegemonic claims may be surveyed and critiqued. By establishing the implied writer's identification with Mfu and by setting the African's personal history within a wider discourse of European colonialism, section 1 of "The Slave Trade" defines the distinctive perspective from which Western iconography will be viewed in the poem's richly allusive second and third sections.

II

I cast him, drew him, and painted him till I had mastered every part.
—Benjamin Robert Haydon, *The Autobiography and Memoirs of Benjamin Robert Haydon, 1766–1846*, 1853, writing about his black model

In *White Man, Listen!* Richard Wright speaks incisively about America's use of the Negro as a "metaphor," a cultural construct forged out of the long history of slavery (72). Through their symbolic representations of black people, Wright suggests, white Americans reveal more about their own deepest fears and desires than they do about black Americans. The second and third sections of "The Slave Trade" transport this insight to the inter-cultural waters of the Middle Passage in order to delineate the cultural, political, and psychological outlines of the representation of a black Other in European culture.[3] Building their critique through a reinterpretation of images drawn from specific art works and from repeated themes in Western iconography, these two sections of the poem draw heavily on Major's tech-nique of associative collage as they explore European culture's normaliza-tion of its own history of conquest through the representation of black people in a hierarchical history of progress.[4]

Section 2 of the poem begins as Mfu undertakes a "tour deep into Eu-rope" in order to "explore / its sense of Mother Nature" (13–14). Mfu thus reverses roles with white explorers who enter into "deepest" Africa by tak-ing European culture as the object of his own analysis. By analyzing in particular European culture's sense of Mother Nature, Mfu seeks to under-stand the relationship between certain Enlightenment tenets—such as the appeal to universal laws of nature—and the history of the Atlantic slave trade. At first view, however, Europe "baffles" Mfu, and the African de-scribes European principles in terms of a striking dualism (14):

> Mother Nature
> in Europe is a giant pink pig
> with a black baby at one tit
> (this is good Europe: charitable, kind,
> compassionate Europe)
> and a white baby at the other. A sucking
> sound,
> plenty to go around.

> And in the background,
> without thought of remission, a band
> of white slave-catchers
> force Africans into submission
> (this is bad Europe: evil,
> mercenary Europe) (14)

In reading the cultural landscape of Europe from the perspective of the At-
lantic slave trade, Mfu here offers a rereading of a specific work of European
iconography. Mfu's description of both aspects of Mother Nature bears a
striking resemblance to the frontispiece for G.-T. Raynal's 1774 history of the
slave trade in the West Indies, *Histoire philosophique et politique des étab-
lissements et du commerce des Européens dans les deux Indes*, surely its picto-
rial inspiration (see figure 1).[5] Indeed, the engraving's two juxtaposed scenes
correspond precisely to the poem's description: a woman with six breasts—
the poem's "pink pig"—represents Nature in the foreground, while in the
background a band of whites overpowers a group of blacks. According to
the description accompanying the engraving's plates, the work was intended
to represent "Nature," who "nurses at the same time and with the same
interest a white child and a black child" (Honour IV, i, 54). But if the frontis-
piece seems originally designed to suggest that slavery perverts the natural
relationship between the two races—a relationship represented by the two
suckling infants—Mfu sees in the juxtaposition of the "two Europes" more
troubling possibilities. His suspicion, of course, is that the two images do
not really stand in relation to one another as opposites, but that "Good
Europe" and "Bad Europe" are somehow more intimately related. Illustrat-
ing the Enlightenment's appeal to natural law, the engraving also represents
that norm as white, revealing that the work functions, in part, as an act
of self-definition. But from Mfu's marginalized position, Europe's bounty
seems piggish, her claims to regard others as equals, mere acts of noblesse
oblige. Suggestive at least of an ironic two-sidedness in regard to stated
principle and actual practice, the two juxtaposed scenes imply further to
Mfu that the cultural ideals of the Enlightenment gloss over—and somehow
support—a material economy based upon human commodification.[6]

The moral ambivalence of Europe is further critiqued as Mfu focuses his
attention upon "a good white monk," a central figure in the poem's second
section. The good monk has apparently escaped the more virulent forms of
racism common to his day: unlike those motivated by profit, he has no
interest "in the gold" of Africa, and the prayers he offers to black saints
point to his ostensible acceptance of black people (15). The monk's liberal-
ism on issues of race is also signaled by his implied skepticism toward
contemporary theories of racial difference, including both ethnographic
accounts of orangutans who are reputed to kidnap black babies "thinking
they" are their "own kin" (15) and naturalists' accounts that attempt to rank
the races on an ascending scale through exaggerated measurements of facial
angles (15).[7] Rejecting, then, the racist scientific theories that burgeoned
simultaneously with the Enlightenment's elevation of reason, the white
monk puts his faith instead in visions of the "Queen of Sheba, / as a healing
spirit for the down-trodden / blacks" (15). The monk's visions in fact intro-
duce a number of painterly allusions into Major's poem, and an under-

Figure 1. *Allegory of Nature.* 1773. Line engraving by Charles Gaucher after Charles Eisen. Frontispiece for volume 4 of G.-T. Raynal, *Histoire philosophique et politique des établissements et du commerce des Européens dans les deux Indes*, 1774. Reprinted by permission of the Bibliothèque Nationale de France, Paris. (Honour IV, i, 55, image 18)

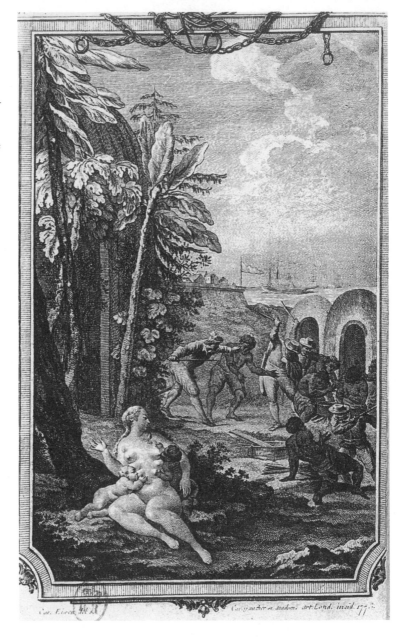

standing of the visual theme of the black Queen of Sheba helps to explain the significance of his meditations.

Compared to the exaggerated diagrams used by naturalists to depict the supposedly ape-like facial angle of blacks, the artistic and often beautiful representations of the Queen of Sheba would seem to provide Western

Figure 2. Solomon and the Queen of Sheba. About 1270. Detail of stained glass window from Church of St. Thomas, Strasbourg. Reprinted by permission of the Musée de Strasbourg. (Devisse and Moffatt II, i, 132, image 102)

iconography with much needed, positive images of black people. As she appears in the stained glass window illustrated in figure 2, the black Queen of Sheba was commonly depicted in works representing her visit to King Solomon. Many of these works portrayed her positively, as a lover of wisdom, and the scriptural source of the queen's visit, found in 1 Kings 10, suggests that she comes specifically to test the king's knowledge. Afterwards,

the queen admits that Solomon's wisdom is superior to her own, and she praises the god who gave him such insight. As one who traveled far for the sake of learning, the figure of the black Queen of Sheba in Western art has often been interpreted as an icon representing spiritual and intellectual enlightenment.[8] Certainly to the good monk, the queen represents the spiritual enlightenment he believes he can offer to the "down-trodden / blacks" (15).

But Mfu's sarcasm in describing the monk's visions not only reflects the sense of moral superiority he detects in the monk's spiritual magnanimity, but also invites readers to reinterpret the iconic significance of the queen's "enlightenment." By shifting the spectatorial gaze from the monk to Mfu, the poem demonstrates that representations of the black queen's visit to King Solomon can also be seen to delineate a clear racial hierarchy, one in which the queen functions disturbingly as a scriptural—and visual—exemplum of the proper respect "inferior" races should demonstrate when faced by a "superior" culture. (Such a racialized reading may be supported by the many Christian portrayals of the black queen's visit to King Solomon that exaggerate the pair's racial differences by portraying a very dark Queen of Sheba and a white King Solomon.)

By inviting readers to view a series of painterly images from Mfu's specific cultural and historical vantage point, sections 2 and 3 of Major's poem make concrete the visual metaphor of the poem's subtitle, "View from the Middle Passage." Indeed, as the poem's painterly allusions accumulate, images drawn from varying time periods cohere to form a poetic gallery that illuminates specific moments in a long history of European representations of racial difference. The cumulative effect of these representations is to provide an artistic ranking of the races that is more subtle—but no less insidious—than the overtly racist hierarchies of the naturalists. In their studies of the representation of black people in Western art, Honour and Devisse have identified several visual themes that recur in the representation of blacks in European art. As these themes evolve over time, they can be seen to provide visual genealogies of certain European attitudes toward racial difference. Two such themes and their unfolding genealogies seem especially important to Major's poem—the theme of the black supplicant and that of the powerful black man at arms.

The theme of the black supplicant in Western iconography forms a visual genealogy that stretches from images of the kneeling penitent in Christian art to representations of the supplicating slave in abolitionist illustrations to depictions of colonial subjects paying homage to their "magnanimous" rulers. This particular genealogy is evoked by the poem's painterly allusions to the Ethiopian Eunuch (16), to the well-known abolitionist seal produced by Josiah Wedgwood (14), and to several representations of colonial rulers

and subjects. According to Devisse, illustrations of the baptism of the Ethiopian Eunuch, like the one in figure 3 from the early sixteenth century, became popular in Western art from the third century on (Devisse and Moffatt II, i, 21). Devisse attributes the popularity of the Eunuch as a visual theme primarily to the rich theological implications he held for Christians as the first non-Jew to be brought into the Christian economy of salvation. In Acts 8:26–40, the Ethiopian Eunuch invites Philip into his chariot to help him interpret scripture. As Philip witnesses to the Eunuch, their chariot approaches a pond. At this point the Eunuch asks Philip if there is anything that prevents him from being baptized immediately. Philip then baptizes the Eunuch, convinced that the Ethiopian believes "with his whole heart." The figure of the Eunuch thus represents a specifically Christian version of the spiritual enlightenment represented by the Queen of Sheba (and in fact the Eunuch is the minister of the Queen of Sheba's literal heiress, Queen Candace). More important, the baptism of the Eunuch was seen by Christian interpreters as the event that establishes Christianity as a universal religion to be offered to all people, not only Hebrews. Understood from this perspective, the Eunuch's conversion validates the proselytizing of all peoples, including pagans.

The baptism of the Ethiopian Eunuch thus serves as the scriptural origin for the missionary efforts Mfu encounters in section 1 of "The Slave Trade," while also providing a visual inspiration for the good monk's meditations in section 2. Clearly familiar with the Eunuch and with the lesson in evangelization he represents, the good monk prays that the "lean Children / of Ham / will be washed clean / by the spirit and say of the Lord / and made as white / as the light of day" (15–16). Identifying the black Other with spiritual sin through the curse of Ham while simultaneously associating his own whiteness with enlightenment and spiritual cleanliness, the monk fetishizes racial difference, revealing that his superficial acceptance of black people is in fact based upon an underlying ranking of souls. Not surprisingly, from the African's perspective, the good monk's prayers conceal a spiritual tyranny "not innate" or even "mean-spirited," but one that reveals nonetheless a "contradiction / implicit in its quest" (16). The theological lesson Mfu draws from the poem's repeated representations of baptism is not the promise of spiritual enlightenment, but the threat of an ethnocentrism that endorses the exercise of power through which "One culture . . . modif[ies] another" in the "name of its god" (14).

The supplicating pose of the Eunuch and the simplicity of his characteristic dress are recapitulated in later abolitionist representations of enslaved people, including the well-known abolitionist seal produced by Josiah Wedgwood (see figure 4). In "The Slave Trade," the missionaries who baptize African converts wear this seal around their necks.

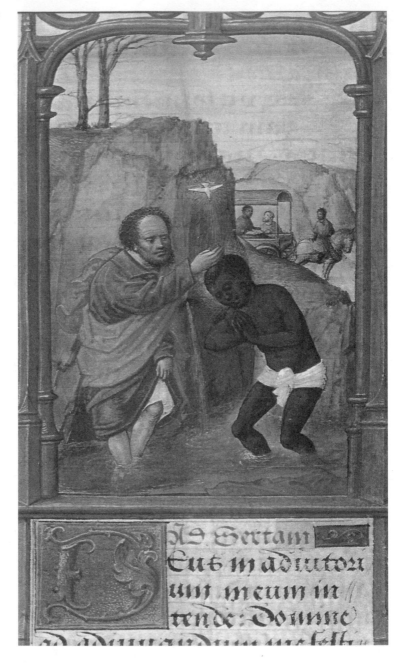

Figure 3. Baptism of the Ethiopian Eunuch. About 1519. From *Book of Hours* of Charles V. Reprinted by permission of Österreichische National-bibliothek, Vienna. (Devisse and Moffatt II, ii, 232, image 244)

They do the dunking.
These are the good white men
who wear Josiah Wedgewood's
medallion
of a pious-looking African face
with the inscription:
"Am I not a Man and a Brother?"
(1787) (14)

By depicting a black man in a pose of humility similar to that found in many representations of the Ethiopian Eunuch, the abolitionist seal defines a role for blacks in asking for their freedom similar to the Eunuch's in seeking salvation: enslaved blacks should not demand, but supplicate for their freedom. Providing the white public with the reassuring image of a docile black man in the position of asking for his freedom, the pose of the supplicating slave in fact suggests a prior emasculation of power that identifies the supplicant as a figurative, if not a literal, eunuch. The person of power whom the slave entreats is present only by implication. Nonetheless, the abolitionist seal could and did serve as a form of self-representation by whites, many of whom wore the medallion to display their own philanthropic sentiments. Pointing out that the seal was used as something of a fashion statement by whites to indicate their membership in a philanthropic elite, Honour discusses the use of its image on personal items such as hair pins, jewelry, and snuff boxes (1V, i, 63). Zachary Macaulay, who served as governor of Sierra Leone, went so far as to have the medallion engraved into his funeral monument, as seen in figure 4. Similarly, by displaying the abolitionist seal around their necks, the missionaries in section 2 of "The Slave Trade" make their own fashion statement, adopting a visual symbol associated with abolition to validate their own evangelical efforts. With the abolitionist seal around their necks providing a material connection between the philanthropic principles of the abolitionists and European colonizing practices, the missionaries in "The Slave Trade" point backward to representations of the Ethiopian supplicant, while pointing forward to later representations of colonial peoples as kneeling subjects gratefully receiving the gifts of cultural enlightenment. By illuminating specific moments in which scenes of enlightenment—spiritual, civic, or cultural—articulate racial difference, the visual theme of the black supplicant thus exposes a philosophy of progress complicit in the rationalization of exploitation.

The popularity of the abolitionist seal also led to the appropriation of its images by those who wished to argue against abolition. Thus in a 1789 image entitled *Abolition of the Slave Trade, or The Man The Master*, the black supplicant is transformed into a white victim in order to illustrate the

Figure 4. Funerary bust of Zachary Macaulay by Henry Weekes. 1842. Marble. Westminster Abbey, London. Reprinted by permission of the Warburg Institute, Westminster Abbey Museum. Photograph © Warburg Institute. (Honour IV, i, 101, image 52)

presumed dangers of ending slavery (see figure 5). The print depicts a white man kneeling in the position of the supplicant slave, while a well-dressed black man strikes him, reversing the power relations suggested by the abolitionist seal. Receding in the background are other scenes which illustrate a similar reversal. In one, whites work at cutting down sugar cane, while blacks are shown banqueting and dancing. Near the foreground, two busts represent the Folly of Abolition and the Wisdom of Regulation. Significantly, Folly wears a foolscap, Wisdom, a military helmet. Wisdom's identification with the military acknowledges—and endorses—the physical force needed to regulate and maintain the slave system. A parody of the abolitionist seal, this illustration is undoubtedly the "cartoon" referred to in section 3 of Major's poem:

> A black man dressed like an English
> gentleman is bludgeoning a poor, suffer-

Figure 5. *Abolition of the Slave Trade, or The Man The Master.* 1789. Etching. Reprinted by permission of the British Museum. Photograph © The British Museum. (Honour IV, i, 73, image 29)

ing white man over the head with an
ignorant-stick. And in the background:
Similar configurations dot the diminish-
ing landscape. Message: Let them go
and they will enslave you. Rationale:
Abolition is folly. (19)

As the poem makes clear, the cartoon argues against abolition by equating freedom for blacks with slavery for whites. Designed specifically to arouse whites' fears of reprisal, the print includes a beheader's ax marked "Retalia-tion" in the foreground. In parodying the abolitionist medallion, the print counters the seal's visual presentation of enslaved people as docile suppli-cants with images of the enslaved as violent revolutionaries. Clearly reflect-ing the hopes and fears of those who produced them, neither image ex-presses the complexity of enslaved people's own subjectivities. Rather, the abolitionist seal and its cartoon parody, taken together, define the accept-able and unacceptable roles for blacks to play in their own emancipation, as seen from the perspective of whites.

As the personal embodiment of this larger process of representation, the good monk reveals a similar displacement of his own fears and desires for the black Other through his icons. Through his visions of the black Queen of Sheba and his prayers to the "black Madonna" (15), the monk sublimates his erotic desires for the black woman who appears to him in secular dreams of the "Sable Venus":

> though this secular dream is out of rhyme
> with his devotion, much of his time is

> spent
> on his vision of the Sable Venus,
> herself a Creole Hottentot,
> surrounded by chubby pink cherubs (15)

If the cherubs who surround the Sable Venus hint at the monk's con-
cupiscence, they also allude to a specific work which names the Sable Venus
as its subject (see figure 6). *The Voyage of the Sable Venus* (1801), an engrav-
ing modeled after a painting by Thomas Stothard, is considered to be one of
the most outrageous works "inspired" by the Atlantic slave trade. The work
depicts a black woman in a pose similar to that of the famous Medici Venus.
The Sable Venus, naked except for a narrow cloth around her hips, stands
on a half shell lined with an expensive fabric. Sea creatures pull her gently
across the Atlantic by chains of gold, while cherubs fly in attendance, shield-
ing her from the sun. King Neptune appears at one side, apparently point-
ing the way to the West Indies. Nude except for his crown and brandishing
the Union Jack, he projects a strange combination of eroticism and empire.
His robust physique, which appears somewhat out of keeping with his
graying head, serves to heighten the sensuality of the work, and his desires
for the Sable Venus are signaled by the arrow Cupid aims at him. An
obscene glossing over of the actual horrors endured by black women mak-
ing the Middle Passage journey aboard slave ships designed to hold hun-
dreds of captives in their holds, the work itself seems designed to portray
the Atlantic crossing as a benign method of procuring black women for the
enjoyment of white men. Reinforcing the work's suggestive connotations, a
poem which accompanies the engraving includes the salacious observation
that black women and white women are essentially alike "at night" (Honour
IV, i, 34). The monk's fantasies about the Sable Venus indicate that his
visions ultimately have more to do with sensualism than with asceticism.
Identifying the black body with his own repressed sexual desires as well as
with the curse of Ham, the monk sublimates his desire for the Sable Venus
in visions of the beautiful pagan queen saved by faith—and, perhaps, in his
own spiritual power over black converts. His sexual anxieties are also ex-
posed by his attitude toward the Ethiopian Eunuch. While early church
fathers interpreted the Eunuch's conversion as an allegory about faith over-
coming lust (Devisse and Moffatt II, i, 22), the monk seems more concerned
about the Eunuch's lingering sexual prowess than with his spiritual princi-
ples. His prayers that "the white Venus and the black / eunuch, / seen
together like white on rice, / will remain cool, nice and chaste" (16) expose
the monk's continuing anxieties about the virility of the black man, while
suggesting that the monastic celibate experiences difficulty controlling his
own libido.[9] Through the monk's complex religious, political, and psycho-

Figure 6. *The Voyage of the Sable Venus.* 1801. Copper engraving by W. Grainger after lost painting by Thomas Stothard. From Bryan Edwards, *The History . . . of the British Colonies in the West Indies*, 1801. Reprinted by permission of the British Library, G4231. (Honour IV, i, 32, image 4)

logical relationship to his icons, "The Slave Trade" exposes the cultural ambitions and personal appetites underlying European representations of a black Other.

A second grouping of painterly allusions raises issues more directly concerned with the subjectivities of marginalized black people. These representations are not of humble supplicants, but of powerful black men, often a king or soldier, presented in elaborate costumes of state. Popular subjects for this second grouping of images in Western art include the black Magi who attended the birth of Christ; the black knight, St. Maurice; and black soldiers, frequently shown in colorful costumes fighting by the side of their white masters. These visual themes are evoked through the poem's references to "Casper at the birth of Christ" (15), through the monk's prayers to St. Maurice (15), and by allusions to several specific works of art depicting black soldiers.

Unlike representations of the penitent Eunuch or the supplicating slave, the iconography of the black King Caspar typically depicts an authoritative male figure. In keeping with his royal status, representations of the king are often quite ornate, and he is sometimes accompanied by an exotic entourage. But if the black king offers a more dignified visual icon for the black man than his more submissive counterparts, like them he is usually shown in a position of deference, and is often portrayed in the act of paying homage to the Christ child. Somewhat ironically, the king's own magnificence helps to define his act of obeisance, since the greater his own prestige, the greater honor that is paid to Christ through his act of veneration. Devisse points out that representations of the "giving of homage" in Western art were often used "to indicate the farthest outreach of centers of power" (Devisse and Moffatt II, i, 25). In particular, since Africa was identified as one of the four corners of the earth before the discovery of the Americas, black figures were used iconographically to represent the furthermost reaches of the globe. From the standpoint of homage giving, then, the black king's visit to the Christ child can be read as a sign of the far-reaching consequences of that event. In other words, the very Otherness of the exotic black king could be used to define the magnitude of the event's importance.

The use of the powerful black male figure as a sign for another's power and influence is also seen in representations of the black St. Maurice in Germanic culture.[10] Martyred for refusing to renounce Christ for Rome, St. Maurice eventually came to be represented as a black knight, as Mfu describes him, "in armor" (15) (see figure 7). Both the richness of his garb and his association with Christianity align St. Maurice with King Caspar. But St. Maurice also came to represent Germanic military and cultural power, as is suggested by his knighthood. Mfu's description of Maurice as the "patron saint / of the Crusade / against the Slavs" (15) captures well the knight's combined military and religious significations. Emblazoned on banners used to lead invading Germanic armies into battle, representations of St. Maurice were in fact used to inspire Germanic expansionism and the forced conversion of the Slavs, as Mfu suggests. Indeed, his identification with Germanic military force was at times so strong that St. Maurice's name was given to eleventh-century Saxon men at arms, called *milites mauriciani*, and the term "Maurician Imperialism" came later to denote the twin activities of conquest and forced conversion (Devisse and Moffatt II, ii, 154, 157). With stained glass windows, churches, and entire towns dedicated to him, and with his image adorning family crests, shields, and even the drinking goblets of the Germanic royal and imperial families, St. Maurice represents *par excellence* the appropriation of the image of the powerful black man to express white imperial, ecclesiastical, and cultural power. By praying to St. Maurice, then, the monk not only demonstrates his personal devotion for a

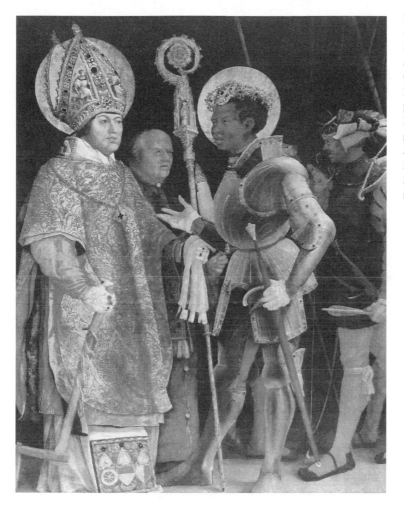

Figure 7. *St. Erasmus and St. Maurice* by Matthias Grünewald. About 1520–24. From Collegiate Church, Halle. Reprinted by permission of the Bayerische Staatsgemäldesammlungen, Alte Pinakothek, Munich. (Devisse and Moffatt II, i, 188, image 151)

black saint, but also identifies his own attempts to convert Africans with a crusade mentality grounded in force.

More important, however, by offering a visual paradigm for the powerful black male who gives his allegiance to Western culture, representations of St. Maurice and other powerful men at arms raise questions about the cultural positionality of black men who gain—at least to some degree—the ranks of the "good Europeans." At the end of section 2, Mfu reflects upon the position of black intellectuals and military leaders who successfully achieve a degree of status in white society:

And Mfu also wonders at the noble, dignified
 presence
 of black intellectuals and military leaders

among the good Europeans:
There is Jean-Baptiste Belley, sad, ironic,
 sardonic,
 aging, elegant, in the French Army,
 a captain during the French Revolution,
fighting, no doubt, for justice for all,
 with strong memories
 of having been born a Senegalese slave
 at remote Gorée (1747). Surely
 this man
 lived with irony as if it were a cancerous
 sore
 in his throat. (17)

By contemplating the example of Jean-Baptiste Belley, Mfu turns from considering the iconographical significance of the strong black figure to focus upon the black man's own subjectivity. Born as a slave in Gorée, Belley was transported as a child to Saint-Domingue, where, by his own account, he overcame slavery through "hard labor and sweat."[11] He joined the French army, was eventually promoted to captain, and served as one of six elected representatives from Saint-Domingue to the French National Convention in 1793. The poem's description of Belley is highly suggestive of a portrait by Anne-Louis Girodet, illustrated in figure 8. The painting shows Belley elegantly dressed in his captain's uniform, his tricolor sash signifying his elevated public position. Looking upward as though lost in thought, Belley leans against a bust of Raynal, frowning slightly. The fluid lines of his body contrast with the straight lines of the marble pillar that supports the bust, lending an informality to the stately tone set by the sculpture and Belley's own dress uniform. Commenting on the painting's identification of Belley with the famous *philosophe*, Honour suggests that the work may have been intended to provide an "image of blacks freed from slavery as a result of the Enlightenment and the French Revolution"; he further describes Belley as "perfectly at ease in this attire and in this space" (IV, ii, 106, 110). To Mfu, however, Belley appears "sad" and "sardonic." Rather than discerning the efficacy of the Enlightenment in the painting, Mfu recognizes in Belley the complex psychological ambivalence experienced by black men who succeed within the cultural horizon of a white society. The figure thus raises several disquieting issues for Mfu, who seems concerned about the degree of accommodation to European principles Belley's success implies, yet sensitive to the intellectual and emotional strain that must result from the captain's inhabiting of a position that is both "dignified" and necessarily "ironic."

The use of Belley's portrait as an icon for the emancipation of slaves is

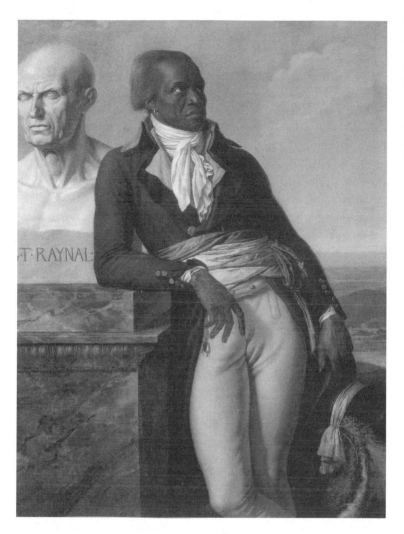

Figure 8. *Portrait of Jean-Baptiste Belley* by Anne-Louis Girodet. 1797. From Musée National du Château de Versailles. Reprinted by permission of Giraudon. Photograph © Giraudon. (Honour IV, i, 104, image 55)

itself suggestive of the difficulty of self-representation for marginalized peoples. Portraiture is often regarded as one of the most personal of art forms. But if Belley's portrait is read iconographically to represent the freeing of slaves in general, both Belley's individuality and his agency are elided. That the work could be used in just this fashion is suggested by the fact that the portrait was given an iconic title in which Belley's name is erased—*Portrait de Negre*—when it was shown in the Exposition de l'Elysee in 1797 (Honour IV, i, 106). Such a representative use of his portrait also seems at odds with Belley's attribution of his social rise to his own "hard labor and sweat." The portrait of Belley thus underscores the difficulty of constructing a self in a society that tends to see one iconographically as representing a type and that consistently attempts to reduce one's identity to the color of one's skin.

Finally, by ending with a consideration of the elegant officer who lives with irony like "a cancerous / sore / in his throat" (17), section 2 of the poem concludes with a more complex and realistic representation of black subjectivity than Mfu's otherworldly perspective, which was established at the end of section 1. Mfu's disinterested stance was in fact never a hermeneutic possibility, as is reflected in his own positioned readings of the European cultural landscape. Hereafter, the voice of the poem will become increasingly engaged, Mfu's imaginary point of view having been deepened through a consideration of the compelling historical position of Belley.

From glorified knights to humble supplicants, the images evoked by the painterly allusions in Major's poem point to a larger social process of representation whereby racial difference is commodified for the consumption of a white public. Designed, produced, and disseminated by the culturally privileged, images of blacks in European culture reflect the artistic—and the social—mastery of their makers. The effects of this process upon black men and women are chillingly captured in the poem's description of the figures found in a child's jack-in-the-box:

> And even Peter Noire
> can be made to leap
> out of a box
> like those that French children play with
> where a black Martinican maid,
> complete with apron and head-
> piece,
> springs up with a jolly smile,
> ready to dust. (16–17)

Removed from the aesthetic realm of high art and reduced to playthings packaged for children's play, the two black figures described above serve as grim illustrations of the social manipulation of black men and women for the purposes of others. The black maid, modeled after a woman from the French colony of Martinique, springs up ready to serve at the children's whim, a "jolly smile" fixed permanently on her face to indicate her perpetual satisfaction with her menial social role. Peter Noire, a figure who carries St. Nicholas's bag of sticks and candy in certain European folk legends, is also confined and controlled, signifying the successful harnessing of the black man's labor. Boxed for the French children's amusement, the two figures exemplify the social marginalization of people who are expected to be both permanently accessible as workers and perpetually amenable to authority. Painted, molded, sculpted, boxed—images of blacks in the "The Slave Trade" document a process of representation that obscures black people's own subjectivities, raising serious questions about the possibilities for their effective self-expression and about the emancipatory potential of art.

III

> If the effect of colonial power is seen to be the production of hybridization . . .
> [it] enables a form of subversion . . . that turns the discursive conditions of
> dissonance into the grounds of intervention.
> —Homi Bhabha, "Signs Taken for Wonders," 1985

By drawing upon actual works of art to illustrate the various ways in which
blackness has been framed by the designs of others and by presenting its
own reconfigurations of European landscapes, Major's poem ultimately
foregrounds complex questions relating to representation, self-expression,
and art. The last two sections of the poem build from Mfu's initial examina-
tion of the "new" world landscape to an explicit consideration of the situa-
tion of the black artist in contemporary society. Section 3 of the poem
begins as Mfu turns his attention from Europe to the Western Hemisphere,
his droll "Ah ha!" satirizing the discourse of discovery that was used to
rationalize European expansion into the New World (17). Leading readers
through a catalogue of offenses that transpire throughout the Caribbean
and the Americas, Mfu associates countries which were the actual destina-
tions of Middle Passage voyages with specific vignettes of human suffering.
In Saint-Domingue, a "group of maroons" is ambushed by "white overseers
with guns" (17); in Georgia and Carolina, "men women and children" toil
in cotton fields (18); in Barbados a crying "mulatto girl" is sexually abused
by a planter (18); and in Jamaica, a "sambo, white as his tormentors" is
bullwhipped until his back runs red (18). Providing a countertext to these
acts of violence against the enslaved, another passage depicts a black army
in Haiti in the act of attacking French soldiers—"pulling them up / by way
of pulleys to hang them / dangling from stakes, / to hang in the sun till they
die" (17).[12] This New World landscape of abuse, violence, counterattack,
and human misery, Major's painterly text vividly suggests, is the logical and
factual outcome of European efforts to civilize the world.

One scene is especially expressive of the dangers this landscape holds for
the people of the black diaspora. In this passage, a black horseman is de-
scribed as he is attacked by a boa constrictor:

> A giant snake, sixty yards long,
> > drops from a massive, ancient tree
> > onto the back of a black horseman,
> > right or wrong, you see,
> > and wraps itself around both,
> squeezing till the horse and the man,
> > taking all they can stand,
> > > stop moving, then swallows first
> the man then the horse. (18)

Encircled by a power from which he cannot escape, the horseman's fate is suggestive of the historical situation of blacks caught within the unyielding system of slavery. The injustice of their condition has no effect upon their circumstances—nor upon the securing of their release—just as the horseman is attacked, "right or wrong you see." The poem's description follows closely the scene depicted in a study by James Ward (1803), which also portrays a black horseman being attacked by a boa constrictor.[13] The snake, which has dropped from a nearby tree, stretches the man's body out over the back of his horse, encircling them both. The black man's muscles are rigid with exertion, but his facial expression reflects the horrified recognition that his struggles will prove ineffective. Although neither the subject nor the naturalistic setting of Ward's study refers to slavery overtly, by recontextualizing the scene among other vignettes of slavery's abuses, the poem invites readers to see the black horseman's ordeal as a powerful visual metaphor for the suffering of black people who are caught up in an system of trade that relentlessly consumes black bodies.

The spectacle of Western slavery prompts Mfu to identify the psychological destruction that threatens to be the final destination of all Middle Passage voyages, real or imaginary—"the insanity / that welcomes us at the other end: / where one does not believe there is hope" (20). To keep from slipping into the despair that overcame him before, Mfu brings to mind two images. First, he remembers a coin given to him by an "Ashanti Ju Ju" girl with the entreaty that he "believe that the good / in human beings will prevail" (20). One side of the coin shows a black man's head with the inscription, "Me Miserum." The other depicts the figure of the "antique goddess" Nemesis, who holds a scourge in one hand and an olive branch in the other (20). The images and the inscription are the same as those found on a medal commissioned in commemoration of the abolition of the slave trade to the Danish West Indies in 1791.[14] Since Nemesis is the traditional scourge of those who use their power unjustly, the coin seems designed to suggest that the goddess will avenge the suffering of the oppressed. The Ashanti girl gives the coin to Mfu in an effort to bolster his hope that, in the long run, justice will triumph over misery. Mfu also strains to keep before him the "gentle face / of, say, Carl Bernhard Wadstrom, / white man, / bent over Peter Panah, black man, / teaching him to read" (20). A concrete example of a white person performing an act of kindness for an African, this image would seem to support the coin's promise that the good in people may eventually win out. This image is also inspired by a specific work of art, a portrait of Carl Wadstrom and Peter Panah by Carl Fredrik von Breda (1789).[15] The portrait depicts Peter Panah sitting at a desk with a book open in front of him, while Carl Wadstrom stands over him, pointing to the page. As Mfu attempts to counterbalance the prior scenes of human

cruelty with this picture of human concern, however, he eventually realizes that he wishes the portrait "*said* something more / than it does" (20).

Mfu's dissatisfaction may be a reaction to an ambivalence inherent in both images. Certainly Nemesis, in her dual aspect, is reminiscent of the morally ambiguous icons of nationality found elsewhere in the poem. Whether she is the savior or the cause of the African's misery is difficult to discern, especially since she holds in one hand the instrument frequently used to discipline slaves. Furthermore, given the tragic history of the Ashanti people under colonization, the Ashanti girl's hopeful predictions for the future are bitterly ironic. Similarly, Carl Wadstrom's educating of Peter Panah is reminiscent of the role that Philip plays toward the Ethiopian Eunuch. Whether his actions are motivated more by kindness or by cultural ethnocentricism is also uncertain, but they are certainly suspicious, especially so given the plans of the historical Wadstrom to start a colony in Africa. Finally, Mfu's wish that the portrait "*said* something more / than it does" may suggest a privileging of verbal expression over the visual arts (in terms of their political potential) and a concomitant call for linguistic self-expression.[16]

Indeed, the striking image of the black horseman encircled by the thick coils of the serpent can also be understood to signify the ensnarement of black individuals in a hostile system of racial representation. The final sections of "The Slave Trade" consider the possibilities for relaxing those bonds—if not for escaping them entirely. One possibility that is explored for mitigating the effects of a racialized social discourse is found in the hybridization of culture that is a result of colonization. In its earlier vignettes of New World slavery, section 3 emphasized the diverse ethnic backgrounds of those captured in the Western slave system—including maroons, Creoles, mulattoes, and sambos. This diversity is the material embodiment of a larger process of cultural hybridization engendered by the slave trade. Although the new cultural combinations created by this process do not reflect all cultures equally—nor affect all people in the same way—Major's poem proposes that the process of cultural hybridization may itself serve as a condition for loosening the bonds of a reified system of representation. A concrete illustration of this process is offered by the function of African American folk song in the poem.

While references to folk material from both European and African traditions appear throughout "The Slave Trade," African American folk songs emerge in section 3 to play an important role by signifying on the poem's more painterly descriptions.[17] Juxtaposed to folk material from other traditions, the songs provide a powerful countertext to the negative representations of blacks those other traditions encode: "Catch a nigger by the toe. . . ? / Let my people go!" (19). Revealing both the ambivalent acculturation of African Americans to mainstream society's linguistic and cultural

heritage and their lived experience of cultural dissonance, the songs are expressive of both communal identity and social alienation. Thus after the description of a white general who fights in a battle while his slaves "watch for him to botch it" (19), a song interrupts to comment on the competing group interests represented:

> *Pharaoh's army sunk in the sea,*
> *Pharaoh's army sunk in the sea,*
> *sho am glad it ain't me.* (19)

The song's identification of blacks with the chosen people and whites with Pharaoh's army also reverses the earlier association of blacks with the benighted in Christian evangelicalism. In another fragment of song,

> *Never will forget the day,*
> *Never will forget the day,*
> *Jesus washed my sins away* (18)

the meaning of baptism is transformed to express blacks' sense of personal righteousness and their hopes for social salvation, displacing the earlier representations of baptism as spiritual enlightenment or cultural ethnocentricism. By embodying both the culture of their captors and the needs and desires of the enslaved, then, the spirituals exhibit a cultural ambivalence that is itself expressive of the concrete historical situation of African Americans. Major has recently described the voices of African American poets as being "constructed out of intense cultural and artistic conflict and cross-fertilization" (*Garden* xli). The spirituals in "The Slave Trade" underscore both the conditioned materiality of that conflict and the opportunities for self-expression afforded by that cross-fertilization.

In *Black Atlantic*, Paul Gilroy notes that black social critics have long suggested that blacks in the West have not placed their hopes for social self-creation in labor, but that instead, "artistic expression" has been seen as the "main means of individual self fashioning and communal liberation" (40). Major attempts to think through the possibilities, and the limitations, of identifying artistic activity as a means for the personal and communal reconstruction of blacks in the conclusion to "The Slave Trade:"

> Mfu remembers Equiano.
>> Equiano (1789) said: "We are almost a
>> nation of dancers, musicians, and poets."

> So, if this is so,
>> why not celebrate?
>> Mfu calls on all of his people
>>> of the Diaspora:

Come on, Connie,
 do the Congo Cakewalk!
Come on, ya'll, put Mfu in a trance! (20–21)

Not convinced by the Ashanti girl's prediction that the good in human beings will eventually prevail, Mfu calls to mind Olaudah Equiano's definition of the African people as a nation of artists. Considering whether this creative productivity may itself be reason enough to "celebrate," Mfu abandons his analytic search for "reasons." Instead, he now seeks conviction through engagement, his "trance" indicating a final departure from the distanced positionality he personified at the beginning of the poem. Calling upon a long list of black artists and other accomplished black cultural figures, Mfu initiates a sort of poetic ring shout that builds for almost a page. The ring shout of the African American religious and musical traditions—designed to excite the spirit and revitalize belief—offers Mfu an alternative model of spiritual enlightenment. He thus attempts to invigorate his personal search for faith by drawing upon a tradition that counters the methodologies of mainstream culture. Mfu's inspirational chant seems, then, to confirm the idea that blacks who have been defined out of the national identities constructed by whites through racialized civic discourse may achieve a degree of personal renovation and communal restoration through hybridized art forms.

But the last stanza of Major's poem suggests that the work's final position is far from an unproblematic assertion of the potential for art to serve as a site for authentic self-fashioning and communal expression:

 Come on, ya'll,

. . .
You can do more than Jackie Robinson
 did for Wheaties, or Joe Louis did for
 Chesterfield.
Mfu says, Come on, ya'll.
 You can get out of the cotton field and
 you can rise
 above the coconut tree.
Mfu says you can get off your knee and change
 your image.
 Do it your way.
 It's nobody's business but your own. (21)

His language parodying the particularly American versions of progress found in popular self-improvement rhetoric, Mfu urges the people of the black diaspora to "get off [their] knee[s] and change [their] image"—explic-

itly comparing contemporary blacks to the supplicant on the abolitionist seal. Combining the commodification of legendary black sports figures in popular advertising jingles with historical examples of the exploitation of black labor in the Americas, Mfu's call for the creation of liberating art forms is situated within particular traditions of cultural production. Framed by contemporary media industries, the efforts of African Americans to change their image can be appropriated, sometimes with the collusion of blacks advancing their own economic and social interests.[18] Efforts at self-improvement lead ironically to the reproduction of the likenesses of success-ful blacks on cereal boxes and in cigarette ads that function disturbingly as manufactured versions of iconic portraiture. These fabricated images point to commercial and technological processes that speed up, rather than chal-lenge, the social system of representation through which blackness can be packaged and sold. The personal achievements of blacks thus seem to bene-fit that larger system of trade, as the individual accomplishments of Jackie Robinson and Joe Louis are seen to increase the fortunes of Wheaties and Chesterfields. The commercialization of representation that characterizes this contemporary landscape thus complicates notions of the emancipatory potential of art by depicting hybridization as a process through which African American culture itself becomes available to be sold as products.

The poem's final position on the emancipatory function of art is also complicated by the concluding lines to the poem, which combine a strong call for action with a problematic image of aesthetic and social redemption:

> Mfu says let's gather in a sky chorus today
>> with all of those gone and all of those
>>> coming,
>> with Josephine and Leopold the King,
>> and make, he says, some sounds mean
>> what they're supposed to mean. (21)

Expressing the hope that reconstructed artistic expression can be used to transcend personal despair and social injustice by making some sounds mean "what they're supposed to mean," Mfu enjoins others to form a "sky chorus" composed of all "those gone and all of those coming." His heavenly choir recalls the kingdom evoked by the spirituals earlier in the poem, which expressed the hopes of African Americans for social emancipation as well as for spiritual redemption. Furthermore, Mfu's final emphasis on sounds points to the voiced as the possible locus for a less restrained repre-sentation and recalls the African's earlier wish that the portrait of Peter Panah "*said* more." Disturbingly, however, the sky chorus Mfu describes may also include a colonial presence. "Leopold the King" may refer to Leopold II, notorious nineteenth-century sovereign of the Belgian Congo.

Furthermore, while the emphasis on music in the last stanza would suggest that "Josephine" be identified as Josephine Baker, the pairing of that name with Leopold the King suggests that the name refers to Josephine Beauharnais, empress to Napoleon and a white Creole from Martinique who was influential in restoring slavery to the Caribbean. If so, the surprising appearance of these infamous colonial rulers in Mfu's sky chorus indicates that not all its music would be expressive of a communal identity like the spirituals of section 3; it also suggests that transcendence to some plane of authentic black expression may not be possible. And yet the poem ends with a forceful call for action that is both aesthetically and ethically engaged: "make . . . some sounds mean / what they're supposed to mean." What *is* the poem's final position on the emancipatory potential of art?

The conclusion to Major's poem confronts readers with an ambiguous contemporary landscape in which the long struggle of black people to free themselves from their status as commodities is complicated by changing systems of trade and the restrictive representations of blackness that those systems reproduce. Major's emphasis upon the historical contexts of artistic production is underscored by his recent assertion that "[a]esthetics aren't a set of abstractions existing outside historical circumstances and daily reality; they're always grounded in the needs and aims of specific artists and audiences, influenced by the social setting and context" (McCaffery and Kutnik 124). By emphasizing the historical motives that shape artistic production, Major distances his views from conceptions of fixed principles and universal laws of beauty often attributed to Enlightenment thought. His painterly approach also distances his work from those who attempt to ground African American literary art in a particular form of black authenticity. In defining the "speakerly text," Henry Louis Gates has argued that its practitioners draw upon the "authority of the black vernacular tradition" in order to construct a "transcendent, ultimately racial self" (*Signifying Monkey* 183). But artistic activity in Major's poem, however, is not suggestive of the attempt to construct essences or to effect transcendence. Instead, Major's painterly juxtaposition of conflicting cultural forms defines artistic engagement as an ongoing struggle over meaning and form that takes place within an arena of conditioned systems of production. By resisting the constructions of blackness in actual works of art, Major's poetry works to destabilize Western representations of racial difference, joining in the critique of fixity or essence often associated with textualist understandings of meaning. Yet the "painterly" part of Major's poetic approach goes beyond the critique of European constructions of racial difference to insist upon the materiality of art forms, of the economic systems in which those art forms are produced, and of the people who work and create within those systems. Given the textual/materialist synthesis attempted within the painterly text,

then, Major's poem not surprisingly combines the critical act of destabilization with a simultaneous call to creative production.

In "Figurations for a New American Literary History," Houston Baker argues that the authors of the slave narratives wrote within certain economies of trade that often necessitated their own participation in the slave trade if they were to achieve increased autonomy and social control. In "The Slave Trade," Clarence Major offers his own refiguration of literary and artistic history that ultimately locates the social function of art in the continuing battle of black artists to negotiate for themselves evolving and complex systems of cultural representation and production. Finally, Major's painterly compositions point not to fixed definitions, concepts of authenticity, or even to an autonomous realm of self-referential signifiers with which his art has often been associated, but to the situated struggle to confer conditional meaning and form.

At the beginning of "The Slave Trade," Mfu considers the situation of slave and slaveowner, "locked in a dry struggle / of social muck" (11). Major's poem suggests that there is no escaping that cultural muck, "then or now" (11). There is no privileged position this side of the grave from which Mfu—or any artist—may be completely "free to speak his music" (1). In a retrospective article on becoming a writer, Major has spoken of his own "long battle with the history of literature and art" ("Necessary Distance" 37). "The Slave Trade" suggests that the situated struggle to render meaning and form through equivocal systems of signification is not a contest that can be settled once and for all. It is a struggle in which personal and social redemption are never guaranteed.

NOTES

1. Clarence Major, "The Slave Trade: View from the Middle Passage," in *African American Review* 28, no. 1 (Spring 1994): 11–22. All references to "The Slave Trade" are to this edition and are indicated by parentheses in the text. For his advice on an earlier version of this essay, I would like to thank Bernard Bell.

2. See Gilroy's discussion of Turner (14).

3. In addition to those works of art examined in this essay, several others are described in enough detail in Major's poem to be identified with reasonable certainty, although it is beyond the scope of this essay to discuss them all. They include (in the order in which they appear in the poem): Henry Fuseli's *The Negro Revenged*, 1806–7; William Blake's *A Negro Hung by the Ribs to a Gallows*, 1792; Francois-Jules Bourgoin's *The Maroons in Ambush on the Dromily Estate, Trelawny*; an illustration of Haitian soldiers for Marcus Rainsford's *An Historical Account of the Black Empire of Hayti*, 1805; John Trumbull's *The Death of General Warren at the Battle of Bunker Hill*, 1775; Thomas Gainsborough's *Portrait of Ignatius Sancho*, 1768; and the frontispiece for B. Frozzard, *La cause des esclaves negres*, 1789.

4. I am deeply indebted to the Menil Foundation's magisterial four-volume collection of representations of blacks, *The Image of the Black in Western Art*, for

help in identifying the numerous works to which Major's poem alludes. In particular, my understanding of the genealogies of various visual themes representing blacks and of individual works themselves has been influenced by volume II, ii, edited by Jean Devisse and Michel Moffat, and especially by volume IV, i, edited by Hugh Honour (which covers the time period of most of the works to which Major alludes). Other works helpful for understanding the representations of blacks in art include Albert Boime's *The Art of Exclusion: Representing Blacks in the Nineteenth Century*, and Christopher C. French, ed., *Facing History: The Black Image in American Art, 1710–1940*. The latter includes an introduction by Guy McElroy, "Introduction: Race and Representation," xi–xxviii, and an essay by Henry Louis Gates Jr., "The Face and Voice of Blackness," xxix–xliv. In addition, several articles in Gates's *Race, Writing, and Difference* are also useful for analyzing European constructions of blackness, especially Mary Louise Pratt's "Scratches on the Face of the Country: Or What Mr. Barrow Saw in the Land of the Bushman," 138–62, and Patrick Brantlinger's "Victorians and Africans: The Genealogy of the Myth of the Dark Continent," 185–222.

5. The work was included as the frontispiece for volume 4 of the 1774 edition of Raynal's history. One of France's leading *philosophes*, Raynal has been accused of some ambivalence on the issue of slavery, and the frontispiece may have been included by a later editor who wished to foreground the treatise's antislavery passages. See Honour's discussion of Raynal (IV, i, 54).

6. The Enlightenment's role in the promulgation of racism is an issue of critical debate. See, for example, Tzvetan Todorov's claim that it is "inaccurate and dangerous" to understand racism as a result of Enlightenment humanism ("'Race,' Writing, Culture," in Gates, *Race, Writing, and Difference*, 373), and Henry Louis Gates's response to Todorov in the same work, 407ff. Major's position on the subject, I believe, is made clear in "The Slave Trade."

7. The reference to the naturalists' diagrams are probably to illustrations for the popular Julien Joseph Virey, *Histoire naturelle du genre humain*, 1775–78; some illustrations are reprinted in Honour IV, ii, 15.

8. Like many subjects that enjoyed a long iconographic history, the meanings attributed to the black Queen of Sheba vary according to time, place, and tradition. Devisse suggests that the particular iconography described in my account gained currency during the medieval Christian period (Devisse and Moffatt II, i, 129). Read typologically, the queen's enlightenment signifies the universal truth of Christianity, intended for the pagan as well as the Christian world. It should be noted here that the queen was not represented as black during her entire iconographic history, and that in many traditions she is represented negatively as a seductress who tempts Solomon.

9. Major is probably referring here to the common artistic practice of pairing the eunuch with a white woman, often a saint, in religious art.

10. The long and interesting history of representations of St. Maurice cannot be summarized here. Devisse devotes half of a volume to tracing the black knight's various appearances (II, ii, 149–205). It should be noted that, like the Queen of Sheba, Maurice was not represented as black at all times and at all locations, but he became black in some areas around 1250. In discussing the grouping above, I do not mean to imply a chronological genealogy for any particular images leading from the black king to Maurice, since specific images of the black Maurice may predate images of the black king.

11. Jean-Baptiste Belley, *Le bout d'oreille des colons, ou le systeme de l'hotel de Massic, mis au jour par Gouli* (Paris, n.d.), 5. Quoted by Honour IV, ii, 104.

12. The image is very likely inspired by *Revenge Taken by the Black Army*, a line engraving by J. Barlow for Marcus Rainsford, *An Historical Account of the Black Empire of Hayti,* 1805. Barlow's illustration depicts the pulleys in clear detail. The work is illustrated in Honour IV, i, 104.

13. Honor suggests that although the work is entitled *The Liboya Serpent Seizing Its Prey,* the subject would be associated with the Western Hemisphere since boa constrictors are indigenous only to South America.

14. Medal commemorating the abolition of the slave trade to the Danish West Indies, designed by Nicolai Abraham Abildgaard and engraved by Pietro Gianelli, 1792 (illustrated in Honour IV, i, 77).

15. Carl Fredrik von Breda, *Portrait of Carl Bernhard Wadstrom Instructing a Negro Prince, Peter Panah* (illustrated in Honour IV, i, 75). Honour points out that Wadstrom's attitudes toward Africans were complex. A Swedenborgian, he wanted to start a colony for blacks and whites in Africa, which he thought would be the site of the New Jerusalem. Believing that blacks were superior in will and affection, while whites were superior in understanding, Wadstrom thought that whites should direct the colony he planned—and guide Africa at large.

16. At times Major points to a lack of parallelism between the arts. For example, he has recently stated that "[l]iterature is unlike the other arts" (McCaffery and Kutnik 134). He elaborates by suggesting that the "reflexive 'problem' all writers have to face is that the materials fiction is created out of—that is, words, language—'mean something,' in the sense of making references to the outside world" (McCaffery and Kutnik 134–35). Elsewhere Major discusses the possibility that literature "can be, in the French sense, a means of engagement" (*Garden* xxviii). These comments would seem to suggest that Major's rejection of Black Nationalist aesthetics has been misread as committing him to a position of radical nonreferentiality that he may not hold, or that his position has changed over time.

17. Not surprisingly, the poem's early references to European folklore reinforce the same racial attitudes found in high art: thus "little Dutch children" try to make their African playmate shine with "Snow-white" soap (16); Hansel is overhead saying to Gretel, "I'm afraid to go / to Africa because cannibals may eat me / as they do one other" (18); and efforts are made to keep black bodies "far from the mistletoe" (16).

18. Joe Weixlmann makes a similar point in interpreting Major's criticism of black aesthetics as a reproach of those "for whom blackness was an extant commodity the writer might simply pour into a literary mold" (77).

WORKS CITED

Baker, Houston A., Jr. "Figurations for a New American Literary History." In *Blues, Ideology, and Afro-American Literature: A Vernacular Theory*, 15–63. Chicago: University of Chicago Press, 1984.

Bhabha, Homi. "Signs Taken for Wonders." *Critical Inquiry* 12 (1985): 144–65.

Boime, Albert. *The Art of Exclusion: Representing Blacks in the Nineteenth Century*. Washington: Smithsonian Institution Press, 1990.

Devisse, Jean, and Michel Moffat, eds. *The Image of the Black in Western Art*. Vol. II: i, ii. Menil Foundation Project. Cambridge, Mass.: Harvard University Press, 1979.

French, Christopher, ed. *Facing History: The Black Image in American Art, 1710–1940*. With an introduction by Guy McElroy and an essay by Henry Louis Gates Jr. San Francisco: Bedford Arts, 1990.

Gates, Henry Louis, Jr. *Race, Writing, and Difference*. Chicago: University of Chicago Press, 1996.

———. *The Signifying Monkey: A Theory of Afro-American Literary Criticism*. New York: Oxford University Press, 1988.

Gilroy, Paul. *The Black Atlantic: Modernity and Double Consciousness*. Cambridge, Mass.: Harvard University Press, 1993.

Hayden, Robert. "Middle Passage." In *Modern and Contemporary African-American Poetry*, edited by Bernard W. Bell, 56–61. Boston: Allyn and Bacon, 1972.

Honour, Hugh, ed. *The Image of the Black in Western Art*. Vol. IV: i, ii. Menil Foundation Project. Cambridge, Mass.: Harvard University Press, 1989.

Johnson, Charles. *Middle Passage*. New York: Athenaeum, 1990.

McCaffery, Larry, and Jerzy Kutnik. " 'I Follow My Eyes': An Interview with Clarence Major." *African American Review* 28, no. 1 (1994): 121–38.

Major, Clarence. "Necessary Distance: Afterthoughts on Becoming a Writer." *African American Review* 28, no. 1 (Spring 1994): 37–47.

———. "The Slave Trade: View from the Middle Passage." *African American Review* 28, no. 1 (Spring 1994): 11–22.

———, ed. *The Garden Thrives: Twentieth Century African-American Poetry*. New York: HarperPerennial, 1996.

Morrison, Toni. *Beloved*. New York: Knopf, 1987.

Weixlmann, Joe. "African American Deconstruction of the Novel in the Work of Ishmael Reed and Clarence Major." *MELUS* 17, no. 4 (1991–92): 57–79.

Wright, Richard. *White Man, Listen!* New York: Anchor Books, 1964.

To Define an Ultimate Dimness

The Poetry of Clarence Major

NATHANIEL MACKEY

The aesthetic underlying Clarence Major's poems has to do with an ethic best expressed in Ralph Ellison's *Invisible Man*: "The mind that has conceived a plan of living must never lose sight of the chaos against which that pattern was conceived" (438). Technically as well as thematically, Major's poetry seeks to be some such bearing in mind of "chaos," of that which what he calls "control version of any / coherence" attempts to exclude (*Swallow the Lake* 28). Major has spoken of the influence of Freudian ideas on his work, particularly on his first two novels, *All-Night Visitors* and *NO*. It seems fair, then, to speak of the oppositional elements in his poetry as a gesture on behalf of the repressed or ignored areas of experience and awareness, on behalf of civilization's discontents. Major is explicit about his own discontent with Christianity in particular, a prime contributor to the repressiveness of Western civilization:

> Christianity is something with which I have been at war almost all my life. When I was a kid I believed the things I was told about God and the devil. . . . These feelings about Christianity are in my work because I agonized with these things in my own experience of growing up, these problems of good and evil and sex. I think that's why there's so much sex in *All-Night Visitors*. . . . Christianity's view toward sex exists because of the great self-hatred that's so embedded in Christian teaching. Look at St. Paul's doctrine of Original Sin. I can see it in everything around us: sex is something that's nasty and something to hide. *All-Night Visitors* was a novel I had to write in order to come to terms with my own body. I also wanted to deal with the other body functions. In *NO* I was trying to exploit all the most sacred taboos in this culture, not just sexual taboos, but those related to the private functions of the body and that's where they all seem to center. (*Dark and Feeling* 134)

Such attitudes as these, I will be arguing in this essay, inform Major's poetry as well as his novels. Before attending to the technical disruptions in his poems—the unconventional syntax, violations of grammar, typographical irregularities, and so forth—I will discuss how his iconoclastic impulse asserts itself thematically, how it figures in the content of the poems.

Originally appeared in *Discrepant Engagement: Dissonance, Cross-Culturality, and Experimental Writing* (Cambridge: Cambridge University Press, 1993), 49–65. © 1993 by Cambridge University Press. Reprinted by permission.

Major's quarrel with social strictures, especially where they take the form of Christian taboos and beliefs, is especially visible in three poems: "I Was," "Inscription for the First Baptist Church as It Comes Out on Saturday to Park," and "Holyghost Woman." "I Was," the shortest as well as easiest of the three, can be quoted in full:

> I said I was the night
> to try to be it. Magic
> a collision of black
>
> music, midnight allies
> when I said I screwed
> a girl, late at night.
>
> While a Baptist Church
> talked thru its loud
> speaker. I said it all. (*Swallow the Lake* 60)

A relatively straightforward poem, it asserts Major's identification with those outlawed powers and proclivities symbolized by "the night" and proclaims his opposition to orthodox religiosity. The Baptist Church figures into the second of these poems as well, as its title indicates. The poem's final stanza suggests a connection between the hierarchical structure of the church (the "high up the totem pole" ascendancy of the speakers over the congregation) and what Freud calls an upward displacement of libido ("thorns of these ages of flesh," "their insensible love songs"):

> thru eerie smiles of irongray faces on wooden benches
> where the certain thorns of these ages of flesh held
> the bold, gentle speakers high up the totem pole safe
> from skepticism even reinforced by the practical paper-
> plates not to mention their insensible love songs
> (*Symptoms and Madness* 7)

"Holyghost Woman" equates the would-be transcendence of the body with a deceitful social mobility, an upward mobility hypocritically aimed at material comfort. Such words as *deception, commercial, material, flirting,* and *cajolery* help characterize Sister Patty Johnson's piety as a ploy used to exploit unsuspecting believers:

> pre-
> tending to BE
> not even flesh wind talked in her way of
> looking transient: DECEPTION spoke out of

stride, the petty quiver
 HIGHER!!!
coming on as flat devotion to a :cause
 (*Symptoms and Madness* 19)

And at the end:

SO BLACK & SOFT gentle honeysweet trusting these
humble people I know so
well & ready to give to her, a woman called Sister
Patty Johnson (ex-slave to nothing but MOTION:)
 EVERYTHING: in the midday of silver leaves
from the moment of the front porch, EVERY-
THING they had to give she ATE, hard. (*Symptoms and Madness* 19)

In "Holyghost Woman" the persistence of appetite in someone who pre-
tends to have risen above it ("she ATE, hard") is pointed out in order to
undercut any such pretensions to bodilessness. Major's work invests heavily
in an insistence on eating as a reminder of human animality, the ines-
capability of the demands of the bodily, appetitive side of human nature.
This is especially clear in *All-Night Visitors*:

I see this poor Mexican, with fifteen kids at home, dig, and here he is at
the Chicago stockyard, Department: BEEF KILL, he's at the hatchet-door,
it's a gate, not a door; and these dumb cows keep coming, . . . The blade
comes down, and I am putting the tender, well-done steak into my
mouth, the acutely sensitive interior of my mouth, almost throbbing with
anticipation, I'm also sweating and melancholy, the blade comes down,
WHAM!!!! takes off the cow's head very neatly, . . . and I'm chewing now,
chewing, grinding my teeth into the secreting meat. . . . I am as involved
in this savage activity as any animal of gluttony would be, the membraney
walls of myself reacting, responding to it. (*All-Night Visitors* 58–59)

Major is particularly attentive to the violence to which human appetites give
rise, the profoundly simple fact that we kill in order to feed ourselves. He
tends to be impatient with any attempt to suppress recognition of this fact,
to apply a cosmetic to what this says about being human. In "The General
Sense of Self" he speaks of civilization's efforts at bolstering up the human
at the expense of the animal, rationalizing human behavior and motivation,
as mere "excuses":

soaked in repressed rhythms
our life myths
are sunk in the useless riddle of
the emptiest excuses

these wornout and yet desperate artifacts
not enhancing our humanity yet remain
imperishable as the idea of
killing food killing for dreams (*Swallow the Lake* 25)

Particularly symptomatic of such "desperation" is the great emphasis American society places on hygiene and cosmetics, especially on deodorants, air fresheners, and such—the various aids designed to neutralize or "civilize" the sense of smell, the most "primitive" of the senses. That odors having to do with the body or with bodily processes are the prime target of these aids further implicates them in a social ruse whose aim is a façade of bodilessness. Some of Major's poems address the fact that, as he says in "Self World," "these monsters, they use deodorant, / and brush their teeth. / And do not know / anything" (*Swallow the Lake* 35). In "The Backyard Smelled of Deodorant and Talc" the perfumed air at the picnic signifies an attempt to disguise or domesticate the Id, to

cut the uncertain portion of the
 self
 back into something be-
tween smiles & popped cans (*Symptoms and Madness* 11)

As do the "practical paper- / plates" in "Inscription to the First Baptist Church," the fact that the picnic is an occasion for eating belies any transcendence of the body or of appetite. The poem ends on a note suggesting that we "do not know / anything," that we so comfortably presume to have risen above animality in an age of supermarkets and packaged meats, able to avoid coming face-to-face with the bloodshed which feeds us:

we are summer meat, spirit eating baked
 life summer outdoor funeyes we have
unwilling
 some of us even unable to
kill
 what we digest
 now in picnic. (*Symptoms and Madness* 11)

"Conflict," another poem that makes use of the idea of perfumery or deodorization as a suppression of the body, is significant in that it shows Major appropriating one of society's preoccupations in order to critique society, taking over the terms of that preoccupation and inverting their customary usage. He confounds the floral scents of which soaps and perfumes are made with the Baudelarian figure "flowers of evil." Viewing this suppression of "offensive" smells as an evil, he answers the commercial

image of a soap-cleansed and therefore lovable body with the "fishy," genital odor of actual erotic love:

> the heart of sweetheart smelling
> Purex product beauty soap, dye drying
> me. Of love, the fishy odor of a boat (*Symptoms and Madness* 12)

The poem goes on to speak of another, perhaps more subtle, even immaterial odor:

> I remember, also I knew a long time
> the strong stink mortal insult of those
> big baggy men without sense
> in their eyes
> standing on the trolley coming
> where they were going. That against the
> nostrils. (*Symptoms and Madness* 12–13)

If these "baggy men" are junkies (as the word *baggy*, alongside the image of eyes "without sense," suggest), this passage suggests that society's castoffs carry the *truly* offensive odor of social ills and injustices, that they are the "flowers" of society's evil. Major's attention, informed by his awareness of how psychical exclusions underwrite social exclusions, gravitates toward the marginal, unacknowledged, or outlawed realms of society and of consciousness—toward, in fact, a redefinition of the terms *good* and *evil*.

This redefinition results in a poem such as "The Unfaithful Wife: A New Philosophy," in which the conventional morality by which the adulterous woman would be condemned is questioned to the point of being turned around. The poem celebrates rather than condemns the woman's breach of that morality, while making fun of the husband's conformity to it:

> well. seems
> coke hash grass anything was a
> bigger success than you tho you
>
> were a steady husband a good
> father a provider and a trusty
> pillow coke was adventure
>
> and he'd be gone next day for-
> ever which was
> the magic of it for her memory (*Cotton Club* 15)

"The Exhibition" likewise applauds a woman's repudiation of conventional expectations, snidely addressing the woman's husband and again citing an affection for cocaine as a measure of the woman's rebellion: "think you

knew all / along coke / had your wife in a / cultural corner" (*Private Line* 19).
Major's identification with those who venture outside the closed circle of
conventional mores is further indicated by a poem like "Private Line" (*Private Line* 24), in which the speaker is the "other man" in an adulterous
triangle. Similarly, in "Kitchen Chair Poem #5" the love the speaker professes for an apparent prostitute compares favorably with that which he
feels for his wife:

> like this dude said who just came
> out of prison, giggling. Man I can't even afford
> to look, with my eyes, funny
> but how could i tell him
> her love had hit me the hardest? with my wife
> standing inside my skull. (*Swallow the Lake* 22)

The stance of the outsider, the cynical observer, assumed in many of Major's
poems aims at unmasking conventional pretensions, unveiling the unmentionable dysfunctions conventional ideals attempt to keep covered. "Possession and Madness," for example, touches upon the sadomasochistic power
lusts that twist most male-female relationships, along with the sexual impairment that often goes along with them:

> Sweet, she sees her
> self taking him:
> in, as he loses
>
> his vital force in
> HER
>
> She tells me this
>
> How she feels in
> her mornings why he
> stands under her
> nylon brush, an
>
> unreciprocal thing:
> he, too, talks to me.
> says she can't come.
> never has (*Private Line* 23)

Similarly, attention tends to be sneeringly focused on exactly those facts of
life that give the lie to collective as well as personal myths of well-being, as in
"Motion Picture" (*Private Line* 15), which reminds the affluent person it
addresses of the racial oppression that supports that affluence; "Author of
an Attitude" (*Private Line* 12), which reminds the woman for whom it's
intended of her egotism; or "Vietnam" (*Swallow the Lake* 44), which con-

fronts the complacency of the American way of life with the turmoil it promotes abroad.

II

The technical disruptions found in Major's poems are generated and underscored by the iconoclastic stance we see at work on a thematic level. Major's targets tend to be the institutionalized blindnesses that buttress consensus. That any definition of reality, any worldview, is compounded of both seeing and not-seeing, blindness as well as vision, is the axiom from which his technical disruptions proceed. In a comment made in the course of an interview in 1973 he insisted upon the indefinability of reality, remarking to the interviewer, John O'Brien: "I think that you should stop when you use the word "reality" because reality itself is very flexible and really has nothing to do with anything. I don't think that reality is a fixed point that theories adjust around. Reality is anything but a fixed point" (*Dark and Feeling* 137). The insistence upon the wrongness or unreality of any system or theory, coupled with the recognition that language itself is a system, a set of conventions and agreed-upon procedures fully implicated in the maintenance of certain assumptions about the world, leads to an assertion of the need for what Major calls "a new kind of creative brutality" (*Symptoms and Madness* 33) in one's approach to the use of that system. In the linguistic realm just as in the ethical realm—as a poem like "The Unfaithful Wife" illustrates—breaks with conventional behavior are to be encouraged. One can call this impulse dissociative, as it seeks to dissociate itself from the seductions of a hegemonic worldview, to loosen the syntactical and grammatical threads that knit that worldview together. Robert Kelly, in the "prefix" to *The Mill of Particulars*, quotes a passage that articulates the intent of this impulse: "Through manipulation and derangement of ordinary language (*parole*), the conditioned world is changed, weakened in its associative links, its power to hold an unconscious world-view (consensus) together" (11).

To question language's access to reality, its claim to being intimate with anything other than its own occasion—to regard it, that is, as an essentially self-appointing *arrangement* of correspondences, projected onto in order to be retrieved from the world or reality it thereby claims to be reporting—is to have already begun the work of dissociation. "All words are lies," Major comments, "when they, in any arrangement, pretend to be other than the arrangement they make" (*Dark and Feeling* 126–27). The referentiality of language thus undermined, "meaning," that peculiarly linguistic imposition upon the world, is viewed as affording no guarantee of accurate insights into actual relations in the nonlinguistic world. It provides an assurance of certain rules of order having been complied with, certain maneuvers known as grammar having been successfully completed, but

The Poetry of Clarence Major 139

possibly nothing more. To the extent that the ordinary notion of "meaning" reifies the successful passage through permissible channels, thereby elevating the skillful negotiation of the grammar's resistances to the status of truth, it entails another eclipse of reality by convention. For this reason Major, in "Dismal Moment, Passing," implicates "meaning" in the "laundering" of reality of which, as we've seen, hygiene, cosmetics, and sexual repression are other examples:

> I think of my mother when I think
> of nature, her beliefs. Those lies, in space
> hanging there to arrange
> human minds like suffixes to structures,
> like societies. Or meaning like a sheet flapping
> on a back porch, people might still
> wash things, hang them up to dry. (*Symptoms and Madness* 9)

Two of Major's poems address language's—and therefore poetry's—presumption to be about things outside itself ("about" both in the sense of having those things as its subject matter and of being "on all sides" of them, having them covered or contained). "Beast: A New Song" offers the figure of a tiger imprisoned in the "cage" of language, a prisoner of the "captions" or words imposed upon it by humans:

> tiger pacing on unable to capsize
> his direction trapped in minds
> of human captions labor of his
> sway up down thru absolute by
> absolute in absolute beyond
> even the absolute cage language
> of this absolute song. (*Symptoms and Madness* 32)

Given the Freudian insistence of so much of Major's work, it is hard not to think of this tiger as representing repressed animal instincts from which society attempts to protect itself. Again, as in "Dismal Moment, Passing," Major notes the role language plays in this repression. In "My Child," the prelinguistic, predefinitional, or pretaxonomic *innocence* this animal world suggests is represented by childhood. Major cautions himself against the presumption of making the child his subject (of *subjecting* her, placing her under his own control, as well as of making reference to her as subject matter). He reminds himself of her autonomy, that she exists independently of both him and the poem, that she doesn't need them:

> her curls, like black sparkling things
> out of the interruptions of music or
> endemic structure of just things, are simply

there, not even needing this poem, nor
me: a mirror, coming in my love to what I vainly
interpret as some vague property, a shadow of my-
self (*Swallow the Lake* 10)

The end of the poem complies with this warning, honoring the caveat the
poet issues himself by abruptly falling silent:

> her 3 year old rendition of the world is
> not inferior to anybody's, her play accepts
> the debt of herself, the simple undefined reality
> of this—. (*Swallow the Lake* 10)

The reader is made to feel the indefinability, the unwordedness of certain
aspects of the world. The poem deliberately draws a blank at the end, short-
circuits its own propositionality in order to be consistent with itsself-
critique, to desist from its infringement on the child's wordless "being-
there."

While acknowledging the ability of words, by way of agreed-upon, pre-
arranged equations, to conjure impressions of the physical world, Major
defines his intention as one of *occupying* rather than projecting outward
from the "arrangedness" or arbitrariness of language, thereby calling atten-
tion to that arbitrariness as a world, a form of life even, peculiar to itself:
"What I try to do is achieve a clear and solid mass of arrangements, an
entity, that passes for nothing—except flashes of scenes and impressions we
all know—much outside the particular shape of its own 'life'" (*Dark and
Feeling* 127). Habit and familiarization tend to efface the arbitrariness of
conventional arrangements, to render the fact of their having been arranged
more and more transparent. In order to overcome as well as critique this
tendency, Major strives for highly idiosyncratic arrangements, their idio-
syncrasies—grammatical, syntactical, and typographical—not only defying
convention but serving to make their "arrangedness" harder to overlook or
to take for granted—indeed, blatant. An example:

> getting to her
> even in the frustrated riddle
> of technology
> :that () theoretically
> protects her in
> her
> !inscrutable "history" ("—for IMM," *Swallow the Lake* 67)

This passage, with its variable margins and its idiosyncratic punctuation
(the colon and the exclamation mark placed at the beginning of their re-
spective lines, the empty parentheses, the absence of punctuation in places

we'd normally expect it), is typical of Major's work. Poems such as "Float Up" go even further in the direction of typographical peculiarity, certain words or entire lines being printed in italics, others totally in uppercase letters, others in boldface. An apparently capricious use of punctuation—in this instance parentheses, colon, slash, exclamation mark, and comma—can again be noted:

> my EYE
> knows the TEAR-STAINED (face
> my) *sister*
> BE:HIND / Glass
> a **moving**! window
> **going carefully along tracks**
> AWAY, to a kind of unreal protection (*Symptoms and Madness* 59)

Here we have an attempt to raise arbitrariness to the level of an ethic. Charles Olson once remarked: "There's no artificial way to be arbitrary. There's only one way—moral" (24). Similarly, Amiri Baraka has argued: "The point of life is that it is arbitrary, except in its basest forms. Arbitrariness, or self-imposed meaning, is the only thing worth living for" (*Black Magic* 41).

The "morality" of these gestures, their honesty, consists of an open display of the willfulness or whimsicality that brings them into being. They bring to the surface the arbitrariness more conventional procedures suppress. Rather than abide by a deceptively referential transparency—a presumably natural correspondence between words and things whereby we look *through* but not *at* language—these gestures insist upon a certain density, the opaqueness of a network of signs that more likely block than facilitate access to an "outside" world. The dredging up of this density requires that discourse—that set of rails meant to insure the smooth running to and fro of acceptable predications—and, along with it, its "lubricants," the rules of grammar, syntax, and semantics, be either jammed or dissected. In Major's work both things are done, the first as a way of undoing discourse's claim to thoroughness, the second its pretensions to continuity. By "dissection" I mean the practice of interrupting or cutting up the flow of an utterance by the insertion of periods, commas, colons, and other such marks of punctuation where one doesn't normally expect them:

> ceremonial objects decorate the
> *in*direct-lit D I N S of very
> smooth, people. i burn
> the invitations and stay into
> my. own touch.
> ("In the Interest of Personal Appearance," *Cotton Club* 16)

Or:

> the deity
> growing inside
> her own. spirit, from
> a tiny spirit, place called
> Elquis. no
> one's heard of
> ("Quick History of an Untarnished Sad Moment in Time,"
> *Cotton Club* 17)

The same thing is frequently done to individual words, as in the case of "BE:HIND" in the above-quoted "Float Up," and Major's use of the slash in such instances as "-o/p/ening" ("The Comic MoneypowerDream," *Symptoms and Madness* 39) and "clash/ing" ("A Poem for Americans at the Top of the TV Screen While Looking Down into Hell," *Swallow the Lake* 26). The effect of this is the introduction of a certain choppy, staccato quality that thickens or "clouds" an otherwise limpid, possibly hypnotic flow. These interruptions or dissections serve as reminders of an inescapable segmentality, the discontinuity within as well as between words that calls to our attention the corresponding gap between words and things. This discontinuity, that space between words, is often visibly rendered on the page:

> My people are in centers, who
> see columns and touch concrete. Cab
> drivers, heavy ("The Silent Essence," *Symptoms and Madness* 70)

What I refer to as jamming works in somewhat the opposite way, run-on rather than halting, the effect of density it achieves being one of overload, interference. What it more specifically dismantles is the notion of the sentence as a completed thought, showing the sentence thus conceived to be at best an artificial holding action. This run-on tendency is an attempt to more accurately graph the *quickness* of thought, its disregard for grammatical obstructions. One of the more simple examples occurs in "The Design":

> I am tired of the
> apartment is dull a place but it comes
> to this each (*Swallow the Lake* 11)

In this case the word *apartment* is the point at which two distinct predications—"I am tired of the apartment" and "The apartment is dull"—flow into one another, the single word serving as both the object of *tired* and the subject of *is*. The first predication is jammed or interfered with by the second in the sense that by the time we get to the concluding terms of the one we're also into the initial terms of the other: "the / apartment." Another example:

If I were adequately armed
And the kind of decision that makes
Or breaks the settlement of
 human arms and human galilees
Would finally mean rejection of Myself
 ("Danger Zone," *Swallow the Lake* 54)

Here the failure to follow the *if*/imperfect clause of the first line with a *then*/conditional clause gives the impression of nothing if not an incomplete, jammed, or a cut-into thought. Since the fifth line begins with the conditional *Would*, the obvious monkey wrench is the *And* of the second line. What it does is make the four lines it introduces seem to be more in collision with or an interruption of the first than would the word *then*, which our grammar has us prepared to hear as a smoother transition in this situation, a logical connective that honors the integrity of each clause.

Another example of jamming is "Overbreak," a poem that describes while enacting what it does. Its very title suggests a jammed, congested condition—"over" as in an overload, "break" as in a breaking point, bursting point. The run-on quality is attested by the fact that the poem, consisting of 49 lines and 328 words, is presented as one long utterance that neither begins with a capitalized word nor ends with a period, punctuated almost exclusively by commas, the exceptions being a colon in one instance and a dash in two others. The poem makes use of no periods at all, indicating an absence of full stops. This run-on quality is referred to in the poem itself as a "verb" quality or a "verb quiver," an ongoingness that makes a point of the kinetic nature of the world and of consciousness, the primacy of flux: "there is a remarkable verb of / things" (*Symptoms and Madness* 16). The sense of dispersal and agitation to which this "quiver" gives rise is reinforced by the occurrence in the poem of such words as *infected, perturbation, cluttered, excitement, devilment, breakdown, delirium, reel, scattered,* and *thrills.* The "verb" quality makes for a murkiness or lack of definition, a promiscuous overlap of one thing with another which erases clear demarcations. This is said to give a more accurate, a "more loyal" picture than do the discriminations language normally affords:

 there is
a quality of which sharp contact is
 the qualification, a remarkable verb quiver
like some hypothesis, an
 irony, a quest, a breakdown, out
of delirium yet continues to enrich hedges
 of the self, definition or cause to become
somewhat more loyal—a description, A REEL OF DESCRIPTION
 (*Symptoms and Madness* 16–17)

The poem earlier speaks of an attempt, which would appear to be its own, "to define an ultimate dimness," an attempt at "the wedding of the conscious and the unconscious" of which Major elsewhere speaks (*Dark and Feeling* 127). The poem's concern with psychological as well as linguistic marginality is brought out by such phrases as "hedges / of the self" and "a sexual assessment baited / in the brain of riddles," as well as by the words *breakdown* and *delirium*. The poem ends with a passage whose density will not be reduced but whose concerns do appear to touch upon, however unsharply, the problematic nature of socially and linguistically upheld dichotomies, especially moral ones:

> a paradox of evil devouring the
> electricity of our flesh, the near-
> ly acceptable tangibility of
> goodness (*Symptoms and Madness* 16)

Such dichotomies, having violated our psychic wholeness, have to be violated in return:

> contact the energy myth taboo all
> this dimness beneath the rhythm, scattered and
> colored, in social fires and thrills so
> slow they burn the skin tight around the brain, quick
> dichotomy—good or evil & company, the
> sense of a world smashed and re-realized, over & like
> nothing touchable in the particular land-
> or inscape we know, in all its contradictions saves
> us yes saves us no here in this
> sustained instant, as we turn in a tacit polarity
> (*Symptoms and Madness* 17)

Major's poetry's technical disruptions, informed by a stance of estrangement and dissent, embody a desire, this poem is telling us, to *un*speak—to silence, to make "tacit"—the polarities that normally govern behavior and thought.

III

I would like to venture a few reflections on the predicament of Major's poems, which is that of avant-garde aspirations generally. It is also the predicament of readers such as myself who are sympathetic to the poems. I should not let this essay end without having said that I find it difficult, problematic, to claim to enjoy these poems. This is not to say that I don't respond to such images as "nurtured waves" ("Overbreak," *Symptoms and Madness* 16), or "absent minded earth" ("Surprising Love," *Symptoms and Madness* 61), to the grace of such a passage as

> My arms at my side. I
> will never be this or that old man feeding birds.
> They scatter trash, they scatter
> the sound, the color it creates in the exact
> time it takes to frighten them always
> caught my eye. ("This Temple," *Symptoms and Madness* 15)

It is not to say that I don't respond to entire poems, such as "Air" (*Swallow the Lake* 38), "Egyptians" (*Swallow the Lake* 50), or the just-discussed "Overbreak." What I mean is that Major, as is evident in the poems' oppositional thrust, is not particularly concerned with providing enjoyment, nor, I would think, with being applauded as having done so. I'm not absolutely certain of this, of course. Perhaps he *is* so concerned. But part of what I see as his predicament is that he should not be. To begin a poem with the line "She knew more about me *than* let us say" (*Swallow the Lake* 16) is to announce a desire to frustrate rather than appeal to the reader's expectations. Unless one likes asking the unanswered question "'*than* let us say' what?" there is no particular enjoyment to be gotten from this. Nor is it irrelevant that the poem in which this occurs is called "Isolate" and tells of wanting to be alone:

> Here she was everything to me, after the crude
> Cramming of Nothing; but now
> I want isolation. I told her what.
> She said, then isolate motherfucker (*Swallow the Lake* 16)

The stance of alienation from which the disruptions I have been discussing proceed makes for a problematic relationship between the work and its audience and between the poet and possible "fellow travelers" as well.

Without going so far as to reduce the poetry's attitudes and disruptions to an antisocial or nonconformist bent, to a pursuit of estrangement as an end in itself, it is possible to see how a desire for "isolation" can lead to a persistent flight from companionship or consensus—even nonconformist companionship or nonconformist consensus. In this regard it is instructive and intriguing to read Major's comments on the Beat movement in his essay "Eldridge Cleaver: And White Writers." Given the sorts of attitudes that recur throughout his work, one might expect Major to feel some degree of kinship or affinity with the Beats' celebration of unorthodoxy, rebellion, sexual freedom, and so forth. I share his impatience with their romanticization of "the Negro," with the inaccuracy of labels, with the popularization which eventually co-opted their stance of revolt, and with the crutch the sense of a "movement" can be used to provide, but I'm still surprised to come across the following:

[T]he best poets critics novelists of these years worked outside the Beat circle. People like Margaret Randall, John Berryman, Walter Lowenfels, Kenneth Patchen, Gil Orlovitz, W. S. Merwin, Marvin Bell and Sandra Hochman. . . . (I like the deep roots of good poems in books by dudes like Galway Kinnell—who was never a bigmouth.) (*Dark and Feeling* 109–11)

I'm not certain what the aesthetic by which these writers are judged "the best" has in common with that which informs a passage of his own such as:

this rubbermetalglass mathematical mobile, Ford
 outshining/growing into distance/timing
 oozing, discharging, trickling
 BANG!
 (unconscious
 CRASH!
death) ("On the First Wake Up of Light, It's Death," *Swallow the Lake* 63)

One cannot help feeling that one (if not both) of these passages amounts to an act of bad faith. Major's poetry, if on the basis of nothing more than the way it looks on the page, would appear to share more with the "New American Poetry," which he dismisses as "an illusion at sea" (*Dark and Feeling* 108), than with that of those poets he designates "the best." Why so emphatic a dissociation from the very trends to which his own work is most related? A desire for "isolation"? He does tell us that "the weak ones need movement[s] always: they can't make it on their own" (*Dark and Feeling* 110). So what are we to make of his membership in the Fiction Collective?

Major's is a persistent unrest, a discontent to which marginality gives rise. The pervasiveness of this air of uneasiness renders "enjoyment" beside the point—or, at the very least, subject to quotation marks. It also results in Freudian thought, with which Major's discontent so largely agrees, becoming a target of that discontent. Major remarked to John O'Brien:

I regret . . . in my haphazard education my exposure to Freudian psychology because it has left me its effects in my thinking. Since I finished *NO* I found myself weeding out so much of it. I can't reject it all because we live in a technological world where we have certain ways of dealing with reality. But that's one thing that I regret about *NO*. I noticed the Freudian influence there and it's very disturbing. That whole sensibility is probably present in my earlier work, too, and it's a sensibility that I want to forget. I don't want to get trapped in terminology. I worry that, despite the fact that *NO* came from the gut level, a large part of it seems to be caught in the sensibility of Freudian psychology. (*Dark and Feeling* 137)

The susceptibility of his attitudes and opinions to systemization—Freudian, Beat, "New American," or whatever—to, indeed, the sort of intellectualization to which I have subjected them in this essay, is a fact that troubles Major's work. Attempting to free itself from the shackles of consensus and discursive thought, to get to the marrow of individual, instinctual impulse, it finds itself involved in a new discourse, a new consensus. The vigilance of its discontent, of a desire for "isolation" (a desire to be without precedent or peer), leads Major, in the poem "Conflict," to dismiss the importance of three forerunners of and possible influences on his stance of disaffection:

air of stale milk, I was under
the influence of power flow the
 mouth of the 3 flowers of evil

 Rimbaud,
 Baudelaire
 Verlaine)

not myself here except I know
(I *knew* beyond sense of the French
decadents example

. . .

 I
claim that knowledge, outside the fragments
 of V, B & R. (*Symptoms and Madness* 12–13)

These lines provide another example of Major's insistence upon the primacy and radical honesty of individual experience, his feeling that "the only way to be revolutionary is to begin from one's deepest motivations" (*Dark and Feeling* 108). That "one's deepest motivations" might have something in common with those of others can prove annoying, however, and Verlaine, Baudelaire, and Rimbaud have to be kept at a distance.

Major's poetry exhibits a certain refractoriness, as though it wanted to surround itself with "No Trespassing" signs. This quality seems related to a nostalgic, even narcissistic desire for something like the uncompromised naiveté of childhood. He writes of Richard Wright, for example:

I try to imagine the type of work Richard Wright would have done had he developed into another type of person. As a child he wrote a story that was of "pure feeling." In his later work there was always some ideology behind everything. I like to play with the idea that original innocence might have saved him from many hallucinations had he been able to save it. (*Dark and Feeling* 71)

The desire for a "gut" level of "pure feeling" and "original innocence" is a futile one, doomed to frustration if one is to work within language at all. What is language, after all, if not a social pact (an ideology), the basis, in fact, of all other social pacts? Even the dissociative assault on language is finally a testimony to its importance and power—is, quite simply, a *linguistic* assault on language. Baraka once wrote:

> A compromise
> would be silence. To shut up, even such risk
> as the proper placement
> of verbs and nouns. (*Dead Lecturer* 30)

But we are not much given to silence. A certain use of language that, in short-circuiting predication, approximates silence is as close as we get. The futility of its fight against language, against the omnivorousness of ideation, leads me to say of Major's poetry what he tells us John A. Williams said of *All-Night Visitors*. It too "gives off a kind of gentle helplessness and anger with no place to go" (*Dark and Feeling* 135). To make more triumphant claims for such work is to miss its point.

WORKS CITED

Baraka, Amiri. *Black Magic*. Indianapolis: Bobbs-Merrill, 1969.
———. *The Dead Lecturer*. New York: Grove Press, 1964.
Ellison, Ralph. *Invisible Man*. New York: Random House, 1952.
Kelly, Robert. *The Mill of Particulars*. Los Angeles: Black Sparrow Press, 1973.
Major, Clarence. *All-Night Visitors*. New York: Olympia Press, 1969.
———. *The Cotton Club*. Detroit: Broadside Press, 1972.
 . *The Dark and Feeling: Black American Writers and Their Work*. New York: Third Press, 1974.
———. *Private Line*. London: Paul Breman, 1971.
———. *Swallow the Lake*. Middletown, Conn.: Wesleyan University Press, 1970.
———. *Symptoms and Madness*. New York: Corinth Books, 1971.
Olson, Charles. *Reading at Berkeley*. San Francisco: Coyote, 1966.

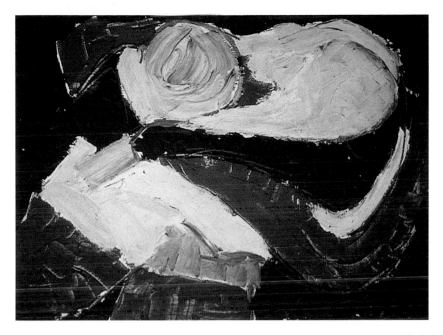

The Embrace. 1976–78.
Acrylic on canvas, 24 ×
32 inches. © 1976–78
by Clarence Major.

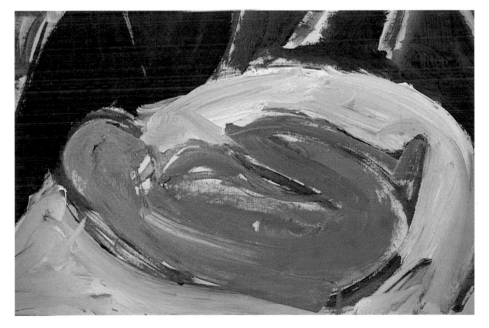

Grief (detail). 1976.
Acrylic on canvas,
24 × 32 inches. © 1976
by Clarence Major.

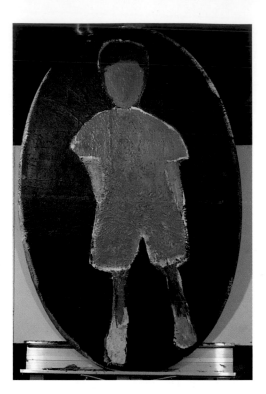

Self Portrait. 1974–76.
Acrylic on canvas, 25 ×
39 inches. © 1974–76
by Clarence Major.

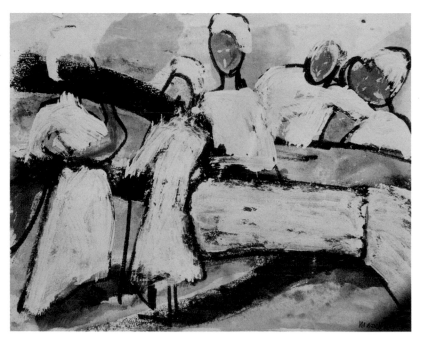

Five Figures. 1984.
Acrylic on paper,
11 × 14 inches. © 1984
by Clarence Major.

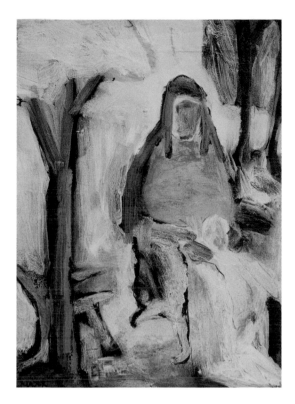

Woman with Child,
1972. Acrylic and ink
on canvas paper, 12 ×
16 inches. © 1972 by
Clarence Major.

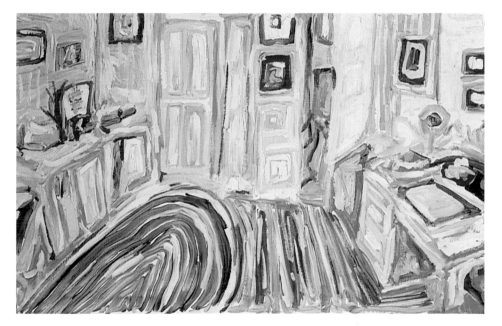

My Room. 1976.
Acrylic on canvas,
24 × 32 inches. © 1976
by Clarence Major.

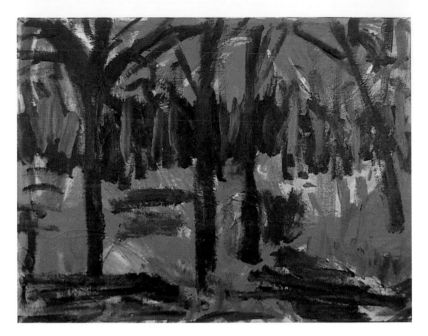

Trees. 1977.
Acrylic on canvas,
18 × 14 inches. © 1977
by Clarence Major.

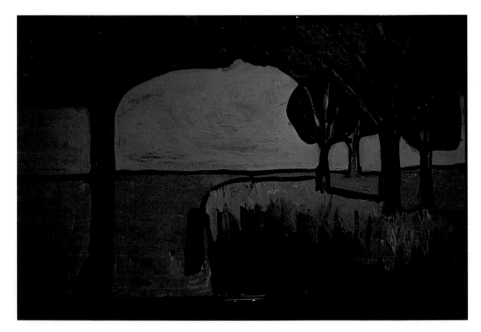

Five Trees. 1977.
Acrylic on canvas,
18 × 20 inches. © 1977
by Clarence Major.

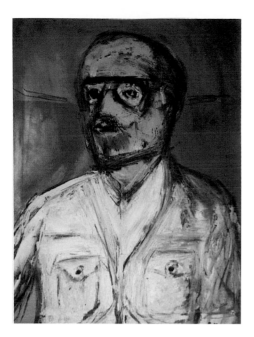

Night Watchman.
1986. Acrylic and
pastel on canvas,
32 × 24 inches. © 1986
by Clarence Major.

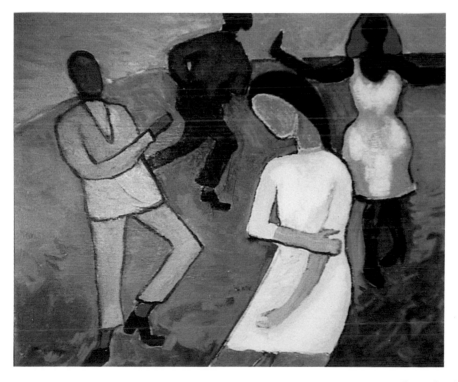

Country Boogie. 1993.
Acrylic on canvas,
26 × 32 inches. © 1993
by Clarence Major.

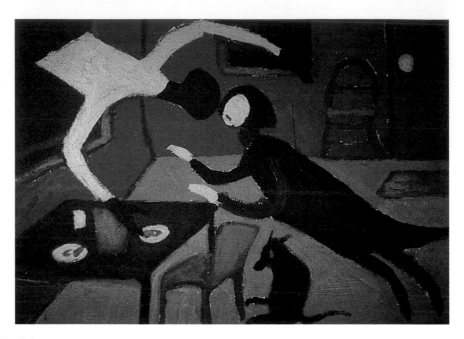

Love at First Sight. 1976.
Tempera on paper,
15 × 20 inches. © 1976
by Clarence Major.

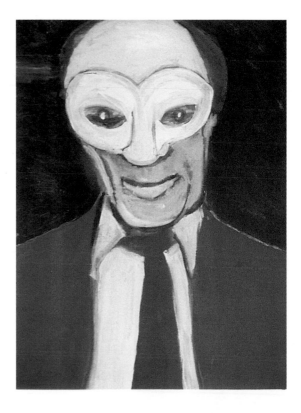

Party. 1973.
Acrylic on canvas,
18 × 24 inches. © 1973
by Clarence Major.

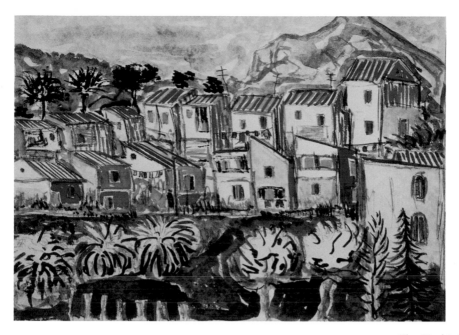

View: Hotel Raito. 1985.
Watercolor and ink, 11¾
× 15⅜ inches. © 1985 by
Clarence Major.

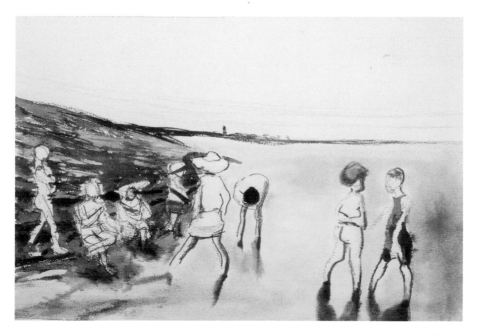

Eight Children. 1985.
Watercolor, 13⅛ × 19¼
inches. © 1985 by
Clarence Major.

Knitting on the Porch
(detail). 1973. Mixed
media on paper, 19½ ×
29½ inches. © 1973 by
Clarence Major.

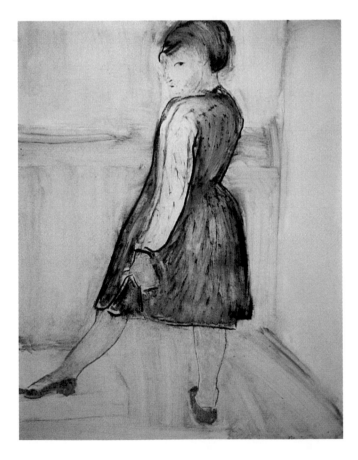

Pose. 1993.
Mixed media on paper,
24 × 30 inches. © 1993
by Clarence Major.

Clarence Major's Innovative Fiction

JEROME KLINKOWITZ

"In a novel," Clarence Major told interviewer John O'Brien, "the only thing you really have is words. You begin with words, and you end with words. The content exists in our minds. I don't think it has to be a reflection of anything" (O'Brien 130). With this statement Major separated himself from the dominantly realistic tradition of both commercial publishing and the academic canon and identified his work with the disruptively experimental style being explored by writers emerging in the 1960s and flourishing in the 1970s and 80s. Whether crafted by Clarence Major and Ishmael Reed or by Ronald Sukenick and Donald Barthelme, such antirealistic (and even anti-mimetic) fiction has been distinguished by its polemical opposition to the established principles of literary form. These finished novels and short stories are by no means imitations of an action or reflections of the world; instead, works such as *Emergency Exit* and *My Amputations* are additions to the world, real things in themselves to be admired for what they are, not as transparent windows to or representations of some preexisting reality.

That fiction should not be offering a representation marks a change in its historical development, a change Major sees as necessitated by social and technological forces that have made life and our tools for recording it so different from conditions in previous times. Television can give us the news, innovative fictionists argue; novels and short stories can better express our response to the news. And so as the camera's invention prompted painters to experiment with increasingly radical forms of abstraction, our current saturation with television news, print journalism, popular history, and autobiography have challenged fiction writers to find a new way of producing their work. The result has been a transformation of subject matter from a topic of fiction to a record of the writer's activity, a process Roland Barthes has described as restructuring the infinitive "to write" as an intransitive verb (Barthes 11). Elements of the real are certainly present in such writing, but under no illusion that they are the work's point. Instead, Clarence Major reminds his readers at every stage how he is using these materials to create a fiction. There is no suspension of disbelief. Quite the contrary: the reader is often asked to help create the work, making his or her reaction an important part of the story.

For all of its abstractness, there is a strongly personal cast to Major's fiction. Part of his anti-illusionistic strategy is to deal with these elements honestly, to use the energy and excitement of his reaction to these events as

Originally appeared in *African American Review* 28, no. 1 (Spring 1994): 57–63. © 1994 by Jerome Klinkowitz. Reprinted by permission.

the substance of his narratives. Although raised in Chicago (on the mid–South Side), his occasional visits to his Georgia birthplace and an especially memorable summer spent there supply the emotional background for both early and recent novels. The Chicago streets are present in his first novel, *All-Night Visitors* (1969), as are the New York City environs Major expressed as a young professional. His early aptitude for art, which led to a brief fellowship at the Art Institute of Chicago following high school, shows itself in the lyrically expressive style of *Reflex and Bone Structure* (1975) and especially in *Emergency Exit* (1979), which includes the author's paintings as integral factors in the narrative. Widely traveled as a visiting professor and writer-in-residence, Clarence Major has drawn upon his European experiences for the structure and fabric (and not just topicality) of his equally ambitious novel, *My Amputations* (1986); his own self-portrait graces the cover, a painting of the painter at work on the picture we see. Not in the least metafictive, this disposition to use one's own energy of life is part of a larger, sometimes submerged current in American literature that reached from Whitman and Toomer to William Carlos Williams, Henry Miller, Charles Olson, Frank O'Hara, and Amiri Baraka (notably in Baraka's early fiction written as LeRoi Jones). The strongest element of person in Major's work is the self-conscious act of creation. The writing of each novel is its ultimate subject—not metafictively, in which the writing reflects itself, but as the record of the writer at work. This record, like the evident pattern of Jackson Pollock's gestures in one of his action paintings, is the most personal part of Clarence Major's life to be shared.

The resulting fiction is brashly self-apparent, and this proud assertive spirit translates itself into the character of Eli Bolton, Major's first protagonist. As the narrator of *All-Night Visitors*, Eli does a good job of reconnecting art with experience, experience being something quite apart from historical reality. "History" and "reality" are, after all, ideas, and neither sums up what Eli Bolton feels he is: "I am not a concept in your mind, whoever you are" (4). The way he expresses himself is equally brash: "My dick is my life, it has to be. Cathy won't ever come back. I've stopped thinking about the possibility. Eunice has of course gone away to Harvard, and I'm taking it in stride. My black ramrod *is* me, any man's rod *is* himself" (4). As in the novels of Henry Miller, the self-creative is sometimes the procreative, and the hero marks his path through life by means of his seductions and seizures. Above all, Eli refuses to be categorized; against a tradition of socially relevant and all too predictable characters, he reminds us that "whatever I happen to be doing, I am not *your idea* of anything" (5). Everything he encounters is expressed in a corporeal way: violence on the street, the bloody display of a slaughter operation at the stockyards, and especially sexual encounters (a fellatio episode, for example, runs twelve pages). At

times the violent description becomes so intense that it is difficult to identify geography, as urban Chicago blends with combat in Vietnam. *All-Night Visitors* discards coherent plot and measurable chronology as well; it is instead an emotionally expressive record of its protagonist's imagination. Major's page is an area for this mind's action, as attention flies from Chicago to Southeast Asia to New York City and beyond.

If the novel has a structure, it would be the series of encounters with various women characters. Tammy, Cathy, Eunice, Anita, Clara, Hilda, and once again Tammy: the names blur into one collective personality, the woman perceived as Other, as Eli's sexuality reduces their individual identities (teenage runaway, middle-class careerist, prostitute) into a primal sense of woman-as-object. Not to say that the protagonist isn't determined by their sexuality himself: the novel's central focus is Cathy's decision to leave and how Eli is panicked to the point of killing her to keep her with him. Every moment is an intense one, experienced as it is in such a writerly way where even the most mundane scene is liable to explode into expression at the outer limits of control:

> As the old man comes toward us, the evil in his encroached face causes him to suddenly blow up with the kind of force behind an earthquake. The vastly immodest sound, the liquids of his body, the spermy-substance of his brains shoot out, his eyeballs, rebellious question marks, hang down suspended on long slimy patheticus strings from his sockets; Eunice's hand, inside mine, tightens; "Oh, damn—look at that! That poor man—He's having a heart attack!" The gooey stuff splashes in nearby plates of food, customers jump back in their chairs, an old woman with a bust as big as a bathtub drops her monocle, falls over backwards in her chair, her floor-length gown flying over her head, her broom-stick size legs, juggling frantically for some balance, her rich, pink Playtex girdle is even drenched with the juices from the explosion—I wonder why some of the folks are beginning to hold their noses: then it hits me, the odor of the substance from the waiter's skull smells like shit. He is a lump of slimy flesh and starched garments, on the floor. Eunice is pulling at my sleeve: "Please, let's go, I'm getting sick. I can't eat here." Eunice, even before we reach the street, is gagging. (43)

Like a jazz musician piling chorus after chorus of improvisation upon a basic chord structure and melody, Major has taken the simple scene of a waiter's hostility and pushed the writing of it as far as he can, with detail after egregious detail and each piece of action striving to outdo the last. As action writing, it is more expressive than expositional. And it is the sum of this expressive energy that constitutes the novel.

The tempo of street life and the urging potency of young manhood create

the expressive style of *All-Night Visitors*. *NO* (1973), Clarence Major's second novel, draws upon entirely different types of feeling: the sentimentality of a youth's first remembered years, and the somnolent ease of a Georgia summer (contrasted to the harsher and faster world up North). The story takes place as two voices—one in conventional print, the other in smaller, indented quotes—pass the action back and forth. Expression, reflection; action, reaction; activity, memory—these two sides to every question expand the novel's emotional scope and give it the characteristics of immediacy and recollection combined. Sexuality is again an interest, but here as perceived by young children, who never get a clear picture but whose imaginations are all the more empowered to fill in the gaps with marvelous invention. The narrator is a budding Eli Bolton:

> I have a weak bladder and I consciously long to overthrow all my Christian hangups! to be equipped with the blessings of no inner pressure ebbing my spirit and psyche, and ultimately to strip naked, body *and* mind, and stroll casually out into wider and wider circles until I cover the world with the beauty of what I have discovered. (22)

Yet before this can happen, there is youth and adolescence to go through, watching the habits of others and developing an approach to the world and its values. Perception is all, short only of finding the proper words for things. Slavery in the past and racial discrimination in the present, for example, are characterized by language from the penal code. When someone dies, it is an occasion for irony: "They brought him back to the house in a casket and he was puffed up and without color but in a black suit he looked for the first time like somebody important and now it was too late to look that way" (121). As in any work of memory, time is a relative matter, and in *NO* the temporal is something that "took up space just happening" (122).

The novel's central event is shocking: a father murders his family and himself because "I ain't going to see you suffer no more" (138). *NO* makes it clear that this is the character's only possible act of freedom in a world that created him according to its own perceptions and prejudices. The narrative ends with its young protagonist having grown up and headed north, yet still seeking an identity: through lovers, work, and these very meditations that form the novel we now read.

Reflex and Bone Structure, Major's third novel, is a perfectly executed example of a narrative whose subject is its own creation and whose making takes place at virtually every point of action. To translate this effect into a manageable story, the author projects a narrator grieving over the loss of his lover—a situation familiar from *All-Night Visitors* and *NO* but which in *Reflex and Bone Structure* becomes a central obsession that generates the

novel itself. The first scene is a party where the guests appear as barnyard characters, an indication that subjective perception lies at the heart of the story. Later that night, as the narrator and his lover, Cora, return home, subjectivity is once again the creative essence of what happens:

> We're in bed watching the late movie. It's 1938. *A Slight Case of Murder*. Edward G. Robinson and Jane Bryan.
>
> I go into the bathroom to pee. Finished, I look at my aging face. Little Caesar. I wink at him in the mirror. He winks back.
>
> I'm back in bed. The late show comes on. It's 1923. *The Bright Shawl*. Dorothy Gish, Mary Astor. I'm taking Mary Astor home in a taxi. Dorothy Gish is jealous. (3)

These episodes at the novel's start are instructive: the imagination, especially when aided by a transformative device such as television or old movies, effectively changes reality from the present to the past. Moreover, as within the privacy of one's home (or even of one's bed) the viewer, necessarily a voyeur, can project himself or herself into the action and become a part of it. A metafictive technique? Only to the extent that film itself is metafictive. Yet the technique is accessible to any audience, all of whom can be transported into the alternative realities *Reflex and Bone Structure* will create.

When Cora leaves the narrator's projected world, however, the issue becomes traumatic. Challenged by this affront to his ideal identity, he tries at the same time to tell what happened plus restore conditions to his own liking. Cora as a lost love becomes the focal point in a triangular relationship among her three lovers: Canada, Dale, and the speaker. There is never any doubt who is in control:

> I'll make up everything from now on. If I want a commercial airline to crash with Cora and Dale doing it in the dark, I'll do that. Or have them go down at sea in a steamer caught in a violent typhoon near Iceland, or in an exploration vessel off the West Indies. I'll do anything I like. I'm extending reality, not retelling it. (49)

Above all, the narrator wishes to remind readers that he is not representing an action, but creating one himself—and that it is therefore in the quality of his own expression that the truth of his life may be found. Dale, for instance, is a difficult character for him to describe, as he lacks an empathetic understanding and at times feels outright hostility. The created characters are themselves, not distillations of someone else, and are drawn from the world's great intertext:

> Get to this: Cora isn't based on anybody.
>
> Dale isn't anything.

Canada is just something I'm busy making up.

I am only an act of my own imagination. I cannot even hear my own voice the way they hear it. I got the "Bullfrog Blues."

Cora does the "Charleston Rag."

Dale sings "Hello Dolly."

Canada covers the waterfront. (85)

The novel thus exists as a fully created work of the imagination, drawing its justification not from any fidelity to the outside world but rather from the expressive energy it transmits from the emotionally generative side of human existence. Its author writes it this way, and the characters so behave: adopting identities from jazz records they play and mystery films they watch on television, existing as orchestrations of their author's most personal impulses.

With *Emergency Exit* Clarence Major confronts the most serious objections to such a style of fiction: that while art and music can indeed achieve fully abstract expression, the novel faces the limitation of having to take its shape from necessarily referential words. Major's answer is found in a useful structural device. Written in a way that emphasizes its components, *Emergency Exit* is first of all a novel of sentences: dozens of them appear with no communicative intent, instead just lodging themselves in the reader's consciousness for use later. Then come component paragraphs, vignettes, and finally self-contained stories. This arrangement is repeated throughout the book, until eventually a narrative line develops that incorporates words and phrases from the initially abstract sentences. At this point, the reader's role takes over, for instead of using the words as signifiers for a reality already existing in the world, the impulse is to think back to the originally disconnected sentences in *Emergency Exit*. In this manner attention is being drawn inward, toward the novel being made, rather than outward to a world in representation. *Emergency Exit* is therefore its own reality, one the reader helps construct with each constituent part.

The story thus construed is a simple one: Al, a ghetto kid, is in love with a rich and pampered young woman, Julie. Her parents have made the journey from Al's world to riches, so certain tensions are evident. Julie's father is having an affair, while her mother expresses certain interests in Al himself. Siblings get involved, as do friends. Meanwhile, the whole life of Inlet, Connecticut, goes on about them, including a curious "threshold law" taken straight from cultural anthropology yet applied without irony to this contemporary American situation. The love story emerges from these qualifying circumstances, which include an attention to the language that records reality (or perhaps creates it) and the tribal practices overseeing the characters' behavior. Throughout, Major as author practices a rigorous de-

tachment, as the anthropologist must: at one point a game of tennis is recorded in terms of court positions and the relative sounds of the ball being hit. Forecourt or back, hard smash or lob: each person's typical behavior is encoded by their game plan, which the novelist dutifully records and thereby reminds readers how "characteristic" are the elements of character.

Although his work espouses an abstract style of expression, Clarence Major refuses to believe that he has ignored social problems. His counterargument is that his own type of fiction is more effective at changing lives than is the more conventional realism preferred in aesthetically conservative circles. In his collection of literary essays, *The Dark and Feeling* (1974), he argues that "[t]he novel *not* deliberately aimed at bringing about human freedom for black people has liberated as many minds as has the propaganda tract, if not more," the understanding being that imaginative and spiritual freedom precede social liberation (25). And in a more recent essay, "Necessary Distance: Afterthoughts on Becoming a Writer" (1989), he explains how not just African American music (including jazz and blues) has influenced the rhythms of his prose, but how *all* the music he's listened to has, from Tin Pan Alley material to European classical, even further liberating his language from restrictions of the dictionary and the page (208–9).

Major's novels of the 1980s—*My Amputations* (1986), *Such Was the Season* (1987), and *Painted Turtle* (1988)—take the energies of his abstract expressionism and apply them to more apparently referential materials. In *My Amputations*, it's the world of European terrorists and expatriation in which an author with a background virtually identical to Major's has that identity seized by an imposter and set loose in the world while he himself languishes in prison. Having to recapture his reputation (and himself) forces this protagonist to face the previously unbearable (and therefore avoided) polarities between church and state, spirit and body, mentality and sexuality, and eventually "clean" and "dirty." It is in the middle ground of separation that he has been caught, and to fight his way out he must contend with political forces of both restrictive nationalism and uninhibited insurgency, providing in the process a fairly accurate road map of personal politics in our time. Significantly, this initial return to the conditions of Western Europe leads in the end to a tribal sense of unity in Africa—precolonial and hence prepolitical—where the separations so vexing to the protagonist do not exist.

From here Major can direct his talents towards something as typically realistic as the family saga. *Such Was the Season* takes a nephew from Chicago to the Atlanta home of an old aunt who helped raise him, but the result is anything but mimetic. Instead, the full range of African American culture is explored, from the "bourgie" society to ethnic power politics. In the hands of Major's first female narrator, the elderly aunt herself, the story

becomes a study in language rather than social action, for the emphasis is not on the events but on her manner of weaving them into a narrative she feels comfortable with and can believe, which is of course the role Clarence Major's sexually expressive protagonists took in his earliest fiction.

Painted Turtle: Woman with Guitar is a similar narrative told from an over-the-shoulder point of view of a young native American woman who struggles for expression through her folksinging in the often hostile world of Southwest cantinas and bars. The episodic adventures surrounding her work are just the superficial part of her story; at the heart of her expression is her poetry, passages of which are reproduced as transcriptions of her songs. Like Aunt Eliza's constructions in *Such Was the Season*, those of young Painted Turtle do not so much reflect a world as build one:

> Not long after Painted Turtle adjusted to the mensus's rhythm of twenty-eight days. Unseen Hands came and shot an arrow in to her back.
> I swear, rather than pain she felt a burst of joy. . . .
> Like a bird that doesn't know it can't swim, Painted Turtle dives into the lake for fish. When She brings it up, it's a song. She sings it:
> My shell is tough
> I shall be tough
> Tough as my shell! (34–35)

Hers is a self-creating lyricism that motivates Major's recent short fiction as well, from the stories of *Fun and Games* (1990) to the disarmingly straightforward "Summer Love" in the Spring 1992 issue of *Boulevard*. Beneath all such expression is a generating sense of the self at work; constructing a world that is the evidence of its component parts allows readers the chance to participate in living the life of fiction, Major's idea of the most practical reality one can find.

Clarence Major's achievement, then, has been to show just how concretely we live within the imagination—how our lives are shaped by language and how by a simple act of self-awareness we can seize control of the world and reshape it to our liking and benefit. In *Reflex and Bone Structure* his narrator has suffered a grievous loss; from it comes the brilliance of creative genius but also the satisfaction of remaking the world in a supremely honest way:

> I am standing behind Cora. She is wearing a thin black nightgown. The backs of her legs are lovely. I love her. The word standing allows me to watch like this. The word nightgown is what she is wearing. The nightgown itself is in her drawer with her panties. The word Cora is wearing the word nightgown. I watch the sentence: The backs of her legs are lovely. (74)

WORKS CITED

Barthes, Roland. *The Rustle of Language*. New York: Hill and Wang, 1986.

Major, Clarence. *All-Night Visitors*. New York: Olympia Press, 1969.

——. *The Dark and Feeling: Black American Writers and Their Work*. New York: Third Press, 1974.

——. *Emergency Exit*. New York: Fiction Collective, 1979.

——. *Fun and Games: Short Fictions*. Duluth: Holy Cow! Press, 1990.

——. *My Amputations*. New York: Fiction Collective, 1986.

——. "Necessary Distance: Afterthoughts on Becoming a Writer." *Black American Literature Forum* 23, no. 2 (Summer 1989): 197–212.

——. *NO*. New York: Emerson Hall, 1973.

——. *Painted Turtle: Woman with Guitar*. Los Angeles: Sun and Moon Press, 1988.

——. *Reflex and Bone Structure*. New York: Fiction Collective, 1975.

——. *Such Was the Season*. San Francisco: Mercury House, 1987.

——. "Summer Love." *Boulevard* 7, no. 1 (Spring 1992): 148–59.

O'Brien, John. *Interviews with Black Writers*. New York: Liveright, 1973.

The Double Vision of Clarence Major

Painter and Writer

LISA C. RONEY

If double consciousness is a factor in the fiction of African Americans, then it makes sense that it would be all the more so in their practice of the visual arts. While the writing of African Americans is "difficult, working in English, a language with a white 'personality,'" at least African traditions of storytelling survived in the slave colonies and evolved into the strong, rich African American modes of vernacular speech, tales, and lyrics (Major, *Dark and Feeling* 26). Unfortunately, this was not true to the same extent for African traditions of visual expression. Although some examples of African-influenced carvings, pottery, basketry, and ironwork are extant from the period, "the surviving visual art tradition was 'generic, simple, and (almost completely) restricted to areas of dense and recent contact with tropical Africa'" (Thompson, quoted in Fine 17).

The Harlem Renaissance of the 1920s provided a modern alternative for those seeking a uniquely African American perspective in all the arts, but it was primarily a literary and musical phenomenon. It produced muralist Aaron Douglas, and the 1930s and 1940s introduced now well-known painters such as Jacob Lawrence, the brothers Beauford and Joseph Delaney, Archibald Motley, Lois Mailou Jones, and Hale Woodruff, but their works were not widely exhibited until years later. So, when a young African American of the 1940s and 1950s, being educated in the Eurocentric tradition, found himself interested in line, color, composition, texture, light, and the allure of gessoed canvas and creamy paper, sable brushes and viscid paints, he had few directions in which to grow other than along the trellis of Western art.

Clarence Major was gifted, as his early experiences with both words and paints make clear, and he was endowed with a drive to become an artist. But his consciousness was split by the nature of being an American of African descent, in an ambivalent political relationship to the Western cultural heritage that he was beginning to love, especially as a painter. My analysis of Major's paintings and his fiction (*Emergency Exit*, *My Amputations*, *Such Was the Season*, and *Fun and Games*), demonstrates that his career as a writer is due, at least in part, to this early splitting of consciousness in the area of his first passion, painting. For years Major deferred, almost even denied, his passion for painting, a passion whose nature—more obviously Eurocentric and less practical than that of his writing—threatened to alienate him from his African American community ("Necessary Distance" 202–

Originally appeared in *African American Review* 28, no. 1 (Spring 1994): 65–75. © 1994 by Lisa Roney. Reprinted by permission.

5). In a sense, he went underground with his painting and got into the habit of *seeing* through his writing, which was easier to conceal. The painting, however, remained a motive force in his literary work. Major's questions about his own identity as an African American and his relationship to the African American community seem to have led him to become a man of double vision, searching for a colorful, but color-blind existence, both through the visual image and the written word.

Major remembers "being the kind of kid that just gravitated toward visual expression," and he says that painting came "more naturally" to him than writing. He still recalls being entranced by a kindergarten assignment to draw a "big, red apple," which he took home and proudly showed to his mother (Major, Telephone interview [TI]). By the time he was twelve, Major's paintings were spilling out of his bedroom into the family's hall. He won "many prizes" in school art contests. One of these awards, granted when he was in high school, provided a scholarship to a program for school-age children at the Art Institute of Chicago, and he stayed with these lessons until he left home to join the air force (Major, "Licking Stamps" 177–79).

It was a formative period for Major, not strictly because of the scholarship program, but because he also met some regular college- and graduate-level Art Institute faculty and students who encouraged him and provided an even greater level of awareness on his part. One of these, graduate student Gus Nall, gave Major private lessons, which he still values today, even though he says that at that time he was "still trying to paint just like van Gogh," whose large exhibit at the Art Institute in the early 1950s had greatly impressed him (Major, TI).

Major found himself answering the "perennial challenge to Afro-American artists," that is, "how to be at once *Black* and *artist*, Afro-American and American, Afrocentric and idiosyncratic" (Yearwood 138). At first, it didn't even occur to him to search for an identity particularly as an African American artist; he considered himself, insofar as he did so at all, as part of the mainstream and worried because he "didn't want to be an Abstract Expressionist" or to work in other "popular modes" (TI). But he had an awareness that on the South Side of Chicago "[n]o self-respecting grown man spent ten years painting pictures he couldn't sell," and during the late 1960s he understood that a large part of the problem was the result of racism ("Necessary Distance" 204). He went on record saying that the "black poet . . . must chop away at the white criterion and destroy its hold on his black mind because seeing the world through white eyes from a black soul causes death" (*Dark and Feeling* 147). During this period Major moved away from painting, but he was soon engaged in it again and was highly influenced by discussions such as the one he had with painter Jacob Lawrence for the

Black Scholar in 1977. Lawrence pointed out the "definite style and tradition" visible in "Japanese, Chinese, Indian, and African art," which, he said, he couldn't see in African American art: "[W]e have all sorts of backgrounds and training. . . . We are in a Western culture. . . . Few of us have had an African experience. . . . To try to work like the African, the black American artist becomes pseudo something" (17–18).

By the 1970s similar ideas were already gelling for Major in the literary vein, as he garnered a reputation for his experimental works of fiction—*All-Night Visitors* (1969), *NO* (1973), and *Reflex and Bone Structure* (1975)— which move "beyond racial and political consciousness to a preoccupation with exploring the boundaries of language and imaginative consciousness" (Bell 316). These novels, having more in common with Euro-American and European postmodern concerns than the works of most other African American writers, had little appeal to most African American readers (Bell 319–20). By the mid-seventies, Major had joined the mostly white Fiction Collective, which would publish his next three novels.

It was during the seventies that Major broke through what he felt were constraints constantly being thrown in front of him by external sources, in both his literary and visual arts endeavors. At one point he had spoken disparagingly of his painting, indicating "that he had neither the conceptual nor the rendering skills possessed by many others at the Institute"—even though he always continued to draw (Weixlmann 153). "I wasn't having luck or success then," Major recalls, "and I wondered all the time about what I was doing." Ironically, he didn't feel good about his writing at the time either because, he says, the two are interrelated and "both tend to go well at the same times" (TI). His visual work, however, has always remained subsumed in his literary reputation in spite of the fact that a large part of his verbal search involves the extremely problematic identity of an African American whose painterly vision is akin to European traditions.

In 1979, with the publication of *Emergency Exit*, Major declared his double identity as a visual artist and writer by including twenty-six black-and-white reproductions of his own paintings. The paintings, he has emphasized, do not function as illustrations—they do not depict particular scenes or even characters in the text—but as extensions of the narrative action, *additions* to the text.

"I didn't paint them with the intention of putting them in the novel," Major explains, "although I was working on them at the same time." Early in the process of writing the novel, he thought of including the paintings because they seemed to fit well with the open-ended, fragmentary nature of the prose. "The novel itself is composed like a group of paintings," Major says, "and the paintings and prose just seemed to begin speaking to each other" (TI). The short fragments in which the novel is written, and which

include a variety of written forms—including names from a telephone book, quotations from dictionaries and other sources, newspaperlike narrow columns, numbered lists of questions, and a bird shape formed out of words—was conducive to further variation. Along with the labor of cutting one-third of the original text, Major meticulously selected locations for the paintings.

While Major acknowledges that some of the combinations are more effective than others, the juxtapositions of text and painting in *Emergency Exit* are for the most part strangely moving. The vigorous brushwork, tormented shapes, and highly contrasted values lend to the abstracted figures and landscapes the same jagged energy found in the prose, the same tense questioning of the relationships between people. Faceless male and female figures pose in a standoff, their bodies estranged and hostile, providing a disturbing tangibility to the dialogue that precedes the painting: "I'm sick of this! I want a divorce!" (153). "The African in search of the mysterious substance called Black Humor" has difficulty finding it, but he leads us to a painting in which two dark, lyrical figures dance in a giddy, every-which-way gesture that seems to ensure their survival, "like the trickster rabbit taught in Black Literature classes" (190). An inverted male figure with a leering pale face hangs suspended above the bottom edge of the canvas, while another male figure, with a darker face, turns away from the picture plane, hands behind his back in what seems an embarrassed wish for escape. Once again the figures are alienated, disconnected—this time by the racial misunderstanding that is reflected in passages on either side of the painting (116).

But there are figures in the novel that do connect, sometimes gently, sometimes violently, sometimes a little bit of both. In the painting on page 87, for instance, what seems to be a group of four people huddle together in the center of the canvas in a desperate circle of swirling, heavy paint. It is sandwiched between the program for "THE ANNUAL DOOR AND THRESHOLD CONFERENCE . . . on the Problem of Emergencies," which looks to be pretty absurd, and a section of brief vignettes whose threatening elements disturb the otherwise ordinary scenes of saunas, shopping malls, family hiking trips, the beach, and so forth. The painting shares with the text the sensation that the "trumpets of doom are heard constantly down the hall" and the "clouds move swiftly overhead" (90). Inwardly, we huddle with the group in the painting.

Even in the text of *Emergency Exit*, Major links his quest for identity and community with his combined calling as writer and painter. Not only does he frequently mention painters like van Gogh and Goya, and develop characters who draw and paint, the narrator connects them in the text itself, in some places with direct statements like "This person that is me is reaching

out in contradictions. I want to paint my way out of this. Write my way out" (7). At other times, the reference is more oblique, as when Al is offended at the idea of the wealthy and relatively pale African American Ingram family cavorting around Africa, and then goes on: "Africa might be a place you could dig after all even after Tarzan and white lies. Little white lies. Hello white lies. White lies uneasily on the canvas" (18).

In the preceding passage, Major uses one of his classic moves: he invests color with an unusual (and changing) presence. "I sleep and wake in the blackness," and the blackness becomes simultaneously the narrator's life and, he says, his own skin, the night, the grimness of twentieth-century existence, and the many shifting forms of the color itself in the form of pigment (15). This effect is not limited to black and white, and in *Emergency Exit* colors appear and reappear in shifting multiple layers of meaning. The light changes in a room, creating a blend of pastel colors (80), and the grass on the hillsides is "sometimes burned red brown black" (109). In addition, "[t]his thing that moves beneath the surface changes color—once when it got stuck between two rocks the water all around it turned red, a fantastic red you have never seen. It amazes me" (71). In other words, colors in Clarence Major's text change and blend, indicating what is perhaps a natural combination of color obsessions in one who is made constantly aware by both his African American roots and his training as a visual artist.

What, the book asks, constitutes color? What happens if you reproduce fully colorful paintings in black and white? Where and for whom is "blackness" defined—on the surface of the skin or in culture? In *Emergency Exit*, these questions seem to me as important, if not as obvious, as the postmodern fragmentation and polyvocalism, and attention to them results in the heightening of powerful racial themes. In a crucial scene, when Al has been shot at by a white man, he says to Julie: "You can't believe it because you're too white yourself. And the minute he said it he knew it was the beginning of their separation" (120). The division between colors—and cultures—has suddenly become painfully distinct.

Shortly after the publication of *Emergency Exit*, Major met and married Pamela Ritter, and from 1980 to 1985 the two of them sailed through a stream of cities, states, and countries, living in Boulder, Amherst, Nice, San Diego, Venice, and Paris. Major also traveled extensively in Europe, Africa, and the American South and Southwest, but in spite of the hectic pace, his new marriage and his overseas experiences satisfied and steadied him. In just over a year in Nice (1981–82), Major started and virtually completed *My Amputations*, even though the frenetic schedule of Mason Ellis's lecture tour grew directly out of Major's own experiences in Europe. Major and character Ellis both hearken back to an earlier expatriate:

I . . . left America because I lost faith in her and in her power to redeem and save our lives. Tormented racially as I was, in search of sanity, I went to Ghana. . . . I was in what might be called therapeutic exile, looking for new insight, a new definition of emotional freedom . . . , a new psychology and sense of history. (Lacy, quoted in Gay and Baber 61)

Indeed, it was an extremely productive and liberating time for Major. Between the fall of 1981 and his return to the United States in the fall of 1984, he wrote three novels, two volumes of poetry, and painted more than fifty watercolors in 1984 alone. But the sense of history Mason Ellis sought in *My Amputations* was more pervasive, more complex than average.

If *Emergency Exit* is where Clarence Major declares himself a painter in the most visual way, *My Amputations* is where he develops the reflections of it in the text into an obsession. This novel, wrapped up like the previous one in questions of identity, goes beyond mentioning a few painters to parade a panoply of painterly, sculptural, and architectural referents across its pages (see Klawans). In *My Amputations* the concern with conflicting identities reaches an apex. The rivalries of writer versus painter, street guy versus respectable professor, polite academician versus radical artist, African American versus white American values, and African versus European artistic traditions all clamor and overlap in a hissing and twisted form. In Major's own words, albeit taken from another context, the storyline is like "a Francis Bacon figure in a bleak landscape: half-formed, trapped—deformed" (*My Amputations* 203). The meaning of being an African American artist is at the heart of sorting it all out.

And Major's texts and paintings do begin to sort these issues out along parallel tracks. During the early seventies, Major had painted mostly figurative abstractions. Like the ones that appeared in *Emergency Exit*, they were characterized by angular shapes, sweeping gestures, and swirling or slashing brushstrokes. The colors were somber and highly contrasted—a range of browns, pale beiges and lurid ochres, blood reds, blacks, and the occasional muddy blue or turquoise. Human faces were obscured in a variety of ways. Some, as in *Party* (1973), were masked; others, as in *Crowd* (1974) and *Twelve Thirty* (1973), were simply faceless, no matter what their color, and the paintings always depicted multihued groups. *Love at First Sight* (1976) depicts two figures, one clearly "black" and the other "white," reaching toward each other in a ghostly, unfulfilled embrace.

Later in the seventies, Major experimented with further obliteration of the figures in his paintings. With paintings like *Love at First Sight* and *My Office* (1976), his compositions were already becoming destabilized, off-center, and askew from the edges of the field. But Major continued to push at the edges of his vision. Works like *Reorganization* (1978) and a series of

tempera-on-paper Franz Kline–like studies maintained his sombre palette, while the brushstrokes let loose in a frenzy of angry, confused energy.

By the early eighties, this style was evolving, just as Major's prose style was. Perhaps partly because of his mobility during these years, Major painted off and on, and he began working more often in quick-drying pigments like acrylic and watercolor on paper, which was easier to store and transport than canvas and stretchers. He also began more frequently to do more naturalistic work, notably delicate plant studies and watercolor landscapes (the latter especially during his travels in Italy in 1984). *Eight Children* (1985) has a luminous, Piranesi-like feel: soft light floods the children, harmoniously small in the foreground of a wide horizontal span and solidly upright on the background of cool, tranquil watercolor washes. Still, half the children contrast their dark lines against a pale watery background, while the others appear starkly white against the dark green tones of shore. It becomes obvious that human color is a matter of light and context.

Major by no means gave up his vigorous brushwork—a 1984 series of acrylic-on-paper works, for instance, hearkens to his earlier figural abstractions with its saturated colors, heavy black slashes, and sometimes faceless figures. These paintings, of groups of figures wearing turbans, odd hats, and tunics and riding horses, carrying swords, and so forth, were perhaps inspired by the travels during which Major encountered such a wide array of cultures. Unlike the serene landscapes and still lifes of this period, these human abstractions contain the same quick sense of motion and turbulence of Major's earlier work. But the figures are frontal, stable, and seen from eye level (the same is true for the more "realistic" self-portrait which graces the cover of *My Amputations*; see Klawans). In some of these paintings the figures even have rudimentary faces, as though the blurring element of Major's double vision might be clearing. In *Five Figures*, while one face is completely obliterated by a heavy black diagonal, another shows simple eyes and nose or mouth. *Seven Figures* depicts what appears as some kind of dance or ritual greeting, four of the group creating a pattern of curves with their arms raised in the air. The faces here are slightly grotesque and masklike, painted as they are in thick white on top of black outlines, but they have clearly identifiable eyes, noses, and mouths. It is as though Major sees in a variety of cultures similar questions about community and how that is and is not determined by surface-level qualities like habits of dress and masks of skin.

Once a reader gets the hang of it, *My Amputations* provides much more narrative coherence than *Emergency Exit* and also brings the question of painterly identity more directly into the text. The first part of the novel, up to the point when Mason departs for his European tour, seems concerned more with sexual identity and the conflict between ghetto values and artistic

ambition, although one recalcitrant African American student introduces early on the question, " 'How come your muse had an Irish name and not an African?' " (*My Amputations* 63).

But looking to Africa doesn't provide satisfactory answers for Mason. While riding in the taxi from National Airport to College Park, Maryland, for a lecture, Mason "imagined he was in Africa, in a big industrial city: the faces along the sidewalks and at intersections . . . were saffron nutmeg black ivory with an occasionally pink or ivory white" (57), a longing description that could be of one of Major's early figure paintings like *Crowd*, where skin colors vary and merge. When he actually gets there, however, Mason finds that "Ivory Coast was a shock: as he was driven into the city Mason felt as though he was in some modern European metropolis: massive traffic jams, skyscrapers, the whole bit" (190). The locales, the cultural connections, the emotions invert themselves, just as the locus of Mason's (and by association, Major's) sense of identity shifts between the Eurocentric and the Afrocentric.

Mason's tour overseas, from page 80 on, is a series of interrogations of artistic and cultural artifacts, and indeed of the people of the cultures encountered. But the emphasis here is heavily on what these cultures offer Mason as an artist: even though his character poses as a well-known author, it is with the great works of visual art that he is most concerned. He walks "peacefully under the shelter" of trees in Cézanne's garden (90), finds the people in Germany "as stunned and stiff as figures in an Ernst Fritsch or a Cesar Klein" (110), and watches the horses in Italy as they "side-stepped the fire with the heavy grace of Degas ballet dancers dislocated in Bartolomeo's *Assumption of the Virgin*" (134). In Athens he spends a long morning at the National Museum, querying the ancient statues of Hygieia, Kikon, Aphrodite, and even Blackface Hermes, but gets little yield. He almost weeps at the sight of a portrait with "lovely African lust linger[ing] beneath its intentions" (135), but with his Irish-named muse, Celt, Mason doesn't fit in once he gets to Africa; it is not home for him, and his main referents while there remain Matisse, Glackens, Pollack, de Kooning, and his own Celt, "bright as a Veronese Venus" (187). Mason, who is welcomed "home" in Ghana, doesn't even recognize the "strange red fruit" that is offered to him there (182). He finds in Africa no more or fewer resonances than in Europe, with the paintings in the Louvre, the room where van Gogh died, the beach at Nice where Mason forgets he's a foreigner in the mix of multihued bodies (100). His "homecoming" has not been what he hoped for in the back of his mind; it does not offer a full-blown, fully *his*, artistic tradition to take the place of the European one, and the character, like the author, must continue to juggle the disparate elements of the Western and the African.

This lack of purity, or a single way of looking at things—in culture, color,

intention, and morality—emerges as one of the themes of much of Major's work, both visual and verbal, and is strongly present in *My Amputations*: "He got up, went to the typewriter, sat, but only gazed out the window: sky full of goldfish. No, look again: that's the building across the street. No, I tell you it's a red sunset" (55). The view, like the content of the imagination, is difficult to pin down, to be certain about. Unlike much postmodern litera-ture, however, *My Amputations* doesn't seem to assert there is no reality, but rather that one must constantly seek it amid all the illusion and deception. Setting out on the European tour, Mason examines his face in the hotel-room mirror:

> He hadn't yet focused on his own reflection but was trying to make out the background. . . . Was this Africa with its delightful myths and rites. . . . He was coming to . . . [his] image slowly. Calmly. Mirror mirror. . . . There was so much chaos behind the image! . . . Despite himself Mason saw himself. . . . *This* wasn't Mason Ellis! Who then? What then? The guy in the mirror was more triangular, Mason himself was closer to the arc of a circle—slightly bent from despair and running. The mirror then might be the intersection of two sets. (81–82)

Despite the fact that Mason never with any certainty finds a unified self, he keeps looking and keeps discovering the bits and pieces that have gone into him. He wants to forget his own color but finds he must face it, and his complex heritage, after all. "[T]he separation of body and spirit was going to remain a problem," Mason acknowledges. "Oneness was lost somewhere back there in the ruins" (172).

Such Was the Season (1987) marked a definitive change in Major's fiction style. The smoother, more traditionally coherent narrative account of June-boy's return to Atlanta to visit relatives after years of absence makes perfect sense, however, if seen in light of Major's concerns about identity and its sources. In *My Amputations*, he carried his protagonist to Europe and Africa; in *Painted Turtle: Woman with Guitar* (published in 1988, but written in 1983–84), he spoke in the voice of a Native American; and in *Such Was the Season* he assumed the voice of a black matriarch based on his relatives in Atlanta, where he was born and spent his first twelve years. The novel retains the subjectivity of a first-person narrator and often speaks through dreams, shared stories of past times, flashbacks, and the characters on television shows, who are every bit as "real" as the "real" people of the novel.

Annie Eliza, the novel's narrator, describes the novel's cause celebre, the week-long stay of her nephew Juneboy, a well-educated scientist researching a cure for sickle-cell anemia who has come to lecture at Spelman and Emory. Major has taken the focus off literary and artistic identity and placed it on familial and cultural, but, as in Major's other novels, the mix-

ture is paramount. Even "back home" dinner is full of Cantonese, Middle Eastern, French, and Mediterranean dishes; even back home Annie Eliza is aware that her son lives on a "cul-de-sac," which is a "French word" that means "dead end" (17). Annie Eliza herself, "a plain down-to-earth common sense person" (16), has a wide array of cultural knowledge: "I was looking at the big bandage on his left ear. It looked like that picture of that crazy artist who cut off his ear. You know the one I mean" (158).

It is through Annie Eliza, in fact, that we are granted glimmers of an aesthetic sensibility. In addition to her imaginative relationship with soap opera personalities, she has a keen eye, and she and Juneboy slip into a familiar rhythm over morning coffee, driving through the countryside, and watching birds. Annie Eliza is excited to see yellow-chested warblers, to watch a woodpecker among the chinquopins and toothache trees in the family cemetery (53–58). Juneboy may be beyond her complete understanding, but the novel makes it plain that he springs from her as much as from other sources. Annie Eliza takes Juneboy's complicated speeches and seems to take them back to the basics and to express them in simpler terms. For example, Juneboy goes into a lengthy explanation of his reasons for returning to the South (7–8), but Annie Eliza has already told us that "[m]aybe his homecoming was a way of coming down to earth, finding out bout us, his people" (1). In a similar sense, Major was during this same period refocusing his visual art emphasis, working on straightforward studies of plants, animals, and household objects like lamps and vases. Annie Eliza's voice seems to echo the paintings of this time period: "I use to go out in the garden and cut a bunch of yellow tulips and put them in a tall pretty blue vase. . . . The bright yellow color always made her smile and the blue right close to the yellow did too" (185). It's as though part of the identity, part of the reality, that Clarence Major had been seeking he was finding in the rhythms of everyday objects and people, in family history and the patterns of nature. It's as though he has finally discovered that visual sensitivity, as he has experienced it, stems from his African American heritage as well as from the great European painters. Both his paintbrush and Annie Eliza lead him to that conclusion, and his double vision, once again, takes a unifying focus.

Major writes mostly short pieces—poems, reviews, and so on—during the academic year and does his novel-writing in the summer. Through this process, he is painting, too, typically for shorter periods of time at the end of a day or week of writing. He acknowledges that, as he works, he doesn't try to connect his paintings and writing, but "invariably the same colors keep turning up, the same clothing, settings, objects. My identity finds expression, takes care of itself without any conscious or willful act," and the same concerns show up in both kinds of work (TI). Working on a novel

about a 1940s/50s blues singer who moves from Chicago to Omaha searching for a sense of self through his music, Major couldn't help but notice the similarity in his paintings.

Suddenly, the paintings are no longer slashed with brooding black and brown strokes. Instead, they have taken on a clarity and calm—large blocks of vibrant colors, a full range of values from dark to light, forms distinct but not barred from each other, lines sinuous and soft. The figures in *Saturday Afternoon* (1993) stand companionably along the curb; those in *Country Boogie* (1993) sway in a lively rhythm. There is still melancholy in these paintings, there is still a nervous quality that makes one dancer seem ready to run off the back of the canvas, but the anger and frustration seem decidedly less than during his more restless years.

"For the last ten years," Major says, "I have been feeling extremely good about the work I'm doing, both as a painter and a writer. For a long time I was less secure; I thought an artist had to be of his or her own time, and I forced myself to do things that weren't very satisfying [in painting]. Finally, I said to-hell-with-it, I'll paint what and how I need to" (TI).

Major's novels and paintings have provided a series of systematic searches into different sources of identity—sexual, literary, cultural, visual, socioeconomic, familial, regional, national, and personal as well as ethnic. Undoubtedly, his struggles with these issues stem in part from the fact that a "positive, healthy perception of ethnic identity is not an automatic birthright for most Blacks," especially in relation to the areas of life that compelled and inspired him—the literary and the artistic (Gay and Baber 37). Today, however, Major seems to be reaching a state where his double vision becomes a mature, comprehensive vision, where he is more able to incorporate the many images that confront him:

> We know when we are in the presence of individuals who have clarified their Blackness and integrated it into their being, not so much by any specific, isolated behaviors as by the sense of security, self-direction, confidence, assurance, and comfort with their ethnic selves that they radiate. They neither apologize for nor proselytize about their Blackness. They simply fuse it with all other dimensions of their being. (Gay and Baber 64)

One place where these strands of Major's identity become clear is *Fun and Games* (1990), his only published collection of short stories, and perhaps my favorite of his works. The collection, like a condensed and intensified version of his range of novels, embodies similar themes, even some of the same characters (Julie Ingram and Al Morris in "Letters," Juneboy and his father, Scoop, in "Saving the Children"). Divided into five sections, the pieces work in a distinct direction from traditional narratives in the first

part to highly subjective, language- and image-oriented pieces in the last section, which is even called, in painterly terms, "Mobile Axis: A Triptych." There are many ways this progression might be analyzed—daily life to intellectual pursuits, childhood memories to adult obsessions, realism to abstraction—but what is most important here is how the stories speak to and enrich each other. They meld and overlap, and over the course of reading them the whole becomes greater than the parts, like a mosaic made with different kinds and sizes of tile.

In "Liberties," the most directly painting-related piece in the collection, we are introduced in *descriptive words* to a series of van Gogh's *paintings*. The juxtaposition, the exercise of translating visual image into words which must then function to re-create visual images in the reader's mind, has a peculiarly unnerving effect. The paintings are *there*; they pop up on the page as tangible as the page itself. We are reminded that "alphabets begin as pictographs, and, though words are spoken things, to write and read we must see. The line between picture and symbol is a fine one" (Updike 7). The narrator proceeds from portrait to portrait, scrutinizing van Gogh's repeated face much as one might concentrate on a text one is searching for clues. He finds both answers and questions but concludes that "each face in each picture represents a version of the man in the window" (117).

Major has reached a point in his career as an artist where he can paint his own face as brown, green, or, as in the cover for *My Amputations*, white with a black outline. As a writer, he can observe similarly that van Gogh's "eyes are sometimes slanted. His skin color varies from dark to pink" (*Fun and Games* 116). Clarence Major's many colors can share one skin and his voices can share one volume, merging with each other into one resonant and touching whole. His double vision has become a genuine gift.

WORKS CITED

Bell, Bernard W. *The Afro-American Novel and Its Tradition*. Amherst: University of Massachusetts Press, 1987.

Fine, Elsa Honig. *The Afro-American Artist: A Search for Identity*. New York: Hacker Art Books, 1982.

Gay, Geneva, and Willie L. Baber, eds. *Expressively Black: The Cultural Basis of Ethnic Identity*. New York: Praeger, 1987.

Klawans, Stuart. " 'I Was a Weird Example of Art': *My Amputations* as Cubist Confession." *African American Review* 28, no. 1 (Spring 1994): 77–87.

Lacy, Leslie Alexander. *The Rise and Fall of a Proper Negro: An Autobiography*. New York: Macmillan, 1970.

Major, Clarence. "Clarence Major Interviews Jacob Lawrence, the Expressionist." *Black Scholar* 9, no. 3 (November 1977): 14–25.

——. *The Dark and Feeling: Black American Writers and Their Work*. New York: Third Press, 1974.

——. *Emergency Exit*. New York: Fiction Collective, 1979.

——. *Fun and Games: Short Fictions*. Duluth: Holy Cow! Press, 1990.

——. "Licking Stamps, Taking Chances." In *Contemporary Authors Autobiography Series*, edited by Adele Sarkissian, 6:175–204. Detroit: Gale Research, 1988.

——. *My Amputations*. New York: Fiction Collective, 1986.

——. "Necessary Distance: Afterthoughts on Becoming a Writer." *Black American Literature Forum* 23, no. 2 (Summer 1989): 197–212.

——. *Such Was the Season*. San Francisco: Mercury House, 1987.

——. Telephone interview with the author, January 13, 1994.

Thompson, Robert F. "African Influence on the Art of the United States." In *Black Studies in the University: A Symposium*, edited by Armstead L. Robinson, Craig C. Foster, and Donald H. Ogilvie, 170–71. New Haven: Yale University Press, 1969.

Updike, John. Foreword to *Doubly Gifted: The Author as Visual Artist*, by Kathleen G. Hjerter. New York: Abrams, 1986.

Weixlmann, Joseph. "Clarence Major." In *Dictionary of Literary Biography*, edited by Thadious M. Davis and Trudier Harris, 153–61. Detroit: Gale Research Company, 1984.

Yearwood, Gladstone. "Expressive Traditions in Afro-American Visual Arts." In *Expressively Black: The Cultural Basis of Ethnic Identity*, edited by Geneva Gay and Willie L. Baber, 137–63. New York: Praeger, 1987.

Reflex and Bone Structure

The Black Anti-Detective Novel

STEPHEN F. SOITOS

Clarence Major's *Reflex and Bone Structure* (1975) is an experimental novel that contributes to the emancipation of black American consciousness by confronting the traditional methods of narrative discourse. Major has written that social protest is not the only way to liberate the human spirit: "[T]he novel not deliberately aimed at bringing about human freedom for black people has liberated as many minds as has the propaganda tract, if not more" (*Dark and Feeling* 24–25). In "Major's *Reflex and Bone Structure* and the Anti-Detective Novel," Major is quoted as saying: "I set out with the notion of doing a mystery novel, not in the traditional sense, but taking up the whole idea of mystery" (McCaffery and Gregory 40). In its pursuit of metaphysical themes, its black double consciousness parody of literary and detective forms, and its lack of final solution, *Reflex and Bone Structure* falls within the anti-detective tradition explored by Stefano Tani and further emphasized by McCaffery and Gregory in their essay, but it also extends the boundaries of the black detective tradition.

The novel's experimental narrative form, with its lack of traditional character and plot development, also makes it a metafictional detective story as defined by Tani in *The Doomed Detective*:

> Thus when we get to metafictional anti-detective novels, the conventional elements of detective fiction (the detective, the criminal, the corpse) are hardly there. By now the detective is the reader who has to make sense out of an unfinished fiction that has been distorted or cut short by a playful and perverse "criminal," the writer. (113)

Metafiction in this sense suggests a renewed emphasis on the construction of the text and the artifice of words. Bernard Bell points us in this direction when he describes Major as having "a preoccupation with exploring the boundaries of language and imaginative consciousness" (317). Other critics, such as Jerome Klinkowitz, confirm this line of reasoning when they emphasize the nature of the book's construction over its content: "Yet *Reflex and Bone Structure* is more than a conventional detective novel, for every element of its composition—character, theme, action, and event—expresses the self-apparent nature of its making" (108–9). The experimentation with structure, character development, plot, and other literary devices in this novel illustrates Major's preoccupation with the trope of double-conscious detection as applied to a critique of Euro-American literary forms.

Originally appeared in *The Blues Detective* (Amherst: University of Massachusetts Press, 1996), 205–19. © 1996 by Stephen Soitos. Reprinted by permission.

Reflex extends the black detective tradition into experimental narrative territory. Houston Baker points out how Major's metafictional novel shares themes with the African American cultural tradition: "The products of Afro-American expressive culture are, frequently, stuttered, polyphonic, dissociative—fragmented, ambivalent, or incomplete. They 'urge voyages' and require inventive response" (Baker 100). Much like a sustained jazz solo, *Reflex* improvises on the black detective tradition by further reinventing the four tropes of black detection, that is, black detective personas, black vernaculars, double-conscious detection, and hoodoo. It also demands a creative response from the reader. I see *Reflex* as a form of signifying on appropriated Euro-American cultural literary conventions, such as character, plot, and description, as well as parodying the detective form. In this sense it is a logical extension and further elaboration of the double-conscious detection theme, paralleling Ishmael Reed's experimentation with form in his novel *Mumbo Jumbo* (1972).

As well as being a primary character in the text, the narrator writes the novel *Reflex* and comments on the process of writing it. Although nameless and never described, the narrator self-reflexively manipulates the plot and characters of this episodic novel. Through his repeated references to the act of writing, we know that the narrator is playfully deconstructing the text while in the process of composing it. "I'll make up everything from now on. . . . I'll do anything I like. I'm extending reality, not retelling it" (49). The narrator is whimsical, forgetful, and unreliable. He refuses to tell a consistent story that follows traditional discursive conventions. His method of engagement is self-reflexive in the sense that the reader is continuously made aware of his manipulation of the text. We know little of the personal history of the narrator other than that he lives in Manhattan. He exists through the act of writing, and his identity is inextricably tied to that process. Throughout the novel the narrator remains aloof, detached, and fearful of growing old.

The other characters are seen exclusively through the narrator's eyes. Cora Hull is a black actress who lives in Greenwich Village in Manhattan. At various times she has intimate relationships with the novel's three male characters: the narrator, Canada, and Dale. She is often in rehearsal for plays but never seems to have any long-term commitments either to the stage or to the other characters. She may have been killed in the mysterious bombing episode that occurs in the beginning of the novel, but because of the convoluted time frame of the plot, we can never be sure until the end. She is described as being twenty-five years old, five feet, five inches tall, and weighing between 112 and 125 pounds. She was born and brought up in Atlanta, Georgia.

Canada Jackson is a black male who may be part of a black revolutionary

group, but he is also described as having once been a policeman (*Reflex* 2). He is Cora's husband and a rival of both Dale and the narrator. Canada collects weapons and keeps a gun in the silverware drawer in the kitchen of his apartment. He is also an actor in New York City.

Dale is a black off-Broadway actor who flits in and out of the text with little definition. The narrator professes to have the most difficult time constructing Dale. Furthermore, Dale threatens the narrator's sense of self. As Cora's suitor, Dale causes more problems than Canada or the narrator. The narrator is very jealous of Dale, and he is often sent on long journeys.

As a detective novel *Reflex* stretches the boundaries of the form by toying with three conventions: the detective, the crime, and the solution. Repeated references to these three conventions give the novel an eerie sense of suspense associated with detective fiction but provide none of the expected behavior or resolutions of the form. A bomb has exploded in the street, and the police are investigating the apparent assassination of two people. Somebody with a suitcase has been murdered, and there are indications that the murder was committed by an unnamed revolutionary group. Hints are given that Canada is a member of a black revolutionary group responsible for the bombing. Canada and the narrator are fingerprinted as suspects. The nameless police return again and again to the scene of the crime with no apparent success. A Puerto Rican boy with a green shirt randomly appears and says he knows who owned the suitcase that exploded. The narrator tells us the boy lies. The narrator also tells us that the crime occurred just outside his apartment. At times, the narrator says that it was Cora who was killed. "Anyway by now I think you find no problem realizing this is her eulogy" (132). However, even this simple premise is complicated by the narrator, who claims that it was he who murdered Dale and Cora, suggesting that the murder is a figment of his literary imagination, as are the characters, including the narrator, and the novel itself.

The interrelationships of these four characters revolve around the murders of Cora and Dale. Due to the fragmented time frame, it is impossible to tell what occurs before or after the murder of Cora. However, Cora Hull is present during most of the novel, which takes place in New York City, except for trips to places such as the Poconos and New England. Since these trips are not described in any detail, we cannot be sure if they really take place. The characters can travel as easily to the South Pole as to the neighborhood theater. The novel is written in the first person, which gives the narrator complete control over the story, the same method used by hardboiled detective writers such as Hammett and Chandler. However, in this anti-detective novel the first-person format, which was traditionally used for clarity of expression and easy reader identification, is used to confuse and alienate the reader. The issue of control and authorial authority is

subverted at every turn. In fact, the narrator tells the reader that he and his characters are simply part of his own imagination: "I do not really hate Dale, but respond this way to him out of lack of interest. I mean, I *should* be interested in him since he's one of my creations. He *should* have a character, a personality" (12). Because of these disavowals of control and the episodic, often contradictory form of the novel, the reader's suspension of disbelief is constantly challenged. In fact, there is little certainty about anything in this novel, which is one of the implied intents of the narrator, who often claims that forgetfulness or simple arbitrariness purposely alters the text.

However, certain motifs recur throughout the text which provide stable points of reference. The primary frame of reference is the narrator, who tells the reader he is writing a novel while he is writing it. The narrator comments continually on the problems he has in constructing the text due to his own misinterpretations, his forgetfulness, his difficulty in describing how things appear or are, and his constant flights of fancy. The other characters are at the mercy of the narrator's whims. They are sent away or drop out of the action depending on the narrator's moods. Often the narrator will contradict himself or even blend himself into the other characters. Though the activity of all four characters takes place in a skewed, apparently haphazard time frame, the story obviously centers on Cora Hull. Cora is described in different and often contradictory ways: "Not only was she involved with a militant white group, she was also part of a revolutionary Black group, plus she was branching out into the women's liberation movement" (31); "She was into Mother Dependency. Unweaned creatures" (33). Often she is described as appearing in a play, but the reader learns little about the drama.

Usually Cora is presented in relation to one of the three other characters in an indeterminate time frame. She is the center of the novel, and all the other characters are redefined through her. But she, too, is endlessly mutable. Commonly, she is the locus of their sexual attention as well as a physical presence to which the narrator returns again and again. Her moods are unpredictable, but no more so than any of the other characters, including the narrator. Although Canada, Dale, and the narrator are fixated on Cora, none of them maintains any long-term relationship. They revolve around each other without really understanding each other. Their closeness is suggested by the interwoven repetition of their personal and sexual encounters, which are presented in matter-of-fact terms. "She got up and came to my side, kissed me. At that moment Canada came in" (46). The narrator claims they all have problems focusing on anything. At various times they live either in the same apartment or in close proximity to each other. Much of the novel takes place inside apartments, in rooms ill defined and vague. The narrator complains about this, claiming they stay inside with closed-in thoughts too much.

From the various locales most commonly mentioned, such as Greenwich Village and the Lower East Side, the reader assumes they live in Manhattan. We know that Cora is often at rehearsals or trying out for plays, but Dale and Canada have no known occupations, although they are associated with the theater as actors. The narrator at one point calls himself a theater director. All of them drift in and out of the timeless plot, sometimes threatening, sometimes friendly, but never really defined. Another recurring motif is the young Puerto Rican boy who wears the green shirt. The boy is seen everywhere and somehow has access to the apartments of the characters. He is mysteriously attracted to Cora and appears at regular intervals throughout the novel without altering the direction of action or having anything to do with the rest of the characters.

The renewed emphasis on the construction of fiction and the ambiguity of the detective presence are part of the postmodern black anti-detective novel. Once again the detective persona is extended and altered, in this case almost reduced to invisibility. It is difficult to determine who the detective is. Is it the narrator? The police? The reader? Or a combination of all three? Certainly the narrator must be looked at closely. He, in fact, calls himself a detective in the text: "I'm a detective trying to solve a murder. No, not a murder. It's a life. Who hired me? I can't face the question" (32). However, he may also be the murderer since he describes the murders of both Cora and Dale that occur (or don't occur) at the beginning of the novel as part of his own doing: "Dale gives Cora a hand. At the edge of the desert they step into a city. They step into a house. It explodes. It is a device. I am responsible. I set the device" (145).

Furthermore, on the second page of the novel we are also introduced to the cops, who are "real" and "funny" (2). They are hard at work taking fingerprints and scraping up blood spots and "scattered pieces of body" (1). Later on in the novel they place the narrator and Canada under suspicion: "[T]he rumor is Canada and I are both very much under suspicion and closely watched" (31). And the narrator in turn suspects them. "Anyway I still suspect the law enforcement officers of murdering Cora" (31). The police drop in and out of the narrative, examining, prodding, and probing. They use the methods of forensic investigation, such as fingerprints and lab work, yet their scientific investigations lead to nothing. At one point Cora looks for a book to read and is momentarily fascinated by "something called *Model Criminal Investigation*. Even this she passed up. The cover is dull" (95). This sendup of police procedural methods parodies the rational aspects of the detective's persona extending back to Dupin and Holmes.

This is about as far as we get with solving or understanding the murders of Cora and Dale in terms recognizable to conventional detective texts. Therefore, we are forced to look for other answers. It soon becomes apparent that the process of detection is somehow linked with the process of

epistemology or the nature of understanding itself. In fact, the reader becomes the detective of the novel, trying desperately to put all the disparate pieces together. A perverse, unnameable menace seems to keep anything from occurring in ways that can be understood. This menace may simply be the intent of the narrator to suggest that the true nature of existence consists of these seemingly random encounters with people and places in which there is no rhyme or reason.

Major intersperses the text with references to popular crime films and movie stars. Well-known literary and cinematic icons such as Agatha Christie and John Wayne appear. Old movies are mentioned as well as actors from early crime films such as Edward G. Robinson. The cinematic references reflect the narrator's interest in film and mirror the cinematic quality of the text, where the action occurs in small "takes." There are also a number of sections that consist simply of lists, more often than not lists of black musicians or other well-known African American artists: "Cora places a stack of records on the record player. For years she listens to Buck Clayton, Thelonious Monk, Bix Beiderbecke, Benny Carter, Hoagy Carmichael, Chico Hamilton. They drench her. She sleeps with the records, dances through the music" (61). All but two on this list are black musicians. The lists seem to function as a type of naive empiricism, proving by their very existence that a world outside the text does exist as well as affirming the positive quality of African American vernacular expression.

The most obvious double-conscious theme in the novel is the heightened and highly creative use of language and narrative experimentation. The novel is composed of small vignettes broken into two sections entitled "A Bad Connection" and "Body Heat." Approximately equal in length, these two sections offer no clue as to the meaning of their titles or their function in the overall narrative. There is no discernible change in storytelling method or characters from one section to the next. In fact, the novel ends much as it began with the narrator slipping in and out of surreal hallucinatory or dream sequences in which the characters blend with each other and into absurd scenarios. The circular movement of the novel revolves around the characters' relationships with Cora Hull. She is the center of attention of the three males, and she in turn flirts with and is attracted to the narrator, Canada, and Dale. However, as these characters intermingle, connect, and disconnect there is a curious static quality about the text. The reader is never sure if anything happens. The narrator adds to the confusion by commenting on the characters, including himself:

> Get to this: Cora isn't based on anybody.
> Dale isn't anything.
> Canada is just something I'm busy making up.
> I am only an act of my own imagination. (85)

The theme of double consciousness in black detection texts traditionally deals with the notion of perception, making the values of black perception the most important aspect of the detective process.

In *Reflex* the trope of double consciousness becomes further complicated through the use of literary masking—the ultimate trickster narrator who uses words to bewilder and deceive. This double-conscious deception is a complex act of communication, indicating important African American language acts. The self-reflexive text is directly related to the black expressive art of signifyin(g). Henry Louis Gates, in relation to the two trickster figures of Esu and the Signifying Monkey, writes that "the central place of both figures in their traditions is determined by their curious tendency to reflect on the uses of formal language. The theory of Signifyin(g) arises from these moments of self-reflexiveness" (Gates xxi). The very nature of a Euro-Americentric fictive voice is challenged in this text. The narrator writes, "I want this book to be anything it wants to be. . . . I want the mystery of this book to be an absolute mystery" (*Reflex* 61). The narrator manipulates the reader with double-conscious intent. The novel refers to hoodoo— "He ran in the wrong direction and a hoodoo fell on him" (12)—but its double-conscious detection is more apparent in its magical reinvention of time, place, and action. Major fractures Aristotle's dramatic verities, creating in their place a complex picture of a more primitive nature. With its bare-boned characterization and negligible plot development, *Reflex* becomes an anti-novel as well as an anti-detective novel. In fact, if there is a death in this text, it is the death of the novel as commonly experienced.

Cora Hull has X-ray pictures of her brain, heart, womb, and bone structure framed and hanging in her living room. The stark, negative images of X rays suggest only the essential outlines of things, and in this sense the novel itself is like an X ray with its four shadowy characters who interact in ambiguous and contradictory ways. Many of the episodes seem to ignite spontaneously from the mind of the narrator, who assumes a major role in their instigation: "Canada and I leave town. It's not easy. . . . For spending change, we stick up a mail train, swooping with seven million, which lasts us a few days . . . we get work at the Palace Theater and Carnegie Hall. We're a smash success. . . . But by now we're exhausted. We separate" (35). The plot reads like the reflex reactions of this unreliable narrator, who puzzles out his existence among characters who may or may not be real. Since everything is consciously filtered through the narrator's viewpoint, and since he tells us he is lying, the reader's response is also much like a reflex reaction. That is, the reader is as bewildered as the narrator and the other characters.

The narrator in this sense can be looked at as the houngan trickster creator who displays his talent in the manipulation of the reader's perception. This trickster mysteriously veils the novel in a magical, surrealist poetry of words: "Cricket frogs jump about on the tables. Whistling tree frogs

are in our bedroom. Patch nosed snakes crawl under the bed . . . blind snakes are in the dirty clothes containers" (76). In example after example, the narrator weaves his spell of bewildering impossibilities. None of it in the end is ever summed up, given concrete form, or explicated in any degree commonly associated with the recognition scene of the detective novel. "I simply refuse to go into details. Fragmentation can be all we have to make a whole" (17). Given this fragmentation and refusal to accept order, there is only one consciousness left that is capable of making sense out of the book: the reader's. It is the reader who in the end becomes the detective and the real creator of the text.

Indeed, the author, Clarence Major, is quite aware of the conundrums preferred by this type of fiction and gives the reader some warning of what is coming. On the inscription page he enjoins the reader: "This book is an extension of, not a duplication of reality. The characters and events are happening for the first time." The author's preamble suggests the spontaneous quality of *Reflex and Bone Structure*. The very short, most often elliptical, and confusing vignettes bewilder the narrator as much as the reader. The narrator is a character in his own narrative, but he does not possess the omniscience of most narrators. The first-person format also contributes to the sense that the story is unfolding immediately in front of the reader. Some of the most obvious conceits of metafiction are included in this novel: a narrator who is unreliable, a text that talks about itself being written, sketchy characters who are confusingly described and often revealed as figments of the narrator's mind, and a jumbled plot that repeats and often contradicts itself. Consequently, the abstract quality of the text often forces the reader to play a primary role in fabricating order.

The characters and plot are reduced to essentials like names and forms. They never seem to progress beyond that point. It is as if Major is forcing the reader to relearn and rename everything taken for granted in Euro-American novels. Early in the book the narrator describes Cora: "Cora switches to a children's program. It's all about P and Y and B and T and G and F and H and E and W and C. It's about the deep dark secrets of the mind. A boy and a girl are exploring a haunted castle called Alphabetical Africa" (5). Like the children in this program, the reader must confront the elemental aspects of fiction's construction. The act of naming is basic to understandable language use, and the narrator plays with the concept of naming as a structural device: "It isn't that I myself forget their names. The truth is I do not really give a shit about the names these men have who happen to be cops. One might be called U" (31). The narrator uses naming as a repetitive motif in the text. "I make too much of names: but then what are things or people *before* they attain names?" (121). Obviously, the narrator is searching for a preverbal, more primitive method of understanding.

The reference to Africa in the passage quoted above might suggest a new orientation to the narrator's struggle for meaning. Major has spoken about this reorientation in one of his interviews, where he comments on the importance of art over what he calls "militant rhetoric" and urges a renewal of artistic inspiration: "I'm not talking about artistic standards based on European-American concepts of excellence. Rather, I'm referring to formative and functional standards that have their origins in African cultures" (*Dark and Feeling* 128). Keith Byerman, in *Fingering the Jagged Grain*, associated this Afrocentric artistic understanding with the importance of naming: "Crucial to this view of art is the concept of 'nommo,' the word that gives meaning to the object created." Naming gives the ultimate meaning. "Thus, a mask of a dead person need have no resemblance to that person because the artist will give it its proper name and thereby its meaning." This emphasis on naming gives all power to the creator, and in *Reflex* this creator is the narrator, who "like the singers of blues rearrange[s] the verses or invent[s] new ones in order to create a certain mood" (Byerman 256). *Reflex* can be interpreted in this way as a palimpsest text of mood and feeling with meaning conveyed on a very abstract plane.

Because the story has a crime, detectives, and an investigation, certain rudiments of the detective novel genre are satisfied, and the mood of mystery infuses the text. However, the investigation stalls, and the unsolved crime stands as a metaphor for the rest of the novel in which nothing gets resolved. The reader is forced to assume the detective role, amassing clues that go nowhere. The reader's role as detective also ends in failure since the key to the crime and the book lies with the narrator, who refuses to relinquish his hold on meaning. The formula of detective fiction as we know it is totally subverted. The details are twisted, the plot is nonexistent, the characters are hardly more than names—nothing can be solved. Order often cannot be imposed, which suggests that the novel might be about the process of understanding itself as well as the nature of language. In the end nothing makes sense but the poetry of the words.

In this way the novel is akin to modern abstract painting, which is self-referential and concerned with the nature of paint and painting rather than the depiction of reality or the illustration of a recognizable object. Major studied painting and painted for many years. Allusions to painting occur in the text: "He takes me on a tour of the museum, showing me various abstract paintings. 'These things are about themselves. Look at the paint'" (99). The analogy between painting and the experimental text of Major's novel is intriguing. Major has commented on this in relation to his novel *All-Night Visitors*: "I saw the work as a kind of drawing to be done with words" (*Dark and Feeling* 16). In *Reflex*, words seem to function like paint in the way the characters and episodes sometimes blend into each other.

Strange apparitions such as insects and frogs mysteriously appear in large numbers, inhabiting rooms or dropping from Cora Hull's dress. The characters are described as being in a room talking or sadly looking out of windows when suddenly, in the same paragraph, they are transported to some remote beach. This fluid and strangely melting quality of the text reminds the reader of the bizarre fusions and juxtapositions of surrealism. The absurd scenes reel out in seemingly random fashion, as if the narrator were asleep or hallucinating. None of the characters acts consistently and with a purpose, and so the meaning must be contained on a surface level of construction, much as abstract painting refers to the paint and the act of painting before suggesting anything representational.

Furthermore, the representational quotient of the abstract painting is often generated only in the eye of the beholder. In Maly and Dietfried Gerhardus's *Cubism and Futurism*, the nature of perception is discussed in relation to abstract painting. The uncertainty of the viewer in front of such a painting is connected with a history of understanding:

> The main reason for this uncertainty is of course that all our knowledge and experience are determined in some way by our previous linguistic understanding of the everyday world. . . . In other words: we do not learn to perceive, for perception as such is an inherited faculty, but we do learn to distinguish perceptions from one another, and do so precisely by means of linguistic hierarchies and divisions. (8)

The connection between linguistic and visual perception is an area of experimentation in *Reflex*. The book's reduction to essential linguistic elements is mirrored by its visual indeterminacy, that is, its willing inability to construct a linear plot and recognizable characters. Visual and linguistic perceptions depend on linking known and accepted hierarchies of word and visual clues. The ultimate dissolution of this Euro-American hierarchy seems to be one of the aims of *Reflex*. With its nonlinear time frame, its character and plot dissembling, and its epistemological fragmentation, the novel forces a new perception.

William Spanos, in his essay "The Detective and the Boundary: Some Notes on the Postmodern Literary Imagination," makes the same point in relation to the symbolist's deconstruction of language: "Its purpose was to undermine its utilitarian function in order to disintegrate the reader's linear-temporal orientation and to make him see synchronically—as one sees a painting or circular mythological paradigm—what the temporal words express" (158). In many ways this new perception is based on contradictions. For all its movement and spontaneous transformations, the novel projects claustrophobia and paranoia—or, as Spanos would put it, an existential dread. Nothing is ever done or accomplished in the novel, and none of the mysteries of its text are elucidated. None of the characters change or

develop because the reader does not really know who they are. The narrator continually bemoans his increasing age, but we do not know what that age is. The novel is reduced to an obsession for indeterminacy.

This sense of incompleteness is what people normally fight against by writing books, creating plays, believing in something. This indeed may be the warning of the narrator in writing such a novel—that we must know ourselves first so that we in turn may know the world. *Reflex and Bone Structure* confronts the accepted Euro-American notions of the novel. In his essay "A Black Criteria" (1967), Major urges a transformation and a breaking away from Euro-American literary structures. Although he later disavowed an "all-encompassing black aesthetic," he nevertheless urges freedom of expression for black writers (*Dark and Feeling* 134). In this sense *Reflex* is a good example of radical fictional experimentation with an underlying theme urging African American expression. It demands to be met on its own terms, which suggests that the key to all reality is elusive and that fiction has a life of its own separate from mimesis or realism.

The novel's pastiche construction, akin to the abstract canvas, forces a new perspective. The text is continuously in a state of rebirth, denying the past, living immediately in the present. Like *Mumbo Jumbo*, it replaces linear time with circular time, always coming back to the essential elements of its own existence. The reader must engage and interact with the text to derive meaning while questioning the nature of fiction and of reality. In this sense I agree with Bernard Bell, who sees Major's work as able to "extend the experimental tradition of the Afro-American novel [through] exploration of sex and language as a ritualistic rebirth and affirmation of self" (320).

Major also extends the black detective tradition by transforming the four tropes of black detective fiction through his use of double-conscious detection. At its most basic level *Reflex* attacks Euro-American control of literary genres and standards of literary excellence, forcing a new awareness of how cultural identity is taught and perceived. Out of this comes a new sense of self and renewal of identity. Stefano Tani in *The Doomed Detective* sees the duality of construction/destruction as at the root of the artistic process in Poe's construction of his tales: "[A]rt's process is as much destructive as constructive: to bring back childhood's sense of innocence, beauty, and wonder, to give substance to the artist's dim intuition of what might be or might once have been, the artist violates and destroys what is" (12). Poe's detective persona, with its essential dualities and complex nature, launched the detective tradition. As we have seen, this sense of self and identity has changed with the development of the black anti-detective novel. Major's reduction of detective fiction to the basics of understanding seems to suggest that a new approach to perception and the nature of learning is necessary. This is particularly important to the notion of black identity in America.

The question of African American identity and how it is expressed in the

black detective novel has been a primary thesis of this essay. Major has brought us full circle from the first stirring of this expression of black identity through black detective tropes in Pauline Hopkins's *Hagar's Daughter* to a deconstructive extension of those tropes. By reducing the text to its basic elements, Major forces a reassessment of the four tropes of black detection. He uses double-conscious detection experiments to present an alternative viewpoint of the African American experience. He infuses language with new power through radical alteration of conventional detective plots and detective persona. By doing so he recapitulates and signifies on the very nature of the black detective and the detective text. Through an emphasis on the poetic nature of language, he stresses the beauties of sensual experience and the special artistic perceptions of black Americans. Such elementary reduction also urges a renewal or new beginning, as does the circular time frame of the novel. Bell recognizes this abstract continuity and extension of tradition when he writes that Major attempts "to resolve Afro-American double-consciousness by the subordination of social truth and power for blacks to the expressionistic truth and freedom of the artist" (320). Major presents the viewpoint of a black American in a radically different way. By example, he stresses the importance of an autonomous and distinct African American poetic identity, which opens the way for other black writers to attempt their own revolutionary reinterpretation of African American consciousness. Major's ultimate achievement is his indication of new possibilities of reconstruction for African American artists.

Major has advanced African American detective fiction into the postmodern era. He uses the primary conventions of detective fiction in a postmodern text that, in the very nature of its self-reflexivity, signifies on the tradition. Furthermore, Major recognizes the four tropes of black detective fiction while transforming them with highly original double-conscious narrative and structural ploys. These creative reinterpretations once again confirm the inexhaustible potential for renewal and affirmation within the black detective tradition as well as in African American culture as a whole.

WORKS CITED

Baker, Houston A., Jr. *Workings of the Spirit: The Poetics of Afro-American Women's Writing*. Chicago: University of Chicago Press, 1991.

Bell, Bernard. *The Afro-American Novel and Its Tradition*. Amherst: University of Massachusetts Press, 1987.

Byerman, Keith. *Fingering the Jagged Grain: Tradition and Form in Recent Black Fiction*. Athens: University of Georgia Press, 1985.

Gates, Henry Louis, Jr. *The Signifying Monkey: A Theory of Afro-American Criticism*. New York: Oxford University Press, 1988.

Gerhardus, Maly, and Dietfried Gerhardus. *Cubism and Futurism: The Evolution of the Self-Sufficient Picture*. Oxford: Phaidon; New York: Dutton, 1979.

Hopkins, Pauline. *Hagar's Daughter: A Story of Southern Caste Prejudice.* 1901–2. Reprinted in *The Magazine Novels of Pauline Hopkins*, 1–284. The Schomburg Library of Nineteenth-Century Black Women Writers. New York: Oxford University Press, 1988.

Klinkowitz, Jerome. *The Self-Apparent Word: Fiction as Language/Language as Fiction.* Carbondale: Southern Illinois University Press, 1984.

McCaffery, Larry, and Linda Gregory. "Major's *Reflex and Bone Structure* and the Anti-Detective Novel." *Black American Literature Forum* (Summer 1979): 39–45.

Major, Clarence. "A Black Criteria." *Journal of Black Poetry* 1 (Spring 1967): 15–16.

———. *The Dark and Feeling: Black American Writers and Their Work.* New York: Third Press, 1974.

———. *Reflex and Bone Structure.* New York: Fiction Collective, 1975.

Spanos, William V. "The Detective and the Boundary: Some Notes on the Postmodern Literary Imagination." *Boundary* 2 (Fall 1972): 147–68.

Tani, Stefano. *The Doomed Detective: The Contribution of the Detective Novel to Postmodern American and Italian Fiction.* Carbondale: Southern Illinois University Press, 1984.

Clarence Major's *All-Night Visitors*

Calibanic Discourse and Black Male Expression

JAMES W. COLEMAN

Readers who have followed Clarence Major's career and know his work realize that as his career develops his work becomes more experimental and increasingly foregrounds the great limitations of fictive portrayal and expression which are the concerns of such white radical metafictional writers of the Fiction Collective as Ronald Sukenick, Raymond Federman, and Harold Jaffe. Major also experiments in his first novel, *All-Night Visitors* (1969), but the experimentation presents itself in the form of a pursuit of the potentialities of black male expression. Postmodern, metafictional, and poststructuralist interpretive strategies are relevant for an analysis of *All-Night Visitors*. But what I want to do in this essay is to utilize various critical paradigms, especially Anglo-American anthropological, African American poststructural, and Cuban postcolonial constructs, that highlight Major's experimental project in terms of black male writing. My purpose is to show that *All-Night Visitors* is a black male text that reflects the problems of black male freedom, empowerment, and voice in ways that are characteristic of other contemporary black male texts.

Black poststructuralists like Karla F. C. Holloway develop their theoretical paradigms through a method of "shift":

> Shift happens when the textual language "bends" in an acknowledgement of [black] "experience and value" that are not Western. A critical language that does not acknowledge the bend or is itself inflexible and monolithic artificially submerges [the significance of this black "experience and value"]. In consequence, critical strategies that address the issues within these texts must be mediative strategies between the traditional [white] ideologies of the theoretical discourse and the [black] ancestry of the text itself. Such mediation demands a shift in the scope (if not the tone) of critical terminology—a redirection that calls attention to different (and often contradictory) [black] ideologies [and paradigms]. (62)

So "shift" is taking critical paradigms developed by white theorists for non–African American cultures and "bending" them so that they become relevant for the reading of African American texts. Because Holloway is talking specifically about the texts of contemporary African and African American women writers, I "bend" the quotation to make it more generally black. I adapt her concept of "shift" to explain the kind of critical paradigms that are relevant to Major's experiment with creating a humanistic black male

Originally appeared in *African American Review* 28, no. 1 (Spring 1994): 95–108. © 1994 by James Coleman. Reprinted by permission.

text. For example, I utilize the paradigm of the black phallic trickster, which black vernacular and poststructuralist theorist Houston A. Baker develops by giving an African American male "shift" to white paradigms of anthropologists Victor Turner and Clifford Geertz (Baker 180–85). And I later "shift" the paradigm of the black phallic trickster further, to make it a variant of black phallic duplicity, a construct especially relevant to black men and black male texts because of their particular locus in the nexus of Western culture, politics, ideology, and racism. I also "shift" Turner's concept of liminality for my analysis of African American texts.

All-Night Visitors is basically a discursive experiment with a deeply traditional Western grounding. The central discourse focuses on erotic encounters between the black main character, Eli Bolton, and several different women. On the surface, the discourse amalgamates a central vulgar, pornographic description and theme, the stereotyping of the black male as sexual beast, and the sexist objectification of women through the first-person point of view that privileges the sexual feeling and gratification of Eli. Eli's primary mode of expression is through crude, vulgar language and sex, and he constantly shows his insatiability.

What I have just described shows the text's deep traditional Western grounding in the pervasive cultural and literary discourse of Caliban and Calibanic phallicism. Roberto Fernandez Retamar traces the history of this discourse in his essay "Caliban: Notes toward a Discussion of Culture in Our America." Retamar locates one of Shakespeare's main sources for Caliban in a Montaigne essay ("De los Canibales" or "On Cannibals") but finds the most influential Western inscription of Caliban in *The Tempest* (14–16). In the play, Prospero takes Caliban's island and gives the "gift" of language to Caliban, who can only "gabble," to make him an effective slave in doing his bidding. Caliban hates Prospero and reviles him and the "profit" he has gotten from language, the ability to curse his persecutor. Caliban shows his resentment when he tries to rape Prospero's daughter, Miranda, and perpetuate his progeny on the island. In spite of Prospero's imperialism, the play's point of view makes Caliban an "Abhorred slave, / Which any print of goodness wilt not take." Caliban is a member of a "vile race" who "Deserved more than a prison."[1] Shakespeare plays on the anagram Caliban/cannibal (Retamar 11, 14–15) and situates Caliban in terms of the European perception of savage dark and black non-Europeans.

As Retamar points out, we see the Caliban/cannibal in the "African black who appeared in those shameful Tarzan movies" (14) and, according to black feminist theorist Hortense Spillers,[2] this character has a portrayal, "feared and despised, from Caliban, to Bigger Thomas" (8). The point is

obviously that this figure and image of Caliban, which is male and highly black, pervades Western discourse. This figure is the inarticulate sexual predator who has somehow missed or misappropriated Western education and civilization. He expresses himself in crude vulgarity and raw, physical sex. The fear of miscegenation associated with him is great. This black male needs to be controlled and locked away, and this discourse of Caliban effectively circumscribes and imprisons the black male.[3]

Major's portrayal of Eli on its surface level clearly situates him within the Western discourse of Caliban. The phallus is the main symbol of Eli and Caliban's threat. Eli is the crude, vulgar rapist and beast who threatens to pollute with his phallus, just as Caliban would pollute Miranda and pollute the island with his issue. This characterization of Eli takes on greater resonance today because of stereotypes of black men similar to the Calibanic expressed at certain times in feminist critiques of black male sexism.[4]

Part of the discursive experiment, however, is the attempt to appropriate and subvert what Major intends to be the surface level of Calibanic discourse. Major does this by subverting the paradigm of Calibanic phallicism with black phallic tricksterism; in the process, he changes the black phallus from a symbol of pollution to one of productivity and proliferating meanings.

In his adaptation of anthropologists Victor Turner and Clifford Geertz, Houston Baker develops a black theoretical "shift" to create the paradigm of the black phallic trickster (180–85). Baker "shifts" Turner and Geertz's analyses of phallic rituals in other cultures to fit the phallic symbolism and ritual of Ellison's Trueblood scene in chapter 2 of *Invisible Man*. Baker says that the

> black phallus is a dominant symbol in the novel's formal patterns of behavior. . . . [It] offers an instance of ritual in which the black phallus gathers an extraordinary burden of disparate connotations, both sensuous and ideological. . . . Ellison recognizes the black phallus as a dominant symbol of the sometimes bizarre social rituals of America and incorporates it into the text of the novel. (181)

Baker concludes that "Trueblood's sexual energies, antinomian acts, productive issue, and resonant expressivity make him—in his incestuous, liminal moments and their immediate aftermath—the quintessential trickster" (184).

Trueblood's successful black phallic tricksterism consists of sexual vitality, rebellious sexual acts opposed to society and morality, the production of progeny, and an economically rewarding and richly resonant linguistic expression. Trueblood's liminal status—outside the conventions and laws of society in a wide-open place of process and discovery—is important to his tricksterism.

Eli fits a pattern of black phallic tricksterism similar to Trueblood's. On the subversive level of discourse, Eli's sexual vitality is rebellious and oppositional in a society that proscribes certain behavior by black males. Eli produces no progeny, but, much more important, the resonance of his language practice creates a figurative and symbolic haven of humanity for him and others. Eli's language practice projects him to a liminal place far away from the horror, brutality, and inhumanity of everyday life, and his language practice maintains his liminal place, " 'betwixt and between,' " in terms Baker takes from Turner (183), ever in productive process. Most important, Eli tries to open linguistic space in the imprisoning discourse of Calibanic phallicism with his methods of black phallic tricksterism.

In my use of the concept of liminality, I have "shifted" Turner's meaning in some specific ways that I need to explain briefly. I have taken the anthropologist's analysis of cultural rites and applied it to a literary text. But even more important, I "shift" Turner's idea of societal "rites of transition," that is, "separation, margin (or limen), and aggregation" (Turner 94), to focus on its second term, liminality, as opposed to the entire process. For Turner, the process ends in aggregation, and concomitantly in completion, closure, or consummation (94). Making liminality primary is relevant and necessary for a significant number of contemporary black male texts, including *All-Night Visitors*, because these texts foreground liminality.[5]

In *All-Night Visitors* Eli's most significant place is symbolically " 'betwixt and between' " in the margins of liminality. The following discussion will show two points. First, oppressive racial/cultural conditions keep Eli, along with the characters in other contemporary black male texts, in a position of liminality and preclude aggregate consummation. Eli liminally and symbolically shows his humanity over and over, but the society will not grant him the "culturally recognized degree of maturation" (Turner 93) requisite for societal acceptance and transition into the state of manhood and humanity, his aggregate state. Second, Eli and other black male characters do not have the male cultural resources and the physiological/racial qualities to help them achieve aggregation either.

For Eli, aggregation becomes secondary; it manifests itself in terms of a wild and, in the final analysis, contrived act of selfless humanity, after which Eli states his own manhood (199–203). Eli's claim of manhood in aggregate societal terms brings the text to an "ending," but it pales in comparison to the text's primary emphasis on Eli's liminality.

Because Major's project in *All-Night Visitors* is an experiment, I want at this point to look closer at some of its specifics in the text, to see how the experiment works, and to talk about its possible success or failure. Major attempts to focus and create the black male self, Eli's self, in *All-Night Visitors*. The various discourses in the book present two different sets of linguistic signs of this black male self. One set of signs engenders Calibanic

phallicism and negative contemporary feminist stereotypes of black male sexists/rapists. The other set of signs brings forth images of a much more cerebral, spiritual, humane, and ultimately loving black male. At this level, the black phallic trickster speaks with proliferating, subversive meanings. These two different sets of signs come together in the novel's central discourse in which Major experiments with a creation of a black male self. Major tries to give the positive conceptions of black maleness ascendance over the negative; he attempts to do this by giving the discourse both a superficial, shallow level of meaning and another level on which one can see positive, humane qualities of black maleness—the levels of Calibanism and black tricksterism, respectively. Major wants to show that the Calibanic level of discourse does not bear the primary meaning and that the main character, who is the black phallic trickster, takes control of the discourse of the text and appropriates and subverts it against its will to make it do what he wants.

The appropriation and subversion take several forms. First, the narrator subverts and appropriates the linguistic signs of the discourse. Superficially, the linguistic signs are Calibanic and suggestive of male sexism in the context of contemporary thinking. The narrator subverts this stage of the discourse with signs that invite us to analyze and participate in the process of self-definition that he undertakes. In this process, the exploration of the higher humanity of the black male self and the self of the female other becomes a dominant topos. This takes the emphasis away from Calibanism and male sexism. Second, Eli Bolton, the artful phallic trickster, creates an urgent tension in the language and sometimes accelerates its rhythm to suggest an almost supernatural level of black human being, a positive black maleness. This is another part of the process of human exploration and definition. Further, Eli subverts the privileging of male feeling, gratification, and well-being at important places by language that focuses on the definition of nonstereotypical female humanity. We cannot separate this strategy from the first two. Finally and more generally, Eli sets up a contrasting context between the text's erotic discourse and the dehumanization and horror of the alternative experiences available to him. When we see how hypocritical, brutal, and callous the rest of the world is, we understand that Eli's definition, so completely in terms of intense and ultimately honest, sensitive, and humane feeling, subverts the discourse of Calibanism and sexism. The discourse thus becomes a parody of all its surface meanings. I will later demonstrate these points with specific examples from and discussions of the text.

There is something especially exciting about *All-Night Visitors*. The characteristic resistance of the novel's discourse to the kind of appropriation that

Eli attempts gives it a vital tension and anxiety. It constitutes a discourse that is highly charged and that generates negative, inflammatory, emotional reactions in a culture that stubbornly refuses expropriation from the meanings and contexts of that culture. For many, nothing beyond the negative will be a possibility.

The following quotation from Bakhtin's "Discourse in the Novel" describes the struggle that takes place among the word, the speaker of private, subversive intention, and a generally agreed upon, embedded discursive intention:

> As a living, socio-ideological concrete thing, as heteroglot opinion, language, for the individual consciousness, lies on the borderline between oneself and the other. The word in language is half someone else's. It becomes "one's own" only when the speaker populates it with his own intention, his own accent, when he appropriates the word, adapting it to his own semantic and expressive intention. Prior to this moment of appropriation, the word does not exist in a neutral and impersonal language (it is not, after all, out of a dictionary that the speaker gets his words!), but rather it exists in other people's mouths, in other people's contexts, serving other people's intentions: it is from there that one must take the word and make it one's own. And not all words for just anyone submit equally easily to this appropriation, to this seizure and transformation into private property: many words stubbornly resist, others remain alien, sound foreign in the mouth of the one who appropriated them and who now speaks them; they cannot be assimilated into his context and fall out of it; it is as if they put themselves in quotation marks against the will of the speaker. Language is not a neutral medium that passes freely and easily into the private property of the speaker's intentions; it is populated—overpopulated—with the intentions of others. Expropriating it, forcing it to submit to one's own intentions and accents, is a difficult and complicated process. (*Dialogic Imagination* 293–94)

The Calibanic, male sexist discourse of *All-Night Visitors* is clearly the kind that does not "submit . . . easily . . . to [this] seizure and transformation into private property." Eli's subversive trickster's voice risks becoming the voice of the discourse that it attempts to undermine. Examples from the novel will allow me to analyze further its discursive practices and then to discuss the success or failure of Major's experiment.

The first section of *All-Night Visitors*, entitled "Tammy," is about Eli's relationship with a very young white woman whom he does not love, but the pure pleasure of their sex takes Eli into his spiritual depths. At the end of the "Tammy" section, Eli gives the following description of the climax of oral sex:

I can't *hold* on much longer, the emission is pushing against the many bevels of the dammed-up walls of myself. *Oh shit*, I think, *oh shit*, this is *too* much! I really begin to submerge, sink down into levels of self as I feel it lift—I am dying, flowing down as the *splash!* enters the first stages of its real career issuing out of the gun, it is coming—now—out—of—the—firearm *valve*, its ordeal beats me back into ancient depths of myself, back down to some lost meaning of the male, or deep struggling germ, the cell of the meaning of Man. I almost pass into unconsciousness the rapture is so overpowering, its huge, springing, washing infiltration into Her, an eternal-like act, a Rain, I am helpless, completely at her mercy, wet in her hands, empty, aching, my ass throbbing with the drained quality of my responsive death. . . .

And she stays at it gently, knowingly, not irritating it unnecessarily, but just long enough to glide it to security discreetly, to empty it of every drop that might leave it otherwise pouting, to suck, suck, suck, suck, pull the very last crystal drop of *cokke* lotion out of me, into this special cycle of herself, beautiful! beautiful! to the last drop, and I'm in a deep sleep again. (14–15)

The Calibanism and sexism in this passage largely reside in the black male voice cursing, expressing his insatiability as he coerces a white woman to perform oral sex, and showing concomitantly what a sexual beast he is. But the preponderance of the language and its tone and rhythm here focus toward the intellectual analysis and figuration of the humanity of the male self and the sacrifice of that self to the female. There is a "pushing against the many bevels of the dammed-up walls of myself," a submersion "into levels of self," a search for the "lost meaning of the male," a giving up of the self to "Her" in a "responsive death," and a surrendering sleep at the end. When read aloud, the accelerated rhythm of the language suggests the heightened human feeling that Eli attains.

If this is true, then it would seem that Eli's tricksterism works, and he expropriates the discourse from its Calibanic, sexist context. But we should not underestimate the power of the discourse to elicit negative emotional responses that would prevent other perceptions and experiences of the text. This is particularly true today given the highly justifiable outrage in our society about sexism and female degradation through pornography.

In another section entitled "Anita," which is about a black woman, Eli curses and expresses some of the same bestial characteristics that he expressed in the quotation above. But near the end, he calls Anita the "knowledgeable Black mother of a deep wisdom, intrinsic in every fuse, every chromosome, every crevice of her epidermis, enormous in the internal cavities of her mouth, anus, the atoms of her urethra, the tissues of her every

thought, liquid of her nerves, the intelligence of her tracts, digestive system, the energy of her bladder, every foetal tissue of her, every psycho-biological process of her protoplasm!" (104). A large part of this passage subverts male privileging with language that suggests an intellectual creation and description of female humanity; in this context, the male also implies his empathy. This deemphasizes the passage's Calibanism and sexism.

But this passage has a particular significance in terms of feelings about sexism in the contemporary black community. The segment of the language that reduces the woman to a sexual object ("the internal cavities of her mouth, anus, the atoms of her urethra") will likely evoke a negative response from many readers and cause them not to look further. The sexual exploitation and abuse of black women by black men has been an issue in the public mind for some time now, and many readers (women in particular) do not tolerate this kind of sexism at any level in discourse. These readers will not see any value in separating the levels of discourse and analyzing what Eli does: the main point is that a black man subjects a black woman to his will. The text's full narrative will likely further valorize this reaction. In the narrative, Anita is never a woman whom Eli likes or appreciates. His true love is a white woman, Cathy, and he portrays Anita in very direct, unfavorable comparison to her. Probably no issue in the black community has been more of a source of controversy and anger than the contention that black men prefer white women over black women. Some black readers, in particular, will hate Eli for his preference of a white woman. Other white readers will hate him for his phallic pollution of a white woman.

Eli later describes a time with Cathy after lovemaking:

> I lay down, in the still coolness of the morning, upon the dark bed beside Cathy, who is sleeping very soundly. It is almost daybreak; the worst hour in the world has gone by, and I survived it: I am still breathing. I am *not* lonely. I feel the comfort of her closeness. There are only the sounds of the night, muffled. The city out there, being milked by the mystic revolutionaries, despite God's coming, for collateral.
>
> Our lovemaking was like a rite in a hungry hour of ritual. A cycle we needed. Grateful, now: we are transformed. The entrance behind us, yet before us.
>
> Gently, I take her into my arms, and she, like a comfortable babe not even waking up while she's handled, comes in her sleep snug against me. Her hot sleeping lips part, the kiss. The taste of night. Of Cathy, her warm sturdy flesh. Our legs lock, our sex coming together, hot.
>
> I know I will be mad when she leaves me. (132–33)

Eli objectifies Cathy less than he does the other women, tries to portray her in positive terms, and tries to show his love for her. But readers will read his

words about Cathy in the general context of the novel and experience them in terms of all the discursive weight that has accrued. The larger narrative context has helped to establish firmly an idea that prevents a positive perception of Eli.

This idea is that Eli is the Calibanic sexual predator and rapist of Cathy. Early in the novel, we have seen that Eli, in his despair and frustration over Cathy's termination of their relationship, raped her on the street (while two people watched from a room above) as he temporarily slipped into insanity and paradoxically tried to keep her through his act. Many readers will not sympathize with Eli because of his mental state and will read his act as a manifestation of his black male oversexuality and bestiality. Major himself has said that he knows he risks confirming myths and stereotypes through Eli's portrayal (*Dark and Feeling* 135). And Keith Byerman states that Eli is "very much the stereotype of the sexually prodigious black man, whose oversized penis corresponds to his insatiable sexual appetite" (258).

Eli hopes to make the point that he raises himself above this, though. Besides his attempted subversion and appropriation of discourse, Eli also establishes a clear contrast between the world inside himself and an outside world that is horrible. Eli experiences virulent racism, lives in an orphanage and experiences its callous, brutal life, sees the cruelty of a fatal stabbing on Chicago's streets, and witnesses unspeakably cruel racist atrocities as a soldier in Vietnam. Eli's internal world, where he defines himself in terms of heightened feeling that sometimes attains an altered state of intense humanity, is undeniably preferable to the world outside. In this context, Eli's Calibanic and sexist discourse obviously becomes a parody of itself; its surface meaning yields to the figuration of his internal world and its humanity. Through his appropriation and subversion of discourse, Eli practices a form of black phallic tricksterism. But of course this is only true if readers will see the need to go, or want to go, beneath the surface. (This brings me back to a consideration of the success or failure of the novel's discursive experiment, which I will make brief concluding remarks about shortly.)

Eli also wants to show that his humanity makes him a true lover. Near the end, he thinks about the "eminence of each second [he and Cathy] spent together. Only one who has known the profoundest most unselfish love, an overwhelming voluptuousness of love—only this person knows the luxury of such selfless outpouring of so much that is beautiful in loving someone" (182–83). Eli concretizes his love and humanity in the last paragraphs of the novel through the symbolic act of giving up his apartment to a destitute woman and her children (202).

Not all readers will accept or appreciate what Major has done. But it is a fact that the words and linguistic structure of *All-Night Visitors* can force the careful, sympathetic reader below the surface. Here Major deals with an

experimental redefinition of the black self by giving Eli the role of a black phallic trickster.

Major turns the discursive redefinition of self in the direction of the positive, but he reemphasizes the positive in the context of indeterminacy and open-endedness. The black phallic trickster expresses his liminality through language. The positive self evolves and reevolves continually in the tension of the language evoking it in the ever-changing situations that Eli encounters. The linguistic signifiers continually produce and reproduce the meaning of the self and text, particularly in the instances of heightened expression. There is always ambiguity. The process is ongoing, and the true, full meaning of the self remains ambiguous and open-ended.[6]

By the end of *All-Night Visitors*, Eli has "become firmly a man" (203), but this does not represent closure in the trickster's process of productive liminality. He remains keenly attuned to this development that defines him. He is "vibrantly alive," feeling the "private crevices of this *moment* [open] in me" (emphasis mine). In the last sentence in the book Eli says, "I stood there until daybreak." He looks at the dawning of a new day which will be part of the ongoing experience of self-definition in which he involves himself. This ongoing quest for the human self projects Eli above the horrible alternative experiences available to him and keeps him meaningfully alive.

My ultimate goal in this essay is to show how *All-Night Visitors* reflects the problems of black male texts and black male characterization, and I now want to look at the text as a unique male mode of expression. I would start by saying that the text depicts an individual, liminal black male self defined by language in terms of the moment. The individual male self, the self of Eli, struggles for a symbolic kind of discursive freedom in an evil present that would destroy him; the open-endedness of language as a symbol of liminal status is crucial in the struggle for freedom. The primary confinement of the black male is discursive; a linguistically symbolic liminality mediates this confinement and also isolates the male from the horrors of the everyday, physical world. And the struggle is decidedly an individual one.

Karla F. C. Holloway's *Moorings and Metaphors*, an excellent, provocative study of figures of culture and gender in black women's literature, provides a useful approach to identifying the terms by which *All-Night Visitors* reflects black male texts generally and how these texts relate to the alternative possibility of black women's texts. Several key terms provide a basis for Holloway's analysis and definition of black women's texts: motherhood, orality, community, spirituality, ancestry, (re)memory, mythology, and, most important structurally, recursion. Holloway says that, in the texts of black women, motherhood, "embraced or denied," "physiological or vis-

ceral," is central to a black woman's sense of self (26, 28). Black women's texts define themselves through recursion, "a certain depth of memory that black women's textual strategies are designed to acknowledge" (13–14). The creative potential of black motherhood is central to a sense of black female self capable of (re)membering and recovering the past and achieving wholeness through a process of recursion. Recursiveness is layers and circles of text constantly enfolding themselves (Holloway 102, fig. 1). Mythologies, the (re)membered and revised histories and self-definitions that black women generate from their collective oral, communal voices (34), layer the recursive process in both the present and past. The orally, communally generated mythologies enfold the physical world and the spiritual world. Mythologies generate (re)membered and revised black female histories that foreground black female ancestry. They draw together (re)memory and metaphor as a source of deep, powerful spirituality. The text does not directly reflect the culture of black women, but it does suggest black women's ways of doing and saying things.

Holloway finds that black male texts lack the orally, communally generated mythologies which revise history and redefine self, and they also lack the fortifying spirituality so important in black female texts (6–11). It seems to me that Holloway says that black male writers fail to find ways, potential or realized,[7] to make the black male self whole in a deeply grounded, recursive context.

I agree with Holloway, but I do not find this to be a shortcoming in *All-Night Visitors*. Like other contemporary black male texts,[8] *All-Night Visitors* concerns itself with the potentials and problems of discourse which has a strong foundation in the written Western tradition. Major manipulates language to open up liminal places in discursive traditions that confine and oppress black men. Eli's predicament is liminal and open-ended. He finds no way to restore, or potentially restore, a self mutilated by the indelible inscriptions of Western discourse and concomitantly buffeted and fractured in an oppressive everyday, physical world. But Major, like other contemporary black male writers, follows the compulsions of his physiology/race, oppressive Western culture, and black male culture.

The point about physiology/race in contemporary black male texts, especially in *All-Night Visitors*, is that the black phallus is such a physical presence and carries so much ideological weight and symbolic creative potential. Symbolically and realistically, the black phallus is different from the black womb, which is so implicitly important in Holloway's argument about black women's sense of self-centeredness in the potential for motherhood (26–31). In realistic terms, I find myself reminded of the old black saying, "Mama's baby, Papa's maybe." In other words, the black phallus can never be sure of its specific generative power. And in *All-Night Visitors*, the

black phallus is a great physical presence, but Major gives it no physical generative power. Its physical presence symbolizes the power to figure liminal places in an oppressive Western discursive tradition. But it does not carry the symbolic and actual generative potential of the womb. Its very externality and uncertain specific generative potential will not allow it to become a symbol or reality that places Eli in a deep recursive process that recovers and restores the self.

Another point about black phallic tricksterism in *All-Night Visitors*, which is true for other black male texts as well, is that the phallic trickster is always aware, on some level and to some extent, of his phallic duplicity.[9] Eli is, after all, a trickster, and in spite of genuine, sincere motives in the overall context of the novel, he realizes at some point that "[a]ll I want her for is to fuck her" (3). Phallic duplicity is tantamount to duality and fracture, and it does not have the moral weight, depth, and surety to provide a basis for full renewal. The phallus as reality and symbol offers possibility, but not potential or actual fullness and certainty. For Eli, it symbolizes the possibility of making open-ended linguistic places in an oppressive discursive tradition.

The Western discursive tradition has, of course, misrepresented black women also, which is one reason that contemporary black women writers have had to revise their representations in their own work. But the case is altogether different when one compares the possibilities that black male and female writers have for revision and reconstruction. Because of their gendered access to black female characters with a potentially very sure and full orally, communally, and recursively generated sense of self, black women writers have revised and reconstructed their portrayals on their own terms and in their own unique ways. This is, I believe, a significant part of the point of Holloway's book. But in the context of what I have said about the real and symbolic potential of black male physiology/race and the precarious moral position of black phallic tricksterism, black male writers cannot as fully escape the confines of the Western discursive tradition. Eli, the black phallic trickster, uses language to create open-ended, liminal places in the Calibanic tradition. However, he does not supplant this tradition with a new history and mythology, as do black women writers who write recursively because of their cultural grounding and gendering in black womanhood. Major has no access to a safe, sure place outside the Western discursive tradition, so he can only try to distance himself from it liminally.

Holloway and other critics make much of the supportive communities in the texts of black women writers, implicitly or explicitly criticizing the strong individuality of black male texts.[10] I believe that this is unfair and unrealistic. Black male texts, like black female texts, do not mirror culture, but the texts do indirectly reflect the culture's rituals and modes of interaction. And I would assert that the cultures of black men and women are markedly different. The culture of black women is indeed largely communal

and supportive, as Holloway says throughout her book. But the culture of black men, at least in its secular aspects, focuses itself much more toward individual assertiveness and competition. And consequently, it does not surprise me to find this individuality, particularly in the form of black tricksterism, reflected in black male texts such as *All-Night Visitors*.

I would say that signifying and playing the dozens are the dominant tropes of black male discourse and culture. Prominent black scholars have not called these tropes uniquely male, but the phallic competition and tricksterism embedded deeply in much of the discourse of the dozens and signifying do testify to their black maleness. Both Stephen Henderson and Henry Louis Gates use "Rap's Poem" by H. Rap Brown as a signature statement of signifying and black language practice.[11] Part of the poem reads as follows:

A session would start maybe by a brother saying, "Man, before you mess
with me you'd rather run rabbits, eat shit and bark at the moon." Then, if
he was talking to me, I'd tell him:
 Man, you must don't know who I am.
 I'm sweet peeter jeeter the womb beater
 The baby maker the cradle shaker
 The deerslayer the buckbinder the
 women finder
 Known from the Gold Coast to the
 rocky shores of Maine
 Rap is my name and love is my game.
 I'm the bed tucker the cock plucker the
 motherfucker
 The milkshaker the record breaker the
 population maker
 The gun-slinger the baby bringer
 The hum-dinger the pussy ringer
 The man with the terrible middle
 finger.
 The hard hitter the bullshitter the poly-
 pussy getter
 The beast from the East the Judge the
 sludge
 The women's pet the men's fret and the
 punks' pin-up boy,
 They call me Rap the dicker the ass
 kicker
 The cherry picker the city slicker
 the titty licker (Henderson 187–88; Gates 72–73)

The poem ends on an individual competitive note: "And ain't nothing bad 'bout you but your breath" (Henderson 188; Gates 73).

The signifying language play of much of the quotation suggests a phallic trickster who is duplicitous, but duplicitous phallic virtuosity is a concomitant of subversive linguistic virtuosity. Brown implies a subversion of white discourse in a quotation that Gates uses from Brown's *Die, Nigger, Die!*: " 'I learned to talk in the street . . . not from reading Dick and Jane going to the zoo and all that simple shit' " (72). I find "Rap's Poem" to be very male, very competitive, and linguistically subversive. And in spite of the group interaction and call and response implied here, the intention of this competition is to achieve individual ends, to see who can prove himself the baddest and set himself apart from the group, as one to be revered and perhaps even feared. This is individual expression that constantly addresses the ongoing moments of black male cultural interaction and, implicitly, the confining places of white discourse and culture.[12]

Black male texts such as *All-Night Visitors* will reflect this black male tricksterism and linguistic virtuosity that is ultimately subversive, and they will also reflect an individuality that is basic to black male culture, that is deeply embedded in its cultural tropes. Eli sets himself apart and does not competitively signify in a black male cultural context. But he very much makes himself the individual phallic trickster whose phallic virtuosity coincides with his subversive linguistic virtuosity. In the overall setting of *All-Night Visitors*, Eli's way is a black male way of creating liminal space for himself. This black male way can only reflect the imperatives of physiology/ race, oppressive white culture, and black male culture.

Clarence Major has always gone in directions that other "serious" black writers have not taken and done things that other "serious" black writers have not done, and the risqué portrayal of Eli in *All-Night Visitors* is part of this experiment. I am saying that *All-Night Visitors* is clearly a black male writer's kind of experiment, dictated in significant ways by the ineluctable forces of black and white culture and physiology/race. Major becomes more radically experimental as his career develops. His stylistic and structural interests, similar to those in *All-Night Visitors*, almost always concern themselves with the limitations of the text and of discursive expressiveness. This, too, is very much a proclivity of several contemporary black male writers.[13] This stands in contrast to the texts of contemporary black women writers in which the authors successfully break the limitations of Western discourse by (re)membering, redefining, empowering, and making whole (actually or potentially) black female characters. So Major's experimentation does increasingly follow the direction of radical white postmodernists and metafictionists; however, it also follows a line that is distinctly contemporary black male.

1. See *The Tempest*, act 1, scene 2, lines 321–74.

2. See Spillers essay. I am indebted to her for her insights about the Retamar essay and for her very fine analysis of the various manifestations of Calibanism in narrative discourse.

3. See Wideman, 115–16, 120–22, 125–51. Wideman does a lot to reinforce my point about the pervasive effect of Shakespeare's Calibanism on Western discourse and consequently on black people. The writer/character in Wideman's text tries, unsuccessfully, to rewrite *The Tempest* to give it a different outcome and change Caliban's fortunes. (On page 140, the text says that "Caliban . . . gets . . . exiled, dispossessed, [and made a] stranger in his own land . . . gets named just about every beast in the ark, the bestiary, called out his name so often it's a wonder anybody remembers it and maybe nobody does.") Because in Wideman's text fictive discourse, or Western fictive discourse at least, shapes reality, rewriting *The Tempest* would change an important root source of much Western discourse and change the oppressive circumstances of black Americans, particularly those of black males such as the writer/character and his son, who is locked away in a prison solitary-confinement cell (115–16).

4. See hooks, 57–64. In analyzing the famous Central Park rape case and the white feminist response to it, hooks asks, "[W]hy is black male sexism evoked [by white feminists] as though it is a special brand of this social disorder, more dangerous, more abhorrent and life threatening than the sexism that pervades the culture as a whole, or the sexism that informs white male domination of women?" (62). hooks comes down hard on black male sexism but suggests that contemporary white feminism attributes a special virulence to black men, thus stereotyping them and reinforcing old racist patterns.

5. Obviously, my general theory of black male texts will not apply to every writer and every text; however, no theory is ever all inclusive. And this short essay, focusing specifically on *All-Night Visitors*, is not the place to draw out the full dimensions of my theory. Here, I just lay out its dimensions broadly enough to cover the text I am discussing. I want to say, however, that black male writers have similar concerns with discursivity and textuality and tend to problematize the portrayal of the black male self, or at least to make it tentative and open-ended (see notes 7 and 9 below). It is the foregrounding of tentativeness and open-endedness that significantly accounts for liminality in the text of contemporary black male writers. My theory of black male writing covers writers as divergent as Ishmael Reed, John Edgar Wideman, Reginald McKnight, Randall Kenan, Charles Johnson, Clarence Major, and Trey Ellis.

6. Signifiers producing open-ended meaning and indeterminacy bring to mind Henry Louis Gates's analysis of his central trope of signifyin(g) in *The Signifying Monkey*. See my later discussion in this essay of the male tropes of signifying and playing the dozens. In this discussion, I show that signifying is the technique of the black phallic trickster.

7. I am implying here a much fuller restorative process in the texts of contemporary black women writers. However, the process in black women's texts is by no means an easy, simple one, and in texts such as Toni Morrison's *Beloved*, for example, it is not necessarily a successful one. But my point is that the potential for restoration does exist in black female character, the black female self, because of the physiological and cultural resources that Karla Holloway talks about in her book. I

mean, more specifically, a sense of self grounded in motherhood (Holloway 26–31) and the mythologies, generated from black women's collective oral, communal voices, that give them the potential to revise their histories and define themselves anew (34). Holloway uses the critical term recursion in her analysis of this process (13–14, 102).

8. Charles Johnson's *Oxherding Tale* and *Middle Passage* and John Wideman's *Philadelphia Fire* are very clear examples of other black male texts.

9. It seems to me that the awareness of phallic duplicity is pretty widespread in the texts of black male writers. It has various forms of manifestation, and black male characters view it with different degrees of seriousness. In chapter 2 of Ralph Ellison's *Invisible Man*, Trueblood weaves an elaborate story, set around a Freudian-type dream, to explain his sex with his daughter. There certainly could be phallic duplicity that Trueblood is aware of, but the text leaves unclear its moral significance here. The invisible narrator in the Sybil scene of chapter 24 of *Invisible Man* tries to practice phallic tricksterism and ends up with ambiguous results. The scene is comic in some ways, and the narrator seems to become aware of his phallic duplicity and its ineffectiveness. In John Wideman's *Philadelphia Fire*, on the other hand, phallic duplicity takes a different form and presents a possibly more serious moral problem. See the section in the novel (63–65) in which the older, ostensibly more responsible writer/character watches, sexually aroused, as the young daughter of his friend and father figure takes a shower. There is a symbolic violation here, and the writer/character reveals a duplicitous self that he would not want revealed.

10. It has become fashionable to criticize black male writers for a number of reasons, and their emphasis on individuality instead of community is one of them. I hear critics and commentators making this criticism in my classes, at literary conferences, and in private conversations. A critical text that states this more explicitly is Mary Helen Washington's *Invented Lives*. See the introduction, "'The Darkened Eye Restored': Notes toward a Literary History of Black Women," especially page xxi.

11. In *Understanding the New Black Poetry*, Stephen Henderson uses the poem as the first piece in section 3 of his critical anthology, entitled "The New Black Consciousness, The Same Difference." Henderson wants, I think, to indicate that Rap's language practice shows the new black assertiveness and confidence of the 1960s and 1970s and embodies attitudes, rituals, and modes of behavior that are very central in black culture. The maleness of Rap's rap makes it clear to me that it is strongly indicative of black male culture.

12. Of course, black women and also white people can signify, especially since, as Gates quotes from Roger D. Abrahams, signifying can "'denote speaking with the hands and eyes'" (75). But first and foremost, signifying is the "black person's use of figurative modes of language use" (74). And I argue that these "figurative modes of language use" are predominantly masculine. Black women may signify, especially through innuendo and indirection, but the primary modes of rhetorical figuration are practiced, with great intention, in black male culture. And perhaps it is true that these modes sift into black female culture. Based on what Holloway says in her chapter "Mythologies" (85–109), I would, at the risk of too heavily extrapolating black women's culture from a textual analysis, say that the oral creation of female mythologies, a mode of language practice and storytelling different from signifying, defines black women's culture. What most clearly distinguishes my-

thologizing from signifying is that it is not language play, competitive or uncompetitive, in the way that signifying is, and similarly, indirection is not its purpose.

Signifying for black males takes other overt forms than the signifying phallic tricksterism of "Rap's Poem." Gates quotes another example of signifying from Brown:

Man, I can't win for losing.
If it wasn't for bad luck, I wouldn't have no luck at all.
I been having buzzard luck
Can't kill nothing and won't nothing die
I'm living on the welfare and things is stormy
They borrowing their shit from the Salvation Army
But things bound to get better 'cause they can't get no worse
I'm just like the blind man, standing by a broken window
I don't feel no pain.
But it's your world
You the man I pay rent to
If I had you hands I'd give 'way both my arms.
Cause I could do without them
I'm the man but you the main man
I read the books you write
You set the pace in the race I run
Why, you always in good form
You got more foam than Alka Seltzer. (74)

The repeated references to "man" emphasize the masculinity of this discourse.

13. Some of these writers are Trey Ellis, Randall Kenan, John Wideman, Ishmael Reed, and Charles Johnson. These writers do not all foreground the limitations of the text and discursive expressiveness in the same way and to the same extent. Reed and Johnson, for example, celebrate discursivity more than they agonize about its limitations. Nevertheless, they do thematize textuality and discursivity. And they may extend and revise Western discursive constructs (and this seems particularly true for Reed), but their process of extension and revision still acknowledges the powerful influence of Western discourse on black characterization. They never recursively break free as much as black women writers do.

WORKS CITED

Baker, Houston A., Jr. *Blues, Ideology, and Afro-American Literature: A Vernacular Theory*. Chicago: University of Chicago Press, 1984.

Bakhtin, Mikhail. *The Dialogic Imagination: Four Essays*. Translated by Caryl Emerson and Michael Holquist. Austin: University of Texas Press, 1981.

Brown, H. Rap. *Die, Nigger, Die!* New York: Dial Press, 1969.

Byerman, Keith. *Fingering the Jagged Grain: Tradition and Form in Recent Black Fiction*. Athens: University of Georgia Press, 1985.

Ellison, Ralph. *Invisible Man*. New York: Random House, 1952.

Gates, Henry Louis, Jr. *The Signifying Monkey: A Theory of Afro-American Literary Criticism*. New York: Oxford University Press, 1988.

Henderson, Stephen. *Understanding the New Black Poetry: Black Speech and Black Music as Poetic References*. New York: Morrow, 1973.

Holloway, Karla F. C. *Moorings and Metaphors: Figures of Culture and Gender in Black Women's Literature*. New Brunswick: Rutgers University Press, 1992.

hooks, bell. *Yearning: Race, Gender, and Cultural Politics*. Boston: South End Press, 1990.

Johnson, Charles. *Middle Passage*. New York: Macmillan, 1990.

——. *Oxherding Tale*. New York: Grove Press, 1982.

Major, Clarence. *All-Night Visitors*. New York: Olympia Press, 1969.

——. *The Dark and Feeling: Black American Writers and Their Work*. New York: Third Press, 1974.

Morrison, Toni. *Beloved*. New York: Knopf, 1987.

Retamar, Roberto Fernandez. "Caliban: Notes toward a Discussion of Culture in Our America." *Massachusetts Review* 15, no. 1–2 (Winter/Spring 1974): 7–72.

Spillers, Hortense. "Who Cuts the Border? Some Readings on 'America.'" Introduction to *Comparative American Identities: Race, Sex, and Nationality in the Modern Text*, edited by Hortense Spillers. New York: Routledge, 1991.

Turner, Victor. *The Forest of Symbols: Aspects of Ndembu Ritual*. Ithaca: Cornell University Press, 1967.

Washington, Mary Helen. *Invented Lives: Narratives of Black Women, 1860–1960*. New York: Doubleday, 1987.

Wideman, John Edgar. *Philadelphia Fire*. New York: Holt, 1990.

"I Was a Weird Example of Art"

My Amputations as Cubist Confession

STUART KLAWANS

If you were to cut away the frame from Clarence Major's *My Amputations*—lopping off the memoirs (whether real or imagined), the slapstick crime story, the fantasies borrowed from porn movies and spy novels—you would be left with the story of a writer on a lecture tour. Mason Ellis, who bounces from city to city across three continents, spends most of his fictional life encountering new forms of food and drink, new landscapes and traffic patterns, new audiences and colleagues and policemen before whom he must explain himself. Under the circumstances, even a character more self-assured than Mason might begin to feel disoriented. Try it yourself.

The text of *My Amputations* is broken into discontinuous fragments, much as a traveling lecturer's time and space are fractured, so that you pick your way through the pieces—some as short as one-third of a page, none longer than eight pages—with a feeling that reality has become unreliable. At any moment, the people you were so busy with might disappear, as you find yourself plunged without transition into a new setting.

Your experience as a reader of *My Amputations* mimics the protagonist's experience, but at the same time, you also stand apart from Mason, playing the role of audience—puzzled, entertained, appalled—during his improbable performances. If you think of the various sections of the book as lectures, then it's also fair to say that the novel provides accompanying slide illustrations. As Mason careens from place to place, appropriate works of art pop up in the background. While he is in France, images by Cézanne, Gauguin, van Gogh flash before you. When Mason moves on to Germany, the images change—you see pictures by George Grosz and Edvard Munch, and perhaps a few stills from a Fritz Lang film. The Italian leg of the tour comes illustrated by Modigliani and the Venetian masters; the trip through Greece involves much wandering through archaeological sites and the halls of museums. When last seen, Mason has all but merged with a work of visual art. He sits in a Liberian village, hidden behind a wooden mask.

Considering this abundance of references, it is risky to give precedence to any one artist or style of art in *My Amputations*. Because there is little sense of hierarchy, the reader can't easily decide which details might be thematic and which are merely local color. Then again, that sense of undecidability might itself be one of the book's themes. *My Amputations* has as its subject a narrator, an "I" (presumably the contemporary African

Originally appeared in *African American Review* 28, no. 1 (Spring 1994): 77–87. © 1994 by Stuart Klawans. Reprinted by permission.

American author Clarence Major). The book's object, or "ME," is its protagonist, a contemporary African American madman named Mason Ellis. It is Mason's principal delusion that *he* is the author; his place, he believes, has been usurped by a contemporary African American with the initials C.M. So much for the certainties of *My Amputations*. Beyond them, we get onto slippery footing. Is the book's "ME" trying to supplant its "I"? Or is the book's "I" (a respectable fellow, with academic credentials) trying to separate himself from the disreputable, low-life "ME"? Why is the biography of the former so teasingly similar to that of the latter? And who is this poor stiff C.M., other than an innocent bystander caught in the crossfire between "I" and "ME"? These shifting, undecidable relationships among "I," "ME," and C.M. are of a piece with the shifting, fragmented world of *My Amputations*. Within that world, with its many cultural citations, there is only one type of art that provides a counterpart to such willful uncertainty: Cubism.

I don't say that Cubism is of any use in *explaining* the book. Cubism has never been much good for explaining anything. But if we abandon the notion that there might be a code to *My Amputations*—the false hope that we might somehow translate the book into a straightforward set of propositions—then we might also see that Cubism is at work in the novel, encouraging just such an abandonment. Cubism serves as a model, an incitement, and a justification for *My Amputations*. It also acts as a thematic spur, digging into the aggravated nerve that throbs all the way through the novel—the anger and anxiety of one African American artist at being attracted to the avant-garde and simultaneously shoved away by it:

> He jus' grew: Chicago, 1955: there's Mason along the lakeshore: gulls cry. . . . He claims he swallowed the lake. Art Institute's lions roared at traffic. Ashtrays and pink salmon. Calendars without dates. A private collage: he was reborn constantly in it: to the gills he settled in this stuff. . . . He came to realize he wanted it all flat or upright and permanent like cubism—like things: surfaces. (2–3)

From 1952 through 1954, Clarence Major studied at the School of the Art Institute of Chicago. We may assume he was as impressionable as any other teenager and similarly ready for novelty and rebellion. So the Art Institute in that period was probably a good place for him. While the school provided a staid-enough academic training, the museum next door would have given him a vivid example of avant-garde agitation through the work of its curator for modern art, Katharine Kuh.

Chicagoans with long memories will recall that Kuh got her start in the 1930s running a pioneering gallery of modern art on North Michigan Avenue (see Klawans). The works she exhibited aroused such outrage that

several wives of Art Institute trustees—members of a group called Sanity in Art—made a habit of disrupting her business. (On one occasion, through clumsiness, they even smashed a window.) But Kuh also had supporters, among them the director of the Art Institute, Daniel Catton Rich. In 1943 he hired her, slipping her past the trustees by first putting her into noncuratorial jobs.

By the time young Clarence Major began frequenting the Institute, Kuh had revolutionized the museum's annual surveys of contemporary art—which before had been chock full of the provincial and the pallid—and had begun an aggressive program of acquiring modern art for the museum. For example, in the year before Major began his studies, she contrived to buy Willem de Kooning's painting *Excavation* after exhibiting it in the annual survey of American art. The passage of forty years has confirmed Kuh's judgment, but at the time, the response of a highly attentive public ranged from mockery to fury. "Kuh-Kuh Must Go" ran the headline in one of the daily newspapers.

So Clarence Major got his earliest formal introduction to the visual arts in a time and place where modernism still had its full power to shock. *Excavation* would not have caused a public fuss in New York at that point, while Cincinnati, say, or St. Louis might not have shown the picture at all. Chicago was both cosmopolitan enough to notice the painting and conservative enough to loathe it.

We must distinguish, though, between the response de Kooning got in Chicago in the 1950s and the response toward artists such as Robert Mapplethorpe, Andres Serrano, and Karen Finley in the 1980s. In the latter cases, the shock came in reaction to an explicit sexual, religious, or political content in the art. The shock at de Kooning's Abstract Expressionism was more a reaction to the work's form. Abstract Expressionist pictures looked crude, unstructured, meaningless. There was "nothing in them"—that is, no representations of identifiable objects. As it happened, *Excavation* did include fragmented images of the human figure—but to a casual observer, "a five-year-old kid could have made them."

Still, a young man with a lively intelligence and a love of art might have wondered what the ruckus was about. *Excavation* and other up-to-the-minute paintings were highly abstract and made with little apparent skill. But why should such formal traits make people angry? Was there some *implicit* provocation—perhaps an outrageous subject matter, hidden behind the weird style? An inquiry would have led Clarence Major, sooner or later, to the resoundingly ambiguous answer. The stylistic experiments of Abstract Expressionism had their origins half a century earlier in Cubism, and Cubism either did or did not have roots in Africa. In a sense, the offensive subject matter—if it existed—would have been Clarence Major

himself. Perhaps he, or one of his cousins, was concealed in abstract art, and that was part of the reason why so many people didn't like it.

We broach the vexing topic of "primitivism." If I have introduced it in the subjunctive, that is because art historians today are still debating over the nature and degree of influence that African objects had on Pablo Picasso during the crucial years 1907–12. When Clarence Major first learned about Cubism, the topic was even more confused. There was only one reliable book on the subject: Robert Goldwater's 1938 *Primitivism in Modern Painting*. Discussions of "primitivism" in more general texts tended to be superficial, often including, however inadvertently, a measure of misinformation. From this relatively small body of literature, one quickly passed to the ideas that were "in the air"—or on the top of the head of some self-appointed critic.

Between the First and Second World Wars, popular notions about "primitivism" were being formed by writers such as Marius de Zayas. De Zayas helped to organize a major exhibition of African art at Alfred Stieglitz's "291" gallery in New York in 1914 (Rubin 260). He also wrote a book, published in 1916, titled *African Art: Its Influence on Modern Art*. We may note two features of de Zayas's theorizing: he overestimated the role that African art played in the development of Cubism, and he grossly undervalued the intelligence of Africans.

De Zayas claimed that modernist abstraction as a whole was the "offspring" of African art, which was in particular the "point of departure" for the "complete evolution" of Picasso's work. But de Zayas's howlers went beyond the aesthetic to the anthropological:

> [T]he cerebral condition of the Negro savage is particularly primitive, and . . . his brain keeps the conditional state of the first state of the evolution of the human race. . . . Though the eye of the Negro sees form in its natural aspect, the state of his brain is unable to understand it and retain it in his memory under that aspect. . . . He does not reason; and does not make comparisons to obtain relative values, because he does not possess the faculty of analysis. (quoted in Rubin 260 nn60, 61)

Now, such attitudes were a long way off from Picasso's thoughts about Africans. Picasso praised Africans' masks and sculptures precisely because the image-making in them was *raisonnable*—that is, conceptual. For example, Picasso had learned as an art student how to model the human figure in clay, making holes for the eyes. So it was a moment of illumination for him when he saw how an African mask-maker had represented the eyes in exactly the opposite way—not as holes in the surface, but as protruding cylin-

ders. Instead of mimicking the *appearance* of eyes (as in naturalistic art), the African artist had felt free to invent an *idea* about eyes (Rubin 18–19).

Some scholars have adopted the shorthand term "intellectual Primitivism" to refer to this aspect of Picasso's admiration for tribal art. But, while marveling at the conceptual *process* of African image-makers, Picasso also recognized the spiritual and emotional *function* of their objects. The shorthand term for this related intuition is "magical Primitivism"—a name that should not bother us, so long as we understand that Picasso was not necessarily imagining tribal people as a savage, superstitious Other. In fact, in his first celebrated encounter with African and Oceanic art, he seems to have felt that the objects were speaking directly to *his* emotions and *his* spiritual state.

In June 1907, Picasso visited the ethnological museum in Paris's Palais du Trocadéro, where the African and Oceanic objects on display affected him profoundly. At various times, he spoke of their "shock," "revelation," "charge," and "force." "For me the [tribal] masks were not just sculptures," he told André Malraux. "They were magical objects . . . intercessors. . . . They were weapons—to keep people from being ruled by spirits, to help free themselves" (quoted in Rubin 255). Evidently, Picasso at that moment felt in need of exorcism. Using the experience in the Palais du Trocadéro both as an inspiration and as confirmation of his existing impulses, he at last completed his breakthrough painting, a spirit-chasing image meant to free him from the demons of sex and death: *Les Demoiselles d'Avignon*.

At the moment of Picasso's breakthrough, "magical Primitivism" was therefore more important to him than "intellectual Primitivism." The next year, though, Picasso and Georges Braque began inching their way into Cubism, producing a much different type of art. The *Demoiselles* was a large-scale, horrifically ugly, garishly colored, Expressionistic image of a brothel. Picasso's Cubist pictures, from 1908 to 1912, were smaller in scale, muted in their colors and effects of light, moody, delicate, and cerebral in tone. Also, instead of representing a disturbing subject, they relied on traditional, inoffensive studio subjects such as the still life and the portrait. If Picasso in 1907 had been exorcising the demons of sex and death, he now was wrestling with the spirits of his ancestors—the Old Masters of European high art.

So from 1908 through 1912—the years of Analytic Cubism—the influence of African art became less directly apparent. Or rather, the conceptual aspect of tribal image-making became quietly pervasive, as Picasso and Braque emphasized the invention of forms over and against the representation of objects. "Intellectual Primitivism" had taken the lead. Then, in 1912, Picasso and Braque moved into a second phase of their long experiment, called Synthetic Cubism. They began to make collages, which were brighter

in color and jazzier in mood. Here, too, we may discern the influence of "intellectual Primitivism," which now was coupled once again with some of the emotional tenor of tribal art. It still would have been difficult to point to any particular visual element and say that it came from Africa, but a sensitive viewer might have recognized in Synthetic Cubism a kinship with the playful, satiric side of tribal art.

Of course, the account I have just given would not have been heard by Clarence Major in the 1950s—let alone by Mason Ellis, given his haphazard education. Back then, Cubism was commonly said to have begun with the *Demoiselles*, which had become the best known of all Cubist pictures, even though it wasn't Cubist. Moreover, the African influence in the *Demoiselles* was often said to be direct; the faces of the two figures on the right side of the painting were believed to have been based on specific tribal masks, even though Picasso could not have seen any comparable masks in 1907 Paris.

Picasso himself further confused the issue. Disgusted at the ignorant speculations that were circulating about his work, he struck back by fudging the chronology. "[F]rom World War II onward," William Rubin has written, "Picasso consistently claimed not only to have seen no tribal art prior to painting the *Demoiselles*, but that his celebrated visit to the Trocadéro had followed rather than preceded the painting's execution" (260).

All this made it seem as if "primitivism" of the magical variety had played a big role in the development of Cubism, and not just of the *Demoiselles*. And that led to a further misunderstanding. People expected to see visible evidence of something "African"—meaning grotesque and savage—in Analytic Cubism. Failing to find it, the more thoughtful viewers could then consult Picasso's phony chronology and confirm their skepticism. Evidently, the Cubist project had been based on Cézanne after all, and the African influence was incidental. So there existed a strange situation: nobody doubted that African art lay behind Cubism, and yet nobody could say how or why it was there.

All that was needed to complete the conundrum was a bit of racism. As Rubin notes, "The Cubist artist's notion that there was something important to be learned from the sculpture of tribal peoples—an art whose appearance and assumptions were dramatically opposed to prevailing aesthetic canons—could only be taken by bourgeois culture as an attack upon its values" (7). Or, in the even more frank language of Robert Rosenblum: "Looked at in the context of the Western artistic tradition of the nude, . . . African sculpture . . . is unbearably ugly" (25).

In other words, Cubism deliberately offended the aesthetic assumptions of the European bourgeois public—assumptions that easily slipped from the aesthetic to the racial, as the above-cited quotations from Marius de Zayas make clear. Does this mean that modern artists and their supporters

were necessarily bigots? No. In fact, many of them had a profound respect for African image-makers and felt a great affinity for their work. It is also important to note that certain artists of color—Wifredo Lam, for example—rejoiced that Europeans had begun to appreciate the artwork of tribal people. For Lam—and perhaps for the young Clarence Major—the European emulation of African art was a source of pride, and a good reason for signing up with the avant-garde.

But aesthetic movements, like political ones, are never entirely progressive. By professing to like tribal sculptures, the modernists were turning accepted values upside down, asserting that African carvers were more admirable than European academicians. This was an insult—and for it to sting properly, Europeans *had to keep believing* that Africans were inferior. For some artists, such as Picasso, the excitement of discovering African art far outweighed this fun of razzing Europe's middle class. Still, there was an inherent contradiction in the relationship between modern art *as a movement* and the "primitive" art it admired. Modernism could retain its full power only so long as the mainstream of white society remained racist.

The very term for tribal art adopted by artists and critics before the First World War—*art négre*—tells us something about the nature of the insult to Europeans. "The usual translation of 'art négre' as 'Negro Art,' loses something of the pejorative flavor of the French 'négre,' " Rubin notes, with considerable delicacy (74). Let's be more open about it: these people were boasting that they liked Nigger Art. As Arthur Rimbaud had written forty years earlier, condemning the society around him in "A Season in Hell": "I am an animal, a nigger. But I can be saved. You're all fake niggers. . . . Merchant, you're a nigger; magistrate, you're a nigger; general, you're a nigger" (my translation).

How would a young African American have felt when he realized that the most adventurous, most revolutionary art movement of his time derived part of its appeal from calling him a "nigger"? How would he have felt when he learned that the century's most exciting art had borrowed something from African sculpture, but nobody could say what? Was there room for the likes of Clarence Major in Cubism? If so, would he be the unrecognized hero of this artistic movement, or its buffoon—the "I," or the "ME"?

So far, I have tried to suggest the ambiguities of feeling that might have formed around the subject of Cubism when Clarence Major first learned about it in the 1950s. Now it is time to talk about the 1980s, when Major wrote *My Amputations*.

To begin again, *My Amputations* is the story of a writer on a lecture tour. Or perhaps it is about an impostor who is posing as a writer on a lecture

tour. Mason Ellis, a petty criminal and half-mad autodidact, is apparently pretending to be a certain African American author, whose initials are C.M. The book's narrator professes to find this imposture pitiable. And yet, the longer Mason keeps up the impersonation, the more he comes to resemble a jumpy, self-doubting, real-life writer—which makes him a more convincing character than the imperturbable, omniscient Author. Is Mason a projection of Clarence Major's internal sense of self, and therefore more substantial than "I," the book's see-through persona? Or is the "I" authentic and internal, while Mason is the mask that cannot be removed—the outward image of the Ghetto Black, which adheres to the narrator no matter how many foundation grants he wins?

While we let those questions hang unanswered in the air, let us think about an exceptionally suggestive passage in the novel. Mason has recently obtained a fake passport, that "proves" his identity as the Author. To make sure that this identity will not be challenged, he has put the unfortunate C.M. on a freight train bound west. So much for the Author—or, as Mason sees him, the Impostor. Now Mason must accomplish only one more task in order to take the place of C.M. He must figure out what the hell the critics mean when they call C.M. postmodern:

> Maybe The Impostor *believed* the text represented nothing outside itself. I don't, thought Mason. . . . Text as permanent property—free of outside clut. Okay. Like Cubism: a peeled conceptual orange oozing Cezanne's blood and sperm: synthetic, analytical, geometric. . . . *Hay*, shouldn't he cut out this shit and call a speakers' bureau? After all, he was a well-known author in need of some immediate action. (54)

At the moment when he impulsively decides to sign up for a lecture tour, thus setting off the main action of the novel, Mason is thinking about Cubism. We should note that "primitivism" plays no role in his thoughts at this point. Concentrating entirely on questions of form, rather than of context or subject matter, he focuses on an imputed sense of permanence in Cubism and in the works of Cubism's main forebear, Paul Cézanne.

In this, Mason is consistent with the art history that would have been available to Clarence Major in the 1950s. To quote Herbert Read, writing in 1959: Cézanne hoped "that the confused sensations of the artist might crystallize into their own lucid order" (20). With Cubism, Picasso and Braque at last achieved "the liberation for which the artistic spirit of the world had been waiting." They "passed beyond a structure which *interpreted* the seen object to the creation of a structure which though *suggested* by the seen object existed by virtue of its own monumental coherence and power" (Read 95–96).

In this view of the subject, Cubist pictures do not refer to any significant

degree to the material world. They are complete in themselves, turning the chaos of experience into the stability of art. But Mason intuits that worldly experience won't go away so easily. Cézanne's oranges might be ideal constructions, but Mason imagines them dripping with the real blood and sperm of a real painter.

Similarly, postmodernists claim that literary texts do not refer to the world but only to themselves and other texts. Individual, lived experience plays a minor role at best in the making of these texts; therefore, the author ought to be banished from literary discussions as an unnecessary fiction. Mason, too, banishes the Author. In his literal-minded way, he actually dumps C.M. into a boxcar, sending him on a one-way ride. Even so, Mason does not accept the idea that texts might exist apart from flesh-and-blood writers. As he insists before a puzzled audience at Sarah Lawrence: " 'The text is not just a pretext. I stand before you. I am not the object of the text' " (65).

This is not the first time that a fictional character has claimed the right to an independent existence. This *is*, however, the most troubled relationship I've seen between a writer and his fictional double. The invented "ME" wants to supplant C.M., but he's also the one trying to rescue the writer's very sense of existence. It's Mason who bears the writer's blood and sperm. As if ungrateful, the writer goes on hitting Mason with a nonstop barrage of custard pies. Mason is subjected to the narrator's derision ("I strain to find something good to say" [15]); told by a pick-up that the *real* author has a bigger penis (70); made to take the blame for the author's relative lack of success (" 'If you're so terrific how come I never heard of you?' " [59]); and run through an obstacle course of terrorist attacks (passim). How fortunate for Mason that he is wrong about his own existence—he *is* the object of the text, and so he can't really be harmed. How unfortunate for Clarence Major that he should stand in harm's way outside of the text, while sharing so many details of Mason's biography.

Perhaps any writer of the postmodern era might have played such a duplicitous game with himself (and so with his readers). In the prepostmodern era, Vladimir Nabokov got as far as being quadruplicitous. We need not ask whether Clarence Major (or any other living writer) can match Nabokov's verbal dexterity and sinister architectonics. Those books have been written; there's no need to write them again. The question, rather, is whether Clarence Major brings a meaning of his own to the game, with his own emotional force. How is it fitting, how is it urgent, for such a fiction to be written by an African American?

Let Mason speak; he's dying to: "I needn't tell you I'm not the Invisible Man; yet race—or its absence—remains part of my identity" (64). So, too, is race (or its absence) part of the identity of modern art in general and of Cubism in particular. That's the connection (not a forced one, I hope)

animating the novel, the link between all the themes: tribal/modern; African American/citizen of the world; flesh-and-blood writer/fictional character. Like a shred of something real (a scrap of newspaper, say) inserted into the unreal, impossible space of a Cubist collage, Mason is "a weird example of Art" (66)—"primitive," contradictory, on the loose in the modern (European) world but destined to wind up in Liberia behind a tribal mask.

He is trying to take the place of C.M., who in turn seems to want to take the place of Claude McKay—"a forgotten Jamaican writer," as a sneering character puts it, "who thought of himself as *international*" (22). Can Mason become international? In Florence, "he look[s] into the facade of the city: workers in stone had made it a towering monument to something he reluctantly understood" (135–36). He pays that something his respects, wandering through the Uffizi Gallery and the Medici Chapel, kneeling in front of Dante's house. But will European culture respect him back? In Athens, at the National Museum, he tries to elicit a sign of recognition from a Cycladic figure: "From her stern place as mother goddess and model for modern sculpture she refused to respond. Mason was unworthy? Insulted, he rushed on. Goddess Hygieia? She would not heal him" (153–54).

And so it goes. Europe gives Mason the come-on and then the get-lost, but Africa proves to be no more comfortable for him. " 'Welcome home, Brother,' " someone says in Ghana. Mason responds with thanks. "But did Mason feel at home? How black was Blackface Hermes?" (182). We find out at the end of the novel. Mason discovers, despite his earlier protestations, that he *is* the Invisible Man—or someone awfully damn close.

So far, I've talked about Mason as if he were exclusively a double for Clarence Major. But he also bears traces of Ralph Ellison's Invisible Man, of Richard Wright's Cross Damon in *The Outsider*, of Herman Melville's Confidence Man, even of Daniel Defoe's Moll Flanders. He is a figure drawn from life but also from art. He is shifting and multiple. In short, he really is like a work of Cubism.

Though Cézanne may indeed have wanted to transform the chaos of experience into an art that was stable and monumental, the Cubists wanted to transform unstable experience into unstable art. In Analytic Cubism, the highlights and shadows are blatantly contradictory; Picasso and Braque make light fall on objects in impossible ways. The space is an insoluble puzzle. You can rarely be sure that a plane is in front of another plane, rather than behind it; the background might be the foreground, and vice versa. Sometimes a patch of brushwork will seem to describe an object, but at other times, the brushwork will go off on its own, independent of any hint of an object. There's no consistency. You might say that an Analytic

Cubist picture mimics experience, evoking the subject as if through memories and fleeting glances. (The reality of a Cubist picture, Picasso said, is like the reality of a whiff of perfume—it's nowhere in particular but everywhere at once, surrounding you.) But the subject being evoked is not just Picasso's experience of this arrangement of fruit, or of that lover. The experience also encompasses *other* still lifes and *other* portraits, as they have been painted by everyone from Velázquez and Rembrandt to Corot and Cézanne.

By this point, I should not have to spell out the similarities between such paintings and *My Amputations*—a book made up of jagged, discontinuous, paradoxical fragments, which evoke or suggest (but never flat-out represent) someone who is both a figure drawn from life and a recollection of other fictional characters. Nor should I have to go into much detail when I note that Synthetic Cubist collages make use of all sorts of homely materials culled from popular culture—materials as homely as the detective stories and spy stories and porn-movie couplings that get glued into *My Amputations*. The connections are there, for readers who want to find them. What matters is the experience of reading—that, and the character who is revealed to us in the book, as if we were meeting him face to face.

On the cover of *My Amputations* is a self-portrait by Clarence Major not Cubist, but unmistakably modern all the same. The figure stands front and center in the sheet, facing outward, in a pose that's unusual for self-portraits. (Why is it unusual? Because it's an awkward way to work. You're almost guaranteed to come up with an expression of unease.) The mouth is pouting and seems to frown. The brow is furrowed. The almond-shaped eyes stare straight ahead—making you, as the viewer, acutely aware that you're in the mirror's place.

Is this figure copying his image from the mirror? Or does he see himself when he looks at you? Is he drawing the self-portrait you're now studying? Or is some other image taking shape on that unwieldy sheet of paper he's cradling in his arm? You can't tell—any more than you can tell whether the rectangle over his right shoulder is a painting hanging on the wall or a window opening onto a scene beyond. The left hand, supporting the sheet of paper, seems isolated against that white field. Cut off from its relationship with the rest of the body, the hand might be signaling—though the meaning of its gesture is unreadable. As for the other hand, you can't see it at all. Maybe it's at work behind that white expanse. Then again, maybe it's been amputated.

WORKS CITED

Klawans, Stuart. *Twentieth-Century Painting and Sculpture at the Art Institute of Chicago: An Informal History*. Chicago: Department of Public Information, Art Institute of Chicago, n.d.

Major, Clarence. *My Amputations*. New York: Fiction Collective, 1986.

Read, Herbert. *A Concise History of Modern Painting*. Rev. ed. New York: Praeger, 1968.

Rimbaud, Arthur. *Poésies Complètes*. Paris: Gallimard, 1963.

Rosenblum, Robert. *Cubism and Twentieth-Century Art*. New York: Abrams, 1976.

Rubin, William, ed. *"Primitivism" in Twentieth Century Art: Affinity of the Tribal and the Modern*. New York: Museum of Modern Art, 1984.

Clarence Major's Homecoming Voice
in *Such Was the Season*

BERNARD W. BELL

"Unlike his previous fiction, which was unstintingly experimental, *Such Was the Season* is an old-fashioned, straight-ahead narrative crammed with action, a dramatic storyline and meaty characterization," writes novelist Al Young (19). This is the consensus of reviewers of Clarence Major's fifth novel. However, although more conventional and accessible on the surface for readers than his other novels, *Such Was the Season* is actually an exploration on its lower frequencies of the double consciousness of the implied author and of Dr. Adam North, whom the narrator/protagonist calls June-boy, as both return to their southern black vernacular roots. Rather than "contagious affection" for his characters, especially Annie Eliza Sommer-Hicks, the black matriarchal narrator/protagonist, Major's homecoming voice is characterized by social and cultural ambivalence.

Set in the post–Black Power and Black Arts era of a black bourgeois 1970s community of Atlanta, Georgia, the narrative structure of *Such Was the Season* is indeed rather conventionally structured. Annie Eliza retrospectively tells us about her "killer-diller" (1) week: Juneboy, her estranged nephew, returns as Dr. Adam North to Atlanta from Yale and Howard Universities to lecture at Spelman and Emory on his sickle cell research and to stay with her and his southern family; Renee, her materialistic, feminist daughter-in-law, announces her candidacy for the state senate at a large dinner party; Senator Dale Cooper, Renee's politic opponent and the incumbent, becomes mysteriously sick with a rare sickle cell disease and is nearly assassinated; the Rev. Dr. Jeremiah Hicks, Renee's husband and Annie Eliza's hustler/minister son, is involved in a local tomato industry scandal and nearly killed by an abused lover; DeSoto Hicks, Annie Eliza's police sergeant son, hosts the family at the policeman's ball; and Annie Eliza aids Juneboy in his quest to reconcile himself to his southern past and family, especially his murdered father, Scoop, a numbers runner and surrogate father to Jeremiah. Annie Eliza is centered in her racial, ethnic, and regional vernacular culture, but the implied author and Juneboy are respectfully ambivalent about her beliefs, values, and behavior. She is a septuagenarian whose own double consciousness is apparent in her ambivalent reference to Renee as a "nigger" (19), her feeling like a "pickaninny" in the company of some whites, her confession of telling a "pickaninny" joke to her favorite white employer (152), and her disapproval of interracial romance even on television, which she watches compulsively. She also has for

Originally appeared in *African American Review* 28, no. 1 (Spring 1994): 89–94. © 1994 by Bernard W. Bell. Reprinted by permission.

many years worn a "blond but kinda red" wig, which may have once looked "real natural" on her, but, as her sister Esther told her bluntly two years earlier, now makes her "'look like one of these here street hussies.'" Defiantly, she says, "I wore my wig all over Chicago, strutting my stuff just as pretty as I pleased" (17).

Is this behavior consistent with Annie Eliza's self-identification as "just a plain down to earth common sense person" (16)? Is she more folksy than folk? To be folksy is to be a stereotypical rather than a typical or individual member of the common people. To act folksy is to exploit surface appearances of reality rather than to explore deeper significations of reality. The informality of folksiness distorts and demeans the ways of black folk for personal survival or self-aggrandizement by reinforcing the mythic sense of superiority of white people. What then is the implied author revealing about the ironies and paradoxes of Annie Eliza's double consciousness as an elderly southern black woman of the 1970s? How are readers encouraged to respond to her voice and worldview, which make little or no fixed distinctions between fact and fiction?

The illusory character of reality and the reality of illusoriness are dramatized and symbolized by the manner in which television informs Annie Eliza's consciousness and language. The rhythms of her everyday life, like the rhythms of her black vernacular speech, are punctuated by the integration of the technology of television with the traditional morality—the passions, prejudices, and pride—of hardworking, churchgoing, home-owning lower-middle-class southern Negro housewives of the 1940s and 1950s who helped to support their families by ironing, washing, and cleaning for white folks. Her vibrant, idiomatic dialect illuminates her uncolleged, opinionated, independent, protective, provincial, pragmatic, politically conservative character.

This is particularly true of the sound and sense of her sayings, slang, and sentences, such as her anxiety about her arthritis, stomach pains, and sex life while she watches the soap opera romance of Luke and Laura on *General Hospital*.

> My body was talking to me something powerful. I sho wont having no labor pains. Specially since I hadn't been nowhere near no man in that respect in many, many years. I ain't had no use for all the bother that goes with being like that with mens. Oh, I tried it one time after Bibb's death, but it didn't work. Just one time. It wont worth it, child. I might as well had a been shelling peas or shucking corn. (12–13)

The multiple negation and inherent variability in the use of past and present verb tenses, as well as the familiar direct-address term *child*, which

implies an intended primary audience of her racial, generational, and gender peers, seem appropriate for the speaker's socioeconomic class, age, race, region, and sex.

Later, at Renee's dinner party the mayor

ast Juneboy what he did and Juneboy told him nicely bout the research he was spose to be doing, he said, into sickle cell anemia. The mayor sounded real interested and ask Juneboy all about it and Juneboy talked up a storm like he knowed everything in the world bout this Negro disease. He used big words too, words like hemoglobin. Juneboy told the mayor some organization done gave him a grant, which is money, and Juneboy let the mayor know that he was spending a year spending his money from the grant peoples at Howard University Hospital. (21)

The only dialectal rules observed here are those of the pronunciation of *ask*, the regularizing of the irregular past form of *know*, the loss of the initial unstressed syllable in *about*, and the completive aspect *done gave*. Conspicuously absent in Annie Eliza's speech is the usual reduction in southern black vernacular English of *-ing* suffixes, as in *singing* to *singin*, and only infrequent uses of the uninflected form of the verb *to be* in a position in which a Standard English speaker would use an inflected form. But the rhythm, inherent variability, and peripatetic style of the literary idiolect seem authentic enough.

As Renee talks about her hospitalized, mentally ill mother, Betsy, Annie Eliza's vernacular reflections on Betsy and the blues tradition further illuminate the color, class, sexual, and cultural conflicts of her personal identity:

For some reason when I think of Betsy I see her in that bright pink dress she had when she and Bob was together in that awful place we saw them once. Place called Tiny's Little Red Rooster in Marietta on a dirt road out where some colored shacks stood by a cornfield. Bibb and me went there not knowing what to spect. There was this old sinner man singing nasty songs bout what he was gon do to some gal when he catch her. He said stuff that no child of God could stand to hear: real ugly filth-stuff bout how big his thang is and what he plan to do with it. All kinda filth came outta his mouth. He talked about going up side the woman's head if she spent his money. He sang another song bout how some gal broke his heart but that old nigger never had no heart to break if you ast me. (35–36)

For Annie Eliza, as for many southern black churchgoing women of her generation and lower-middle-class status, the blues was the music of sin and sinners rather than a unique secular form of cultural affirmation of the physical and spiritual resiliency of ordinary black people.

Equally revealing of Annie Eliza's character and the moral, intellectual, and cultural ambivalence fostered by the implied author's double con-

sciousness is the pride of the narrator/protagonist in the material success of her sons, Jeremiah and DeSoto. Worried "bout Juneboy's pearance" at Renee's big dinner party, she says:

> You see, I didn't want him to embarrass our side of the family. Esther's children never had the privileges my boys had. They didn't have a proper father. I mean, they were sorta raised here and there first by Momma and they no-good father and his crazy sisters. Then Esther took them up to Chicago but she had to work all the time. They didn't come up with good strict home training. That's the only way children learn good manners. (18)

Ambivalent about Jeremiah's wife, Renee, she tells Juneboy and us that "she just one of them nigger gals spoiled something you wouldn't believe, and, child, so full of herself she can't smell her own stink. And all just cause she comes from the Wright family. You know the Wrights is one of the biggest and richest Negro family in politics in Atlanta" (19).

Expecting Juneboy to be as impressed as she is by the driveway "full of Cadillacs and Mercedes-Benzes" and the musical door bells of Jeremiah's and Renee's home, Annie Eliza wryly comments on his disappointing response: "[W]ouldn't you know it, the poor boy was so unused to such class he just didn't pay no tention to it the way polite people with right kind of background would have. I could hear them bells in there making all that sweet music and I just gave praise to the Lord that at least one of my boys had made it big in this world" (19–20). This is more than mere verbal irony (the night before, Annie Eliza had suspected that Juneboy was trying to impress them with his stories about his travel experience in Poland!). As is the case with Jeremiah's youthful numbers running to pay for his college education, his use of Scoop's bank accounts to build his church, and his involvement in the tomato industry scandal, the dramatic irony here invites the reader to share the mixed emotions of the implied author and Juneboy for the simplicity and sincerity, but also for the prejudices, provincialism, pragmatism, and paradoxes of Annie Eliza's residual folk beliefs and values.

Atlanta-born Major, who tells interviewers that he remembers the mature vernacular voices of the women in his family, and who has just published a revised, expanded edition of his 1970s dictionary of African American slang, succeeds in capturing the literary idiolect of the time, place, class, sex, and individuality of Annie Eliza. The pronunciation, vocabulary, and grammar seem authentic and authoritative for the individualized vernacular speech of a southern black woman who claims to have changed the diapers of her sixty-three-year-old sister Esther. Raised in a segregated black urban Georgia speech community at the turn of the century, she has lived in East

Point for thirty-six years, since her dead husband, Bibb, bought the house in 1947 with his veteran's benefits. Although not as important in the literary reconstruction of spoken dialect as grammar, such lexical items as *killer-diller, killer, hussie, no-count, doodly-squat,* and *hootchie-kootchie man* were popular during that era. Annie Eliza tried for a while during the sixties to use *Blacks* instead of *Negroes* as her preferred term of racial identification, but it just didn't feel right to her tongue. "You called somebody black back in the thirties and forties when I was coming up," she explains, "you insulted them something terrible" (22).

The most striking aspect of the double consciousness of the implied author and Juneboy is manifested in the pride that Annie Eliza expresses in her Cherokee heritage and the first family homecoming. As she recalls, homecoming

> use to be a big thing, a custom in our family. Nowadays only time folks get together is . . . when somebody dies or somebody marries or has a baby. But we Sommers use to all go down to Monroe to see Momma and Poppa when they was still living. We did it in the spring, in the first week of May. . . . At them homecomings everybody was feeling real good. We all helped Momma cook up a lot of fried chicken and made potato salad and we ate watermelon and drank lots of ice tea. Sometimes the men folk would sneak off and drink whiskey but we womens just pretended we didn't know. We singed a lot of happy songs too. (3)

At the first homecoming, her African American and Cherokee father, Olaudah Equiano Sommer, "talked Indian" and "told us a story bout his father, a important man in the Cherokee Nation, who helped collect money to send colored families to Liberia. You see, back then a lot of Negroes still wanted to go back to Africa." At other homecomings her father would tell stories about "how his father made good luck come to the tribe. . . . So homecoming was a time of happiness, storytelling, a time when we all come together and membered we was family and tried to love each other, even if we didn't always do it so well" (4–5). In *Such Was the Season* both Major and Juneboy are returning after many years to the South for their homecoming.

Like Annie Eliza and Juneboy, Major, as he reveals on the back cover of his book of poems *Some Observations of a Stranger at Zuni in the Latter Part of the Century* and in his autobiographical essay "Licking Stamps, Taking Chances," has memories of stories told by his maternal grandmother of her Cherokee ancestry. As is the case with most of his central male characters, Major has much in common with Juneboy. Both were born in Atlanta and left the South at an early age with their divorced mothers; both were first married to black women, fathered two sons, and were divorced at a young age; both currently have intimate commitments to white women; both have advanced college degrees and teach at predominantly white universities;

both have traveled in Europe, including Poland, as professors; and both returned briefly to the South on lecture trips and stayed with relatives after thirty or more years' absence. As black intellectuals and professionals, both also have mixed emotions and success in reconciling the tensions of their double consciousness—their biracial, bicultural identities—in returning to their southern vernacular roots.

Juneboy tells Annie Eliza,

> You know, I've come here because of the lecture they asked me to give at the university, but I have another reason for returning to the South, especially to Atlanta. I have been suffering spiritually, longing for something I think I lost a long time ago. Aunt Annie Eliza, as old as I am, I should have resolved so many questions that I haven't managed to. Who am I? Where did I come from? My first questions, and they are still unanswered. I've been running from my early self, and now I want to stop. Somehow, I am hoping that I can get back in touch with that little boy I was, looking up into my mother's and father's faces and discovering the world. I tried to become a different person and I guess I succeeded. But now I need to find that earlier self and connect it with the new self that I am now. (7–8)

Juneboy's quest, in other words, is similar to that of the quasi-autobiographical male protagonists in most of Major's fiction.

Juneboy's mixed emotions about his homecoming are apparent in the failure of his Spelman lecture and the failure to find his father's grave. " 'It was like trying to make an egg stand on its end,' " he tells his aunt. " 'The time of year, the season, was wrong. I worked at it, I worked hard at it, Aunt Annie Eliza. I told them what I dream of discovering and they listened as well as any audience can, but I felt sq[ua]re, in the end, that I had not reached them, they had not understood. Not a single face in the audience gave off that certain light of recognition' " (7). The allusion here to the book's title, borrowed from Jean Toomer's poem "November Cotton Flower," gives resonance to the thematic and stylistic irony of homecoming as a ritual of reintegration and regeneration even in unfavorable climate. Annie Eliza ashamedly concludes that "maybe Juneboy didn't know as much as he thought he did" (7). But the frustration and estrangement voiced here about the distance between himself and the black intellectuals at Spelman seem more regional, cultural, emotional, and psychological than intellectual.

Juneboy's efforts to visit the grave site of his hustling yet compassionate father, Scoop, in order to reconcile himself with his father's memory prove unsuccessful. Annie Eliza considers Scoop "a no-count person," although

he became her son Jeremiah's surrogate father while alive and his economic sponsor after death. She drives Juneboy eighty miles north past Athens to the town of Lexington, where Scoop was buried after being killed in a gunfight in a gambling dispute with a white man. On the way, Juneboy asks his aunt to stop in Monroe so that he can see his grandparents' old home and the family graves, where he takes pictures.

When they finally arrive in Lexington, they are surprised to discover that the "colored cemetery" where Scoop was buried is now under the concrete parking lot of a housing project. " 'In a way,' " says Juneboy with mixed emotions, " 'it's a fitting burial for Scoop. It's like he has lent his flesh and spirit to the continuation of the culture. The little kids playing in those parking lots are the ongoing spirits of all those silent souls down beneath the concrete. Scoop's spirit reaches up through the hard surface and spreads like the branches of a summer tree' " (60).

Although he is unsuccessful in paying his respects to his dead father, Juneboy feels that the week he has spent with his family has been good for him. " 'This is to say thank you, Aunt Annie Eliza, Donna Mae, Whitney, DeSoto, Buckle, for your hospitality,' " he says in a dinner toast the evening before leaving the South. " 'But you've given me more without knowing it. Through you I've rediscovered who I am and now I can go on from here. I love you all very much' " (199).

"I started *Such Was the Season* after I had taken a trip to Atlanta," Major told interviewers McCaffery and Kutnik, "and to some extent Juneboy is based on some of my experiences on that trip. But . . . correlations start to break down very quickly once narrative and aesthetic demands and all sorts of other things start to operate on these 'facts' " (126). The book was originally titled "Juneboy" but by the time Major got to the creation of Annie Eliza he found that this was the first novel in which he was not the model for the main character. "[F]rom the outset," Major says, "I felt more secure with the woman's voice I was using in *Such Was the Season*. I didn't have to think about inventing that voice because I'd grown up hearing it, I knew its rhythms from the way my relatives in the South speak. It was already there, so all I had to do was just sit at the computer and correct the voice by ear, the way you would write music. If the rhythm was wrong or the pitch off, I knew it instinctively because I'd lived with that voice all my life" (McCaffery and Kutnik 127). As a result Juneboy comes to be "presented through this folksy, down-to-earth woman's point-of-view" and Major's "own presence is so diminished in Juneboy's identity that he is at best a catalyst rather than a true persona" (McCaffery and Kutnik 125, 126). Actually, as I have attempted to demonstrate, Annie Eliza's compelling voice in Clarence Major's homecoming in *Such Was the Season* is more folk than folksy, yet it evokes mixed emotions from the implied author, Juneboy, and this reader.

WORKS CITED

McCaffery, Larry, and Jerzy Kutnik. "'I Follow My Eyes': An Interview with Clarence Major." *African American Review* 28, no. 1 (Spring 1994): 121–38.

Major, Clarence. "Licking Stamps, Taking Chances." In *Contemporary Authors Autobiography Series*, edited by Adele Sarkissian, 6:175–204. Detroit: Gale Research, 1988.

——. *Such Was the Season*. San Francisco: Mercury House, 1987.

Young, Al. "God Never Drove Those Cadillacs." *New York Times Book Review*, December 13, 1987, 19.

Against Commodification

Zuni Culture in Clarence Major's Native American Texts

STEVE HAYWARD

[A]ny one can drive onto the reservation but
and this is a big but
people are expected to know the customs.
—Clarence Major, *Some Observations of a*
Stranger at Zuni in the Latter Part of the
Century, 1989

Not too far gone are the days when any county museum served the naively colonial role of representing Native American cultures to all who ventured in. The centerpieces of such exhibits were the dioramas, all of which, no matter the tribe (if, indeed, any gestures toward tribal variation were made), seemed to ensure every scout troop and picnicking family passing by would leave with a few central notions of what Native American life meant.

The characteristics of the diorama are telling in regard to the dialectics of representation and colonization facilitated by commodification. The diorama is dependent upon freezing time and neutralizing distinctions in space; the "Indians" always resemble no one but other diorama Indians and diorama cave-people. While freezing the latter in a specific time is viable due to the extinction of those ancient cultures, casting the former in similar pretechnological settings suggests a similar extinction or, at best (for the viewer), a delightfully nostalgic primitiveness. At the same time, temporal freezing isolates the figures in the diorama into single, typically stereotyped, actions, thereby containing them and enabling viewers to generalize the whole of Indian life. The diorama, like so many "Western" films, levels the specificity of tribal location and, thus, of tribal identity and culture. For both, an exigence exists for establishing the stock ness of the Indian. Motives for this leveling likely stem from a need to depersonalize the humanity of the Indian, though museums could be driven by such added material factors as a lack of artifacts or the ability to identify one culture from another.

The diorama elicits the charm of an artifact masquerading as something built by invisible, supremely objective, quasi-divine hands. It suggests an unmediated and pristine correspondence between its subjects and what, within the terms of the epistemology operant in the production of the diorama, objectively exists in a real, outside world. Who but a god is capable of building life, let alone a whole village? The lack of any obvious nod to the

Originally appeared in *African American Review* 28, no. 1 (Spring 1994): 109–20. © 1994 by Steve Hayward. Reprinted by permission.

subjectivity and interestedness of the maker is indeed suspicious. Its final quality, the erasure of any indications of construction and the illusion of objectivity implicit in such an erasure, makes the diorama a serviceable paradigm of the type of representation to which Clarence Major's two volumes built around the Zuni culture sit in opposition.

In contrast to the dioramic paradigm, Clarence Major's *Some Observations of a Stranger at Zuni in the Latter Part of the Century* and *Painted Turtle: Woman with Guitar* resist commodification and what I would like to call dioramafication. In my examination of Major's Zuni texts, I will pay particular attention to the thematized subjectivities of the two texts, and the similarities of these aspects to those that Walter Benjamin found in Brechtian theater. In so doing, I hope to describe Major's postmodern response to the artist's representational paradox: How is it possible to follow the will to represent, without falling into a colonial will to dominate?

One way of approaching this reading is by looking at Major's work in light of the notion of authority. We can accept, at least in part on etymological grounds, the commingling of authorship with authority.[1] And certainly this sense of authority inherent in authorship is facilitated by the guises of objectivity created in so many texts. Major resists this connection in two ways: by insistently foregrounding the fundamental subjectivity of both his characters and himself in a way which suggests a certain hierarchical set of qualifications which condition the accuracy and value of a given character's, speaker's, or author's speech/writing, and by thematizing the obfuscation which occurs when those who aren't qualified to speak do so.

To a large extent, both *Some Observations* and *Painted Turtle* engage a form of the question of subalternity. Who has the authority to speak about and create representations of marginalized cultures? In *Some Observations*, Major provides an elaborate discussion of this question in the form of a poem titled "In Hollywood with the Zuni God of War." The title alludes to an incontrovertible example of the ways in which, in this case at the hands of the Hollywood film industry, once vital cultural information is so readily ground up and represented as kitsch. First to go in this hegemonic cultural reinvention are distinctions among various tribal identities and narratives. When one of the Zuni actors points out his Zuni-ness, presumably to suggest that something is gravely wrong with a Zuni playing in a film about Cochise and other Apaches, Major's director replies, "Do you wanna work or not?" (17). This mocking interrogative response in the vernacular clearly exemplifies the dilemma faced by native workers in an economy of cultural commodification. The Zuni actors must either be the desired stereotypic Indians or be unemployed.

For "Zugowa," the key figure in the poem, who may well be the person-ification of the god of war, as well as for the nameless speaker and all the other Native Americans employed by the film industry, the pain at this erasure of tribal identity and culture is mediated, if not anesthetized, by the need for income. As Zugowa states:

"They did not care
 which tribe we came from."
Zugowa swore this was true
 in the name of Awonawilona,
 by his own mili.
We all looked alike.
 Being herded and shot
paid better than oranges in S.D.
 County,
or the H.D. in Arizona—that is,
 if you could get yourself shot
at least once
 per month. (20–21)

Here is a scathing critique of the nature and psychology of the colonizing economies Native Americans have no choice but to function within. To survive colonization requires the colonized either to sell their bodies in one of many forms of grueling manual labor or to sell their likenesses for representations designed to serve the purpose of reaffirming the hegemony of the colonizers themselves, by re-creating the "glory" of the genocidal acts which secured their power to begin with. Major makes this last point vivid in the lines,

A liberal
 from back east wanted to make
a flick on Cherokee Gatumlati till
 somebody told him she was half
Negro. Studio pulled the plug
 out of his oxygen tent:
 white audiences in the South
might not buy it. (21)

These lines demonstrate the intricacies of racism witnessed through the economics of film production.

The profit motive sanctions and perpetuates the politics and psychology of "racial" stereotypes. While it is good business to reconstruct homicidal/genocidal representations of ignoble Native American "savages" on the screen, African Americans, for a southern audience, are below the gaze of

even homicidal/genocidal representation. All of these points are wrapped up dramatically when Major closes the poem with Zugowa and the "speaker" being "farmed out / parking cars for peanuts in South / L.A." (23–24), leaving the cost of the film industry on Native Americans clear: in the picture business, even the gods are reduced to being lackeys.

It seems viable at this point to describe "In Hollywood with the Zuni God of War" as a type of perspectival reversal, in which those who typically are represented take on the (superior?) position of being the ones doing the representing. The poem is a look at the exploitative practices of the economy of a certain type of filmmaking, through the eyes of those, in this case Native Americans, who are exploited. On first analysis, this would make the poem akin to other genres in which the victim/witness tells the story of whatever violence the perpetrators have inflicted. Survivor narratives from the Holocaust and countless other attempts at genocide, victim statements taken by police, courtroom testimony from battered spouses and children— all of these share a key factor: each demonstrates a move toward usurpation of power inherent in authorship, allowing each, for what may be the first time, to engage in a Rortian re-description of those who have for so long described them in ways which facilitate domination and terror.[2]

To play with this idea further, it is possible that poems like "In Hollywood . . . ," as well as those texts found in the various genres mentioned above, aspire to shatter the barriers of silence created by those like the Hollywood producers, barriers which foster the "agreement—or at least the determination—of all executive(s) not to produce or sanction anything that in any way differs from their own rules, their own ideas about consumers, or above all themselves" (Horkheimer and Adorno 122). When Major produces works such as the volumes under examination here, or when any of the other producers of similarly engaged texts do the same, they are, in a sense, effecting a revolution in the economy of cultural production/reproduction, thereby enabling themselves to influence ideologies being disseminated by the various vehicles of production.

But revolutions of this type are not simple either in practice or on paper. The types of engaged texts we are discussing indicate authorship by those who have typically been written about, but who have themselves been denied the right to write. (I will focus on this issue in Major's work shortly.) But as Horkheimer and Adorno stress in their critique of "the culture industry," authorship is a necessary but insufficient step in the production of cultural materials. While it may be possible for the "represented" to write, writing is mute without the involvement and sanction of some form of monied person or persons with access to, and the ability to pay for, the

material production of texts. These persons or groups are situated in the same genealogies as are those at "Chrysler and General Motors" and "Warner Brothers and Metro Goldwyn Mayer," all of whom function to reproduce themselves, in part, by stifling any challenges to their health and by fostering a sameness in all their products, a move beneficial to the entire class (123).

Then what of the texts mentioned earlier? A closer inspection of the relation between the texts themselves and their various means of production suggests that what initially appeared as a disruption, a revolutionary tension, may be alternatively described as a graceful cohabitation. The atrocities each describes preserve the anonymity and innocence of the publishers: the police report points to a single, aberrant individual who committed the type of direct violence all may safely condemn. The survivor narrative is similar, only there, it is a group and a historical period which may safely be condemned. What these share, for the publishers, is a safety in knowing that the finger in each of these crimes will never turn on them. In fact, the publishers stand to be valorized for their courage in publishing these texts, a fact that could lead to an increase in their sales and thus their profits. All the while, their true crimes, the economic injustices committed in comparative invisibility by the publishers and others of their economic position, as well as texts which could serve to expose their involvement in both economic and cultural hegemonies, remain unprinted, silenced in the very way alluded to by Horkheimer and Adorno.

Now that these difficult questions are on the table, what of Major? More specifically, how does he deal with the tensions of the aporia of artistic/ cultural production? How do his texts *Some Observations* and *Painted Turtle* avoid becoming what we may now describe as just more fuel for the blast furnace of the industry of textual production, or, to use one of Major's descriptions, another Hollywood film, or, to use one of mine, another diorama? One result of such an inquiry, and one which is persuasive on a number of counts, is that Major's texts finally cannot avoid becoming more raw material for the culture industry—a point made clear by the dialogue carried out between Benjamin and Adorno over Brechtian theater, which I will discuss shortly. Thus, the lowest common denominator of an economic analysis of the production of these texts reveals the impossibility of Major's escape from the aporia Adorno articulated. First, the nature and presence of the texts in my hands suggests an important point: money was made in their production, both by Major and by the publisher, Sun and Moon Press. As for the latter, while I have not seen a report on their ownership, I can safely assume that the press is not a tribally owned entity, which means the

nature of the economy in which these books are a commodity is one in which engaged, committed texts, in Adorno's sense, are being commodified by those somewhere in a line outside that of those who have a need to be engaged.

Having said this, I can offer a cogent counterargument.

While it is in all likelihood true that the means of publication of the two works are not Zuni-owned, it is also true that Sun and Moon Press is a small, independent entity. As such, its links to the likes of Warner are greatly diminished. Further, it is quite likely that the Zuni tribe owns no press, and if it does, it does not own one capable of distributing texts on the scale of Sun and Moon, which itself is very small. I accept these points and will abstain from the counterpoints, because, as is the nature with aporia, such cross-examinations may continue ad infinitum.

Having looked at, and tenuously put to rest, the role of the press in the production of the two texts, I will now turn to the role of the author himself. Major seems well aware of all of these tensions endemic to the relations between a text of commitment and the material means of textual production. Further, while his interestedness, in the economic sense, in the books' production needs to be viewed through his claim—on the books' dust jackets—of partial Native American, if not specifically Zuni, ancestry, he makes concerted efforts in both texts to highlight his "take" as author on works built of Zuni cultural information. The remainder of my work will focus on these attempts and offer discussion of their effects.

Apparently aware of the difficulties inherent in creating culturally in-formed, committed texts, Major creates a number of measures in *Painted Turtle* and *Some Observations* which mediate the dilemmas inherent in his undertaking. The texts seem bent on problematizing any sense of commen-surability between themselves as texts and all notions of the "real," "outside" world. By overtly rendering suspect any hope at correspondence between the text and the world which they describe (in this case, the world of the Zuni) Major is in effect defetishizing the texts by highlighting their text-ness. In so doing, he devalues the books in the economy of artistic/cultural commodification.

Before discussing the various tools with which Major carries out this economic deconstruction of his own work, I would like to present an analogy and vocabulary with which to describe Major's undertaking. For this, I turn to Walter Benjamin's discussion of Brechtian theater, for in it I find a number of parallels to the works under discussion. Benjamin quotes Brecht on the subject of the dialectic between the means of production and the work:

The lack of clarity about their situation that prevails among musicians, writers and critics . . . has immense consequences that are far too little considered. For, thinking that they are in possession of an apparatus which in reality possesses them, they defend an apparatus over which they no longer have any control and which is no longer, as they still believe, a means for producers, but has become a means against the producers. (265–66)

Benjamin adds to this that the theater of the Brechtian moment, "whether in its educating or entertaining role—both are complementary—is that of a sated class for which everything it touches becomes a stimulant. Its position is lost" (266). In a way which for today's reader may seem a bit too party-line Marxist, Benjamin describes the mechanisms of cultural commodification operant in Brecht's Europe. In an economy in which the means of production are owned and controlled by the "sated," all that can be created through such means serves as pleasantly reaffirming barbituates for those who own the machinery. This analysis seems to offer a useful template through which to view Major, a point already made in the discussion about Major's relation to his means of production.

Interesting for our purposes is Brecht's response, according to Benjamin, to this bind. Facing a situation in which the "theater," with all of the implications of the material and economic underpinnings of that institution, would effectively cancel out any attempt at committed work, and in which all such work would in fact serve the counterpurpose of reassuring those sitting in the audience of their self-perceived rightful hegemonies, Brecht sought to "enter into debate with" the theater itself (266). His approach to this—an approach which Major parallels, albeit via a different genre—was to expose at all turns the theatricality of the theater itself, to thematize the act and economy of theatergoing in a manner which would leave viewers keenly aware of the ramifications of their role and involvement as audience (Benjamin 266–69).[3] For both Brecht and Major, this problematizes the viewer/reader's commodifying relation to the work itself, transforming the work's original commitment into a mere anesthetic for a bourgeois status quo.

I see at least three ways in which Major parallels Brecht's response to cultural commodification: by identifying and qualifying the nature of his subjectivity as author in the books, by foregrounding the textual-ness and Derridian written-ness of the texts, and by relying on a visibly fragmented understanding of Zuni language, and thus of Zuni culture in general.

The title *Some Observations of a Stranger at Zuni in the Latter Part of the Century* names the insistent perspectivalism Major underscores in the book. Nothing is promised in the title—nothing except uncertainty. Rather than offering anything so epistemologically bloated as, say, reports or stud-

ies or interpretations, Major offers only the comparatively random and far less certain "observations." While "observations" are frequently thought to be made by those operating through an epistemologically sound platform of science, Major destabilizes this idea by pointing out that these are but "some," presumably among many, of the observations. A shadow of randomness is cast over the process of selecting which of these many epistemologically grounded "observations" to include. Further, any claim to objectivity, a claim underlying so much anthropological work and other texts assuming documentary postures, is shattered from the outset by the fact that these random observations are being made via the perspective of a "Stranger."

If the title of *Some Observations* makes the suggestion that *identity*, in all the ramifications of the word, influences perspective and claims of what is seen—that the nature of the observer and of observations is one conditioned, if not controlled, by subjective perspective—the books themselves develop this theme. For this, Major develops the notion of what I would like to call mudhead subjectivity/perspectivalism. The mudhead is Major's and, according to the texts, Zuni culture's personification of something like the postmodern ethnographer, who is candidly aware of the outsiderness of his/her presence, outlook, and observations. This status, though, cannot be had except through ancestral inheritance, and thus it is inextricable from ancestral identity. Specifically, according to Major, mudheads are "children of incest" who, due to the nature of their background, spend their lives on the outskirts and perimeters of Zuni culture (*Painted Turtle* 18). Major literally situates them there in a number of dances and ceremonies, at which they can be found "stumbling along the walls of Sacred Plaza," in roles which seem vaguely reminiscent of those of rodeo clowns (*Some Observations* 33). Without clan, these tribal buffoons—portrayed variously as mystical and terrifying—are barred from full access to the rights of tribal membership and Zuni life, as is clear in the lines, " 'even if you become a priest (they told her) / you will never make the prayersticks / or enter the kiva' " (*Some Observations* 26). But this alienation goes beyond the religious, for mudheads "had no claims on the pueblo" (*Some Observations* 27).

In both texts, the mudheads not only serve the role of metaphoric personification of the perspectival outsiderness which characterize Major's speakers and narrators, but also offer a metacommentary on Major's role, readers' roles, and the nature of the texts themselves. This can be seen if we trace the theme of cultural ostracism manifest in the mudheads into other areas in the texts.

From the start of an analysis of ostracism in the texts, one point becomes clear: Major is intent on underscoring the primacy of ancestral and cultural authenticity among the Zuni he has created. Thus, when Painted Turtle

drifts too far into what for a Zuni would constitute otherness, specifically into the bars and honky-tonks of Gallup, New Mexico, she is required to undergo a form of cultural reintegration in order to gain permission to leave the reservation after returning for a visit.[4] As she prepared to leave,

> the councilmen sent word that she could not leave the reservation till she learned how to make the Sayatasha belt to perfection. In their message they told her that if she left without permission she would be picked up and would thereafter have to learn to do many things, many other, more difficult things commonly expected of women. (*Painted Turtle* 97)

When Painted Turtle satisfies the men and leaves, her next attempt to return fails, even though she recites a litany of her cultural background to the "line guards," who negate each claim in succession:

> She told them she was born at the Middle Anthill and they had no right to keep her out. They told her her family was doing well and did not miss her. She showed them her old headband. They shook their heads and said it didn't matter. She told them she used to get up at five to help her mother bring in the firewood. It didn't mean anything now. When they had a goat, she fed it. When they had two hogs, she fed them. She went to sheep camp with her father. They told her to stick it in her ear. (*Painted Turtle* 100)

Major's point is that, among tribal peoples, any complicity in leveling or erasing specific tribal distinctions is grounds for tribal/cultural ostracism. For Major's Zuni, to have someone say, " 'But you have lived among / the anglos / and your ways are not different from theirs' " is to be reduced to the status of the mudhead—or worse, since the mudheads are at least granted access to the reservation and many, though not all, features of community life (*Some Observations* 31).

If those who forgo the traditional ways are reduced to quasi-mudhead status, cast to the perimeter of the tribe, and feared and ridiculed by those at the center, Major ascribes a roughly parallel status to members of other tribes, in particular to tribes who live near the Zuni. Considering that *Some Observations* and *Painted Turtle* function as companion texts, it is fair to assume that the identity of the Stranger/speaker in the former is homologous to Baldwin Saiyataca, the narrator in *Painted Turtle*. Baldy, as he lets us know his friends call him, identifies his tribal ancestry in the prologue by stating, "Even us Navajos (and I'm part Hopi) never went in for good old American charm" (*Some Observations* 7). Later, in a chapter devoted to Baldy's self-reflection, he states, "Having a Navajo father in Hopi land wasn't exactly a picnic. Hopis had nothing but a history of trouble with them Navajos. My mom had trouble with my dad. So it goes" (*Some Obser-*

vations 144). If this ancestral division renders Baldy into a parallel of a mud-head on his own reservation, it no doubt exacerbates his responses to Zuni castigation of all tribal "others," exemplified in his observation of a Zuni woman: "She gave me only a half-smile—not even that, really. Zunis are like that, especially toward us Navajos. I saw her sizing me up right away. But I didn't let that coldness stop me" (*Some Observations* 8). Baldy's use of the phrase "us Navajos" is of course a tenuous one, given his history and identity, for in all likelihood, among Navajos his use of the same phrase would raise more than a few eyebrows, given his partial Hopi ancestry. (Further, the passage can serve as evidence for the vehemence with which Native Americans might respond to the tribal leveling inherent in the diorama.)

Major's insistence on the outsider-ness of both Baldy and the Stranger, and the nature of his speaker's insistent and acknowledged subjectivity and mudheaded-ness, leads both to resemble that Heideggerian notion of *Dasein*, a consciousness bound to and aware of its own subjective perceptions of events over which it has no influence. If we can apply Rorty's description of *Dasein* as that which "knows . . . that it is only contingently there where it is, speaking as it does," to Baldy and the Stranger, we now have the means with which to question the nature of their narratives (Rorty 109). Simply, all that these voices speak is suspect, by the nature of being radically subjective, as well as by the nature of the correlation to tribal authenticity, to the perspective described in the text itself. Given the terms of what it takes to "know the customs" of Zuni, those subjectivities through which our view into the culture is mediated are by no means ideal for the task.

Major's highlighting this renders the very nature of narration suspect, in a way which parallels Brecht's moves in the theater to highlight the theatricality of the performance. Both serve to rupture the aesthetic of art by foregrounding the material nature of its creation; for Brecht, according to Benjamin, this took the form of reducing the illusions inherent in the theatrical set, of interrupting the progress of the epic as a reminder that what was on stage was just that—on stage, and not in the "world." One of Major's parallel moves is to underscore the subjectivity, and hence the fundamental contingency, of his narrator's work.

This analysis clearly begs a bit of problematization, particularly in the analogy between the two texts at hand and Brechtian theater. To do so, allow me to mention that, while we have seen how Major reduces his narrators to *Dasein*/mudhead/call-them-what-you-will, we have yet to explore what, if anything, he does to render the notion and role of "narrators" similarly suspect. Certainly the analogy between Brecht and Major warrants this move; Brecht, we know from Benjamin, engaged the totality of theater in a dialogue, with purposes of exposing the material sources of the venue. In so doing, his eye fell on everything from the physical accoutrements of the

theater to stage directions. To create a parallel, our analysis to this point has shown how Major makes the actor on his stage, and those viewing him, aware of the limits of perceptions and statements. We have not seen, though, if Major's indictment of textual/cultural commodification reaches the scope of Brecht's.

Let us begin this stage of our analysis with an examination of the nature of Major's identity and relationship with his ostensible subjects. As we have seen, Major portrays a Zuni culture very aware of the implications of the ancestry and identity of those operating in and around the community, as well as those using the culture as the basis for commodities. ("Inkpen," Baldy and Painted Turtle's agent, is the exemplar of those Anglo outsiders profiteering via Zuni cultural goods.)[5] Given the degree to which Major thematizes these issues, it seems within the terms of the works to turn our study of the dialectic of identity and subjectivity in cultural representation back onto Major himself.

Knowing that Major, like the Stranger, has "lived among the anglos"; knowing too, that, while Major makes claim on partial Native American ancestry, he certainly is not as Zuni as, say, the councilmen expect Painted Turtle to be; and also knowing, from what is on the dust jacket, that Major's knowledge of Zuni comes from having spent time with Zuni people, we can safely make the claim that not only Baldy and the Stranger, but Major, too, as author, are radically subjective mudheads, in the sense that I have been using the term. This leads us to extend the haze of uncertainty that we have for the narrators to the texts themselves. To map these relations would sound something like: Major, himself a mudhead, writes about mudhead Baldy/Stranger writing about Painted Turtle/an unidentified woman, both of whom are ostracized from Zuni. There are three layers/filters of subjectivity in these texts through which readers must navigate, assuming that they, by the end of this process, still have faith that anything like a diorama of Zuni exists to be found.

I turn now to the fact that Major's work resembles Brecht's epic theater in its thematized written-ness. While not dismissing the notions of textual fluidity developed by a number of postmodern theorists, I will rely on a notion of the text as a product or commodity which is traded with, for, and so on, in the economy of the "culture industry" as described by Adorno and Horkheimer.

We have seen the nature of Major's identity and its effects on the work itself. Major asserts his authorial (mudhead) presence in the work in a

number of places. If the effect of interruption in Brecht's work was one of reasserting the theater-ness of the performance by thematizing the act of textual composition itself, Major is effecting a similar interruption, a sort of online reminder that the text is just that—a text, a product of a certain writer's labor, and not a vehicle for a seamless correspondence between itself and a "real," "outside" world.

Major intersperses these reminders of the texts' written ness throughout. At times, these reminders may better be described as reminders of the texts' narrativity, as when Baldy states, "In my mind I saw her mother as she washed the Little Turtle. When she finished she placed her in the sandbed. The mother's hands were crusty and strong and warm" (*Painted Turtle* 9). Phrases like "In my mind I saw" have the effect of destabilizing any attempt at assuming commensurability between the text and "real Zuni" people, because they highlight the fact that the text is the product of what may be described as sitting in the same genealogy as daydreams and hallucinations. These reminders of Baldy's condition as narrator are placed frequently in the text, often enough that, when a reader may begin to nod into the veil of commensurability between the text and the "world," a reminder along the lines of "Close your eyes. Try to imagine this" (32) jars the reader awake into the full light of the text's essential textuality. The nature of Baldy's perspective and subjectivity further contributes to this destabilization; *Painted Turtle*, in short, is being told via a nonqualified narrator who invents most of the story in his head.

The thematized written project and narrativity of the text continues throughout. In places where Baldy is left stumped as narrator, he simply announces, "Now, at this point we must return to my reliance on imagination" (132). Such gaps serve to authenticate the notions of perspectivalism and subjectivity in narration and authorship presented elsewhere. Baldy is an outsider, and as an outsider he is left in a position of writing/constructing from a distanced and ostracized perspective.

But if one of Baldy's roles is to deconstruct any claim to objectivity and control over the cultural other, who/what deconstructs Major? Major deconstructs Major, albeit in a less visible way. He does so by more explicitly addressing the actual written-ness of his texts within the texts themselves. For example,

One winter her aunt—on her father's side—was selected to go up to the top of Corn Mountain to bring the winter flame back from the burning light there and her sisters and grandmothers and other aunts cleaned the winter stoves and fireplaces and ovens and fasted for four days and the sword swallowers that winter were wonderful as they held forth quite seriously in the plaza. Phew!—what a sentence! (18)

"Phew—what a sentence!" seems to evoke a Wizard of Ozian reversal by claiming "pay full attention to the man behind the green curtain," a.k.a. the writer—Clarence Major. It is writers who release sighs of metacommentary over the immensity of their sentences. When Major as writer makes these little cameos, another layer of textual calcification forms. Now, we have a Baldy who is not only, due to features of his subjectivity, hindered from offering a commensurable representation of Zuni, but who also, we learn late in the text, "met Painted Turtle in the Blackbird Cafe in Cuba during her opening night," and therefore must have invented much more about her life than he let on, and who finally is a figure written by Major, an author just as distanced from Zuni as Baldy, if not more so (108). Phew!—what a sentence!

Major's underscoring of the written-ness of the texts is further visible in the manner that he uses Zuni and other tribal vocabularies. Both texts are steeped in what seems to be a Native American lexicon and phraseology, so much so that certain pages appear to be bilingual:

and this Navajo hombre said
 why
 did the Navajo
need a Bilagaana—must have
 been Kit Carson's face!
 or did your ancestors screw
that many blue-eyed settlers?
 and the black gods?
What's with the black gods—
 Bitsiislizhims?
 And you say we shot down
our black saviour!
 He was no saviour, Saiya! (*Some Observations* 22)

Reading this would be next to impossible, if by "reading" we included a need to understand all of the allusions present. Fortunately, a reader thinks, Major included a "Glossary" to explain these references. This is where things get interesting. While Major provides a glossary, thereby giving his text a feature similar to, say, an anthropology text or a travel guide, the glossary itself is very fragmented and incomplete. None of the non-English terms in the above passage are defined there. Because of this fracture, there is no way to feel "certain" that those words actually in the glossary are defined as indicated. Thus, a reader is left simply without a clue about a good many terms—and left suspicious of those apparently "translated." Major leaves what seems to be Zuni language on the pages but effectively

denies access to it, in effect circumscribing the language from the machinations of cultural commodification.[6]

The effect of all of this is one of defetishization of the texts themselves. In economies of cultural commodification, like those within which Brecht operated and Major still does, threats in the form of engaged and committed art are neutralized by the material means in which they are produced, and especially by the nature of their consumptions. Adorno, in an extended comment on Sartre's "What Is Literature," writes, "A work of art that is committed strips the magic from a work of art that is content to be fetish, an idle pastime for those who would like to sleep through the deluge that threatens them, in an apoliticism that is in fact deeply political" (301). Major strips this magic away, precisely by creating barriers to the types of reading those who sleep enjoy the most—an uncomplicated/nonimplicated look at what, for them, is taken as an equivalent of the culture represented in the text. What is "deeply political" in this is the assumption that owning the text which corresponds to and is commensurable with the culture is equivalent to owning the culture itself. Major's work is a critique and disruption of precisely this chain of logic. Only the sleepiest of readers could read these texts without feeling, at some even pre-verbal level, that they are being subjected to a critique of the way they read. We may now have a new understanding of why Major is thought by some critics to be underappreciated: his texts challenge and subvert conventional readings that commodify culture in the manner of the stagnant controllability of the diorama.

I would feel disingenuous, however, were I to conclude without problematizing the claims made in the preceding paragraph. To do so, I need only turn self-reflexive and acknowledge the nature of the economy in which I write and in which I use Major's texts as the raw material for my work. In so doing, I see that Major's texts have in effect been appropriated by a type of writing endemic "to the seminar rooms in which they inevitably end" (Adorno 301).[7] This doesn't mean that we should stop what we are doing; rather, it suggests a need to acknowledge the nature of the economies, politics, and interestedness of our work.

NOTES

1. Foucalt comes to mind as a writer who, in "What Is an Author?," explores the commingling of authorship with authority over that which is written about. While it is true that Foucalt describes authorship as a collective, rather than an individual, function, his point is nonetheless demonstrative of this type of thinking, which is popular in various forms among many of Foucalt's contemporaries.

2. My notion of *re-description* is derived from Rorty's *Contingency, Irony, and Solidarity*, ch. 1, passim.

3. While Benjamin's analysis of Brecht focuses specifically on epic theater, the section seems equally applicable to poems and novels, as is suggested by his discussion of René Maublanc at the end of the essay.

4. In a point which offers a fascinating destabilization of what Major portrays as a Zuni primacy of cultural and ancestral heritage, he mentions in a 1994 interview with Larry McCaffery and Jerzy Kutnik that "a black man—a huge African—apparently visited the Zunis in the 16th century with a group of Spanish explorers and then stayed on. He must have seemed extremely commanding to the Zuni, because he became some kind of God for them—he had dozens of wives, and he appears in a lot of early Zuni legends and stories, and so on" ("'I Follow My Eyes': An Interview with Clarence Major," *African American Review* 28, no. 1 [Spring 1994]: 127). This legend mediates Zuni claims regarding the importance of purity: although Major doesn't mention any descendants of this man, he does mention multiple wives.

5. Major thematizes Zuni involvement with the likes of Inkpen also in his description of the seemingly farcical "Olla Maiden Dance." Seeing the dance with Painted Turtle, Baldy states, "This, the Turtle told me in a whisper, was in no way a sacred dance. The Zunis share it all the time with strangers. I had seen it before, without a great deal of interest" (142). It is this dance which is characterized by the statement, "'We march with pots on head. White sponsor makes money'" (143).

6. An interesting exploration, though tangential for the present work, could be had by examining Major's use of Zuni and other Native American languages in light of Gilles Deleuze and Félix Guattari's chapter "What Is a Minor Literature?" in *Kafka: Toward a Minor Literature* (Minneapolis: University of Minnesota Press, 1986). Conceivably, use of such languages could signify for the minor linguistic option rather than that of the major. Still, having access to this option may render Major something other than minor.

7. My reading of Adorno stems from the sections "Kafka, Beckett and Contemporary Experimentalism" and "The Politics of Autonomous Art" in the essay "Commitment."

WORKS CITED

Adorno, Theodor W. "Commitment." In *The Essential Frankfurt School Reader*, edited by Andrew Arato and Eike Gebhardt, 300–318. New York: Continuum, 1987.

Arato, Andrew, and Eike Gebhardt, eds. *The Essential Frankfurt School Reader*. New York: Continuum, 1987.

Benjamin, Walter. "The Author as Producer." In *The Essential Frankfurt School Reader*, edited by Andrew Arato and Eike Gebhardt, 254–68. New York: Continuum, 1987.

Horkheimer, Max, and Theodor W. Adorno. *Dialectic of Enlightenment*. Translated by John Cumming. New York: Continuum, 1989.

Major, Clarence. *Painted Turtle: Woman with Guitar*. Los Angeles: Sun and Moon Press, 1988.

———. *Some Observations of a Stranger at Zuni in the Latter Part of the Century*. Los Angeles: Sun and Moon Press, 1989.

Rorty, Richard. *Contingency, Irony, and Solidarity*. Cambridge: Cambridge University Press, 1989.

Clarence Major's Singing Voice(s)

Although widely published as a poet, anthologist, lexicographer, and essay-ist, Clarence Major has, since 1975, been most well known for his fiction. Building on the achievements of his early novels—*All-Night Visitors* (1969) and *NO* (1973)—Major has, in recent decades, attracted critical attention principally in response to his seven book-length works of fiction published between 1975 and 1996: the short story collection *Fun and Games* (1990) and, especially, the novels *Reflex and Bone Structure* (1975), *Emergency Exit* (1979), *My Amputations* (1986), *Such Was the Season* (1987), *Painted Turtle: Woman with Guitar* (1988), and *Dirty Bird Blues* (1996). In formal terms, these six novels have moved from being extremely, and very effectively, avant-garde to becoming, over the past decade, far more linear in their plotting and decidedly less metafictional than was his work through 1986.

As both novelist and critic, Major had, throughout the decade leading up to 1987, overtly championed what he called "serious fiction,"[1] work designed to push the boundaries and expand the horizons of the novel; in fact, as I have argued elsewhere (Weixlmann 1991–92), his literary project through 1986 could be understood as the deconstruction of the African American novel as genre. An espoused purpose of the Fiction Collective, a group Major helped to found, was to publish and promote formally experimental fiction, which Collective members believed commercial publishers neither welcomed nor appropriately supported, and between 1975 and 1986 Major published three formally self-conscious novels with the Fiction Collective, two of which (*Reflex and Bone Structure* and *My Amputations*, which won the 1986 Western States Book Award) were critical successes and helped to redefine the character of American and African American fiction.

In his first two novels, *All-Night Visitors* and *NO*, Major had depicted fragmented fictional personae—within relatively linear narrative structures. With *Reflex and Bone Structure*, however, Major began radically to de-construct both traditional notions of the novel and Western society's con-ventional means of perceiving and structuring reality. Whereas the central premise underlying the "realistic" school of American writing, of which the preponderance of African American fiction is so much a part, is that fiction directly mirrors life, *Reflex and Bone Structure* demonstrates that literary works are necessarily bound to the phenomenal world only by their status as artifacts within that world and by virtue of their being extensions of authors whose imaginative acts brought them into existence. "I'm extend-

ing reality," quips the implied author of *Reflex*, "not retelling it" (49). The world of *Reflex and Bone Structure* is a multivalent realm in which investigation of phenomena is more likely to *widen* the number of possible alternatives than it is to ferret out the "truths" of existence.

Major's metafictional explorations continued in *Emergency Exit*, a highly episodic, digressive, and self-conscious book dedicated "to the people whose stories do not hold together" (vii). Amidst a dizzying array of love triangles and triangles-within-triangles, the characters tend to blur in much the same way that Cora's trio of male lovers merge in *Reflex*, at times assuming a generic identity "He"/"She" (152) or "One"/"Two" (181). Never memorable, the lovers' language sometimes becomes indecipherable, occasionally degenerating into what might be called linguistic static (see 126, 132, 140, 187, and 194). At other times, the words and sentences are intelligible, but there is no way in which to match them with a particular speaker or set of speakers (see, for example, 77–78). The least satisfying of Major's eight published novels, *Emergency Exit* nonetheless extends the deconstructionist project announced in *Reflex and Bone Structure*—and sounds a call that Major responded to in what, for me, remains his most successful novel to date, *My Amputations*.

Dedicated "to the people who must find themselves," *Amputations* dramatizes the attempt of its narrator, Mason Ellis, to establish a stable identity within a destabilized environment. A would-be author and ex-convict, Mason has, while in prison, so intensely read the writing of the Author that, at least at times, he seems to have "convinced himself that he was the writer and no longer the reader" (40). While Major never allows us to forget that *My Amputations* is a work of fiction, he includes elements that are all too real, at times blending autobiography and literary self-creation and interweaving the phenomenal and the imagined so effectively that the reader often lacks a basis for distinguishing between the two. As I observed in 1992,

> Here, as in no previous work, Major's critique of realism spills beyond the literary into the sociopolitical arena. Less sanguine about the possibility of the individual's achieving a genuine African American identity than [Alex] Haley, [Toni] Morrison, or even [Ralph] Ellison, Major depicts a world more akin to Richard Wright's. For the African American writer in particular, identity has always been a central issue, and Major, in *My Amputations*, signifies on a tradition that goes at least as far back as the slave narrative, in which the individual's status as human or animal was ever a matter of debate. (76)

Having traveled across America and Europe in search of his identity, Mason returns to mother Africa as a would-be prodigal son, only to end up the bearer of a note like the one that Ellison's Dr. Bledsoe gives to the Invisible

Man: "Mason pulled it from his pocket and handed it over. The old man ripped it open and read aloud: '*Keep* this nigger!'" (204). Ellison's protagonist is several times given the opportunity to recover, but as Major's novel concludes, Mason—oppressed by the heat and humidity, unable to separate his *anima* from his various *personae*, and numbed by his life's experiences—is left standing in a hut with the smell of "cow rocks, turtle piss and smoke" burning in his nostrils (205).

Given Major's studied devotion to undermining the conventions and intellectual underpinnings of literary realism in his fiction for more than a decade, given the fact that, in *My Amputations*, he found a particularly effective means of blending medium and message, and given the fact that each of his three post–Fiction Collective novels is, at least by comparison to his earlier work, quite conventionally structured, it stands to reason that his more recent novels have raised certain critics' eyebrows. As Major observed in a 1994 interview with Larry McCaffery and Jerzy Kutnik, some believe that, in his recent novels, he has "jumped ship, betrayed [his] experimental goals" (125).

As it happens, I am not among those who believe that Major has become a traitor to the cause of literary avant-gardism. But his recent fiction is decidedly different, and as someone who has followed Major's career quite carefully over the past two decades, I am convinced that we must develop new understandings about what is clearly an evolving fictional practice. Writing is, among other things, about freedom, and writers unquestionably have the right to change styles, themes, genres—and much more. They must be free to invent and reinvent—in life, no less than on the printed page. In his interview with McCaffery and Kutnik Major describes the recent shift in his fictional practice in this way:

> [W]hat we're talking about here, both in terms of my writing and my life, is an evolution, not a sharp break. Exploring different personae in my earlier novels was something that grew out of my sense of personal fragmentation. Those feelings have changed somewhat as I've gotten older and had some opportunity to resolve some of those conflicts about myself and recognize integration rather than separation. (125–26)

He continues:

> Like other authors working against the grain of traditional realism, I thought it important back in the seventies to keep reminding readers that when writers start putting words on the page, they're not "representing" anything except the way their mind works. But once you say that, what does a writer do with it? Having said this fifteen years ago, . . . I simply don't need to do [it] again. (130)

One way to understand the new, more centered phase of Major's career as a novelist is to highlight the emphasis he has begun to place on projecting a more unified narrative voice in his fiction. In "Clarence Major's Homecoming Voice in *Such Was the Season*," Bernard W. Bell makes this very argument about the first of Major's three post–Fiction Collective novels to be published.[2] In *Such Was the Season* black Atlanta matriarch Annie Eliza speaks forthrightly, even brashly, about a host of subjects, including family members and Georgia politics. By contrast, the narrative voice of Baldwin (Baldy) Saiyitaca, the Navajo-Hopi who narrates *Painted Turtle*, is consistently soft and lyrical as he recounts the life of the woman he loves.[3] Narrated in the third person, *Dirty Bird Blues* is different still; in his most recent novel, Major takes the reader inside the consciousness of Manfred Banks, a Chicago blues man who, along with the implied author, embodies the black vernacular.

In this essay, I explore Major's fictional practice in two of these novels, *Painted Turtle: Woman with Guitar*, which Major tells us he began writing the day after he completed *My Amputations* (see "Licking Stamps" 197), and his most recent novel, *Dirty Bird Blues*. Not only are these two books, for me, more interesting novels than *Season*, but looking closely at them allows one to span the time period between Major's Fiction Collective work and the present. Moreover, both novels can be read as being in dialogue with one another, and both evidence Major using what I am calling his singing voice(s) to help create a new and important body of fiction.

Painted Turtle owes its genesis to the last of Major's Fiction Collective novels, *My Amputations*, in which the character Painted Turtle, a Zuni folksinger, appears briefly. The working draft of *Painted Turtle* was entitled *Folksong*, and it was narrated by Turtle, but in the published novel, Major has Baldy, a guitar player of mixed Navajo and Hopi heritage, present the life story of the woman he loves. Sent by their mutual agent, Peter Inkpen, "to make [Turtle] more commercial, to get her to switch [from acoustic guitar] to electric" (7), Baldy finds her music and person so captivating that he quickly abandons his assignment and, over time, becomes romantically involved with her.

Much has been written of male spectatorship, but Baldy's "gaze" at Turtle is always respectful, never leering. "I was patient," Baldy states simply, "and we became lovers" (111). He observes that "I hardly cared anymore about Inkpen's plans for me. I was in love with a great artist, a poet, and a beautiful person" (136). Characters in Major's earlier books couple freely and often, but *Painted Turtle* is, in its portrayal of human sexuality, a very different, very chaste book. Certain sexual acts serve as markers of Painted Turtle's evolution from childhood to adulthood, but Baldy reveals few details about Turtle's rape as a girl of eleven or twelve, about the time she spent as a

prostitute beginning at the age of nineteen, or, for that matter, about the physical relationship that he and Turtle share.

The emotions his terse description of her rape most evoke are pain and suffering: Keith Leekela "cut her open with his hardness. He was a jagged edge of a sardine can" (30). Sensuality is briefly introduced in the first of the chapters that deal with her life as a prostitute, ironically titled "Gentleman John"—Turtle calculatedly moves her hips to provoke the gaze of a "John," and she "unbutton[s] her blouse"—but it is violence, not sensuality, that is on this John's mind: "She felt the blow before she saw anything. Then she tasted the blood in her mouth. . . . She heard the thud of bone against bone. . . . She knew . . . , as she lay on the ground, that she was being kicked in the head" (69). In the next chapter, lyrically named "Segovia's Guitar," she propositions a "grandfather-looking guy" (72), who turns out to be a policeman and busts her. Finally, Baldy's description of the physical relationship he and Turtle share could hardly be less titillating: it is both defined by and limited to the word *love* ("we became lovers" [111], "we made love" [120]). No other details are given; apparently, none are needed. The narration in *Painted Turtle* actively eschews the impulse to dwell on human sexuality, even though the incidents would lend themselves to more detailed treatment.[4]

Moreover, Baldy's gaze rarely turns inward. Rather, it remains focused on his beloved Turtle. The one chapter in which Baldy speaks of himself ("An Interlude: My Story") occurs near the book's end and provides an overview of his life, homeland, and family in six pages. And even here, Painted Turtle is given voice, and some prominence, as she offers Baldy a new lens through which to view his parents, whom we, as readers, are viewing for the only time:

> She told me she thought my mother had modern ideas. She said that she envied me for my mother. . . . I couldn't believe what I was hearing. . . . In all of my thirty-three years I never thought of my mother as modern! Painted Turtle said she thought [my parents] were good together. Something else I never gave a thought! . . . Another thing: the television. What about it? Well, she said, they don't just watch it stupidly. They select certain programs to watch. Before dinner, she reminded me, Ruth and Mike had checked . . . the tv listing and having found nothing of interest had decided against turning it on after dinner. (149)

Baldy permits himself a short rebuttal ("Okay, that was all true. But . . ." [150]), yet ultimately he here accords Turtle what he grants her throughout the book: virtually complete agency.

Because Baldy did not know Turtle until she was an adult, two-thirds of his first-person account is written in the third person—with first-person

asides, and occasionally with consciously anachronistic first-person in-
volvement in the action. These asides, as critic Steve Hayward reminds us
(117–18), emphasize the text's constructedness. Baldy can recount Turtle's
past only because she has disclosed that past to him, and such reconstruc-
tion necessarily means elaboration: "I of course imagine this, making it up
from what Painted Turtle told me" (13). But Baldy's asides also enhance the
narrative's immediacy. He is an *active* teller who would have the reader
believe that he can, after some fashion, view the action he did not see in life.
He observes, for example, that "I keep watching the Turtle in this setting.
Maybe I watch her with the eye in the back of my head or out the corners of
my real ones" (13). Later he writes, "I see the Turtle shiver in confusion"
(14)—and still later, "I can hear her sobbing" (22), or "I have the clearest
view of her in that posture" (24). He even goes so far as to enter, retrospec-
tively, into her childhood doll-making: "She rolls cornhusks to make the
ears. I stick them on her head one at a time. She makes a black face showing
herself with white crescent eyes. With my finger I trace her zigzag nose. . . . I
speak to her" (27). In other words, while *Painted Turtle* possesses the focus
and pacing of novels in the realistic tradition, the narrative practice Major
employs in the book is decidedly innovative.

The introductory note to Major's 1989 collection of poems *Some Obser-
vations of a Stranger at Zuni in the Latter Part of the Century* indicates that
the verse collected there, and by extension the novel *Painted Turtle*, was
"inspired by spending time at Zuni and by living with the spirit and history
of the Zunis and with the spirits of Southwestern Indians." The works "also,
in a way, come out of [Major's] memory of [his] grandparents telling of the
Indians among [his/their] ancestors in the Southwest" (5). But in his inter-
view with Larry McCaffery and Jerzy Kutnik, Major explains that what
initially drew him to the Zuni pueblo south of Gallup, New Mexico, where
he began absorbing Zuni culture firsthand, was "a black man—a huge
African—[who] apparently visited the Zunis in the 16th century with a
group of Spanish explorers and then stayed on. . . . he became some sort of
god for them—he had dozens of wives, and he appears in a lot of early Zuni
legends and stories." Yet after researching this African off- and on-site in
Zuni, Major would eventually erase this figure from the novel because "[h]e
is irrelevant to contemporary Zuni culture, which is finally what I wound
up wanting to explore." Major explains that "[l]etting go of this story was
disappointing. . . . But in the end his presence just didn't fit into my
story" (127).

This, however, is only part of the explanation, for as Major certainly
realizes, while Baldy does not write the African of Zuni myth into his
narrative, that narrative establishes an implicit link between Zuni and Afri-
can American peoples. In 1994 Major stated "that Native Americans often

suffer as much discrimination as black Americans . . . the minute they cross the line of the reservation" (McCaffery and Kutnik 128). In this sense, then, the huge African remains written, subtextually, into the book. The tone, subject matter, and form of *Painted Turtle* may be unique within Major's oeuvre, yet issues of racism, racialism, cultural malaise, and the attempt to forge a stable identity are as central to *Painted Turtle* as they are to any of Major's novels which deal overtly with the experiences of African peoples in America. Or, to describe the matter in a somewhat different way, "the self," as Major remarked to me in a telephone interview in 1991, "operates on a deeper level in this book."

The narrative tone of *Painted Turtle* is rich and evocative, but the story itself is easily recounted. Undervalued because of her gender while a child at Zuni, Painted Turtle is raped immediately following puberty and bears twin sons whom she tries to drown several months later in order to put them "out of what she called their misery" (45). After a stay in a mental hospital and working for a time as a prostitute, Turtle begins traveling throughout the Southwest and, to the accompaniment of her acoustic guitar, singing songs based on her life and culture in small cantinas. In one of these, she and Baldy meet, explore their differently troubled pasts (and presents), and establish the foundation of what would appear to be a solid love relationship. Baldy speaks of being happy at the book's close: "[A]s we moved along the highway . . . , on a perfect morning, that old voice of mistrust made itself heard again," but, he says, "I responded by telling it—like Satan is told in the song—to get behind me" (159).

There is an overt contrast between this ending and the conclusion of the novel written just prior to this one, *My Amputations*, where, at book's end, a befuddled Mason stands in a hut with the smell of "cow rocks, turtle piss and smoke" burning in his nostrils (205). In the more recent work, Turtle and Baldy, as a couple (and to a lesser extent as individuals), enjoy a degree of contentment unknown to the characters in any of Major's first five novels. The bond that exists between them mediates the pain of the past.

The *events* of the past, however, cannot be mediated, nor can the sense of cultural dislocation that each has suffered and, in some measure, continues to suffer. And this fact links *Painted Turtle* with Major's earlier, less optimistic works. Turtle is a modern-thinking Zuni woman whose partial alienation from her culture results inevitably from her having been born into a traditional society that relegates women to second-class roles. "Boys at Zuni could look forward to initiation . . . after the visit with the men to the kivas, they stepped into the daylight like gods born out of the ashes of the dead" (17). Women and girls, on the other hand, remain confined by tribal practice to supporting roles; they are watchers, not doers.[5] Further exacerbating matters is the fact that Turtle's sons—having been conceived through rape,

their paternity not officially acknowledged[6]—are effectively precluded from initiation into the kiva rites. They cannot be Zuni men, and she becomes a third-class citizen—an unfit Zuni mother, a "devil-woman" (36).

Baldy, as the product of a marriage between a Hopi woman and a Navajo man, is similarly marginalized. Since early childhood, he has been "kidded for being a half-breed." Raised on the small Hopi reservation in northeastern Arizona that sits in the middle of a vast expanse of Navajo land, he is chided by Hopis who think "the Navajos pretty loose and arrogant and without traditions. A high-school teacher once told the class that the Navajos were nomad bums" (147).

To these intra- and inter-tribal difficulties are added the problems Painted Turtle and Baldy face as Native Americans living in the Southwest in the 1950s. Pariahs *on* the reservation, Turtle and Baldy are unable to secure suitable accommodations in any of the small towns to which they travel *off* the reservation, since clearly motels do not "let rooms to Indians" (111). That this situation has a parallel in the conditions faced by blacks in the Jim Crow South is no more accidental than is the fact that the present-time action of *Painted Turtle* occurs during the early years of civil rights activism in the South.

It is also noteworthy that *Painted Turtle* ends with a sentence—indeed, the only such sentence in the book—that contains an overt African American cultural reference: "I responded by telling [that old voice of mistrust]—like Satan is told in the song—to get behind me" (159). Turtle's songs employ Zuni cultural referents to tell her life's story, and we know only that Baldy played electric guitar until, under the Turtle's influence, he switches to acoustic. But as the book closes, he is, metaphorically, the classic blues man at the crossroads.

In the novels beginning with *All-Night Visitors* and running through *My Amputations*, Major introduces his readers to a series of African American men and women with marginalized, and sometimes functionally nonexistent, identities. In contrast, the principal characters in *Painted Turtle* come to enjoy some measure of meaning in their lives through their relationship with one another. Still, their individual identities, especially insofar as these are culturally defined, are by no means resolute. Painted Turtle's songs may be rooted in her cultural experiences, but the Zuni councilmen, and many of the Zuni women, want nothing to do with her. And Baldy, while viewed less openly as a pariah by the Hopis, can never possess a full sense of cultural belonging to the tribe within which he was raised.

Turtle, harangued at one point by a tribal "wise man" for what she has reason to regard as patriarchal cruelty but which he regards as her many indiscretions, "look[s] up at the scattering of stars and planets" and concludes "that she w[ill] never understand anything as long as she live[s]"

(107). If the ending of *Painted Turtle* is, as Baldy states, "happy" (159), that happiness must be understood as an emotion that is, to use Major's word, "deeper," a feeling based on some element of connectedness that exists *beneath* the racial and racialist surface of the culture(s) in which Turtle and Baldy function. Baldy observes that "the Zunis had strict and severe beliefs about half-breeds but I also knew that Painted Turtle was not prejudiced" (147). Unfortunately, most of those with whom they interact, on and off the Hopi and Zuni reservations, are just as prejudiced at the tale's end as when Baldy and Turtle were born. Baldy and Painted Turtle have found each other, but they have not found an answer to many of the difficulties that have beset them, and will continue to beset them, throughout their lives. Absent in *Painted Turtle* is the pessimism of Wright's *Native Son* or "The Man Who Lived Underground"—or Major's own *My Amputations*. Rather, the qualifiedly optimistic note Major sounds at the book's end is akin to Ellison's somberly intoned question, "Who knows but that, on the lower frequencies, I speak for you?" (503). If, in gaining life experience, Major took advantage of the "opportunity to resolve some of those conflicts about [him]self and recognize integration rather than separation" (McCaffery and Kutnik 125–26), then there remain with him other conflicts—including, one assumes, those precipitated by what Du Bois called "the problem of the color-line" (23).

An implied narrator—or extradiegetic voice—presides over *Dirty Bird Blues*,[7] but in an intradiegetic move, Major frequently takes the reader deep inside the psyche of Manfred Banks, the book's twenty-six-year-old, blues-singing protagonist. We are regularly exposed to those of Man's conscious thoughts that occur within the present-time action of the novel, which opens in Chicago on Christmas Day 1949 and concludes in Omaha, Nebraska, in the fall of 1950 ("Then he thought, that nigger shooting at me" [1]). The protagonist's subconscious, associative mental processing frequently moves the reader back in time to Man's childhood and adolescence in Lexington and Atlanta and to his early adulthood in Atlanta, New Orleans, and Chicago. And the book's nine italicized dream sequences, along with several lesser dreams, take the reader inside the unconscious mind of Major's protagonist. Occasionally, the narrative lens zooms in even closer, projecting Man's thoughts in the first person ("Some folks say to write a song you gots to be smart but I say all I needs is a start" [96]).

Thus, whereas *Painted Turtle* exposes the innermost thoughts of a female Zuni folksinger, chiefly through the first-person narration of her lover, and exposes the reader to formative experiences from her past, *Dirty Bird Blues* exposes the innermost thoughts and significant past and present actions of a male African American blues singer, chiefly through third-person narration that allows us to view Manfred Banks from without and within. Signifi-

cantly, Manfred's ability to see himself and his ability to know himself, both from without and from within, are perspectives that he, too, must gain in the course of the novel in order to preserve and strengthen his relationship with his wife, Cleo, and daughter, Karina. Man develops these perspectives, in significant measure, through his exposure to the life situations of Solomon (Solly) Thigpen, Man's "other self."

Just as *Painted Turtle* owes its genesis to the novel that preceded it, *My Amputations*, *Dirty Bird Blues* has one centrally important feature in common with each of Major's first five novels: the use of the double. However, whereas the doubling in each of these early novels involves the protagonist's fragmentation, the doubling in *Dirty Bird Blues* consists of Major's using a character to serve as a foil for his protagonist in order to help dramatize Man's development into a whole person by the novel's end. Throughout most of the novel, Manfred and his friend Solly vigorously pursue "wine" (or, more precisely, Old Crow whiskey—the "Dirty Bird" of the title), women (their wives and others), and song (as professional, albeit ill-paid, blues men). However, Solly's inability to control his passion for drink and womanizing eventually leads to his being deserted by his wife, Holly, and their young daughter, Annabel, the destruction of his friendship with Man, and the loss of his employment, whereas Man learns to control first his sexual appetite and then his passion for alcohol in order to save his relationship with his own wife and young daughter. The description of Man's reaction upon learning of the drunken adventures that lead to Solly's being fired is telling: "It was *like seeing part of one's self* tossed out into the ocean unable to swim" (274; italics added). Symbolically, Solly *is* Man's other self— the drunken, womanizing persona he must will into oblivion. At base, *Dirty Bird Blues* dramatizes Man's self-integration, as he evolves from an abused child (" 'From the beginning everybody said I wont gon mount to nothing. Specially my daddy. That nigger laid into my ass all the time' " [208]) to a marginally functional adult (" 'I been trying to get myself out of being like that, the way they made me be' " [209]) to a caring husband and father. And as in *Painted Turtle*, the road the protagonist travels is thickly gendered and rife with racial tensions.

To be a married African American woman in *Dirty Bird Blues* is, in many cases, to be subject to physical and psychological abuse.[8] But these women, even when abused, do not lack agency. As the novel opens, Man's wife, Cleo, tired of her husband's drinking and infidelity, has moved in with the Reverend Eddie Bedford. But when Eddie physically abuses her, she leaves him and moves in with her sister Shawn. Cleo subsequently returns to Man, with their daughter, Karina, but only after securing from him a promise that he will amend his ways—a promise that Man comes to understand he must fulfill. "Cleo had this real sweet disposition, you see. Calm-like. She couldn't

stay mad at [Man] for long, but she wouldn't take any shit. She would laugh and all but she was serious" (13). Nor does Cleo, following the couple's reconciliation, respect her husband's wish that she stay at home full-time to raise Karina; instead, she begins working in her sister-in-law's beauty shop. Told by Man that " '[a] baby needs her mother,' " Cleo responds:

"Yes, but Fred, what good is a crazy mother to a baby?"

"What you mean, woman?"

"I mean I'll go nuts in this place. I want to go to work." (116)

And she does. Early in the novel, Cleo's "double," Holly, appears to be tolerant of her husband Solly's carryings-on, but by the novel's end she, too, tires of Solly's inebriation and sexual promiscuity. Believing (with ample justification) that Solly is not going to mend his ways, she leaves for Chicago without him, and with their daughter, Annabel, in tow.

But unlike *Painted Turtle*, in which Major explores the psyche of an Indian woman living in patriarchal, racist societies on and off reservations in the American Southwest, *Dirty Bird Blues* does not focus on women and women's issues. Rather, Major's more recent novel explores the psyche of an African American male living in similarly patriarchal, racist societies in two midwestern cities: South Side Chicago, well-known to readers of African American fiction as the setting of Richard Wright's *Native Son*, and Omaha, Nebraska, a less hostile but still racist environment.[9]

Echoing—with a twist—the racial politics of *Painted Turtle*, in which Major dramatizes white-on-Indian and intra- and inter-tribal racism, with only passing reference to white-on-black racism, *Dirty Bird Blues* is suffused with white-on-black racism but contains one scene that evokes white-on-Indian and intra-tribal racism.[10] When Man moves to Omaha, he hopes to be free of the blatant white-on-black racism (and black-on-black violence) that characterizes life in Chicago and to succeed as both a husband and a professional blues man. But from the outset, the reader understands that the opportunities open to African Americans in Omaha are proscribed.

Driving Man home from the train station after his arrival in Omaha, Man's sister Debbie proclaims that, in her husband Lyle's factory, " 'they treat the colored boys well' " (52). If the phrase "colored boys" weren't unsettling enough, she immediately cautions Man that an African American dare not speed in town because " 'they watch Negroes something terrible' " (53). Shortly thereafter, the theme of lynching, which resurfaces several times in the remainder of the novel, is introduced in another of Debbie's remarks: " 'Oh, I remember what I was saying. How they lynched that boy— William Brown—shot his body full of bullets then dragged it through the streets and burned it. Lynched him right over there on the corner of Eighteenth and Harney—about five or six blocks from here' " (55).[11]

Although Malcolm X is never mentioned by name in this novel set in 1950, Major certainly must hope that his readers will recall "Nightmare," the opening chapter of Malcolm's famous autobiography which begins, curiously enough, with a prenatal "recollection" from 1925: "When my mother was pregnant with me, she later told me, a party of hooded Ku Klux Klan riders galloped to our home in Omaha, Nebraska, one night" (1). The Klansmen were in search of Malcolm's father, the Reverend Earl Little, who happened to be out of town that evening. Six years later, in Lansing, Michigan, Earl Little was found dead, his "skull . . . crushed in" and "his body . . . cut almost in half" (10). These related events are conflated in *Dirty Bird Blues* when Man recalls having been told by Solly's landlady, an African American woman with a "passion for politics," that "when the Klan killed Reverend Little she went to the funeral. . . . Old-timers still remembered that" (214). In other words, Major figures Omaha as the site of the lynching of Malcolm X's father, whose crimes were being a strong, outspoken black man and being a staunch supporter of the Back-to-Africa ideology of Marcus Garvey.

In subsequent chapters, Debbie and Lyle's sons are stopped by the police for no apparent reason other than the fact that they are black adolescents ("'All we was doing was walking down the street'" [65]). Man's white landlady, Sofia Sweeney, shows that she is racially obsessed:

> While standing there [Man] heard this voice, Sofia's voice downstairs . . . , "So sick of these goddamned niggers. Sick! Sick! Sick! Sick to death of sonsofbitching niggers. Niggers! Niggers! Niggers! Everywhere I turn, niggers! Goddamned niggers! Stupid asshole niggers! Rotten no-good asshole niggers! Niggers! Niggers! Niggers! Niggers over me, niggers all around me!" (108)

Moreover, Man is demeaned on the job by white coworkers (see, for example, 85–87) and is eventually hounded out of a job at the Lomax metal factory because—he later learns—he accepted a ride across town from a white woman and was seen by his "boss," who falsely—and stereotypically—assumes that Man was sexually involved with her (see 171–72).[12]

Throughout the book, Man uses an African American slang term to refer to any nonmusician's job: it is "a slave." And so it is telling that Eliot Selby, Man's white foreman at Lomax, is identified as "the boss" (85), a plantation term, and that the phrase "brain-lynch[ing]" is used to characterize the process by which Eliot the bossman robs Man of his livelihood (see 164), as he seeks simultaneously to eradicate Man's manhood. (My pun on *manhood* is very much intended, for Man is, in certain respects, a black Everyman who must regularly resist being labeled "boy" or "nobody" [see 83–84].)

Man's lynch and castration fears surface very dramatically in the italicized dream sequence, set at the Lomax factory, which opens chapter 20:

He's raising the load up, holding the [crane] lever firmly . . . he keeps his eyes on the load, making sure it stays straight. Then suddenly there is a loud scream—EEEEEEEEEEEE! The cry of some male thing getting his balls cut off . . . in his panic he releases the lever and looks straight down below the cab. On the ground, lying spread-eagle is Eliot. Half of his head torn off where the edge of the stack of beams has torn into it. A gut-deep fear grips Man's bowels and he thinks he might be pissing in his pants. He's killed a man, a white man. Image of himself swinging at the end of a rope with the smell of kerosene all over his body and flames leaping up at his legs . . . he knows sure as shit, he's going to die in a minute or two. And the rope touches his right cheek.

Fortunately for Man, this incident is not "real," but that it cuts deep into his psyche is captured in a lyric which the nightmare evokes: "Went to the river, all I caught was a shiver. Cain't get across, cain't get back loss, cause of that goddamned boss" (158). Linking the secular and the sacred, the blues and the spirituals, the lyric conjures up both the hunted slave and also the time, at the end of Man's mortal life, when he would cross over Jordan to eternal life—only to have his path blocked by the bossman/Satan.

Later in the novel, after working for a time on a more menial "slave," mopping floors in a Sears department store, Man one night finds himself sick from too much alcohol and general depression and determines that he must leave. (" 'Hey, Mister Bossman,' " mocks a coworker, " 'I gots a belly-ache, please suh, let me go home' " [216].) Arriving after midnight at his empty apartment, sick and disoriented, Man believes that Cleo has taken Karina and left him once more—this time for good. After a wild series of misadventures in which he threatens his next-door neighbor, misdials the phone number of his sister (with whom Cleo, unbeknownst to Man, has been having dinner), calls Cleo's sister in Chicago, threatens a church pastor whom he imagines Cleo to be staying with, and avoids a police cruiser called to the church to quell the disruption Man has initiated, Man works his way back home. There he finds Cleo waiting for him, collapses, and has a second lynch/castration nightmare:

He feels the hard new rope resting loosely around his damp neck. A mob of about a hundred jeering dog-faced white men are gathered around the base of a pile of scrap metal on which he stands. . . . Closing his eyes, he sees a little birdhouse, and looking through the little hole, inside he sees a little old man sitting in a rocking chair. The old man is himself, a self that will never be. . . . Man's feet suddenly feel cold and he strains to look down. The pile of scrap metal has become a pile of scrap wood. He smells kerosene. . . . He knows he's in the Lomax main bay but at the same time it seems like a hellish semi-open area steaming with smoke from a recent fire. . . . He smells a fire torch burning. . . . One man to his left throws a bucket of bird and mice droppings

onto the pile. A mop and a broom are thrown on. . . . He turns his head . . . and sees the backside of somebody . . . feeding the body of a child into the machine . . . he realizes it's his daughter. . . . He's standing on his own grave and he knows it. But he has stopped shaking. Terror has turned rotten, like loose shit, in his veins. It is as though he's already dead. . . . Gabriel's horn is blowing. . . . The mob is screaming joy. . . . The flames are gaining power, lapping up at his pants legs, cutting into his crotch. (234–35)

At the heart of this lynch-dream, which clearly evokes his work experiences at both Lomax and Sears, and which portends the death of his future, including his progeny, is the death of his masculinity—the flames cut into his crotch.

Upon waking, Man recognizes that he has "had himself a revelation. Saw his own naked fear and had himself a scared-shitless revelation" (237). Determined to win back his manhood, and with an understanding—now—of how to go about it, he sets aside the bottle and focuses his attention on his wife and daughter and their needs, as well as his own. Major would have the reader understand that a key factor affecting the book's central action—namely, Man's quest to *be* a man, to establish his manhood as a citizen, husband, and father—is the threat of lynching, both lived and dreamed, historical and fictional. Man can affect his fate, but that fate is not wholly within his control, or any (wo)man's control—especially if that (wo)man is black.

The vagaries of the black man's fate in 1950s' America—that, to paraphrase a B. B. King title, is why Man's singing the blues. We feel Man's anguish: "How many mo years—? Lord, how many mo years this got to go on?" (160). But we also hear aspirations toward freedom: "May done dug my own grave but ain't gon be no slave" (169), or "Don't care where you bury my body, / It gon rise like the sun" (240). And a blues-singing voice, with metaphor and sexual double entendre, tells of love lost ("When you hear them bedsprings popping, / Popping, popping till the morning bell toll, / You know somebody copping, copping / Off you jellyroll" [262]) and of love found ("Sepia baby with pretty thighs, / I a crawling blacksnake with two eyes. . . . High-class sugar, you my high tone. / I'm gon love you right down to the bone" [101]).

Sometimes it is Man himself whom the reader "hears" singing. That is, the lyrics reproduced in the text are often ones that Man is singing to an audience—patrons of Bob Jones' Entertainment Palace, on the one hand, or family and friends, on the other. Like most of the folk lyrics which Painted Turtle sings, Man's audience-directed lyrics are, for the most part, introduced conventionally ("The sax was saying what he was saying—" [17]; "Then he started singing—" [38]; "After a good long shot of whiskey, Man cut into—" [140]). More often, however, the lyrics in *Dirty Bird Blues* are

not being sung in the "real time" of the narrative; rather, they appear associationally to reinforce a feeling or narrative action. It is possible to "hear" these untagged lyrics as Man's, or as those of another singer—or of other singers. And this tension is reinforced by the fact that, while some of the lyrics in the novel originate with Major, many come from traditional blues. Major's formal inventiveness here produces a powerful effect on the reader, who remains wrapped in the cadences of the blues even when it would appear that no one in the book is singing them. The technique also serves to reinforce the fact that, at some level, Man is Everyman, that the novel inclines toward the universal as it explores the particular.[13]

Man plays the blues, but the blues are more than a musical form in this novel. In fact, the blues are sometimes figured as life itself—"I said the blues ain't nothing . . . / Ain't nothing but you staying alive, / You keeping on keeping on" (261–62). Or as Jorena tells Man, " 'You sing straight up from your guts. It comes out everything that you are' " (206).

Though a skilled blues man, Man has been quite poorly paid for singing the blues. Yet blues playing is most decidedly *not* a slave. Toward the novel's end, Man is given an opportunity to return to Sears, but he focuses instead on "his growing success"—and burgeoning income—at Bob Jones' Entertainment Palace:

> The last couple of times Jorena had given him seventy-five dollars and his total weekend tip take had been over a hundred. . . . Got Cleo. . . . Got things going nice at the Palace. No craving. Ain't raving. . . . Just gots to take yo time. Own sweet time. He could hear in the rhythm of his foot-falls, a music: slap do blap, slap do blap, slap do blap, slap do blap. (276)

In a rich and complex sense, playing the blues is, for Man, a *profession*—that is, both a calling and a declaration of African American cultural authenticity and expressivity. The blues embody his life—and the lives of many of those in the African American communities in which Man lives and has lived. The love of his family and playing the blues—these are the things that help make Man whole at the book's end.

But while the blues are the most prominent musical form in the novel, black church music also plays an important role. Man eventually comes to understand that the church is not a place where Cleo seeks escape either into human love or religious dogma, but a setting in which the music moves her to joy in much the same way that the blues affect him. Walking down the street one day, with his mind on Cleo, Man "hit[s] a rhythm in his stride" that leads him to realize, "for the first time," that

> Cleo got her own music. It's there in the church. And he remembered the first time he saw her get happy, in Chicago in the church where they were

married. . . . The choir was jamming up a breeze, shouting one of them happy-sad sorrow songs . . . and there was Cleo right with them, grinning like a Halloween cat, clapping her hands, tapping her feet, and singing like nobody's business. The woman was in her heaven. (179)

African American music—in Man's case, secular; in Cleo's case, sacred—plays a central role in the life of each character. Music is both a palliative and an expression of key aspects of the characters' existence. Unsurprisingly, then, Man comes to conceptualize his daughter Karina as a kind of music: "She was his music. And she made Cleo all the more important. She is a life growing out of my life. In her own time. She's mine and not mine. She belongs to herself. Cleo belongs to herself too. Jes passing through" (244). These are Man's mature thoughts. They evidence his growth out of selfishness and into a fuller appreciation of his family members, their needs and rights, and their individuality. The novel concludes with Cleo approaching Man with Karina in her arms: "He got up and met his wife and daughter" (279). The word choice here is telling: Man *greets* his family members, but to the extent that, for much of the novel, he has not understood, much less fully valued, Cleo and Karina, he is also *meeting* them for the first time as a whole person.

Even more so than in *Painted Turtle*, the principal characters in *Dirty Bird Blues* develop meaning through their relationships with one another. There will certainly be trials ahead: Man may have matured, but the racial environment in Omaha remains fundamentally hostile to African Americans; alcoholics are always recover*ing* rather than recover*ed*; Cleo is her own person and is unlikely to tolerate any significant backsliding; raising children requires patience and considerable attention; Man has no guarantee of ongoing employment; and so forth. Still, the reader of Major's fiction accustomed to multiply entangled love triangles and indeterminant and/or pained endings finishes *Dirty Bird Blues* with the image of a very different kind of triangle—an intact nuclear family! This is by far the most positive conclusion in Major's fictional canon.

Having remarked above that the pessimism of Wright's *Native Son* and "The Man Who Lived Underground," works to which *Dirty Bird Blues* alludes (see note 9), is fundamentally absent in *Painted Turtle*, I would add that Major's most recent novel can be read as a partial answer to personal concerns that gnawed at Wright. More unqualifiedly optimistic than the note sounded at the end of *Painted Turtle*, the conclusion of *Dirty Bird Blues* speaks even more directly to Major's desire to "recognize integration rather than separation" (McCaffery and Kutnik 126) in his life and work.

Formally, neither *Painted Turtle* nor *Dirty Bird Blues* is a perfect book. Twice in *Painted Turtle* the overvoice of an implied author intrudes on

Baldy's narration in ways that serve more to break the narrative flow than to make a metafictional point. The first instance occurs on page 18. Following a paragraph that is typical of Baldy's restrained voicing (sixteen sentences appear there, with an average length of between ten and eleven words) comes this differently voiced paragraph:

> One winter her aunt—on her father's side—was selected to go up to the top of Corn Mountain to bring the winter flame back from the burning light there and her sisters and grandmothers and other aunts cleaned the winter stoves and fireplaces and ovens and fasted for four days and the sword swallowers that winter were wonderful as they held forth quite seriously in the plaza. Phew!—what a sentence!

There are other sentences of moderate length in the novel, but none exhibits this (unpunctuated) fusion of clauses, stitched loosely together with the conjunction *and*. The first sentence, then, is arguably not Baldy's, but the implied author's. And the self-conscious exclamatory remark "Phew!—what a sentence!" is *surely* that of the implied author. This sort of self-conscious authorial intrusion, common in Major's Fiction Collective novels, where the writtenness of the literary construct is everywhere underscored, here serves principally to disrupt the otherwise smooth, lyrical flow of Baldy's account.[14]

A second, less striking metafictional moment occurs later in the book: "And that's when xyz hit the fan" (114). Baldy's narrative voice may be restrained, but he is not a prude. Earlier on the same page he tells the reader that he "got pissed." "Crapped" (122), "damned" (122), and "putas" (137) are also in his vocabulary. Thus, the use of "xyz" would not seem to be a prudish attempt to avoid the word *shit* but a second intrusion by the implied author. I find "xyz" to be more problematic than the paragraph on page 18, since that paragraph, at least, functions to establish the work's constructedness, whereas the use of "xyz" might well be misunderstood by readers unfamiliar with Major's metafictional practice. At any rate, there is some dissonance here as Major attempts to work both within and against the conventions of literary realism.

It would also be good to know more about Baldy—if only to understand Painted Turtle's attachment to him more fully. We know that he plays electric guitar professionally, but we do not know anything about the style in which he plays, much less the traditions from which his musical creativity springs. From the outset, Baldy tells us that Turtle's music shows her to be "culturally bound" and "that seriousness and lack of ambiguity were part of her charm" (7), and in the course of the novel, these observations are given very concrete meaning. But the reader learns next to nothing about Baldy's musicianship, which is not so much ambiguous as it is a lacuna.

Dirty Bird Blues has its shortcomings, too. Although the book focuses tightly on Manfred's struggles for respect and for personal and familial wholeness, the plotting that immediately precedes his "conversion" from alcohol abuser and unfaithful husband to devoted spouse and father is somewhat contrived. Man's (and the reader's) surprise at learning that Cleo has not left him for a second time following his return to an empty house three-quarters of the way through the novel has an O. Henry–like abruptness to it, and while it is plausible that such an event might shock someone into changing his ways, Man's subsequent transformation is starkly complete. Moreover, the narrative energy of the novel occasionally falters as Major self-consciously overwrites sections of the text, pouring the lexicographic research he did for *Juba to Jive: A Dictionary of African-American Slang* into his novel in an apparent attempt to heighten the sensory impact of selected scenes ("Use that nigger to mop up a greasy floor, make that nigger think a mob of Georgia crackers lynching his ass, work my mojo on that nigger, pistol-whip that nigger till he bleed green pee. Make that nigger look like a pot of gumbo filé . . ." [1]). While both novels engage the reader intellectually and emotionally, and while my reservations are modest ones, neither book sustains its narrative intensity from cover to cover quite so well as it might.

These reservations notwithstanding, *Painted Turtle* and *Dirty Bird Blues* amply demonstrate Major's ability to redefine and revitalize his fictional practice. In the 1960s and 70s, literary realism proved limiting to a number of African American novelists seeking to find, or at least imagine, a better, more promising future. And the metafictional forays in which Major engaged for more than a decade provided a means for moving beyond the structural and intellectual boundaries realism and naturalism had imposed on the novel, and on novelists—especially women and nonwhite males. But such formal experimentation can eventually become its own box, and Major has never been willingly contained as a writer.

Both *Painted Turtle* and *Dirty Bird Blues* show Major continuing to innovate. A poet as well as a novelist, Major, in *Painted Turtle*, blends prose and poetry (in the form of the Turtle's song lyrics)—in the process "worrying" the distinction between the two genres. He also, as I have noted above, makes inventive use of the first-person point of view in the book. Major's experiments with narrative structure and his fusion of fiction and song continue in *Dirty Bird Blues*, and in his more recent novel he finds compelling ways to write a blues life. Moreover, while Major's vantage point expands in these novels to include Native American as well as African American subject matter, he remains true to his ongoing critiques of racism and racialism in America and to his critique of Freudianism.

Clarence Major's recent novels certainly differ in important ways from

his earlier works, but the changes evident in them do not constitute an abandonment of the issues that concerned him in midcareer. To the contrary, Major's recent fiction shows that he has found ways to extend his reach as a novelist while continuing to explore the issues that have long fueled his literary imagination. Through the voices of his singers, and through his own singing voice(s), Major has staked out important new literary terrain in the past decade, and those of us who respect his work are anxious to see what the next chapter in his grand and multifaceted literary opus will reveal about both the man and his fictional practice.

NOTES

1. See, for example, Major's two-part essay "The Crunch on Serious Fiction."

2. Although *Painted Turtle* was written a year before *Season*, *Season* was published a year before *Painted Turtle*.

3. In draft, the book was narrated by Turtle, but Major could not make her voice "come alive. *Painted Turtle* taught me that, if I were going to write in a woman's voice, it had to be a voice I felt comfortable with—one that would come naturally rather than something I'd have to invent completely. That was a big help when I started *Such Was the Season* a year later" (McCaffery and Kutnik 127).

4. Reviewing the book for *MELUS*, Deborah Fairman Browning praises *Painted Turtle* as "a novel which can be compared favorably with contemporary American Indian portrayals of Indian Life" and which evidences "an American Indian sensibility" (133–34). Yet she complains that "Major . . . recounts this coming of age story completely within Painted Turtle's sexuality, focusing on her first menstruation, her rape and subsequent pregnancy, her life as a prostitute, and her role as the lover of Baldy" (134–35). Missing from Fairman Browning's analysis of how the novel functions within a Native American literary tradition is an understanding of how *Painted Turtle* fits within the context of Major's oeuvre. Beginning with *All-Night Visitors*, Major has engaged in an unrelenting critique of Western culture's obsession with sexuality (including an in-depth analysis of that culture's aversion to menstrual blood—see, for example, the opening pages of his fourth novel, *Emergency Exit*). It is within this context that I am reading his treatment of sexuality in *Painted Turtle*.

5. "She was with her mothers and sisters—watching. That was life. Boys, without a doubt, were more interesting" (19).

6. "Under normal conditions Keith Leekela's mother would have been there to take charge of the newborn infants, but . . ." (41).

7. This extradiegetic voice, while technically removed from the consciousness of the book's protagonist, Manfred Banks, is usually closely aligned with him. Sometimes, however, it is a distinct voice ("Electric waves, like you see in the comic books, from out in space, went all through him" [10]).

8. Man's sister Debbie and his Aunt Ida are noteworthy exceptions.

9. It is, however, Wright's "The Man Who Lived Underground," rather than *Native Son*, that has more crucial intertextual connections to *Dirty Bird Blues*. The name of Major's protagonist, Manfred, who is alternately called "Man" and "Fred" in *Dirty Bird Blues*, would appear to allude directly to Wright's novella, in which the underground "Man" of the title is named Fred Daniels. Moreover, Major's

opening chapters, in which Man is roughed up by two policemen, Lizard and Bullfrog, are reminiscent of the concluding sequence of "The Man Who Lived Underground," in which three policemen beat Fred Daniels and eventually take his life. That *Dirty Bird Blues* ends far more positively than Wright's novella offers further evidence of Major's psychological as well as stylistic evolution as a writer.

Of course, the police scene—and indeed the entire novel—is rife with intertextual referents to others of Wright's works as well. For example, Lizard repeatedly refers to Manfred as "Big Boy," a name which evokes the protagonist of another of Wright's literary creations in which anti-black violence figures prominently. For more on the intertextuality of *Dirty Bird Blues* and Wright's "Big Boy Leaves Home," see note 12, below.

10. I refer to the scene in chapter 18 in which Matilda, an Omaha-Winnebago, briefly relates her decision to leave the reservation and move to the city of Omaha, Nebraska. Matilda's description indicts not only the whites who took control of tribal lands but also her kinsmen ("'[N]ot many Indians here,'" Matilda says. "'I like it that way'"). Another of Matilda's comments links the plight of African and Native Americans: "'I lived in North Platte for a few years. But they throw you in jail there, if you Indian or colored'" (149).

11. While this passage overtly introduces the *theme* of lynching into the narrative, the *word* appears on the novel's first page.

12. In Wright's "Big Boy Leaves Home," Bertha's (unwarranted) fear of being raped begins the chain reaction of incidents that culminate in Bobo's being lynched; in *Dirty Bird Blues* the scene in which Man learns of the reason for his dismissal from Lomax functions intertextually with Wright's short story (as well as other African American texts such as James Baldwin's *Blues for Mister Charlie*) to extend the meaning of the lynching theme in Major's novel.

13. Particularly apropos here is Houston A. Baker's contention that, "rather than a rigidly personalized form, the blues offers a phylogenetic recapitulation—a nonlinear, freely associative, nonsequential meditation—of species existence. What emerges is not a filled subject, but an anonymous (nameless) voice issuing from a black (w)hole" (5).

14. A more positive take on this aspect of the novel's constructedness can be found in Hayward 116–18.

WORKS CITED

Baker, Houston A., Jr. *Blues, Ideology, and Afro-American Literature: A Vernacular Theory.* Chicago: University of Chicago Press, 1984.

Bell, Bernard W. "Clarence Major's Homecoming Voice in *Such Was the Season.*" *African American Review* 28, no. 1 (Spring 1994): 89–94.

Browning, Deborah Fairman. Review of *Painted Turtle: Woman with Guitar.* *MELUS* 16, no. 4 (1989–90): 133–35.

Du Bois, W. E. B. *The Souls of Black Folk.* 1903. Reprint, Greenwich, Conn.: Fawcett, 1961.

Ellison, Ralph. *Invisible Man.* New York: Random House, 1952.

Hayward, Steve. "Against Commodification: Zuni Culture in Clarence Major's Native American Texts." *African American Review* 28, no. 1 (Spring 1994): 109–20.

McCaffery, Larry, and Jerzy Kutnik. "'I Follow My Eyes': An Interview with Clarence Major." *African American Review* 28, no. 1 (Spring 1994): 121–38.

Major, Clarence. "The Crunch on Serious Fiction." *American Book Review* 2, no. 1 (1979): 14–15; 2, no. 2 (1979): 6–7.

——. *Dirty Bird Blues*. San Francisco: Mercury House, 1996.

——. *Emergency Exit*. New York: Fiction Collective, 1979.

——. "Licking Stamps, Taking Chances." *Contemporary Authors Autobiography Series*, edited by Adele Sarkissian, 6:175–204. Detroit: Gale Research, 1988.

——. *My Amputations*. New York: Fiction Collective, 1986.

——. *Painted Turtle: Woman with Guitar*. Los Angeles: Sun and Moon Press, 1988.

——. *Reflex and Bone Structure*. New York: Fiction Collective, 1975.

——. *Some Observations of a Stranger at Zuni in the Latter Part of the Century*. Los Angeles: Sun and Moon Press, 1989.

——. Telephone interview with the author, December 10, 1991.

Malcolm X. *The Autobiography of Malcolm X*. With Alex Haley. New York: Grove Press, 1965.

Weixlmann, Joe. "African American Deconstruction of the Novel in the Work of Ishmael Reed and Clarence Major." *MELUS* 17, no. 4 (1991–92): 57–79.

Selected Bibliography of Clarence Major's Works

A Article
E Essay
EC Edited collection
LE Letter to the editor of a periodical
LP Long poem in book form
N Novel
NF Nonfiction prose book
P Poem
PC Poetry collection
R Review
SA Short article
SC Story collection
SF Short fiction
SS Short story

The Fires That Burn in Heaven. Chicago: no imprint, 1954. PC
 Reprinted in *Galley Sail Review*, no. 20 (1968) [variant of original]. P
"Bud Powell." *Coercion Review*, no. 1 (Summer 1958): 13. SA
"Editor Writes." *Trace*, no. 27 (June 1958): 14. LE
"The Legend." *Coercion Review*, no. 1 (Summer 1958): 12. SA
"Frank London Brown: A New American Voice." *Proof* 1, no. 1 (July 1960). A
"George Altman: Football Star." *Proof* 1, no. 1 (July 1960). SA
"Girl in a Boat." *Hearse*, no. 6 (1960). SS
"Rev. Bodie and the Greater Harvest Baptist Church." *Proof* 1, no. 1 (July 1960). SA
"My Art and I." *Pendulum of the Time and the Arts* 4, no. 34 (March–April 1961). P
"Sherri Martinelli." *Anagogic and Paideumic Review*, no. 6 (1961). E
"Eddie Cleanhead Vinson: A Permanent Fixture in Modern Jazz." *Bronze Mirror* 1,
 no. 1 (1962). A
"On Negro Digest Poetry." *Negro Digest* (1964). LE
"The Best Poets Now . . ." *Trace* (Winter 1965). LE
Love Poems of a Black Man. Omaha: Coercion Press, 1965. PC
"The Poetry of LeRoi Jones." *Negro Digest* (March 1965): 54–56. E
"The Renegade Press." *Coercion Review*, no. 4 (Winter 1965): 17–20. SA
"A Call for Black Mobilization." *New Left Notes* 1, no. 49 (December 23, 1966): 6.
 SA
Human Juices. Omaha: Coercion Press, 1966. PC
"Malcolm the Martyr." *Negro Digest* (December 1966): 37–42. A
"A Black Criteria." *Journal of Black Poetry* 1 (Spring 1967): 15–16. E
 Reprinted in *Black Voices: An Anthology of Afro-American Literature*, edited by
 Abraham Chapman, 698–99. New York: New American Library, 1968.
 Reprint, New York: St. Martin's Press, 1970. E
 Reprinted in *Nommo: An Anthology of Modern Black African and Black
 American Literature*, edited by W. Robinson, 258–59. New York: Macmillan,
 1972. E
"Hippies of the East Village and the Revolution." *New Left Notes*, November 6,
 1967. E

Introduction to *Writers Workshop Anthology*. New York: Harlem Education
 Project—The New Lincoln School, Summer 1967 [prose and poetry by
 students]. SA, EC
"Black Art." *Caw!* 1, no. 1 (1968): 35. E
"Church Girl." *Human Voice Quarterly* (1968). SS
"Close to the Ground: A Note on Walt Whitman." *American Dialog* 5 (1968): 35. E
"Excerpt from a Novel in Progress." *Trace*, no. 68 (1968): 296–304. SF
"The Faerie." *Loveletter*, nos. 4, 5, and 6 (1968): 5–11. SF
Introduction to *Man Is a Child*, edited by Clarence Major. New York: Macomb's
 Junior High School, 1968 [prose and poetry by students]. SA, EC
"Looking for Militant Black Poetry." *Nickel Review* 1, no. 7 (May 1968). SA
All-Night Visitors. New York: Olympia Press, 1969. N
 Reprinted as *I Visitatori Della Notta*. Translated by Antonio Tronti. Milan:
 Olympia Press Milano, 1969. N
 Paperback edition. New York: Olympia Press Special, 1970. N
 Reprinted as *Damonen*. Translated by O. P. Wilck. Frankfurt: Olympia Press
 Sonderreiche am Main, 1970. N
 Excerpt reprinted as "Anita." In *The New Olympia Reader*, edited by M.
 Girodias, 364–84. New York: Olympia Press, 1970. SF
 Excerpt reprinted as "Gypsy." In *19 Necromancers from Now*, edited by Ishmael
 Reed, 183–88. Garden City, N.Y.: Doubleday-Anchor, 1970. SF
 Excerpt reprinted as "We Is Grunts." In *19 Necromancers from Now*, edited by
 Ishmael Reed, 177–83. Garden City, N.Y.: Doubleday-Anchor, 1970. SF
"How *All-Night Visitors* Was Made." *Nickel Review* (April 1969). E
"I Am Reading My Poems." *Nickel Review* 4, no. 9 (October 31, 1969): 8. E
"The New American Dream." *Nickel Review* 4, no. 10 (November 1969): 4–7. E
The New Black Poetry, edited and with an introduction by Clarence Major. New
 York: International Publishers, 1969. EC
 Paperback edition. New York: New World Paperbacks, International
 Publishers, 1969. EC
"Reckless Enough to Be a Man." *Nickel Review* 4, no. 4 (September 26, 1969): 8. E
"Sound Poetry in a Third Grade Classroom." *Nickel Review* 4, no. 6 (October 10,
 1969). E
"The Tender Wrinkle between Her Eyebrows." *Nickel Review* 4, no. 8 (October 24,
 1969): 8. E
"Vague Ghost after the Father." *Nickel Review* 4, no. 5 (October 3, 1969): 7. E
"Weekend Improvisation." *Nickel Review* 4, no. 10 (November 1969): 8. E
"Black Universities of Survival." *Nickel Review* 4 (April 6, 1970). E
Dictionary of Afro-American Slang. New York: International Publishers, 1970. NF
 Paperback edition. New York: International Publishers, 1970. NF
 Reprinted as *Black Slang: A Dictionary of Afro-American Talk*. London:
 Routledge and Kegan Paul, 1971. NF
 Paperback edition. *Black Slang: A Dictionary of Afro-American Talk*. London:
 Routledge and Kegan Paul, 1971. NF
"Public Education and Creativity." *Nickel Review* 4, no. 39 (May 11, 1970): 4–5. E
Swallow the Lake. Middletown, Conn.: Wesleyan University Press, 1970. PC
 Paperback edition. Middletown, Conn.: Wesleyan University Press, 1970. PC
"Taping the Sounds of Our Eyes." *Nickel Review* 4, no. 20 (January 23, 1970): 6–7. E
"The Clinton Program." *Teachers and Writers Collaborative* 4, nos. 1–2 (May–
 October 1971). A

"The New Black Poetry: Introduction." In *Blackamerican Literature: 1760–Present*, edited by Ruth Miller, 737–40. Beverly Hills: Glencoe Press, 1971. E

Private Line. London: Paul Breman, 1971. PC

Symptoms and Madness. New York: Corinth Books, 1971. PC

 Paperback edition. New York: Corinth Books, 1971. PC

The Cotton Club. Detroit: Broadside Press, 1972. PC

"Dossy O." *Black Creation* 3, no. 4 (1972): 4–5. SF

"Early Grave." *Fiction* 1, no. 3 (1972): 9. SS

"Eli." *Lotus* 1, no. 3 (1972): 54–56. SF

"The Explosion of Black Poetry." *Essence* 3, no. 2 (June 1972): 44–47, 66. E

"The Future." In *Ten Times Black*, edited by Julian Mayfield, 112–24. New York: Bantam Pathfinder Editions, 1972. SF

"A Life Story." *Essence* 2, no. 10 (February 1972): 53, 65. SS

"Sue and Tee." *Center*, no. 4 (1972): 48–49. SF

"Dear Ralph Ellison." *American Poetry Review* 2, no. 6 (1973): 17. A

 Reprinted in *Contemporary Literary Criticism*, no. 3 (1975): 146. E

"Dear SJS." *American Poetry Review* 2, no. 5 (1973): 54. A

"Drama in Flames." *Some*, no. 4 (Summer 1973): 80–81. SF

"Introduction: Related Poems by White and Black Americans." In *From the Belly of the Shark*, edited by W. Lowenfels, 231–32. New York: Random House, 1973. E

NO. New York: Emerson Hall, 1973. N

"On Censorship: An Open Letter to June Jordan." *American Poetry Review* 2, no. 4 (1973): 51. A

"Realism: A Dark Light." *Chelsea*, no. 32 (1973): 100–101. SF

"Ten Pecan Pies." *Essence* (December 1973): 64–65, 86. SS

 Reprinted in *Hampton Roads Journal and Guide*, December 1984. SS

 Reprinted in *Providence Sunday Journal*, November 25, 1984. SS

 Reprinted in *Sun Magazine/Baltimore Sun*, December 16, 1984, 22, 27, 28–29. SS

 Reprinted in *Upstate Magazine/Rochester Sunday Democrat and Chronicle*, December 23, 1984, 5–6. SS

 Reprinted in *Sacramento Bee*, December 21, 1986, 1, 11–12. SS

 Reprinted in *Christmas Stories*, edited by John Miller, 29–41. San Francisco: Chronicle Books, 1993. SS

The Dark and Feeling: Black American Writers and Their Work. New York: Third Press, 1974. NF

"Dear Ernest." *American Poetry Review* 3, no. 5 (1974): 57. E

"Dear Puff." *American Poetry Review* 3, no. 2 (1974): 47. E

"Dear Students." *American Poetry Review* 3, no. 1 (1974): 42. E

"The Father Surrogate." *Oyez Review* 8, no. 2 (1974): 42–44. SS

"Gratitude." *Chicago Sun-Times*, May 26, 1974. LE

"Just Think: Survival." *B.O.P. (Blacks on Paper)*, no. 1 (1974): 103–4. SS

"Making Up Reality." *Fiction International*, nos. 2/3 (1974–75): 151–54. E

"Preface to an Untitled Work by Harold Carrington." *Gallimaufry*, no. 3 (Fall 1974). E

The Syncopated Cakewalk. New York: Barlenmir House, 1974. PC

"All American Cheese." *Seems: Prose and Poetry* 2, no. 6–7 (Summer 1975). SS

"An Area in the Cerebral Hemisphere." In *Statements*, edited by Mark Leyner, 133–38. New York: Venture–George Braziller, 1975. SF

"Dear Charlie Chan." *American Poetry Review* 4, no. 3 (1975): 45–46. E

"Dear Jake and Ray." *American Poetry Review* 4, no. 2 (1975): 40–42. E

"Dear Jean Toomer." *American Poetry Review* 3, no. 6 (1975). E

"Dear Soho." *American Poetry Review* 4, no. 5 (1975): 20. E

"Escape the Close Circle." *B.O.P. Chapter* 111 (1975): 23–28. SS

"Fish, Tomatoes, Mama and Book." *Seems: Prose and Poetry* 2, no. 6–7 (Summer 1975). SS

"Freudian Slips/Dear Freud." *Dodeca* 1, no. 6 (September 1975): 3. SF

"Maria Sinus." *Out of Sight* (1975). SF

Reflex and Bone Structure. New York: Fiction Collective, 1975. N

　　Paperback edition. New York: Fiction Collective, 1975. N

　　Reprinted as *Reflexe et ossature.* Translated by M. Couturier. Lausanne: L'Age d'Homme, Vladimir Dimitijeric, 1980. E

"Social Work." *Black Scholar* 6, no. 9 (June 1975): 35–39. SS

"Thomas Jefferson Harding." *Hoo Doo*, no. 6 (1975). SF

"Dear Charlie." *American Poetry Review* 5, no. 1 (1976): 39–40. E

"Excerpts from Inlet." *Bachy*, no. 8 (1976): 11–12. SF

"The Invention of Lubin." *Dodeca* 2, no. 2 (February 1976). SF

"Poet on the 8th Floor." *Dodeca* 2, no. 2 (February 1976): 18–19. SF

"Clarence Major Interviews Jacob Lawrence, the Expressionist." *Black Scholar* 9, no. 3 (November 1977): 14–25. A

"The Life of the Life of Fiction from Small Presses." *Soho Weekly News*, October 20, 1977, 59, 61. A

"Excerpts from *Emergency Exit.*" *New Earth Review*, nos. 5 and 6 (1978): 5–13. SF

"Fun and Games." *Seattle Review* 1, no. 2 (Fall 1978): 26–30. SS

"The Crunch on Serious Fiction, Part One: The Commercial Press." *American Book Review* 2, no. 1 (1979): 14–15. A

"The Crunch on Serious Fiction, Part Two: The Small Press." *American Book Review* 2, no. 2 (1979): 6–7. A

Emergency Exit. New York: Fiction Collective, 1979. N

　　Paperback edition. New York: Fiction Collective, 1979. N

"*Three Lives* and Gertrude Stein." *Par Rapport: A Journal of the Humanities* 2 (Winter 1979): 53–65. E

"A Letter." *John O'Hara Journal* 3, no. 1/2 (Fall/Winter 1980): 109–10. A

"Party with Masks." *Agni Review*, no. 12 (1980): 79–83. SS

"Rudolph Wurlitzer." *Contemporary Literary Criticism* 15 (1980). E

"Trumpet and Sand." *Accessories* 1, no. 1 (1980): 46. SF

"Writer." *Pacific Poetry and Fiction Review* 8, no. 2 (1980): 5–6. SS

"A Meditation on Time and Space in Bamism." In *Postmodern Fiction: Performance and Representation*, edited by Maurice Couturier. Montpelier, France: Publication de l'Université Paul Valery, 1982. E

"Microcosm." *Hambone*, no. 2 (Fall 1982): 12–17. SS

"Scat/Excerpt from a Novella in Progress." *Alcatraz*, no. 2 (1982): 235–39. SF

"The Erotic Facts of Life: A Personal View." *Révue Francaise d'Etudes Américaines*, no. 20 (May 1984): 261–64. E

"Excerpts from *My Amputations.*" *Genre* (Fall 1984). SF

"Excerpts from *My Amputations.*" *Nethula Journal* (Fall 1984). SF

"Gest Pits." *Alcatraz*, no. 3 (Spring 1984). SF

"Prince Michael." *Hambone*, no. 4 (Fall 1984): 152–56. SS

"T.V." *Callaloo*, no. 22 (Fall 1984): 60–69. SF

Inside Diameter: The France Poems. London: Permanent Press, 1985. PC

My Amputations. New York: Fiction Collective, 1986. N

 Reprinted as "Meine Amputations." Translated by Werner Schmitz. *Schreibheft Zeitschrift zur Literatur*, no. 31 (May 1988): 101–5. SF

"Tatoo." In *American Made: New Fiction from the Fiction Collective*, edited by Mark Leyner, Curtis White, and Thomas Glynn, 155–64. New York: Fiction Collective, 1986. SF

Such Was the Season. San Francisco: Mercury House, 1987. N

 Reprinted in *Breaking Ice: An Anthology of Contemporary African-American Fiction*, edited by Terry McMillan. New York: Viking Penguin, 1990.

"Clarence Major." *Michigan Quarterly Review* 27, no. 1 (Winter 1988) [statement on American fiction]. SA

 Reprinted in *Writers and Their Craft: Short Stories and Essays on the Narrative*, edited by Nicholas Delbanco and Laurence Goldstein, 173–74. Detroit: Wayne State University Press, 1991. SA

"Clarence Major on Wallace Thurman's *Infants of the Spring*." In *Rediscoveries II: Important Writers Select Their Favorite Works of Neglected Fiction*, edited by David Madden and Peggy Bach, 193–99. New York: Carroll and Graf, 1988. E

"Letters." *Central Park*, no. 14 (Fall 1988): 47–54. SS

"Licking Stamps, Taking Chances." In *Contemporary Authors Autobiography Series*, edited by Adele Sarkissian, 6:175–204. Detroit: Gale Research, 1988. E

Painted Turtle: Woman with Guitar. Los Angeles: Sun and Moon Press, 1988. N

Surfaces and Masks: A Poem. Minneapolis: Coffee House Press, 1988. PC

"Introduction/The Baxter Hathaway Prize in Poetry." *Epoch* 38, no. 2 (1989): 77–78. E

"Mobile Axis: A Triptych." *Witness* 3, no. 2/3 (Summer/Fall 1989): 108–22. SF

"My Mother and Mitch." *Boulevard* 4, no. 2 (Fall 1989): 1–11. SS

 Reprinted in *The 1990–1991 Pushcart Prize: Best of the Small Presses XV (1990)*, edited by Bill Henderson, 110–20. Wainscott, N.Y.: Pushcart Press, 1991. SS

"Necessary Distance: Afterthoughts on Becoming a Writer." *Black American Literature Forum* 23, no. 2 (Summer 1989): 197–212. E

 Reprinted in *Black Writers on Black Writing*, edited by Charles Johnson. Bloomington: Indiana University Press, 1992. E

 Reprinted in *Speech and Power: Political, Social, and Personal Essays by African-American Writers*, edited by Gerald Early. New York: Ecco Press, 1992. E

 Reprinted in *African American Review* 28, no. 1 (Spring 1994): 37–47. E

Some Observations of a Stranger at Zuni in the Latter Part of the Century. New American Poetry Series 2. Los Angeles: Sun and Moon Press, 1989. PC

Fun and Games: Short Fictions. Duluth: Holy Cow! Press, 1990. SC

"Asylum." *Hambone*, no. 10 (Winter 1991). SS

"City Flesh and Country Manners." *Callaloo: A Journal of African-American and African Arts and Letters* 14, no. 1 (1991): 4–8. SS

 Reprinted in *Ancestral House: The Black Short Story in the Americas and Europe*, edited by Charles H. Rowell, 340–45. Boulder: Westview Press, 1995.

"My Adventures as Agnes Moorehead's Sister." *ZYZZYVA* 7, no. 2 (Summer 1991): 46–49. SS

"Summer Reading." *American Visions: The Magazine of Afro-American Culture* 6, no. 3 (June 1991): 50. SA

"Chelsea Snow as a Plot against Humanity." *New Myths/MSS* 1, no. 2 (1992): 130. P

"*The Dial.*" In *American Literary Magazine: The Twentieth Century*, edited by
Edward E. Chielens, 79–86. Westport, Conn.: Greenwood Publishing Group,
1992. E

"First Time in Print." *Poets and Writers Magazine* 20, no. 4 (July–August 1992): 22,
24. SA

"Honey Dripper." *Michigan Quarterly Review* 31, no. 2 (Spring 1992): 244. P

"The Little Review." In *American Literary Magazine: The Twentieth Century*,
edited by Edward E. Chielens, 181–86. Westport, Conn.: Greenwood
Publishing Group, 1992. E

Parking Lots. Mount Horeb, Wis.: Perishable Press, 1992. PC

"Present Tense." *Epoch* 41, no. 2 (1992): 260. P

"Scat." *The Sound of Writing.* Public Broadcasting Corporation [radio]; New
York: Anchor Press, 1992. SS

"Summer Love." *Boulevard* 7, no. 1 (Spring 1992): 148–59. SS

"Weaver." *Michigan Quarterly Review* (1992): 245–47. SS

"*The Yale Review.*" In *American Literary Magazine: The Twentieth Century*, edited
by Edward E. Chielens, 387–90. Westport, Conn.: Greenwood Publishing
Group, 1992. E

"Young Guns." *A.N.O. Quarterly Journal of Short Articles, Notes and Reviews* 5, no.
4, new ser. (October 1992): 215. SA

Calling the Wind: Twentieth Century African-American Short Stories, edited and
with an introduction by Clarence Major. New York: HarperCollins, 1993. EC
Paperback edition. New York: HarperPerennial, 1993. EC

"They Hear America Talking." *New York Times Book Review*, June 27, 1993, Letters.
LE

"Chicago Heat." *African American Review* 28, no. 1 (Spring 1994): 29–32. SS

"I Was Looking for the University." *African American Review* 28, no. 1 (Spring
1994): 28. P

Juba to Jive: A Dictionary of African-American Slang, edited and with an
introduction by Clarence Major. New York: Viking Press, 1994. NF
Paperback edition. New York: Viking Penguin, 1994. NF

"On Trying to Imagine the Kiwi Pregnant." *African American Review* 28, no. 1
(Spring 1994): 25–26. P

"On Watching a Caterpillar Become a Butterfly." *African American Review* 28, no.
1 (Spring 1994): 23–24. P

"Sketch." *African American Review* 28, no. 1 (Spring 1994): 33–35. SS

"The Slave Trade: View from the Middle Passage." *African American Review* 28,
no. 1 (Spring 1994): 11–22. P
Reprinted in *Configurations: New and Selected Poems, 1958–1998*, 300–319. Port
Townsend, Wash.: Copper Canyon Press, 1998. P

"View from a Rock at Dusk." *African American Review* 28, no. 1 (Spring 1994): 27. P

"September Mendocino." *New American Writing*, no. 13 (Fall/Winter 1995): 97–
100. P

"Clay Bison in a Cave." *Callaloo: A Journal of African-American and African Arts
and Letters* 19, no. 2 (1996): 612. P

Dirty Bird Blues. San Francisco: Mercury House, 1996. N
Paperback edition. New York: Berkley Putnam Signature Edition, 1997. N

The Garden Thrives: Twentieth Century African-American Poetry, edited and with
an introduction by Clarence Major. New York: HarperCollins, 1996. EC

"The Great Horned Owl." *Callaloo: A Journal of African-American and African Arts and Letters* 19, no. 2 (1996): 611. P

"Horse Says Goodbye (And Good Riddance) to the Twentieth Century." In *American Poets Say Goodbye to the Twentieth Century*, edited by Andrei Codrescu, 227–37. New York: Four Walls Eight Windows/Exquisite Corpse Press, 1996. P

"In Walked Bud with a Palette." *Brilliant Corners: A Journal of Jazz and Literature* 1, no. 1 (1996): 37–38. P

"Large Room with Wood Floor." In *The Garden Thrives: Twentieth Century African-American Poetry*, edited by Clarence Major, 166–67. New York: HarperCollins, 1996. P

"The Story of Rebekah." In *Genesis: As It Is Written*, edited by David Rosenberg, 151–58. San Francisco: HarperSanFrancisco, 1996. E

"Territorial Claims." *Callaloo: A Journal of African-American and African Arts and Letters* 19, no. 2 (1996): 613. P

All-Night Visitors. Unexpurgated edition. Boston: Northeastern University Press, 1998. N

Configurations: New and Selected Poems, 1958–1998. Port Townsend, Wash.: Copper Canyon Press, 1998. PC

"In Your Country." *River City: A Journal of Contemporary Culture* 18, no. 1 (Winter 1998): 82. P

"A Note on the Cover Art." *Brilliant Corners: A Journal of Jazz and Literature* 2, no. 2 (Summer 1998): 4. E

Contributors

BERNARD W. BELL is a professor of English and African American studies at Pennsylvania State University. He is the author, editor, and coeditor of numerous critical articles and books, most notably *The Afro-American Novel and Its Tradition* (1987), *W. E. B. Du Bois on Race and Culture* (1996), and *Call and Response: The Riverside Anthology of the African American Literary Tradition* (1997).

JAMES W. COLEMAN is an associate professor of English at the University of North Carolina at Chapel Hill. He is the author of *Blackness and Modernism: The Literary Career of John Edgar Wideman* (1989).

STEVE HAYWARD is an essayist and poet who lives in New Mexico.

STUART KLAWANS is the film critic for *The Nation* and writes on art for the *New York Daily News*. He has published essays and fiction in a variety of periodicals. His most recent study is *Film Follies: The Cinema Out of Order* (1999).

JEROME KLINKOWITZ, professor of English and University Distinguished Scholar at the University of Northern Iowa, is the author of over thirty books, most recently *Keeping Literary Company: Working with Writers since the 1960s* (1998).

JERZY KUTNIK is professor of American studies at Maria Curie-Sklodowska University in Lublin, Poland. He has published a variety of books and critical articles in English and Polish on postmodern American literature and art.

LARRY MCCAFFERY is the author of four volumes of interviews, including *The Tragic Distance: Interviews with Innovative American Writers* (1994).

NATHANIEL MACKEY teaches literature at the University of California at Santa Cruz. He is the author of numerous works of poetry, criticism, and fiction, including his most recent collection of poetry, *Whatsaid Serif* (1998).

LISA C. RONEY is pursuing a Ph.D. in American literature at Pennsylvania State University. She is the author of *Sweet Invisible Body: Reflections on a Life with Diabetes* (1999) and has published a short story in *Harper's*.

LINDA FURGERSON SELZER teaches English and American studies at Pennsylvania State University. Her primary fields of interest are nineteenth- and twentieth-century American literature, with a focus on intertextuality and the African American literary tradition. Her articles have appeared in the *African American Review*, the *Nathaniel Hawthorne Review*, and the *Rhetoric Review*.

STEPHEN F. SOITOS is a prize-winning author and internationally respected painter. He is the coauthor of several mystery novels and the author of *The Blues Detective: A Study of African American Detective Fiction* (1996).

JOE WEIXLMANN is a professor of English and dean of the College of Arts and Sciences at Indiana State University. He is the author of several critical essays and the editor of the *African American Review*.

Index

Bullins, Ed, 77
Burroughs, William S., 78
Byerman, Keith, 183, 197

Calibanic discourse, 8, 190–97, 199–200
Calling the Wind: Twentieth Century African-American Short Stories, 1, 3, 81
Caspar (biblical king), 115, 116
Cassatt, Mary, 71
Cast the First Stone (Himes), 80
Catcher in the Rye, The (Salinger), 66
Cézanne, Paul, 70–71, 90, 212, 214, 215, 216, 217
Chagall, Marc, 71
Chandler, Raymond, 177
Chaplin, Charlie, 92
Chopin, Frédéric, 73
Christianity, 109, 133, 134
Cocteau, Jean, 66
Coercion Review, 72–73, 77
Coleman, Ornette, 73, 90
Collage, 7, 79, 104
Colonization, 229
Color: in Major's writings, 165
Coltrane, John, 73
Commodification, cultural, 126, 227–40
"Conflict," 29–30, 136–37, 148
Conrad, Joseph, 4, 66
Corot, Jean-Baptiste-Camille, 217
Cotton Club, The, 77
Country Boogie, 171
Creeley, Robert, 77
Crowd, 166, 168
Cubism, 8, 94, 208, 209–17
Cullen, Countee, 4
Cultural hybridization, 123, 126
Culture industry, 230, 231, 237
cummings, e. e., 66

Dark and Feeling: Black American Writers and Their Work, The, 77, 157
Darwin, Charles, 4
Dasein, 236
Daumier, Honoré, 72
Davis, Miles, 73
"Death in the Woods" (Anderson), 63
Defoe, Daniel, 216

Degas, Edgar, 71
De Kooning, Willem, 72, 209
Delaney, Beauford, 161
Delaney, Joseph, 161
Demoiselles d'Avignon, Les (Picasso), 211, 212
"Design, The," 37–38, 143
Detective novel, 8, 175–86
Devil in the Flesh (Radiguet), 65
Devisse, Jean, 108, 109, 116
De Zayas, Marius, 210, 212
Dictionary of Afro-American Slang, 3, 88–89
Dirty Bird Blues, 1, 6; excerpt from, 43–46; critique of, 243, 246, 251–58, 260
"Dismal Moment Passing," 35, 140
Dolphy, Eric, 78
Dorsey, Thomas, 4
Dos Passos, John, 66
Dostoyevsky, Fyodor, 66
Double consciousness, 1–4, 6, 176; in *Such Was the Season*, 1, 219–24; in *Reflex and Bone Structure*, 7–8, 175, 180–81, 185, 186; and Major as painter and writer, 161–68; in *Dirty Bird Blues*, 252
Douglas, Aaron, 4, 161
Du Bois, W. E. B., 3, 251

"Egyptians," 146
Eight Children, 167
"Eldridge Cleaver: And White Writers," 146–47
Eliot, T. S., 4, 66
Ellington, Duke, 4
Ellison, Ralph, 133, 191, 216, 244–45, 251
Emergency Exit, 167, 243, 244; literary importance of, 78; Major's paintings and, 79, 152, 163–65, 166; innovativeness of, 151, 152, 156–57
Emerson, Ralph Waldo, 66
Enlightenment, 104, 105, 118, 127
Equiano, Olaudah, 125
Ethiopian Eunuch (biblical figure), 108–9, 110, 111, 114, 123
Ethnic identity, 3
Eurocentrism, 2, 5, 81, 104
Excavation (de Kooning), 209
"Exhibition, The," 137–38
Expressionism, 77–78

Kerouac, Jack, 73, 78, 89
Kilmer, Joyce, 66
King, B. B., 256
King, Coretta Scott, 84
Kinnell, Galway, 147
"Kitchen Chair Poem #5," 138
Klinkowitz, Jerry, 81, 87, 175
Kokoschka, Oskar, 71
Kuh, Katharine, 208–9
Kutnik, Jerzy, 225, 245, 248

Lady Sings the Blues (Holiday), 66
Lam, Wilfredo, 213
Larsen, Nella, 4–5, 66
Lawrence, D. H., 71, 90
Lawrence, Jacob, 72, 161, 162–63
Leonardo da Vinci, 72, 74
Leopold II, king of Belgium, 126–27
"Liberties," 172
"Licking Stamps, Taking Chances," 223
Liminality, 190, 191, 192, 198, 199–200, 202
Little, Earl, 254
Louis, Joe, 126
Love at First Sight, 166
Lowenfels, Walter, 147
Lyotard, Jean-François, 5

McCaffery, Larry, 175, 225, 245, 248
Macaulay, Zachary, 111, 112
McKay, Claude, 4, 80, 216
McPherson, James, 4
Magical Primitivism, 211, 212
Major, Clarence: transgressive voice of, 1, 6; Native American texts of, 1, 7, 84–86, 227–40, 246–51, 252, 258–59, 260; and double consciousness, 1–4, 7–8, 161, 175, 180–81, 185, 186, 219–24; and subordination of race and politics, 2, 3–4, 6; and style, structure, language, 2, 4, 78–79, 87–88, 93–94, 139–45, 149, 153, 156, 163–65, 170, 175–76, 182, 184–86, 195–200, 244, 259, 260; identity issues of, 7, 78, 82–84, 162, 166–69, 171, 185–86, 244–45; associative collage technique of, 7, 79, 104; deconstructive inclinations of, 7, 176, 186, 243–44; and Cubism, 8, 94, 208, 209–10, 213–17; and detective fiction genre, 8, 175–

86; autobiographical reflections on writing of, 63–76; importance of music to, 73–74, 79, 89–90, 157, 257–58; Freudian influences on, 74–75, 95–96, 133, 134, 140, 147, 148; and postmodernism, 77, 78, 189; and realism, 78, 79, 82, 88, 185, 244, 245, 259, 260; on black aesthetic, 80–81, 185; and experimentalism, 82, 92–95, 189, 192–93, 197–98, 202, 243, 245, 260; on use of female narrator, 84; on television and the media, 86–87; influences on, 88–89, 90; on black slang and speech, 89; as visual thinker, 90–91, 95, 102, 163, 165, 183–84; on poetry vs. fiction writing, 91–92; on technology's impact, 93; on title selection, 95; and death as theme, 95–96; and sex as theme, 95–96, 114–15, 133, 138, 152, 154, 190–202, 246–47; on creative energy maintenance, 96–98; poetic themes and aesthetic of, 133–49; and social strictures as theme, 134–35; and eating as theme, 135, 136; and odor as theme, 136–37; and redefinition of good and evil, 137–38; treatment of reality by, 139–40, 156, 169, 182, 185, 220, 243–44; innovativeness of fiction, 151–58, 163; and metafiction, 175–76, 182, 260. *See also* Visual arts
Major, Pamela Ritter, 79, 95, 97, 165
Malcolm X, 254
Malraux, André, 211
Man Is a Child, 77
Mansfield, Katherine, 71
"Man Who Lived Underground, The" (Wright), 251, 258
Mapplethorpe, Robert, 209
Marx, Karl, 4
Master (meta) narratives, 5
Matisse, Henri, 71
Maurice, Saint, 115, 116–17
Media: Major's view of, 86–87; stylistic innovation and, 92; contemporary African American images in, 126
Melville, Herman, 66, 216
Merwin, W. S., 147
Metafiction, 78, 155, 175–76, 182, 189, 244, 259, 260; conceits of, 182

Tani, Stefano, 175, 185
Tanner, Henry, 72
Tempest, The (Shakespeare), 190
Tintoretto, Jacopo, 72
Toomer, Jean, 1, 4, 66, 69, 90, 95, 152, 224
Toulouse-Lautrec, Henri, 71
Transgressive voice, 1, 6
Trickster figure, 181–82, 190–93, 195, 197, 198, 200–202
Turner, Joe (singer), 73
Turner, Joseph (artist), 71
Turner, Victor, 190, 191, 192
Twain, Mark, 88–89
Twelve Thirty, 166

"Unfaithful Wife: A New Philosophy, The," 30, 137, 139
Utrillo, Maurice, 71

van Gogh, Vincent. *See* Gogh, Vincent van
Velázquez, Diego, 217
Verlaine, Paul, 148
Vermeer, Jan, 72
Vernacular. *See* Black vernacular
"Vietnam," 33, 138–39
Visual arts: and Cubism, 8, 94, 208, 209–17; linked with Major's writings, 63, 90, 94, 152, 183–84; Major's background in, 68–72, 79, 162, 183, 208, 209; and influences on Major, 90; African American tradition in, 161; Major's double vision and, 161–72; Major's refocused emphasis in, 170–71, 172; and *My Amputation* as Cubist collage, 207–17

Vizenor, Gerald, 85
Voyage of the Sable Venus, The, 114, 115

Wadstrom, Carl, 122, 123
Walker, Alice, 6, 78
Walker, Margaret, 5
Ward, James, 122
Washington, Dinah, 73
Waters, Ethel, 4
Watts, Alan, 75
Wedgwood, Josiah, 108, 109
West, Cornel, 5
White Man, Listen! (Wright), 104
Whitman, Walt, 152
Wideman, John Edgar, 6
Williams, John A., 149
Williams, William Carlos, 64, 66, 73, 77, 152
Wolfe, Thomas, 80
Woodruff, Hale, 161
Woolf, Virginia, 4
Wright, Richard, 1, 66, 67, 69, 148, 216, 251, 253; social concerns of, 80; as influence on Major, 90; on metaphorical use of black people, 104; Major on feeling vs. ideology and, 148; and pessimism of *Native Son*, 251, 258
Writers Workshop Anthology, 77

Young, Al, 219
Young, Lester, 73

Zuni, 8, 227–40, 248–51; nonlinear narrative of, 84–86